→ 5y5t3m 0K

R0M 0K

R4M 0K

→ L04d1ng...

→ WipEout: Futurism
→ The Graphic Archives

→ Duncan Harris

Foreword by Ian Anderson
With over 400 illustrations

 →

CURLY S4Y5 G0!

C0nt3nt5

→

305

Somewhere in the tDR-kive™, lost in space down the back of Dexion overloaded with Techno probably stuck between the pages of a '90s Japanese cyberporn mag, is a time-faded fax from Psygnosis to The Designers Republic™. On it there are eight words.

‘Re: *WipEout*. Change the way videogames look. Forever.’

This was the brief. Probably set in Arial.

Now then. *WipEout*'s design narrative is essentially one of time travel. Imagining 'what's next' based on near and far-fetched futures past and present, plundered then forgotten. And repeated.

tDR™'s *WipEout* work was never conceived or designed as game graphics, rather the birthing of a world, and everything in it, for the game, or more accurately the Anti-Gravity Racing League, to inhabit. I've never been a gamer and the original design concepts and narrative (proto-lore) never really considered gameplay at all. tDR™'s mission was to construct an environment designed to direct player behaviour both in and post-game. I loved to watch the otaku worship at the arcade altars of 'the amusements'.

We weren't designing a game set in the future, we were designing The Future itself because we were bored waiting for it. Our reference points being near/next future fiction, and the utopias/dystopias us mortals create (and typically spoil… and why).

That future needed to be expressed in terms of the present so people playing 'now' could make sense of its nonsense in a world before virtual reality was a commodity, and when Artificial Intelligence was just an album on Warp Records; where the heavens were no longer a confusion of astral gods and horoscopes, but felt like they were about to become dirty-luxury holiday destinations.

We wanted to stretch (beyond belief) the finite world Nick Burcombe and his team had created, populate it with client-free designs for product-free brands and opinion-free characters with potentially infinite reach, relatable to and identifiable for players in the right here right now back then. If the gameplay was to feel more real, we had to design as if for a real world populated by real people (hung up and strung out on real people's obsessions and belief systems) to engage with.

We wanted to create something emotive enough for the in-game's teams and pilots to inspire the partisan allegiances football teams do, something to identify with tribally – a game played by the few, but debated and argued over by the many.

We needed to translate pixels and LEDs into something visceral. How can a two-dimensional experience be made flesh? The 'reality' is we already experience(d) most of what we think we know via TV. Whether you choose to believe what you see is always a question of faith, of what you want to see. In that sense driving pixels around a screen is no less plausible than watching 22 people chasing a bag of wind around a field, or people arguing over whose imaginary friend is better.

How would 'we, the *WipEout* world people' be? Who would be the audience for anti-gravity racing pre/post *Fifth Element*? It had to be more than an evolution of Formula 1 (even before life imitated art with F1's 2017 rebrand). Or would it be closer to *Rollerball* and *Death Race 2000*… or maybe a religion?

If it's true we read best what we read most, what would we be reading in 2052? Would we be reading? Would typography be reduced to a kanji-esque iconography? How would brands, products and influencers guide us to feel happy thinking what we're 'supposed to be' thinking? Would the AG Racing team we supported be dictated by nature or nurture? Or would everything be so fucked we wouldn't care anyway?

→ Th3 P5ygn0515 R3v0lut10n [1984−94]

Any child of the UK rave scene knows the feeling: life accelerating to the point of standing still, a blur of colour and noise that's suddenly in focus, everywhere and forever. And then, it's over. *Did all of that really happen?* →

↓
Shadow of
the Beast
(Reflections,
1989)

↓↓
Shadow of
the Beast II
(Reflections,
1990)

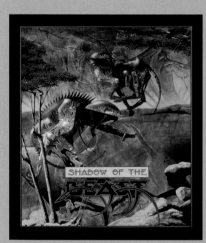

The videogame *WipEout* was, for what felt like an eternity, the essential PlayStation experience. A game from beyond gaming, that married blistering 3D graphics and narcotic tunes to hyperactive marketing and design – feel free to swap the adjectives. It birthed the notion of games as post-pub entertainment. Sequels attended the launch of almost every Sony console, home and handheld, keying into whatever new futurism the technology allowed. Round and round, skirting the impossible, a luminous Möbius strip. Then it, too, was gone, and life crashed back to normal.

It bears repeating that *WipEout* is a racing game. Debuting in September 1995, scarcely anything about its artwork or even vehicles told you what to expect, and what you got was as much a blueprint for the future of an entire industry as it was a product. Games weren't just leaving the bedrooms they'd grown up in, they were breaking the sound barrier to escape.

Cut to 17 years later and the closure of developer Studio Liverpool, formerly UK publishing giant Psygnosis, left fans a new kind of dazed. How could such a niche product – a niche within a niche, even, being an arcade racing art game – have beaten the odds to deliver nine games across eight platforms? Then again, how could such elemental Sony software ever not be on a PlayStation? How had this not happened sooner, and why was it happening now?

● B0X1NG CL3V3R

As Merseyside cultural birthplaces go, the Shrewsbury Arms isn't exactly The Cavern Club. Over the river and into the village of Oxton, Liverpool, this cosy pub sits in a maze of lively Regency housing that really separates the men of taxi cab sat-navs from the boys. Its garden is such that, at the right place and time, the sun carves so deliberate a path through the landscape – over the historic skyline and harbour, up into the Wirral, through the terraces – that you'd think there was something mythic to the glowing circle of pints consumed by Jim Bowers and Nick Burcombe. And sure enough…

'I'm not kidding,' says Bowers, motioning around the table, 'it was this. A table of empty glasses. Two of us getting rat-arsed, doing what I always loved the most: brainstorming.'

Many have documented the origins of *WipEout* and much of this is legend: how fledgling game designer Burcombe was deep into the local rave scene, hooked on *Super Mario Kart* and convinced that playing his favourite tunes over Nintendo's in-game music unlocked a trance-like state of play, not to mention better lap times. Keen to share his discovery, he had chosen the vehicles to deliver it: the ships of 1990 Amiga racer *Matrix Marauders*, which was a critical dud but had a slick CG intro that Bowers had engineered. A few pints later came a vision: a retooled version of the oft-covered Fat Boys hit Wipeout, as engineered by The Prodigy's Liam Howlett, thrashing away as those ships raced round a track.

'Empty glasses usually result in creativity,' Burcombe laughs, crediting that occasion with the impetus and direction that indeed set anti-grav wheels (pads?) in motion. But that's not the whole story. The fact is that nothing would have happened were it not for the view through the bottom of those glasses. In 1994, that vista was of a political, cultural and technological maelstrom, which Bowers and Burcombe's employer, Psygnosis, was playing a pivotal role in.

With its iconic insignia, a metallic owl airbrushed by prog rock artist Roger Dean, Psygnosis was born from the ashes of Liverpool's Imagine Software. To know Imagine and really understand Psygnosis, one must first go back to the dawn of Britsoft itself as it existed in the north of England. The Winter of Discontent, the economic despair that had been felt so keenly in industrial cities like Liverpool, had paved the way for the election of Margaret Thatcher as Prime Minister in 1979. Recovery from the crisis became synonymous with autonomy and a free market. New technologies and liberated entrepreneurs would, it was hoped, save the country from recession – and nothing felt newer than home computing.

In 1981, early software publisher Bug-Byte set up an office in Liverpool designed to lure in people from the local computing scene, which was already a hotbed of emerging talents. Key to that community was businessman Bruce Everiss, former owner of one of the country's first specialist computer stores, which automatically made it a hub for regional hobbyists and academics. Keen to draw parallels

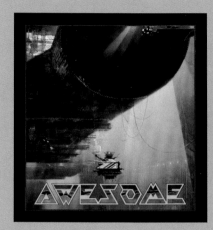

between Britsoft and Beatlemania (a path for working-class kids from the mean streets to global stardom), Everiss had an ear for hype and an eye for presentation, becoming Bug-Byte's marketing consultant and an evangelist for image-making and premium packaging. This focus on glamour, budget be damned, drove a wedge between Everiss and Bug-Byte's founders, and in 1982 he joined friend Mark Butler and finance director Ian Hetherington to form Imagine Software, bringing with him talented (generally considered an understatement) programmer Dave Lawson.

Lawson's first game for Imagine was *Arcadia*, a shoot-'em-up for 8-bit computers that was considered a graphical powerhouse upon release in 1982, and a breakthrough hit in the making. However, that would need a level of mass-market swagger that computer games barely knew they wanted, much less needed, but which retail veteran and hype man Everiss seemed born to deliver. He almost single-handedly convinced the gatekeepers of UK computer retail – in the early 80s this meant chemists (Boots) and newsagents (WHSmith) among others – to bring beautifully packaged games like *Arcadia*, *Alchemist* (a 1983 adventure game) and *Schizoids* (a 1983 shooter) out of the backrooms and to the attention of the general public. It signalled the first shots of a charm offensive aimed at the specialist press, European outlets and, increasingly, the UK tabloids, who thrived on the stories of a fledgling developer as much as the games themselves. Rags, riches, cars, consumption: the headlines couldn't get enough of them.

What citizens of Thatcher's Britain would discover, of course, is that none of this is sustainable, especially when the hype itself is so expensive. Imagine increasingly styled itself as a cultural revolution that warranted boundless growth, not to mention a large international distribution network, but its grandiose claims and projections – Butler, Everiss and Lawson claimed to be worth £10m each in 1983 – were increasingly under scrutiny, while the quality of games like *Zzoom* (1983, a shooter-cum-flight sim) and *Stonkers* (also 1983, a prototypical and buggy RTS game) threatened to give a reputation for gimmickry over gameplay.

All of this came to a spectacular head the following year with the announcement of *Psyclapse* (for Commodore 64) and *Bandersnatch*

(for Spectrum), a pair of Imagine 'Megagames' so notorious that as recently as 2019 they inspired an episode of the nightmarish sci-fi anthology show *Black Mirror*. A complete mystery in terms of genre and appearance, these were instead promoted – audaciously, even by Imagine standards – as the work of four company-groomed rockstar programmers: Eugene Evans, John Gibson, Mike Glover and Ian Weatherburn. 'Brought together to pool their awesome talents to create the two most sensational, mind boggling games ever imagined...' shrieked the press ad, 'will they maintain their sanity, or what's more to the point can you control your patience?' But after a catastrophic production gambit the previous Christmas that saw Imagine sat on hundreds of thousands of unsold cassettes, the question from some insiders was whether anyone was in control at all.

By the time the BBC documentary programme *Commercial Breaks* arrived to cover both Imagine and Manchester's Ocean Software, presumably to eulogize their success, stories were emerging of the former's unpaid creditors and production partners. With little progress to report on the Megagames, the *Breaks* crew instead found itself watching Imagine implode, the company forcibly dissolved on 9 July 1984. As historian Jimmy Maher writes in his brilliant and exhaustive *Games On The Mersey*: 'If the enduring image of the company's brief heyday would always be that parking garage full of exotic cars, that of the collapse would be a few dozen confused young men milling around outside a door that had just been locked in their faces.'

The dust was barely settling, though, when co-founders Lawson and Hetherington set up Finchspeed, a new software company that became home to several Imagine veterans. *Bandersnatch* morphed into arcade title *Brataccas*, and 'Psyclapse' became a publishing label – one of two, confusingly, along with 'Psygnosis'. Armed with the more sophisticated games, Psygnosis would survive to become nothing less than a treasure of 16-bit computing, and arguably a whole lot more.

On the Commodore Amiga, especially, it held peculiar dominion. Shedding the less desirable aspects of Imagine's business, but retaining the prodigious output, bluster and genuine vision, it bore all the hallmarks of the Megagames plan:

↓
Obliterator
(David H. Lawson,
Garvan Corbett,
Jim Bowers,
1988)

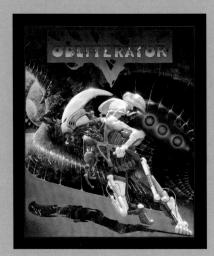

gorgeously wrapped products making technical boasts, priced accordingly. 'If you're asking so much for a piece of software,' Hetherington told *The One* magazine in 1990, 'you can't package it like a Brillo pad.'

The luxurious house packaging style – glossy black boxes blessed with logos and art worthy of sci-fi novels and prog rock sleeves, supplied by the very same artists – earned a cult following, as Burcombe recalls:

'We'd go to these consumer shows and Jonathan [Ellis, co-founder] basically wanted to clear out the warehouse to make space. Loads of stuff – *Captain Fizz Meets The Blaster-Trons* and any other shit – and he'd say, "Get it on a bloody van and don't come back with it."' Games and badges and T-shirts were thrown into crowds of adoring fans who'd wait until the show's bitter end to see what was given away. 'Everyone wanted those black boxes. The games looked amazing when you put them on a shelf.'

That the company was known for delivering style over substance, even in marquee titles like *Shadow of the Beast* and *Awesome,* didn't seem to matter. 'The criticism goes: the games looked great, smelled great, tasted great, but gave you indigestion after a while because they didn't have the longevity,' says Tim Wright, who, as 'CoLD SToRAGE', composed many a Psygnosis soundtrack. 'But you didn't care because the next one had come by then and yum-yum. It's like the demo culture: always another quick fix.'

Serendipitously, Burcombe's father owned the firm that printed all those boxes, which were stuffed with whatever merch would build the Psygnosis brand while justifying premium shelf prices. 'He'd come home with chromalins for *Brataccas* and stuff as far back as 1984, when Imagine failed.' Still at school, the junior Burcombe volunteered as a tester on games like 1987's trader-shooter *Terrorpods.* 'To be stood in front of people like Garv [Corbett], with his hair down to here, just blew me away. To see how it was put together, then learn how it was put together. You always wanted more.'

Burcombe was offered a job by Psygnosis in 1989 and 'bit their hand off.' He was employee number twelve; Bowers was number eight.

● BL4CK L1GHT
During the 1990s, the pillars of Psygnosis – the technology, artistry and willingness to

let gameplay take a backseat – had made it the perfect company to sell expensive Amiga hardware. Below-the-line format wars may break out every day between tribal Xbox and PlayStation fans, but before there even was an internet those wars were fought with nukes – and no one brought the fire like Psygnosis.

'They'd put an extra couple of disks in there just for the intro, which is insane when you think about it,' says Wright. 'But it's all part of the grandstanding. All those companies at the time, in the UK and Europe – it was almost like a big room full of jugglers and magicians, all doing their thing. "How did you do that? How do you juggle seven balls?"'

That question was often answered by Bowers, who used Commodore Amiga raytracing software Sculpt 3D (the flagship demo for which is, aptly enough, a juggler) together with Deluxe Paint III to create intros for games such as *Aquaventura* and *Awesome.* Don't let the name fool you, either: those slices of painstakingly rendered CG, mere seconds long, often outshone the games they 'introduced', and could sell an Amiga almost single-handedly.

'Customers were blown away by those graphics,' says Burcombe. 'Some of the best in the world, right? There were moments in some of those that no one could compete with.'

Presentation was king, and there is no overstating the pains that it often required. The average Psygnosis title screen was an exact replica of a game's box-art, ostensibly machine-scanned copies of the big-name art. In fact it had been meticulously built by-the-pixel in Deluxe Paint, the artwork traced onto acetate with a marker pen and literally stuck to an artist's screen. 'You had 32 colours,' recalls Bowers. 'You'd be dithering purples with greens. They could take forever, months to do.'

Psygnosis used an in-house art team, headquartered at the dockside Century Buildings, to unify games made by often very different developers. Its talent-first approach led to the publication of future giants such as DMA Design (maker of *Menace, Blood Money, Lemmings* and, as Rockstar North, the Grand Theft Auto series), Reflections (*Shadow of the Beast, Awesome* and *Driver*), Traveller's Tales (*Leander, Puggsy* and no small number of LEGO games) and Martin Chudley (*The Killing Game Show* and developer at Bizarre Creations).

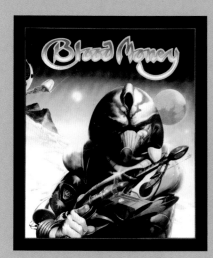

The head of this department was art manager Jeff Bramfitt, who Bowers remembers 'was only really interested in one thing: getting artists in who could actually draw and animate – and let the rest come when they got there. I'd never touched a computer before I started. They gave me an Amiga, sent me home, and a week later it was like, "Let's see what you've come up with."' Bramfitt himself insists that he only joined Psygnosis as an artist because he was desperate for a job, and only joined management because 'everyone took one step back and left me standing at the front.'

Meanwhile, Darren Douglas, an artist whose resume spans this entire book, was hired out of Birmingham University. He was a disgruntled graphic designer whose showreel was so full of 'goofy guys shooting space aliens' that he'd been assured he'd never find work.

'Jeff goes: "Do you like *Star Wars*?" I went yeah. "*Blade Runner*?" Uh, yeah. "Drinking? I think we can find a place for you here." And then he walked me to the bus stop. That was getting a job back then. He then proceeded to drink us senseless for the next few years of our lives.'

Bramfitt didn't hire artists for what software they knew because, generally speaking, no one knew anything. Instead, a love of sci-fi, animation and in particular 'old-school stuff like Ray Harryhausen' could get you through the door. Adverts were placed in *The Guardian*, an odd-sounding choice today, but one of few that made sense when the industry was still young and without attendant recruitment firms. Psygnosis operated a six-month probation period for hires to 'get their act together,' though no one was ever let go.

'Picture this,' says Douglas. 'The girl next to me was drawing some arty starfield type thing, and I'm copying this newspaper photo of Richard O'Brien, just a guy I liked off the telly. Just as I think I should be doing something even slightly clever, Jeff comes over and goes: "I see you're getting the gist of it. Now do us a dinosaur and we'll show you how to make it walk." I thought, I've made it!'

● TH3 T0M0RR0W P30PL3
So much that was to come, for both Psygnosis and Studio Liverpool, is explained by Ian Hetherington's unwavering belief in getting a head start on technology, coupled with a desire to nurture and enable talent.

Foreshadowing the kind of cross-platform, cross-generational bugbears that still exist today, Psygnosis emerged at a time when Commodore Amiga games were routinely hobbled by the need to support the inferior Atari ST. Without the Amiga's formidable graphics and sound chips – known as Agnus, Paula and Denise – the ST simply lacked the overall grunt of its competitor and found early success rebuking that. But today was never enough. Interviews from the time that promoted revolutionary 32-colour games like *Shadow of the Beast* wound up eulogizing 256-colour VGA PCs instead and lamenting the small market share of the Acorn Archimedes – an ambitious model due to its 32-bit ARM process, among other things. 'The markets just aren't there,' Hetherington told Advanced Computer Entertainment in 1989. 'We need machines that will…take the graphical element much further.'

His frustration with the landscape was understandable. Psygnosis had an enviable international distribution network that tapped it into key computer game markets of the time, such as Germany and Scandinavia. But not all of those countries had a large Amiga install base, and so many Psygnosis games were ported down to popular 8-bit formats, stripping them of their cutting-edge audiovisual appeal. Meanwhile, lucrative console licences were drawing many Britsoft companies towards platforms such as the Sega Mega Drive/Genesis, where it was hoped that American spending power would offset the up-front cost of those systems' proprietary cartridges.

'Psygnosis was actually hurting quite a bit on all that,' recalls Wright. 'One game in particular, *Puggsy*, ended up with lots of Mega Drive cartridges left over. And they'd been hurt like that before: there was the game *Nevermind*, where people would ask [producer] Steve Ridings for the sales figures, and he'd go, "Never mind." Some real disasters.'

This was partly down to that old Imagine vice of flooding the channel with software. But as early as 1990, Hetherington suspected something else: that the hardware itself had become saturated. 'There's no real difference between consoles and 16-bit computers,' he complained. The solution? Compact disc, which,

with its elegant form and tremendous storage capacity, had obvious appeal to a company known for image and animatics. But, Hetherington cautioned: 'It concerns concepts. What do you do with 600Mb when you can't get it off the disc that quickly? Walking around with a video camera or licensing film footage isn't the answer.'

It would take two years, by Psygnosis' estimates, for the necessary gaming hardware to appear. But the technology was so revolutionary, the leap so exponential, that the time to make the jump was now. 'Because otherwise, when it happens, you're going to be ten years behind, not two. You're never going to catch up.'

'This is where I have to credit Ian, in particular, and in some respects [product development manager] John White', says Burcombe. 'They knew, whether through insight or information, what was about to happen. Amiga sales were dying and the costs of Mega Drive and SNES were through the roof. I remember a pep talk by Ian about how games would end up looking like movies, like television. This is back when we were dealing with sprites. To hear all that... I was starstruck.'

The future, quipped Hetherington to the press, would be 'new with a capital N'. Whether he meant it at the time or not, history recalls that this meant Nintendo, which had been working on a hybrid CD console with Sony since 1988. Psygnosis' two-year estimate was thrown into disarray when a rift emerged over the control of the new medium, which challenged Nintendo's strict cartridge-based licensing model. The partnership fell apart literally on the eve of the console's big reveal at the 1991 Consumer Electronics Show. Nintendo retreated to a cartridge-first stance for its new next console, the Nintendo 64, but needless to say, Sony had other plans.

This was somewhat incidental to Psygnosis, who, as a publisher, was more focused on the disc than the machine housing the drive. Specifically: what do you put on it, and how do you get that off? This was the express concern of its Advanced Technology Group (ATG), founded in 1991 and home to Bowers, coders David Worrall and Paul Frewin, artist Neil Thompson, technical director Dominic Mallinson, and crack Imagine programmers John Gibson and Graham 'Kenny' Everett.

Chief designer was Richard Browne, Psygnosis employee number 33, who 'wasn't even allowed in the ATG for the first few months of my employment. It was the hidden door that was always locked.' And behind it? The sum of Psygnosis' CD-ROM research: the Fractal Engine, designed to stream pre-rendered graphics off a disc and into a game, effectively making playable the Bowers intros of old.

A demo, *Planetside*, depicted a realistic 3D landscape scrolling fluidly beneath a player's fighter jet, which wowed members of the trade and press. 'What you are about to see is a prototype of a future interactive experience', it proclaimed, as Hetherington boasted, 'We're more likely to make a good interactive product than say Warner Bros. or Columbia.'

Planetside was never that product, though. It was nothing more than a render demo designed to woo the press. Psygnosis' actual CD debut was supposed to be a Star Wars game it had pitched to George Lucas, for which Bowers 'made this frickin' amazing 3D stormtrooper running,' recalls Browne. The ATG had received its first Indigo workstations from high-performance computing firm Silicon Graphics Inc., 'and Jim and Neil Thompson basically hoarded them.' All, it should be noted, before Silicon Graphics' Indigo computers rendered the dinosaurs of *Jurassic Park*, the first of eight consecutive Academy Award winners powered by its machines.

'It would have been January 1992 when Ian flew to San Francisco with that Star Wars game,' continues Browne, 'only for Lucas to basically can it.'

The fallout of LucasArts opting to make its own FMV-driven rail shooter, 1993's *Star Wars: Rebel Assault*, was Hetherington signing a deal with Fujitsu to make a game for its CD console, the FM Towns Marty. *Microcosm* became a poster-child for the new medium, with its SGI rendering, six-gigabyte intro (before compression), original music from Yes frontman Rick Wakeman and an Imagine-worthy development budget reported to be in the region of $750,000. It arrived at just the right time to make the first cover of illustrious games magazine *Edge*.

As Fujitsu ordered a follow-up in the form of *Scavenger 4*, known on other platforms as *Novastorm*, Hetherington and his colleagues

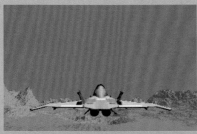

built Psygnosis into a very capable (and, it must be said, saleable) organization. Satellite studio Psygnosis Stroud, formed from the ashes of famed simulation publisher MicroProse, was joined by new subsidiaries in Chester and London. The company also moved into devkit manufacture, enlisting Martin Day and Andy Beveridge (who engineered *Xenon 2: Megablast* and 16-bit devkit SNASM under the banners of The Assembly Line and Cross Products respectively) to create Psy-Q, a standardized toolset for CD platforms.

Browne indicates that Psygnosis had many suitors in the run-up to 22 May 1993, before the following made it official:

> *Sony Electronic Publishing Company [has] acquired the Liverpool-based computer and videogame software developer and publisher Psygnosis Ltd., a recognized leader in videogame and CD-ROM products. The acquisition of Psygnosis significantly enhances Sony Electronic Publishing's in-house development capabilities. Psygnosis will continue to market and distribute computer software under the Psygnosis brand, as well as develop software for Sony Electronic Publishing's videogame division.*

'It all dates back to *Mickey Mania*,' Browne explains.

Developed by Traveller's Tales, and notable as the debut of *Twisted Metal* and *God Of War* mastermind David Jaffe, this visually extravagant platformer was something of a courting ritual between Sony Imagesoft and Psygnosis, and the first of several games based on Sony-owned IP. These included *No Escape* ('horrible Ray Liotta movie,' complains Browne), *Mary Shelley's Frankenstein* ('lovely Kenneth Branagh movie') and the Arnold Schwarzenegger juggernaut *Last Action Hero* ('clusterfuck across the board').

These were made by Psygnosis Liverpool, with London collaborator Bits Studios providing ports to other platforms. Martin Linklater, a local graduate who joined Psygnosis during *Microcosm*, remembers the day when management walked into the Century Buildings, some 400 yards from the ATG and marketing teams. The artists and coders were shown an SGI-rendered fly-by of a castle. '"Right,"

they said, "go and make that, you've got nine months." No producer, no designer, just us in this unit cobbling it all together. And those were truly awful games, no structure or anything.'

Cliffhanger, based on the Sylvester Stallone movie, was 'a truly disgusting piece of software' according to Future Publishing's *Mega* magazine. Never one to be outdone by his A-list rival, Arnold Schwarzenegger decided halfway through the making of *Last Action Hero* that he'd stopped liking guns. 'One poor guy spent a year animating him before it was decided Schwarzenegger was a comedian,' recalls Bramfitt. Worse, what started development as a side-scrolling shooter had to be reworked into a fighting game. And by 'fighting'…

'Arnie wanted people in his games throwing pizzas at each other,' laughs Douglas,' who joined Psygnosis right in the middle of *Frankenstein*.

'Christian Ramsay Jones, who was a new producer at the time, said to me: "Do us Helena Bonham Carter in a dress and we'll have her for the beat 'em up section." I tried to give her some dignity but ended up with this 32-pixel character with heaving bosoms in a bustier. I remember Nicky [Place, artist] coming over and whispering, "Darren, get rid of them boobs." Then: "They're still too big, take another pixel off." Those were the battles I was having.'

Bram Stoker's Dracula, meanwhile, starred team member (Bruce) Lee Carus performing the martial arts upon various ghosts and goblins. Linklater sighs: 'We just needed someone who could punch and kick.' Blue-screening Carus into the game meant the urgent unspooling of giant rolls of blue paper 'to the sound of popping light bulbs at three in the morning.' *Mean Machines* magazine lauded the pioneering effects, but prescribed for the game itself 'a good dose of the rough-hewn stakes.'

These early days of multimedia, hard to describe nowadays with a straight face, saw an orgy of full-motion video. 'If you could write a video player on the Mega CD you were hailed as a programming god,' says Linklater. As predicted, getting video playing from a CD-ROM was the pinnacle of technical achievement. Turning it into a game, however: 'Well that's basically storytelling, and we didn't have anyone who could write. We were programmers and pixel artists just doing our best.'

● 5T4T35 0F PL4Y

Browne would like it stressed that Sony did not buy Psygnosis to thrust its culture and IP upon it, but rather 'for its talent and publishing wherewithal.' With the latter it would grow its nascent game distribution empire into Europe via the London office of UK executive Phil Harrison; the former would supply software – games and the tools to make them – from a loyal network of developers. Central to it all was a new console, delivered to the Advanced Technology Group in Liverpool as the 'PS-X' development unit, soon to be known as PlayStation.

What Bowers remembers as 'a prop from Doctor Who' was 'unbelievably noisy,' adds Burcombe, 'basically a photocopier with fans strapped everywhere.' Documentation was written entirely in Japanese and the unit was determined to only talk to a Sony NEWS Workstation, which the team could only source from the backroom of a Sony store in Basingstoke. 'I don't think even Sony knew what that thing could do,' says Bowers.

Clearly, something homegrown was needed if anyone was going to make any games. SN Systems' Psy-Q would thus lay the foundation for systems still making PlayStation games today.

Browne fondly remembers the first PlayStation development conference, held before the best and brightest UK developers in late 1993, and so early in SCE's European history that the floor of the Great Marlborough Street office was still being laid that morning. It was the first time anyone outside the company had seen the famous dinosaur demo up and running. 'We had the best in the business sitting there going, "How are you supposed to do this?" They'd all been working in 2D. They just didn't know.'

Microcosm and *Scavenger 4* had taught Psygnosis the whys and wherefores of using full-motion video, and the arrival of id Software's *Doom* in 1993 put the potential of interactive 3D worlds beyond doubt. In 1994, Psygnosis published *Ečstatica*, an eight-year project by Andrew Spencer that used ellipsoids rather than polygons to achieve organic-looking models. The ATG had built prototypes such as a mecha game set in a polygonal 3D city, which would later become 1996's *Krazy Ivan*.

'Things got sorted out at Psygnosis when that stuff started happening,' recalls Linklater. 'FMV [full motion video] games were just filler: once you got past generating it and decompressing it in realtime, there was nothing interesting left. Then 3D happened and we understood: It's about miniature worlds. It's about content.'

It was a time of fierce creativity at the Liverpool docks: a work-hard, play-hard culture of 'constant crunch,' remembers Linklater, apparently unchecked by Sony and left to flourish by the top brass. 'There was this sense, in the Century Buildings especially, that you were at the beginning of something and there was an opportunity to play,' says Steve Gilbert, who joined the company in 1995 just before its move to the nearby Wavertree Technology Park.

'A lot of times we'd pile into a car at two in the morning and drive around just trying to wake up. Windows down, loud music, going through the tunnels between the Wirral and central Liverpool, just clearing the cobwebs. There was a butty place in the Century area where you'd go and get your kickstart coffee for a 36-hour shift. That's not a culture you can create, though I've seen a lot of middle-of-the-road people try. You need people with a very joined-up vision of what they want to do, somehow in a position to do it.'

We won't be seeing a 'Wolf Of Wavertree' any time soon, but anyone familiar with early-80s Atari knows roughly what happens when innovators work ungodly hours and need to unwind. What happened in the clubs that inspired *WipEout* must stay there, we're assured, in venues like Voodoo at Le Bateau ('pure techno, small and underground,' says Burcombe), the Blackburn Raves and Bootle's 'amazing and electric' Quadrant Park. Tim Wright, meanwhile, was driving around Liverpool in a bona-fide tank.

The Daimler Ferret 'was a bit of a cry for help,' he admits. It cost him £4,000, and the only guarantee from the seller was that if you had to brake hard while towing it down the motorway with a mere-mortal car, you'd never know what happened next. Its V12 engine 'ran on anything from petrol to chip fat'. Wright looked inside when he got it home and found US army helmets, a Geiger counter and a Bren gun.

'I was young, my first proper relationship was going south and we'd all gone down to an American diner on the Dock road when I thought out loud, "Wouldn't be insane to turn up here in an actual American tank?" Everyone agreed, but

it may have been Steve who had to warn them that if I say something, chances are I'll do it. My mum, the poor woman, had it parked in her garage for two years. It was actually how I met my second wife.'

Steve Gilbert recalls buying a Shelby 427 off a fellow programmer. 'Nick and Nicky had the racing Clios with the gold trims and the rest of it, and being in Liverpool we of course all had our wheels nicked. Two of the guys had Subaru Imprezas and were clocked by the RAC office on the M5 who assumed they were stolen and called the police.'

But things would start to change – because in stories like these they must – with the move to Sony's Wavertree office, a winged fortress of glass that remained a seat of Sony's UK operations until 2022. *WipEout* writer Damon Fairclough explains:

'When I first went to Psygnosis, in 1994 when it was in the Century Buildings, people from other departments just wandered in and had a chat. It all seemed very fluid. But that really did stop over the next three or four years. Even the architecture of Wavertree meant it felt fractured: marketing in one department, development in the other and security doors in between.'

Sony's use of Psygnosis' publishing might had given it an eye-popping 80 per cent market share in software sales for Christmas 1994, but questions were being asked of where in that sprawling organization money was being spent. Founders Hetherington and Ellis were, by all accounts, generous employers, Burcombe recalling how wages were bumped up before the buyout 'to make sure everyone got a decent pay-rise out of it.'

'None of us really knew how lucky [we] were at the time,' says Gibson. 'The amount of arguments there were about pay or when we'd get bonuses. I don't think any of us appreciated how much we actually were getting paid by UK standards. We were young, arrogant and always pushing in every way.'

Decades later and the sun is setting at The Shrewsbury Arms. Burcombe leans towards his friend. 'Think about it, Jim. All the technology that's now mainstream for movies and has crossed over into games, it's all founded on the stuff that was done years ago on those Silicon Graphics machines.'

Indeed, it speaks to the small teams, big personalities, glorious boasts and wondrous feats of what we must now call 'the early years' that, as the sun more figuratively sets on its people, gamers remember Psygnosis with reverence and nostalgia, regardless of what went on at Imagine.

Ian Hetherington passed away at 69 years of age in December 2021, David Lawson just three months earlier, at 62. 'Dave has always meant a lot to me because he gave me my first job in the games industry,' recalled 'eternally grateful' programmer John Gibson (of that famed Megagames quartet) on social media. 'He took a gamble on me when I had nothing to commend myself to him other than my enthusiasm.'

Of Hetherington, amid an outpouring of thoughts from careers he touched – sometimes quietly, but often profoundly – Richard Browne wrote: 'Ian knew where the future was headed. He invested insane money...and he insisted everything we rendered would be done in real time one day. He gave so many individuals the kickstart to incredible careers. He'd move all the obstacles out of the way of small teams, so they could focus purely on writing the games of their imaginations. He was Willy Wonka! I would have walked on hot coals for him at any time. Pretty much everyone at Psygnosis would do the same.'

'Everyone has their version of events with Ian and the rest of it, but Psygnosis facilitated so much by just letting it happen,' continues Burcombe. 'Everything was connected back then, and reflected in our personalities and our lifestyles and what we did at that company. The politics, the rave scene and those moments we just wanted to capture and make again, for ourselves and anyone else. Get lashed, bounce ideas and maybe, you know, make it all into a game. And then we did.'

Th3
Futur3
→ Th3
Futur3
of
th3 Futur3 [1994—95]

'I suppose Tom Cruise deserves some of the credit.' Before Jim Bowers and Nick Burcombe got themselves trolleyed enough to invent one of the most important videogames of the '90s, the former had been called into a meeting.
'I was told we had to come with a game, and I'd just watched *Top Gun* and *Days Of Thunder*. That's why we made *WipEout*,' he deadpans. →

Whatever, there's a lot more to its inception than just *Super Mario Kart* and pints. More even than the barely modified ships of *Matrix Marauders*, which Bowers notes 'was released on Psyclapse because it was shit.'

For one thing, like so much in 1994, *WipEout* was a rebuke to the Conservative UK government's vindictive Criminal Justice Bill, which, among other things, gave police powers to 'remove persons attending or preparing for a rave,' citing 'the emission of repetitive beats' as a cause of 'serious distress' to locals. Burcombe, a clubber as well as a developer, was thus loyal to two snowballing youth movements, one of which was under attack, the other of which could fight back.

Then there was the dynamic between the two creatives: Bowers the rendering maestro, Burcombe the company's first Gameplay Director – whatever that meant. 'Try and make this play in any way, shape or form,' he suggests. 'Well, we needed a game designer or something,' adds Bowers, and when producer John White made that official, the first game for Burcombe was Danny Gallagher's *Aliens*-inspired first-person shooter, *Infestation*.

'Danny was a wonderful lunatic from Leeds,' he recalls. 'Blonde-haired lad, black Peugeot 205 GTi. Used to skid around the car park out the back of Psygnosis.' The company had just published Gallagher's bike game *Red Zone*, having urgently dropped its original title 'White Line Fever'. *Infestation* 'wasn't great,' admits Burcombe, 'but it got good reviews.'

Bowers and Burcombe then worked closely on *Microcosm*, a man-sized lump of pre-rendered graphics in which the player is shot into the arm of an executive poisoned by nano-machines, leading to on-rails shooting through some very lifelike human guts. Though old-school Psygnosis in a lot of ways – light on gameplay but huge on tech – it's the game Burcombe believes put it 'square in the right place at the right time, because Sony then showed up and went, "Who knows how to fill a CD up?" And we'd done it.'

Sony's acquisition of Psygnosis in 1993 made the Liverpool studio ground zero of PlayStation development in Europe, and all the immeasurable things that would come to mean. Artist Nicky Place remembers unprecedented security around the Advanced Technology Group in particular: 'The technology was in this secret room with

a keypad and paper over the doors. I wasn't allowed in there, wasn't even told what it was.'

'But there was a reason,' says Bowers. 'That stuff was under supermassive NDAs. They couldn't risk anyone getting in there. I mean – this was before the internet – can you imagine someone getting photos of PlayStation development at that time? The really early stuff?'

There was the machine itself, of course, with its abundant fans and legendary noise. There was the dinosaur demo, at first just a head you could move and manipulate, which became a full body with the addition of twin PCI graphics cards to the hardware. But just as important were the Silicon Graphics Indigo – and later, Onyx – machines, all of which arrived in Liverpool before being forwarded to hungry developers. 'Though there was that one occasion where I kind of borrowed them all for something for two weeks,' recalls Bowers, 'which management weren't too happy about.'

Sony's then-product development director Phil Harrison had called Psygnosis from his base in London. He'd been speaking to the production company behind *Hackers*, an upcoming techno-thriller movie starring Johnny Lee Miller, Angelina Jolie and some very '90s forecasts of where cyber-culture might be heading. An early scene shot in London's famed entertainment complex The Trocadero called for some cutting-edge 'gameplay' to help introduce Dade (Miller) and Kate (Jolie) – he beats her score, she mopes off, a cigarette hangs from an onlooker's lip – which is where Bowers' guerrilla rendering job comes in.

Though 'controlled' with two big PC flight sticks and shot from a lurching POV that would have you holding on tight to your lunch, this wonderfully anachronistic sequence is still unavoidably *WipEout*. The ships, the construction-tape track details, the PlayStation logos… If it weren't for it playing more like the trench run from *Star Wars: A New Hope*, with spherical bombs and targets, people would have called it alpha footage.

Bowers winces. 'That was just a mental period. A few weeks of nuttiness. The actors would be down there for this two-day shoot, and I just had to say sorry to everyone at Psygnosis 'cause I need all the kit to get the rendering done. We'd got a proper opportunity

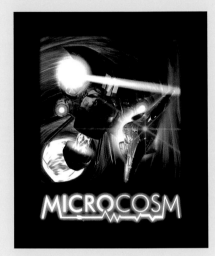

there. A couple of us literally didn't sleep for six days straight.'

With art support from Psygnosis residents Andy Ellen and Digby Rogers, Bowers enlisted Burcombe to help design the segment, making it a kind of pre-visualization-cum-vertical-slice or, as Burcombe sees it: 'The perfect design razor. We'd tried a load of things with pop-up walls, shooting balls into spaces, all of that. *Hackers* made it very easy to say what *WipEout* was and what it wasn't. I've designed games for 30 years now, and drawing that line has got easier thanks to moments like that.'

Bowers nods vigorously. 'It's all a decision-making process. In any creative endeavour, as soon as the decision-making goes to pot, the whole thing goes. Are we going to make this red or blue? Round or square? It's stuff that simple. You can amble around with ideas for ages and ages, but with *Hackers* it was, "Right – fuck – these people are waiting for this footage." It didn't go brilliantly to plan, either, but we could start showing people what we'd been thinking.'

● XP4ND3R
Prior to joining Psygnosis as a 'marketing designer,' 'creative disruptor' or whatever else the higher-ups would pluck from the ether, Keith Hopwood was a natural born advertiser. As a child he'd code up games in BASIC via the pages of *Sinclair User*, but take it further than most by then creating his own boxes and packaging. As he puts it: 'I always wanted to somehow combine the idea of doodling for a living with making games, but what was that? The whole industry was an unknown.'

He was hired in 1992 by marketing manager Maggie Goodwin: 'an amazing lady, so bright and full of energy.' There was product manager Sue Campbell, head of distribution Roy Barker (brother of horror novelist Clive): 'played the ukulele, amazing chap.' And somewhere in between would be him, 'to try and add more of a professional feel to the remit.'

He felt lost at first – because what did that that even mean? So, he went back to his roots, 'trying to take all the energy of the Liverpool and Manchester design scenes, screwing it up – I'm doing that with my hands as I'm speaking – and turning it into something professional in the creative showcasing of it all.'

At university, Hopwood harboured plans to set up his own design studio inspired by rising stars like Attik and Why Not Associates, the latter of which had recently changed the look and feel of fashion retailer Next. 'There was a heavily layered visual feel to those catalogues,' Hopwood explains, 'very typographically led.' From that perch, the homogeneity of Psygnosis' house style seemed strange.

'All around was this amazing artwork by the likes of Roger Dean, all framed on the walls. Maggie had lots of battles – positive, constructive ones – with Ian and Jonathan over ways to push the marketing.

The company had no shortage of aspiring partners; ad houses were pretty much beating down its doors. 'Some were quite exciting but the majority quite lame. They just didn't really get it, and the more of them I met, the less I felt we needed them.'

At the same time, Psygnosis' output was diversifying apace. Whimsical cartoon capers such as *Brian the Lion*, *Creepers* and *Wiz 'n' Liz* would strain the melancholic grandeur of earlier packages, using the topsy-turvy jocular styles of classic Britsoft to target younger audiences of the Commodore Amiga and Sega Mega Drive.

But when Psygnosis partnered with Fujitsu to make *Microcosm*, threatening the succession of CD cases over cardboard boxes, Hopwood saw his chance. 'I remember thinking, "This game is going to have no presence in that case." I never wanted to lose that heritage feel of the Roger Dean artwork. That was the roots. So, it was about stretching the imagination, bridging the gap.'

The result was the *Microcosm* limited edition, which quite literally brings together the jewel case format with the incumbent black box, one acting as a frame around the other. Opening this 'tamper-proofed' package meant going in via cardboard, manual and T-shirt before you could access any plastic, within which waited the game and accompanying soundtrack CD.

There was, of course, resistance from some of the company's senior figures. Challenging the orthodoxy of Dean and the big-box artists threatened the company's identity. 'And if you're breaking brand consistency then you're breaking the rules of marketing,' says Hopwood.

The team would meet weekly to try and solve that dilemma, looking at competitors, agencies

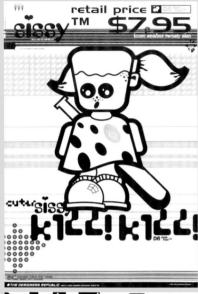

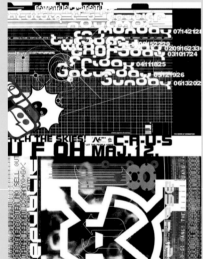

and increasingly the music industry. 'Games were being sold in Virgin Megastore and HMV, sharing a medium with the music on the next aisle. So, what were those guys doing?'

Hopwood's desk was a mess. 'People threw all sorts on there – but then if I'd have had my way, there'd have been things on the walls and windows, too.' Psygnosis artist Lee Carus had left one particular item from another of Hopwood's idols. So striking was it that a meeting was arranged at once.

● 3NT3R TH3 D351GN3R5 R3PUBL1C™
Founded in 1986 by firebrand designer Ian Anderson, tDR™ is a figurehead of the SoYo™ (as in South Yorkshire) movement, self-styled opponents of an older, supposedly stagnant design scene in London. Its style is one of Russian Constructivism bred with Asian logotypes and '90s information overload – altogether dubbed 'Nihonpop' by fans. But in truth it is more varied, as shown by tDR™'s work with electronic music label Warp Records. Much of its output is anti-establishment, littered with merry bastardizations of corporate brands and slogans. Now Keith Hopwood, a Sony man, was at its door.

'Ian was spiky,' he recalls. 'I'm embarrassed to say I was completely in awe of him and what they stood for. He was a bit dismissive which meant I was a bit downbeat. But really it was all about damage control, because the worlds of advertising and games had no real connection; agencies had wanted to dabble but the big names weren't interested.'

tDR™'s big four were co-founders Anderson and Nick Philips, Michael Place and Nick Bax. Bax, an art and graphic design graduate, had joined in 1990; Place, by his own reckoning a pugilistic academic failure – 'my tutors just did not accept sleeve design was a profession one could succeed in,' he said in 2007 – was mentored by famed designer Trevor Jackson at BITE IT! before joining tDR™ in 1992. Each would have seminal careers.

Bax was 24, Place thereabouts, while Anderson was early thirties. Bax had just returned from London studio Mainartery, designing for clients like Sony and EMI. 'Gaming,' he remembers, 'was geekier back then. I'm massively generalizing, but people into dance music and designing cool things were not into *Dungeons & Dragons* and

videogames. A lot comes down to the enthusiasm of the Psygnosis team kind of stroking our egos.'

Key to those discussions, and indeed to *WipEout* as a whole, was Psygnosis artist Nicky Place, later a senior artist on *WipEout 2097* and art director on *WipEout 3*. She was another of Jeff Bramfitt's local graduate hires – hired, she reveals, and almost fired. 'He said, "Sorry, you're not cut out for this," after my first three months but I pleaded with him. So yeah, I was nearly out the door.' 'And thank God you weren't!' snorts Burcombe. 'I don't think *WipEout* would have happened the way it happened.'

'My background was just completely different,' she explains. 'I was on the illustration course at Liverpool Polytechnic and didn't even know this world of games existed. A lot of them [at Psygnosis] were like, "This is all I've wanted to do since the Spectrum," and I just found it all very weird.'

When tDR™ was tapped to produce *WipEout*'s packaging, Place instinctively bristled at the art of the game itself, which, suffice to say, used a lot of bevelled metal lettering. 'I could see where it was going, which was the standard route,' she explains. 'I was saying to Keith, "This sounds ace but why are we stopping at the box?" And he was like, "Good question…"'

Microcosm had struck a chord with Hopwood. 'It was the whole *Innerspace* thing,' he explains, 'that idea of going inside of something from the outside. I was looking at that big box that was the initial PlayStation, then moving that dinosaur's head around, seeing all the processing power, and thinking: What if? What if the game wasn't this otherworldly thing when you start playing? What if the outside world could come in? What about the customer journey?'

Hopwood puts the cost of commissioning tDR™ at around £10,000, with eventual PlayStation retail units for each of its members thrown in as a sweetener. Bax confirms: 'It was just before Christmas when we took them all home, these massive boxes. We were so excited.' Hopwood just needed to run the proposal past Psygnosis boss Jonathan Ellis, banking on the thrill of a preceding game demo by Burcombe to seal the deal. 'It felt great. I got to talk about the what-ifs with the packaging, moving away from the screenshots and airbrushing…'

It almost cost him his job.

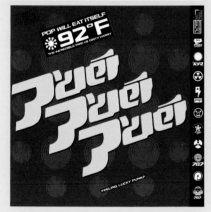

'I thought I was going to be sacked on the spot; Jonathan didn't like the idea at all. It was basically a case of, "We're not putting all this on the line only for it to fail." It was too far removed from where they were. And of course Sony was stepping in then, which meant a lot more people to answer to. The growth at that point was exponential, just way out of proportion.'

With some gentle persuasion, Hopwood got the green light on the understanding that if it all went horribly wrong, everyone would know where to look. And many, he remembers, already were. 'The feeling was, "Hmm, I've actually pissed a few people off here." People I used to have drinks with, and would still have to have drinks with because we were promoting all these other games as well.'

It was the artists who might have been the most irked. Artists such as Darren Douglas, who admits mistaking input for interference. 'We'd done this properly sporty HUD for *WipEout*: slanted F1-style graphics, drop shadows, the speedometer on a bend with a sort of kink in it. It was just the first thing you do if you're doing a racing game. Then, suddenly, "We're paring that right back down." I was like, "Rubbish!" And of course I was wrong.'

Invited into the process further than its industry had even been, tDR™ would design weapon icons (Anderson), team logos (Bax), pilot insignias (Place) and a growing miscellany of in-game artefacts, not least some of the giant trackside billboards built to hide many a technical sin. For them, of course, none of it felt as groundbreaking. tDR™ owed much of its early reputation to work with agitprop grebo band Pop Will Eat Itself, which it fashioned as a futuristic corporation making all kinds of consumerist noise, riffing off logos from Pepsi and McDonalds.

'In the 80s I'd go to this comic and sci-fi shop called Sheffield Space Centre, which is still there, and buy these little Japanese robot models that snapped together without glue,' says Bax. 'I bought them for the packaging, really, which was a big inspiration for the *WipEout* stuff. We had two big books of Japanese trademarks we called our 'bibles', and you could just take those into a dark room with a PMT camera and copy them for use as a starting point – an inspiration deck, if you like.'

Just as invaluable were team names and backstories fed from Psygnosis and Damon Fairclough, one of two in-house writers, who'd assign each other games by writing names on bits of paper and pulling them out of a bag. Fairclough, a tDR™ and Warp Records nut, 'couldn't trump the process but thankfully pulled out *WipEout*. I didn't work in tandem with tDR™ but knew what they were about, that way of implying worlds without spelling them out.'

If the world shared by Qirex, Auricom and the rest of the Anti-Gravity League feels more believable than many a story-based game, the secret is that tDR™ treated each of those teams as an imaginary client no different to Coca-Cola or Aphex Twin. It was, says Place, 'pure branding.'

'We were lucky that brands like AG Systems and FEISAR didn't have real CEOs telling us to change everything, but we approached it with all the rigours of a real branding process. That perspective, and the level of thinking it needs, made the world feel bigger and more tangible.' It also gave the game a visual language born in print rather than pixels, streamed across its box as if from the disc itself.

Bax explains how when he returned to tDR™ from London, he brought with him experience of layer-based design software such as Photoshop. Previous tDR™ work had been literally drawn and fixed on boards, marked up and put on a train to London for print. 'Mike made better use of it than anyone; he really got a head for intricacies and heavy detail, and the patience to make it work. Ian used to say at the time that while lots of people copied the style, they didn't get the thinking.'

It's the balance between negative space and information overload that takes the breath away when returning to *WipEout*'s cover. [p046-051] Haemorrhaging in-game type and iconography, its use of noise is clinical, foregrounding the ship, logo and flavour text. Necessary evils like a big PlayStation logo and hardware specifications don't just fit, but appear positively on-message, weaponized for war against rival consoles.

Then there's that stylized 'E', of course, which, even if it's not a recreational drug thing, is still naughty enough to mess up this book's grammar. And it really isn't a drug thing. Previously used on a tDR™ cover for

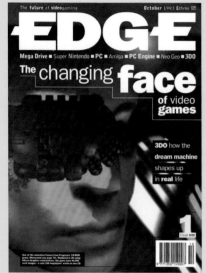

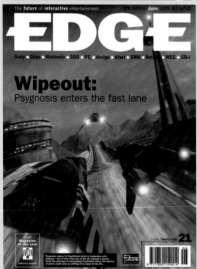

Joey Beltram's *The Caliber EP*, and before that for Sheffield community radio station Forge FM, its form is purely mechanical.

As Bax explains: 'The point with that font is that it's actually the number "8" cut in various ways to make up other letters, and that's just how you do an "E" when you're working in that scheme. Then we saw people referencing the game with the rest of the title all in lowercase. It wasn't intentional; we instigated that whole thing unwittingly.'

Alas, Hopwood's dream of a 'consumer journey' does hit an unfortunate bump when it comes to the game proper, which Place identifies as 'a complete artistic jamboree.' Wildly divergent ideas of what the future should involve literally take turns on tracks like Silverstream and Terramax, fighting for ad space on giant billboards. 'Basically, anything un-hip and un-trendy and really uncool is mine,' laughs Darren Douglas.

Case(s) in point: *WipEout: The Movie*, wherein a ship flies out of an explosion behind Richard O'Brien's head. 'Slime Creatures From Outer Space' is a tribute to a Weird Al Yankovic song. 'CAUTION: YETIS CROSSING' warns another. 'Anything that had people going, "What the hell is that doing in this?" is all me, I'm afraid.'

Douglas also remembers the pilot portraits that appeared after every race, for which Burcombe requested two of each character to cover whether they won or lost. 'I'm like, "Of course I can, but holy shit, Nick." I was pulling all-nighters to get them pilots done. The security guy's sat on my desk having a chat, while I'm thinking, "There's a reason I'm here at 4AM, mate."'

But at least it all meant he could get his stamp on the game despite whatever fears he'd had of a Designers Republic™ whitewash. It didn't go unnoticed, either. 'The only review I ever read of the game said it was "amazing, cool, trendy, on-point…" I was so happy. Then it said something to the effect of: "…except those shit Deluxe Paint characters at the end of each race. What were they thinking?"'

Douglas was also charged with the game's track textures, putting him at the coalface of a 3D revolution he felt 'was a little bit disappointing, if I'm honest. You could really get into detail with the pixels on sprite games, but now you were dealing with low-poly

models mapped with low-res textures, just a compromise all the way. It certainly wasn't a dinosaur stomping around, I'll tell you that.'

His first attempt at a circuit was 'ludicrously ornate. It had all these pipes and everything, these weird bits of repeating machinery I thought would be helping the ships move along. One of the programmers put it all on the track and it was like a kaleidoscope, just horrible.' So, Douglas went back to the basics of Jim Bowers' original renders and ended up 'with a mottled brown texture and chevrons that would have taken me an hour to do six months earlier.'

● T1M3 TR14L5
'What the flying fuck?'

It would be wrong to suggest development had gone swimmingly before Bowers was called into a meeting and told *WipEout*, to be sure of hitting PlayStation's European launch, was to have an already brutal deadline shaved by a further three months. Any notion that Psygnosis could have seamlessly slotted into the company making those decisions seemed similarly farfetched.

The ATG man recalls how, along with Dominic Mallinson and studio head David Rose, he had to 'go back and tell everyone, "Oh, by the way, guess what?!" We did a lot of that in those days, a lot of firefighting. A lot of stupid, nonsensical, arbitrary decisions being passed down. The overriding thought would be: "Are you trying to fuck this game up on purpose?" We've got direction now, we're getting there, and you're throwing fucking hand grenades into the opera.'

What may as well be called The Game Developer's Lament continues: 'Part of the creative process, especially the creative kind, is figuring out why they hate you. It's like Greek myth: the gods throwing thunderbolts down, with no rhyme or reason. People thousands of miles away, who could get some kudos from what you're doing, having to have their input so they can say, "I made this."'

Bowers hasn't discussed this publicly before, and now you can probably guess why. Nor has he made much effort to rejoin an industry that could certainly use his talent, whether or not it appreciated it. His subsequent resume as a digital matte painter (for movies such as *Casino Royale*, *The Golden Compass* and *Skyfall*)

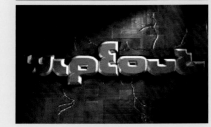

suggests he never looked back. Burcombe, conversely, never left.

'We were buzzing and we were young and we were mugs,' says the designer. 'If you added my hours up against my salary and thought about anything that was close to minimum wage, there's no way you'd have paid for that time. But I didn't resent putting it in at all. I absolutely loved it.'

Bowers bristles. 'It used to fuck me off. Certain people in management like to think it was for the love when really it was because they'd cut our fucking deadlines. What am I going to do? Walk out halfway through? Leave all that work? And we almost did have a walkout in one of the studios once.'

Both agree that the *WipEout* team was exhausted even prior to Sony's decrees. 'Really quite stressed out,' says Burcombe. 'Absolutely shagged,' nods Bowers.

It had started with the PlayStation devkit itself, arriving without SDK or (English language) documentation. Its tools were being built, from scratch, at the precise moment an artist needed them. 'All of those technical problems and the programmers were just going, "Try this. No? Okay, this?"' recalls Nicky Place, who cites the precipitous drop in track Altima VII as a prime example.

Designed to send players so high into the air that they could pick whereabouts they landed, the drop was trialled by Bowers and Burcombe during the work on *Hackers*. 'Could we execute in real-time?' asks the latter. 'Absolutely not.' The hardware couldn't draw far enough and so they literally covered it up, the airborne ships diving straight into a tunnel.

Not even gravity, it seems, could ease the struggle. When everything is new, every job is colossal. Exporting assets from Softimage as PlayStation-friendly 3D; stopping the foreground clipping plane chopping off all the polygons around the screen edge; juggling game and front-end menus in the console's limited RAM without it crashing. 'It was absolutely cutting-edge stuff,' says Burcombe, 'and incredibly dynamic because you'd just have to ditch things instantly. "Doesn't work? Fuck it. Kill it." We'd do something else.'

At worst, he continues, this saw 'the whole first half' of *WipEout*'s development scrapped because no one even knew what pixel resolution the PlayStation was expected to achieve. The UK's PAL format supported 576 visible lines, and the team had been pushing for a 640x480-pixel resolution despite suspecting the whole time that it wouldn't hold its framerate. 'A lot of learning' later and this dropped to 320x240px, at 30Hz.

'We didn't even have a functioning game when [Sony Computer Entertainment president] Ken Kuturagi came to the studio and said we'd never make it. And of course that was like a red rag to a bull for us lot. We were like, "Woah, woah, woah, we've put our hearts and souls into this!" Maybe it was designed to kick us up the arse. It certainly kicked us into focus.'

● PR0C3553D B34T5

It seems so obvious: a game conceived to be powered by music, delivered on discs designed to play music, published by an empire synonymous with music. What's there to explain?

'Didn't they send you George Michael?' asks Bowers. Burcombe sighs. 'Sony sent me a load of CDs to go through, and most of it was fucking shit. None of it had any street credibility at all. Bollocks.

'I get it: they were trying to promote this stuff internally as a music company. But it was just so far removed from the underground 12-inches we were listening to at the time, going to see specific DJs at the right venues.'

Burcombe handed Psygnosis marketing's Sue Campbell a wishlist featuring artists such as Carl Cox, but what came back was: '"We can't go with this. These aren't names. They're not Sony." So none of the tunes I originally wanted in *WipEout* ended up in it.' What he didn't know was that rave icons Orbital, makers of techno anthem Chime, were signed to a Sony subsidiary. What's more, when asked, they got it.

'Paul Hartnoll and I got on like a fucking house of fire,' says Burcombe, who was treated to an early version of P.E.T.R.O.L., an unreleased track deemed perfect for rollercoaster videogame racing. 'I'm sat in a meeting with Sue and these two guys, trying to explain my vision for this kind of out-of-body racing experience, and they didn't need it explaining at all.'

Then he told them he didn't like P.E.T.R.O.L..

'It was a little bit too sparse and broken up, and didn't have that driving ba-da-da ba-da-da that would absorb you into the race.'

Tim Wright laughs. 'I can't believe Nick actually went to see them and had the balls to say, "…Nah." And then rather than, "Fuck you!" Paul says, "Alright then!" and sends Nick a new version he was a lot happier with.'

Orbital were about the only people outside of *WipEout*'s inner circle who had a clue what it was trying to achieve. 'That game took a leap of faith from everyone,' says Bowers. Psygnosis had sold itself to Sony with a vision of filling compact discs with movies, and now it was talking about music and real-time 3D. 'There was almost no understanding of music licensing at all,' explains Burcombe. 'Sue wasn't into the rave scene or The Designers Republic™ or any of that, but she pushed really hard to get the company behind it, to understand it culturally.'

Somewhat surprisingly, this meant convincing Tim Wright as well. The Psygnosis composer was, by his own admission, 'an 80s man. Howard Jones, Nik Kershaw. Not that acid-house sampled chord shit.' But he was a fast learner, too. 'The perfect soundtrack guy,' says Bowers. 'Give him clear direction and he'd turn four violinists into a fucking orchestra. Or, yeah, do dance music!'

Wright's journey with Psygnosis had crossed the realms of 8-bit chip tunes and 16-bit samples to the now 'infinite vista' of compact disc. He was always learning, never comfortably. Known for his work on *Shadow of the Beast II*, *Lemmings* and a slew of older titles, he arrived at *WipEout* via then-unreleased mecha shooter *Krazy Ivan*.

'Big guys in metal suits,' he explains. 'Musically, that meant Industrial. I spent three or four hours one afternoon recording a lot of short-wave radio crap, even bits of distant radio stations. I listened to some Nine Inch Nails. The music for *Krazy Ivan* wasn't me at all, stylistically, but I did it. Then Nick came along with this demo and said they needed music that "made you want to go faster". I took that to mean I could adapt the whole angry industrial style to a rave BPM. I mean… He was very kind about it, really.'

Wright gave it another try but struggled to see what separated The Prodigy track 'No Good', which was being used as scratch music, from what he'd been listening to for *Krazy Ivan*. 'My brain didn't get it, the nuance. It was a scene I'd largely ignored. All those glowsticks and whistles… It just seemed a bit childish.'

So, Nicky Place took him clubbing. 'My experience of all that had been getting hammered, flailing about and going home before you vomit. But we just drank water. No drugs. And I got it: the subtle changes in frequency, in tracks that go on for 25 minutes.'

Scratch to three decades later and Wright's tracks for *WipEout* are as treasured as any of their licensed peers, to the point of there being fresh outrage every time they're omitted (as with Sony's 1995 *WipEout: The Music* album) or overlooked (by 2017's *WipEout Omega Collection* despite Wright offering them for free). 'Tim's tunes are as iconic as anything else in the game,' declares Burcombe, 'even if you'd be dead if you tried dancing to them.'

● THR33… TW0… 0N3…
On 29 September 1995, a game Nicky Place calls 'a car crash we just had to kick out the door,' joined *Ridge Racer*, *Battle Arena Toshinden*, *Street Fighter: The Movie* and others alongside PlayStation itself. Psygnosis wouldn't publish Reflections' *Destruction Derby* until October, making *WipEout* its only UK title at launch.

Place recalls, 'I remember standing there at the launch event in Manchester thinking, "Fucking hell, we've done it, against all those odds."' Burcombe was there, too, walking the line of customers and asking what they'd buy. '"*Ridge Racer*, *WipEout* and *Toshinden*," went the first guy. Then the next guy, and the next, and bloody hell, we're in everybody's list here.'

The game was far from perfect. Launch titles seldom are. 'The collisions were shit, all sorts of things wrong with it,' says Burcombe. But launch titles aren't meant to excel, they're meant to excite. Even the stringent *Edge* magazine, already a vocal supporter, conceded that 'it's hard to criticize such a beautifully realized and well-produced game which exploits the PlayStation's power so well.'

Sony's various TV campaigns merit a book of their own, made over the years by visual provocateurs like Chris Cunningham and David Lynch, each a finely crafted dose of unreality designed to shake the ground under gamers' feet. In 1995 they gave us SAPS (Society Against PlayStation), a made-up public interest group with a stark warning for buyers of the new grey 'bagel toaster' and its compact 'deadly donuts': Do not underestimate the power of PlayStation.

That enduring slogan has never just been about hardware. As *WipEout* pulsed out from demo pods sent to clubs and pubs, people who'd never even heard of Psygnosis learned what those hangers-on at the 16-bit computer fairs had known for years: when the owl locks its eyes on you, there's no point trying to escape.

'This is where that magic really came into its own,' declares former Studio Liverpool head Clemens Wangerin. 'I was at E3 when Psygnosis had its stand showing *WipEout*, and the fact that people were struggling with the game never put them off or stopped them being excited. Partly that was 3D gaming: nobody had a point of reference outside of the odd arcade machine. But it was also the allure.'

Writer Fairclough remembers the game's presence in Liverpool super-club Cream. 'It continually amazes me that such a rock-hard game was there, of all places. People were queuing up to play it but this was the mid-'90s, at the peak of that culture; everyone was absolutely battered. They were clunking into one side of the track then the other, and yet the mystique was building, this idea that this game was the future, that planets were aligning.'

This was a far cry from the weeks and months before, when development of *WipEout* felt tugged in every direction by indifferent forces. Bowers isn't blind to the idea that the slashing of the game's deadlines may have put it in the right place at the right time. 'Who knows: had we not been forced into that pen where decisions had to be made, we might not be sat here today.' (Suffice it to say Bowers disagrees.)

'Security called me "The Ghost of Psygnosis",' says Bowers darkly. 'The doors would be open in the early hours and there would be me. Adrian Parr, who was head of development but had been a proper MD of companies like Kellogg's, sat in a meeting with me once, looked at me and said, "Jim, what's it like to work for two days without sleep?"

'Certain people in management would have said for me, "You fucking love it," and that would justify them letting me do it. Adrian asked and I just said, "It's shit," and started crying.'

Steve Gilbert, the Psygnosis film editor who worked on several of its intros and promos, has similar memories.

'I didn't go home for about two or three weeks during *Colony Wars*. Jim was working all night on the animated sequences and I was editing; in the day he was rendering and I was doing post sound in Manchester. I remember someone having to drive in front of me down the M56 while all I could do was focus on their brake lights, thinking, "This is terrible, my family must never know."'

It changes people, suggests Burcombe, this need to make good in a world of ones and zeroes, pounds and pence. To be the only variable in the equation.

'You're only as good as the last thing you did,' explains the man who in the years since has set up studio Playrise Digital, which secured a £100,000 investment from his brother-in-law to make the game *Tabletop Racing*. He knew the money wouldn't last and so 'crammed it all in.' It almost cost him his marriage. 'That habit was learned at Psygnosis, on projects like *WipEout*. To me it was normal; to my wife and kids it was absolutely not.'

Games grew up thanks to games like *WipEout* – but everyone misses their childhood just a bit. Emblematic of a supercomputer cool that's defined consoles like PlayStation ever since, *WipEout* makes it all too easy to forget the people, and the pain, that made the future possible.

←

Initial logo
sketches
for *WipEout*
(Psygnosis,
1995)

Michael Place:
'This was from
the very first
round, very much
hand-drawn, where
it was just,
"Alright, let's
have a go."'

WIPEOUT
WIPEOUT
WIPEOUT
WIPEOUT
WIPEOUT

wipeout

wipeout

wipeout

Composite

WIPEOUT
WIPEOUT
WIPEOUT
WIPEOUT
WIPEOUT

Composite

← ↖ ↑
Further logo
tests, this
time created
in FreeHand MX

Michael Place:
'Being asked to
work on *WipEout*
was how I imagine
it was like to
be asked to work
on Star Wars.
"It probably
won't do very
well, this." But
then it becomes
the biggest
thing you've
ever done.'

Composite

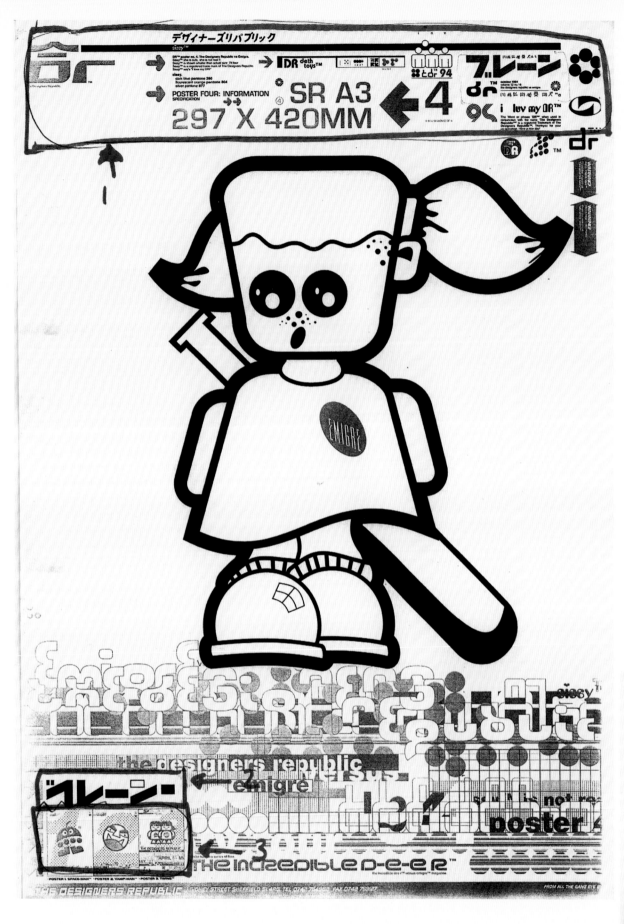

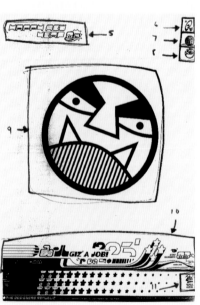

←

The Emigre cover annotated by Psygnosis

↓

tDR™ mascot 'Vampireman'

Michael Place: 'This is for the *WipEout* intro where Lee [Carus, Psygnosis artist] took the top of the Sissy poster and stuck it to the side of one of the ships. This was very typical of our style at the time: robbing and re-appropriating as much as we could.'

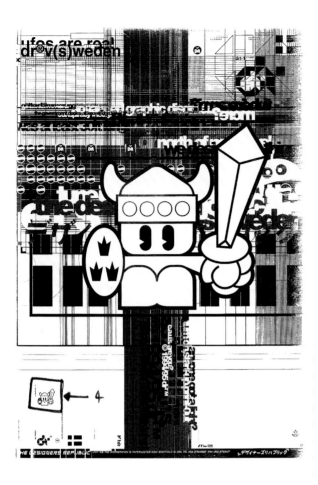

↓
A page of
artefacts from
the Emigre tDR™
issue

Michael Place:
'We'd take these
old Japanese logo
books, pick out
a logo for some
obscure Japanese
company, change
it a bit and
stick it on a
cover.'

↑
tDR™ mascot
'Viking-Man'

Michael Place:
'Sissy, Angry
Man, Sweden,
Emigre...All
these little
elements Keith
[Hopwood] was
either sent or
got hold of.'

0742 754 982

no. of pages. 1 this is page one.

If you do not receive all pages please call the number below sharpish!

to. Keith Hopwood

company. Sony Psygnosis

from. Ian

reference. WipeOut

date. 07.04.95

To Keith "GoodGuy" Hopwood

I'm sorting your stuff out over the weekend - it's got so chaotic here the end of this week that I'm really not getting a chance to get stuck in to the Wipeout gear. It's really just a question of drawing things up on screen as I've got most of it sorted in terms of ideas now - the only problem is that I desperately need another member in the team here as Gary, the lad I told you about, left sooner than I expected before I had sorted out a replacement! So... no pub for me this weekend!

I'm really sorry to drop you in it but you will be lauded and praised at the end of the day!

Call me on Monday when you get the faxes and we'll take it from there. I'm in and out today so please fax me if you have any comments about the stuff that was sent through the other day that you think might be relevant to the weekend work.

Bye.

From Ian "Bad-Guy" Anderson

the designers republic. address 1 sidney street sheffield s1 4rg. city post code. international dialing code +44 742 u.k. dialing code. 0742 voice. 754 982. u.k. dialing code. 0742 facsimile. 759 127.

Early discussions between tDR™ and Psygnosis' marketing department

Michael Place: 'Ian was "Bad-Guy" Anderson because he just wasn't very good with time. This would have been us delivering late... as usual. Keith was probably much more professional than we were.'

→
Early discussions
between tDR™
and Psygnosis'
marketing
department

Nicky Place:
'There's one
fax on the next
page where I've
written a note
asking if Ian
had "an e-mail
address". It
wasn't a given
back then, it was
just starting to
come in.'

facsimile

fao "Bad Guy" ANDERSON
from "Lordy-lordy" HOPWOOD
date 07.04.95

Chaos strikes back.....

Dear Ian "What-a-geezer" Anderson

Huh! Well what can I say except no pints this weekend - or perhaps you're gonna need 'em. Got those preliminary ideas which look good. The WIPEOUT logofont 0.2 works well with the Joey Beltram-esque face, although I liked the idea of having this italicised as you displayed on some of those sketches when we visited sunny Sheffield. And it has lost a bit of its dynamism (heh I know its a visual so I'll wait to see more on Monday). Works well with the outline, could it work with an overall outline encompassing the whole. How do you see the icon being tagged to it?

I'm not sure if Nicky has spoken to you directly yet but they've been dropped in it (me too also then) and it looks like we'll need the logo now for Thursday next week so it can be rendered into the intro in time. I believe thaere's a couple of changes to the weapons icons which I'm sure Nicky will confer with you later today.

If I can help in any way with the weekend Wipeout work give me a call at work today, or otherwise I'll be tied down to the computer at home over the weekend and call us there.

Best regards

Keith "Lordy-Lordy" Hopwood

Psygnosis Limited
South Harrington Building
Sefton Street
Liverpool
L3 4BQ

Telephone 0151 709 5755
Facsimile 0151 709 6466

but like I say it was a ____
discovery I made today.
Thanks very much,
ta-da Nicky.
p.s. do you have a e-mail address??

PSYGNOSIS ATG
Unit 310, Century Building, Brunswick Business Park, Liverpool L3 4BQ U. K.
Telephone: UK (0)151 707 0654 FAX (0)151 707 0439

Hello!
Please grant your permission
to use these wonderful stetches!
Nicky.

permission granted!
Michael DR
17/04/96

Nicky & Nick
Sony Psygnosis
Liverpool Dock Zone
Europe NW60098X

Ian Anderson, Ambassador for The Designers
Republic Free State, has instructed me to submit a
copy of our letterhead for your files. I look
foward to the Wipe'Out" Championships. I trust the
promotional machinery is in full place to maximise
Auricom publicity. Keith Hopwood has assured us
that we have exclusive exploitation rights for the
sport having bid higher than AG Systems. I am a
little concerned that despite the funds having
left our account, there is as yet no sign of it
registering in the Psygnosis World Fund.

Cirius K Technoburger
Auricom Research
AD1999

fax: 0151-707-0439

FACSIMILE

To: Ian Anderson
From: Nicky @ Psygnosis
Date: 7/4/95 No. Pages 84

Ref: Approval Please!

Hi,
Please could you look at the
following 3 pages at the ~~the~~ boxed
areas and tell us if it's ok to use the
_____ ___ way. The areas within each

PSYGNOSIS ATG

To: Ian Anderson
From: Nicky @ Psygnosis
Date: 18/4/95 No. Pages 1/2

Hi Ian —
I just received the faxes

What we want to do:

Finalise Ship Designs (5 designs - 1 each for the 5 teams) and build/texture them.

Current idea is to take existing 4 ships + 1 new one (which must be of a similar scale and shape)

Modify them slightly (make sure they all only have 1 central engine)

Colour them in fairly obvious colours so that effectively each team has a colour scheme (this colour scheme is to be confirmed by DR but will probably be 1 or 2 primary colours per team (e.g. Blue/Yellow for FEISSAR or Red/White for AG Systems)

Texture them with team logos and general textures

Then for each team/ship do 3 lots of number/id textures (there are 3 ships per team, therefore 15 unique ships). These id textures will probably just be numbers.

When we need it done by:

Part 1 - End of this week: 1/3 (Fri)

First of all get 4 existing ships (minus textures) and the new ship into a scene and converted into the game

Modify existing ships so they all only have one engine

Fix any model problems with other (new) ship

Colour them (gouraud or plain?) into their team colours and get that converted and into the game

Start on general texturing (e.g. dirt marks, engine housing, warning textures etc.)

Part 2 - After you come back:

Finish any general texturing

Modify colour scheme if necessary to fit in with DR logo colours (we'll have DR ideas by then)

Texture with DR team logos

Texture individual ships (3 of each type) with numbers/id's

Fri 2 - Laura to finish Track 5.

Mon 5 - Team meeting 2 (4 tracks complete).
 Laura to start new Track 8.

Tues 6 - Lou to finish Track 7.
 Nicky to finish Track 6.

F.A.O. Ian

Psygnosis Ltd.
Napier Court, Stephenson Way, Wavertree Technology Park,
Liverpool L13 1EH, United Kingdom.
Telephone 0151 282 3000 Fax 0151 282 3001

no pages: 9

Ian, Heres an updated schedule (some things are gone). I've asked nick to call you asap. tomorow (Tues) but he still has to think on names etc. The wipeart name won't be known for a while so that slot will obviously have to be rescheduled - I'll let you know whats best for us for least interruptions/disruptions! I've also included some useful info.
Speak to you soon,
Nicky ?!

REGISTERED IN ENGLAND No.1039371

DONG SEO INTERACTIVE INC.
560-11, DEUNGCHON-DONG, KANGSEO-GU, SEOUL, KOREA.
FAX : (02)3661-2918 TEL : (02)3661-0578

TO: Ian Grieve	COMPANY: Psygnosis
DATE: Feb. 29, 1996	PAGE(S): 1

Dear Mr. Grieve,

I have an issue which needs your cooperation as follows.

Regarding Wipeout, we are having some difficulties in getting an approval from the Korean Ethics Committee due to the appearance of Japanese words in the backgroud screen of the game. The mentioned agency does not allow any form of Japanese language within the game; neither voice nor screen text.

In order for us to get their approval, we need to delete the Japanese words or translate them to some other languages. Could you please let us know if you can provide any help to us regarding this problem?

Following is the Japanese words which the agency asked us to delete.

- バグ
- フーレソ
- 車体心ム
- 心ム等多数

Please let us know, if you want to check the above words within the game. We can send you a video tape which contains the related scenes.

Thank you in advance for your assistance in this matter.

Best regards,

Wipeout Character Designs

All the information regarding these characters are not finalised. If anyone want to come up with further or better suggestions for any of the characters' catagories or the characters themselves, please do - these are not strong enough in my opinion.

Team 1 - AG Sytems
Character 1
Name:	John Dekka
Alias:	"John Boy"
Sex:	Male
Age:	38
Nationality:	American
History:	One of AG Systems finest test pilots.
Height:	6' 0"
Weight:	198 lbs
F3600 ID:	DEK200.0.0.11
Appearance:	White - Square jawed hero - Smug
Ship Colours:	Yellow black and light green

✱ Character 2
Name:	Daniel Chang
Alias:	'Danny'
Sex:	Male
Age:	29
Nationality:	Chinese
History:	Defected communist test pilot.
Height:	5' 8"
Weight:	210 lbs
F3600 ID:	CHAN210.0.3.4
Appearance:	Chinese - Intense - compact - muscular
Team Colours:	Yellow black and light-mid blue

✱ Team 2 - Auricom Research
Character 3
Name:	Arial Tetsuo
Alias:	None

18/04/95 17:55 Fax from : 01142759127

Runes always italicised -10%

18/04/95 17:55 Pg: 6 Fax from : 01142759127

Runes always italicised -10%

WIPEOUT LCD RUNES

16.04.95
STATUS: WIPEOUT LCD RUNE VARIATIONS

CYBER-JAPANESE/ALIEN LCD ICONS BEING DECODED. I CAN SEND YOU
THE BASIC GRID - THE IDEA IS THAT IF WE ALL
USE THE SAME GRID THEN WE CAN ADAPT THE RUNES TO
WHATEVER WE NEED AND YOU DON'T HAVE TO CALL US
EVERYTIME YOU NEED ONE FOR THE CONTROL PANEL ETC.

Fax from : 01142759127

LCD RUNES **0.1**

←←
Further exchanges
between Psygnosis
and tDR™

↑ ↗ →
LCD glyphs
evolved from
Nick Bax's early
logo tests

Fax from : 01142759127

WEAPON ICONS

01.04.95
STATUS: INCOMPLETE [WORK-IN-PROGRESS]

TURBO/ELECTRO-BOLT/ECM POD DESIGNED AND IN PRODUCTION.

WEAPONS **0.1**

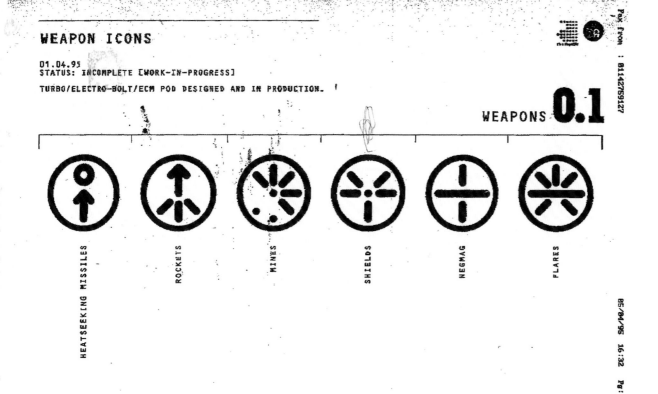

HEATSEEKING MISSILES

ROCKETS

MINES

SHIELDS

NEGMAG

FLARES

05/04/95 16:32 Pg: 2

09/04/95 17:06 Pg: 2

WEAPON ICONS

08.04.95
STATUS: AMMENDED PROPOSALS. COMPLETE SUBJECT TO APPROVAL*

*VARIATIONS EXIST FOR SHIELD/ELECTRO-BOLT/ECM POD/TURBO
ICONS. SEE FOLLOWING SHEETS (0.2/S; 0.2/E-B; 0.2/ECM;
0.2/T):
SELECTIONS HERE ARE RECOMMENDED!

WEAPONS **0.2**

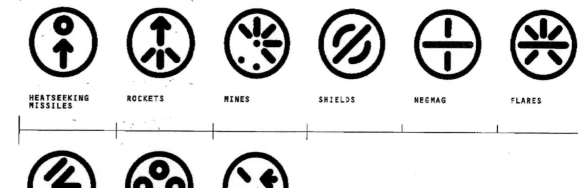

HEATSEEKING
MISSILES

ROCKETS

MINES

SHIELDS

NEGMAG

FLARES

ELECTRO-BOLT

ECM-POD

TURBO

↑ →
Weapon and
power-up icons
for *WipEout*
(Psygnosis,
1995)

Nicky Place:
'Nick [Burcombe,
game designer]
did a lot of
sketches around
these icons. He
was very well
versed in what
the game needed.'

Fax from : 01142759127

WIPEOUT LOGOFONT

05.04.95
STATUS: LETTERING COMPLETE

ACCOMPANYING GRAPHIC(S) / CHARACTER IN PRODUCTION
CYBER-JAPANESE/ALIEN LCD ICONS BEING DECODED. SPEED/MOTION
STRIPES BEING TESTED. PACKAGING LAYOUT ASSESSED.

LOGOFONT **0.1**

Fax from : 811427591Z7

APPROXIMATE ACTUAL SIZE ON PACKAGING

wipEout

ENLARGED FOR YOUR PLEASURE

wipEout

05/04'95 16:32 Pg : 3

© 1995 THE DESIGNERS REPUBLIC

↑
Early designs
for *WipEout*
(Psygnosis,
1995)

→
A billboard
design for
WipEout
(Psygnosis,
1995)

TDR:TM PRODUCTS
IT'S A FAX- 0114 275 9127

→

A prototype cover
for *WipEout*
(Psygnosis,
1995)

↓

tDR™'s
repurposed Pop
Will Eat Itself
font

titles2 22/4/95 6:15 pm

22/04/95 18:20 Pg: 2

Fax from : 01142759127

abcde
fghij
klmno
pqrst
uvwxyz

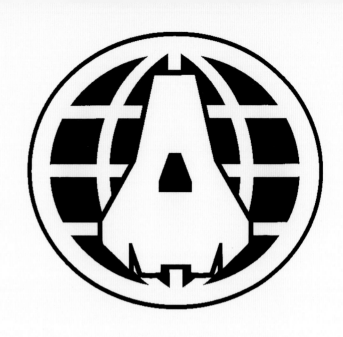

← ↖ ↑
Team and racing
league identity
concepts
for *WipEout*
(Psygnosis,
1995)

← ↙ ↓
Racing league
identity concepts
for *WipEout*
(Psygnosis,
1995)

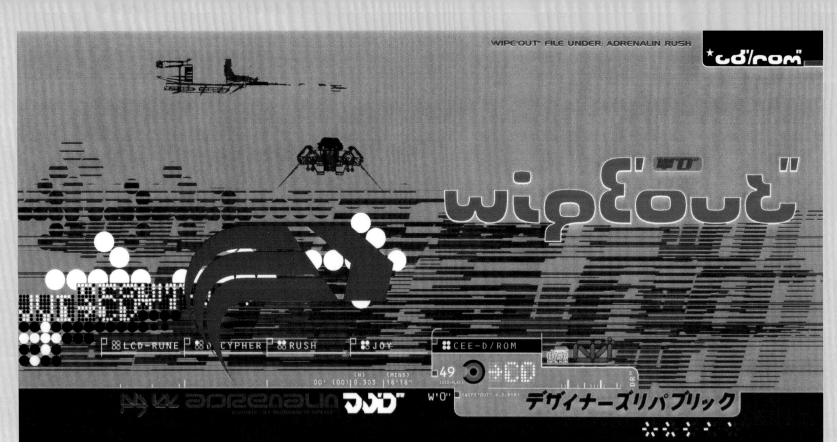

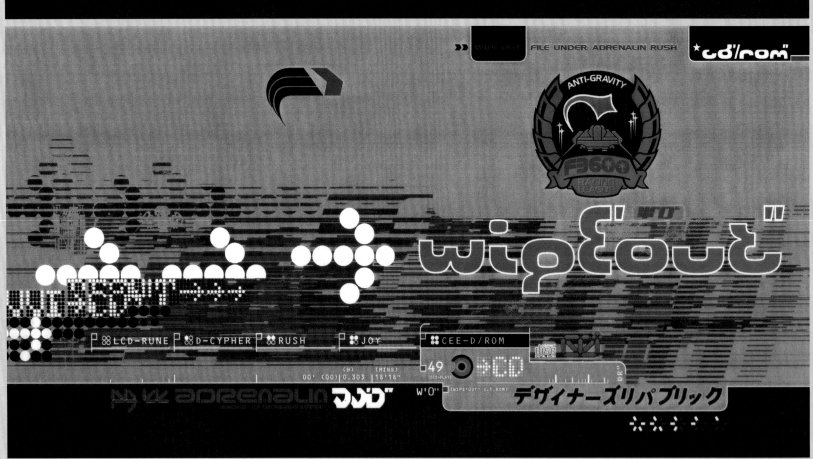

Box art
prototypes
for *WipEout*
(Psygnosis,
1995)

Michael Place:
'There was a bit
of a fight around
having to have
a ship on the
cover. We were
sent a ship in
3D so we could
manipulate it.'

A back cover
concept for
WipEout
(Psygnosis,
1995)

0:W1'P3"OUT"'

0:W1'P3"OUT"'

7243 8 2842-3

made in england

5 411659 169386 >

*cd'rom"

wipEout

W'O"

36K A-G RACING

WIPEOUT IS SPONSORED BY

ADRENALINE™ IS A REGISTERED TRADEMARK OF WIPEOUT

DR"

TM

2WO PLAYER HEAD-2-HEAD RACING (WIPE'OUT" 1745ff) (IN>TRO>>)

1700 POWERSTATION4 SRHT SINGLE CENTRALLY MOUNTED WEAPONS: QUANTAX D-MODEL 4
PRO-AM PB90 ENHANCED QUAD FINS FEISAR4 ARMACALL
SYRUS 660 MK IV

PlayStation

PAL

COMPACT
disc

デザイナーズリパブリック

65

W'O"
WIPE'OUT"

PMS877

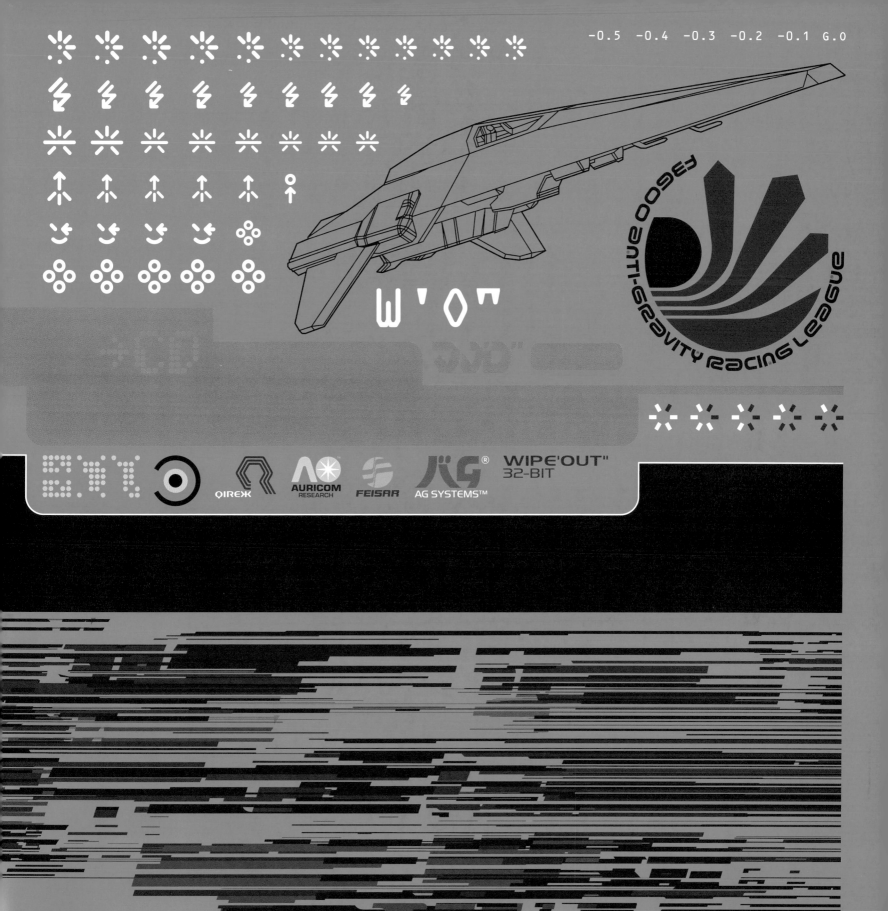

WIPE'OUT"
32-BIT

QIREX

AURICOM
RESEARCH

FEISAR

AG SYSTEMS™

ADRENALINE™ IS A REGISTERED TRADEMARK OF WIPEOUT

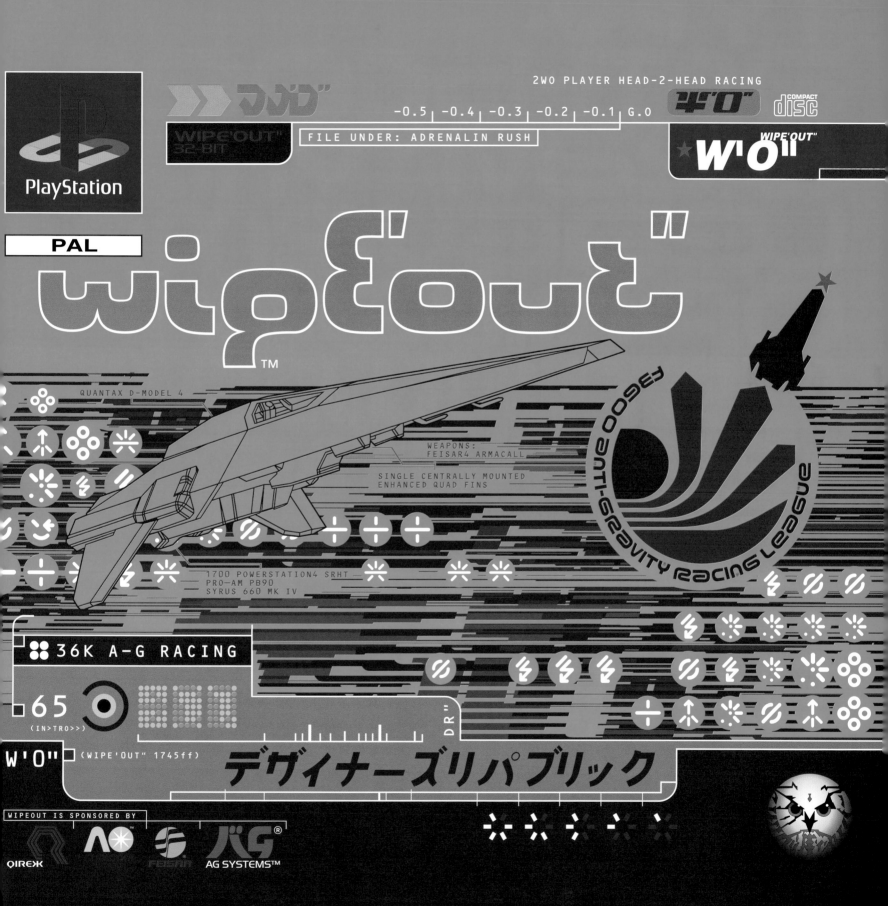

TYPO:

ANTI-BCDEF
GRAVITYHIJK
LEAGUEMN
OPQRACIN
GSTUVWXYZ
123456789

↑
F3600 ANTI-GRAVITY RACING LEAGUE
OFFICIAL CUSTOM TYPEFACE

↑
UPPERCASE
ONLY

25R45G110
6225ROG2
5623OR80
G20b

↑
F3600 ANTI-GRAVITY RACING LEAGUE
OFFICIAL COLOUR PALETTE

↑
F3600 RACING LEAGUE
LOGO

↑
F3600 LOGO CONSTRUCTION

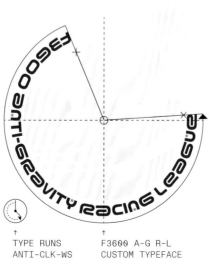

TYPE RUNS
ANTI-CLK-WS

F3600 A-G R-L
CUSTOM TYPEFACE

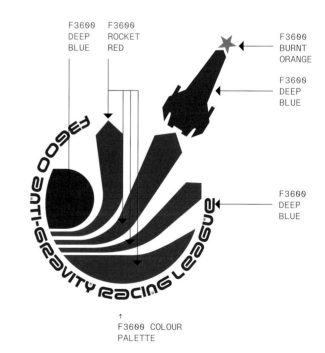

F3600
DEEP
BLUE

F3600
ROCKET
RED

F3600
BURNT
ORANGE

F3600
DEEP
BLUE

F3600
DEEP
BLUE

↑
F3600 COLOUR
PALETTE

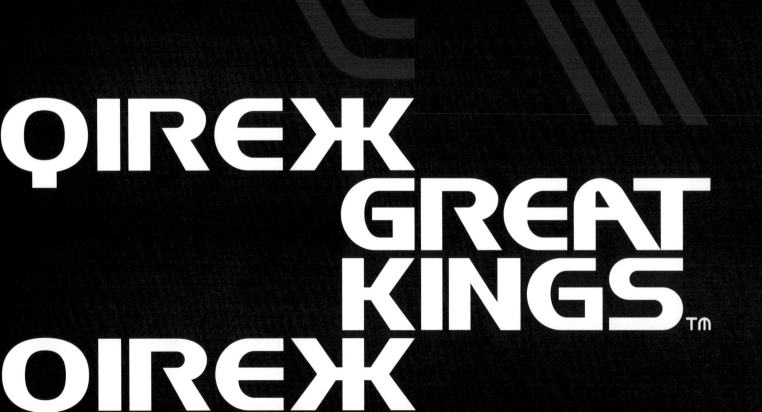

QIREЖ

GREAT
KINGS™

QIREЖ

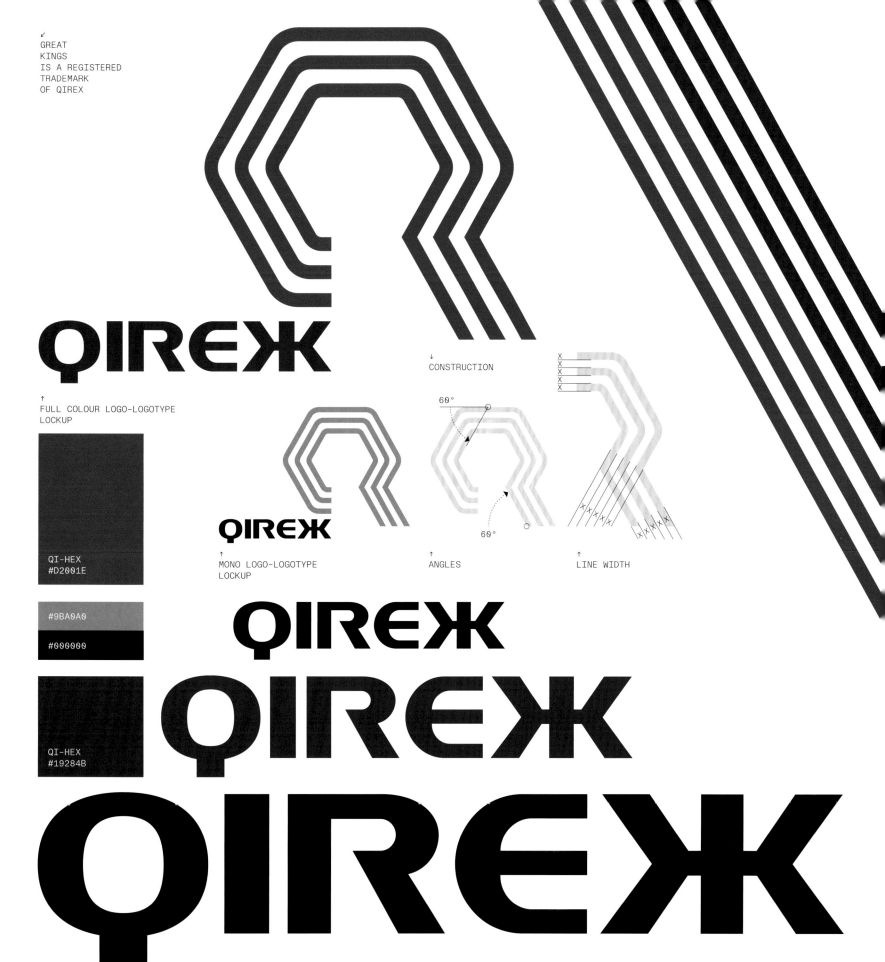

QIREX

↑
FULL COLOUR LOGO-LOGOTYPE
LOCKUP

QI-HEX
#D2001E

#9BA0A0

#000000

QI-HEX
#19284B

QIREX

↑
MONO LOGO-LOGOTYPE
LOCKUP

↓
CONSTRUCTION

60°

60°

↑
ANGLES

X
X
X
X
X

↑
LINE WIDTH

QIREX

QIREX

QIREX

AURICOM
RESEARCH

AURICOM
RESEARCH

AURICOM
RESEARCH

↑
OUR
FLAGS
↓

↑
PUBLIC
CORPORATE
↓

AURIC✦MTMTMTMTMTM
RESEARCH
AURIC✦MTMTMTMTMTM
RESEARCH
AURIC✦MTMTMTMTMTM
RESEARCH
TMTMTMTMTMTMTMTM

TMTMTMTMTMTMTMTM

TMTMTMTMTMTMTMTM™

AURICOM RESEARCH
IF IT MOVES TRADEMARK IT™

→
AURICOM
RESEARCH
MAIN
LOGO/
LOGOTYPE
LOCK-UP

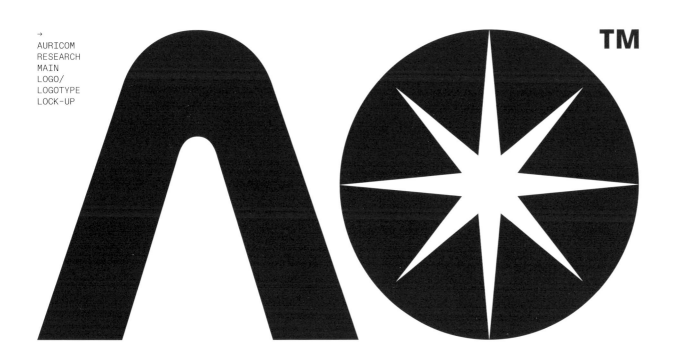

™

AURICOM
RESEARCH

↑
COLOUR VERSION

↓
COLOUR PALETTE

↓
MONO VERSION

→
RED
220R
0G
25B

315° 0° 45°

90°

225° 180° 135°

↑ STARBURST™

→
RED
220R
0G
25B

→
RED
220R
0G
25B

→
GRY
155R
160G
160B

→
BLK
0R
0G
0B

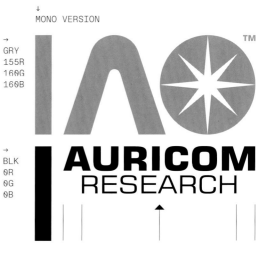

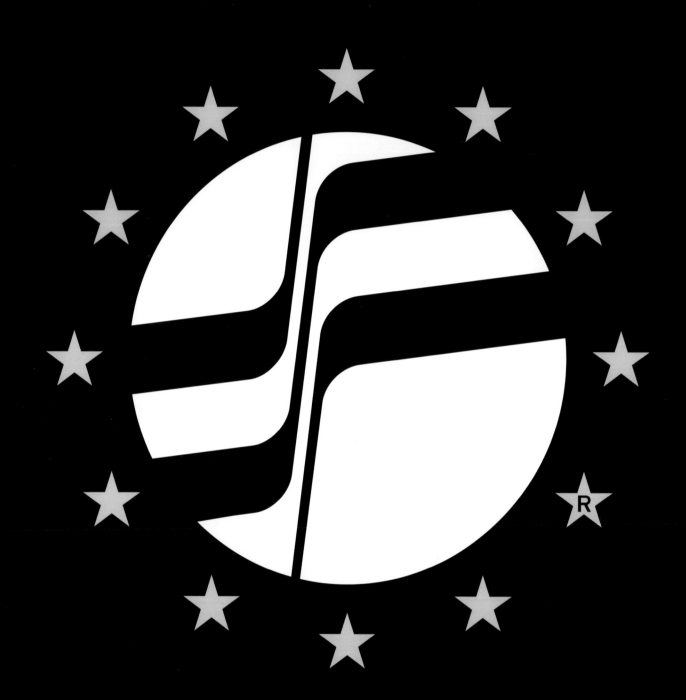

FEISAR ALWAYS in!

NOT OUT!

ANTIGRAVITY SYSTEMS™
ANTI
A GRAVITY
 G
GRAVITY SYSTEMS™
G SYSTEMS™ S
S ANTI
SYSTEMS™ A
S ANTI
 A GRAVITY
ANTI G
A GRAVITY
 G SYSTEMS™
 S
 G SYSTEMS™

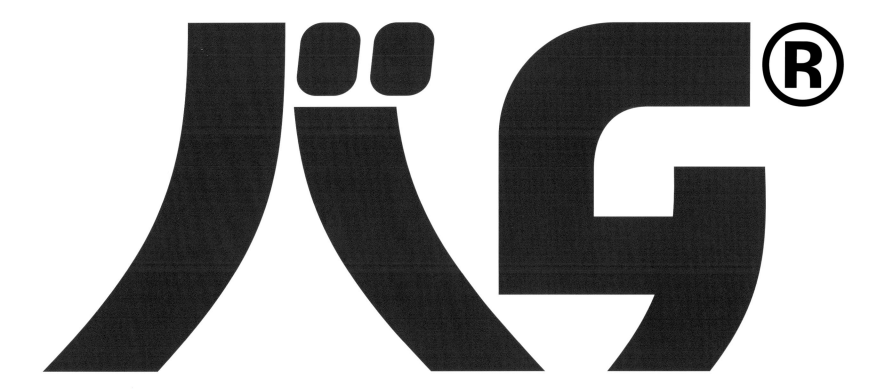

AG SYSTEMS™

↑
THIS IS OUR LOGO

AB C–USTOM™

↑
THIS IS OUR TYPEFACE

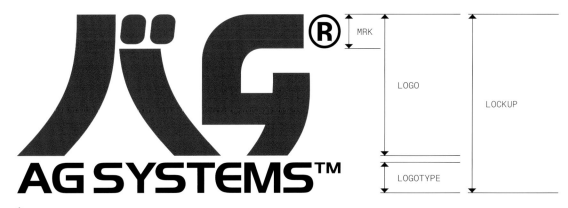

		MRK
	LOGO	LOCKUP
	LOGOTYPE	

↑
THESE ARE OUR COLOURS

↑
THIS IS OUR LOCKUP

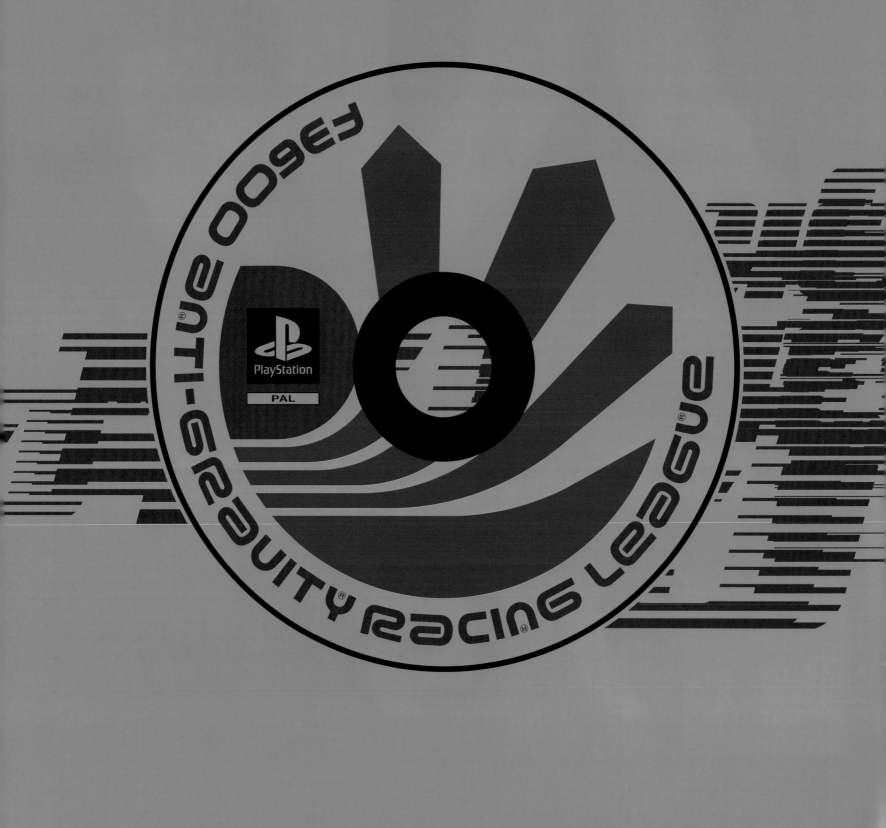

← ↓
Weapon and
power-up icons
for *WipEout*
(Psygnosis,
1995)

↑↑
Disc labels
for *WipEout*
(Psygnosis,
1995) and *WipEout*
2097 (Psygnosis,
1996)

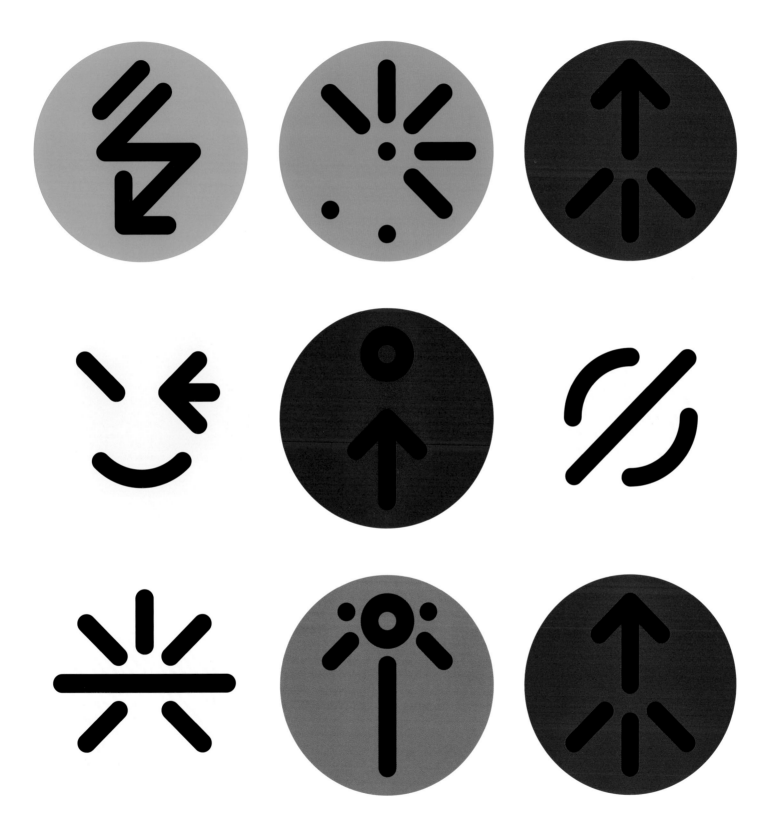

SOFIA
DE LA RENTE FEISAR

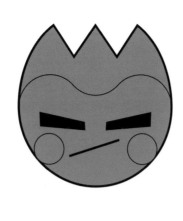

ARIAN
TETSUO QIREX

PAUL
JACKSON FEISAR

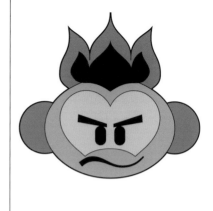

JOHN
DEKKA AG SYSTEMS

ARIAL
TETSUO AURICOM

ANASTASIA
CHEROVOSKI AURICOM

↑ ↗ →
Pilot logos
prompted by
WipEout writer
Damon Fairclough

DANIEL
CHANG AG SYSTEMS

→ D4m0n F41rcl0ugh: H0t Bl00d

With its vision of a bloodied, catatonic Sara Cox in clubby T-shirt with neither controller nor television in sight, *WipEout*'s most notorious print ad helped spearhead the age of provocation-as-promotion, sending a clear message that tabloid folk devils had all the best tunes. It would have caused a right stink, too, had it not been thoroughly eclipsed by Virgin Interactive's 'Previous High Scores' campaign for the original *Command & Conquer*, with its gallery of real-world dictators and war criminals. According to Psygnosis writer Damon Fairclough, though, *WipEout*'s was never meant to be quite so 'on the nose'. →

Part of my role at Psygnosis was a kind of ad creative; by some historical quirk, it only seemed to be the copywriters who were. We didn't work with a designer on ad concepts, it was me and another writer, Huw, who'd kind of squirrel ourselves away in a room and bash out ideas. We'd assumed some kind of rendered artwork with a headline, some screenshots and a bit of body copy: how Psygnosis had done things for years.

In the middle of '95 a guy called Paul McGarvey oversaw a lot of our marketing stuff. He used to drift in a couple of days a week – always up from London – have some meetings, tell some people what to do and carry a mobile phone that would not stop ringing. Not many people even had a mobile phone back then. We were like, 'Who is this guy?' He just operated on a different level. He called a day-long meeting between me, Huw, our line manager Keith Hopwood and an art director type who came with him. His mission was to put together ad concepts for the whole PlayStation software launch; and his thing was that these are new games, on a new console, in a new generation. 'We don't have to do ads the way games companies always do.' *WipEout*, with how it drew upon club culture and music, was top of the tree in that regard.

We sat around and looked at some material that McGarvey's mate had brought with him, in particular a book of Hipgnosis artwork. That Hipgnosis/Psygnosis connection had probably been in his head, and the book was full of this hyper-real, deeply saturated photographic imagery. He also brought a load of ads by the clothing firm Diesel, which had quite a distinctive style at the time: everyday photographic scenes where something odd was happening if you looked a little closer. We hit on this notion – which is to say we basically copied Diesel – of these ads being really colour-saturated. Instead of rendered art and stuff, there'd be one big, bright image with no screenshots at all and possibly not even body copy.

In that day we came up with concepts for the whole PlayStation slate, our intention being that all Psygnosis titles going forward would have the same style. That was eventually watered down as we came face-to-face with various product managers all over Europe, and it was the same problem we had with the games' packaging: people found it hard to figure out how it was going to work. 'How will people know to buy the game if there are no screenshots?' And our argument was

always that these ads are appearing in magazines that are absolutely stuffed with screenshots. 'This is a new generation, we're trying to do something new, and come on, everyone, support us.'

● 5H0CKW4V3
The *WipEout* one was by far the most successful in conception and execution. It was a really weird situation for me and Huw, as we suddenly became these ad production guys who had to sort out all kinds of stuff, like actually casting the ads. We went over to Manchester Model Agency, I think they were called, and saw a load of people. Sara Cox was one of those, and an absolute nobody at the time. But it was while we were there that the woman in charge called Sara over and said, 'We've got a letter from Channel 4.' And so Sara opened this thing saying she'd got a gig on *The Girly Show*, which was her breakthrough. So she's absolutely hyper, and everybody else in the room, all these Manchester models, are looking daggers at her, just consumed by jealously. Lots of false smiles. 'Oh, well done, Sara.'

Sara was also broke at the time; we had to give her a cheque there and then that she could take back to Manchester. She was vaguely interested in this thing being a game, but not much, really. We couldn't find the right lad to use in the ad with her, so McGarvey mysteriously sourced one from some London agency. The photographer was Andy Earl, another McGarvey contact, who had done shoots for Pink Floyd, Madonna, Johnny Cash, Prince, etc., and was just an all-day fund of anecdotes. It really felt like going into another world from sitting at my computer all day in Liverpool. Sara came down on the train, and we set up this little scene with the wallpaper and the sofa.

The nosebleed thing was meant to be the merest hint of blood, but the make-up was by some theatre and film guy who absolutely went to town on it. And already, even while it was happening, there was this slight feeling of, 'I don't know how this is going down when we get back to Liverpool.' But anyway, it happened.

There was an important trade mag at the time called *Computer Trade Weekly*. That was where these things tended to get launched every Monday morning. I remember the *WipEout* ad hitting, which in a trade mag meant this big colour picture. And the shit absolutely hit the fan that morning. In that spirit of breaking new ground and not quite having the right

structures in place, it seemed there'd been a not-very-robust sign-off process. A whole load of people from Sony who'd never seen this were suddenly confronted with it in the press, and had absolutely no idea what it meant.

The drug inference hadn't been top of our minds at all, but suddenly, in the cold light of day, it was really fucking obvious. We had to do a bloodless version for the German market, because that's a legal thing over there, and that one looked even worse!

Actually, though, it dawned on people pretty quickly that this thing wasn't doing any harm at all. Without social media, we weren't getting feedback from the punters. The trade were mystified, but then copycat stuff started happening and things suddenly changed. Virgin went for the shock, bad taste thing, but it was all a bit accidental with *WipEout*.

● TH15 Y34R'5 M0D3L
A couple of the other ads we did were misunderstood quite badly by people trying to copy them. The *Destruction Derby* one was a page-three type woman sat on a really bashed-up car, which was meant to be a pisstake of when they'd have a 'bevy of beauties' at car launches. But it quickly became this thing of companies putting page-three models in their ads, because that's what we in the game industry were now doing. That was our fault a little bit, but again accidental.

We tried to keep the photographic thing going for a little while. There was one ad for *3D Lemmings* with all these guys in suits, with green hair, in a London tube station. *Krazy Ivan* was this big beefy Russian guy photographed in the Roman spa in Bath. *Discworld* was meant to be another one, with all these Discworld characters in a swimming pool for some reason. I presented that to Terry Pratchett's agent – he was a right one – and he had a face like thunder. 'On absolutely no account can this go forward.' Because the Discworld characters can't appear in our world, apparently. *Adidas Power Soccer* was supposed to be another one, but then they got Paul Gascoigne involved and the ads became all about him. The whole thing just sort of petered out in the end, with this feeling that everyone was trying to copy it but was doing it all wrong.

■ Damon Fairclough is a Liverpool-based freelance copywriter and journalist working in advertising, marketing, videogames, arts and culture.

←
Faced with a
quick succession
of titles for
new, certifiably
next-generation
hardware, the
creative studio
at Psygnosis
spent all of June
27th 1995 holed
up in Liverpool's
Adelphi Hotel,
tailoring high-
impact ads for
an unprecedented
level of hype

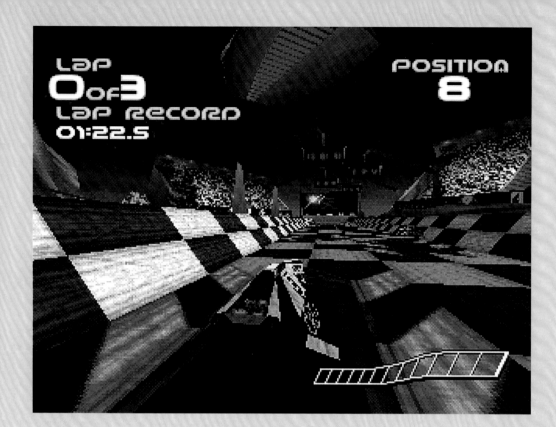

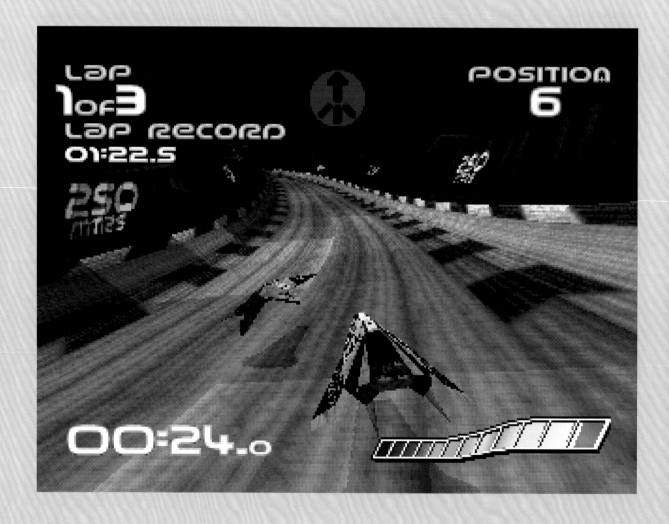

↑ ↗ →
Karbonis V,
WipEout
(Psygnosis,
1995)

00:42.8

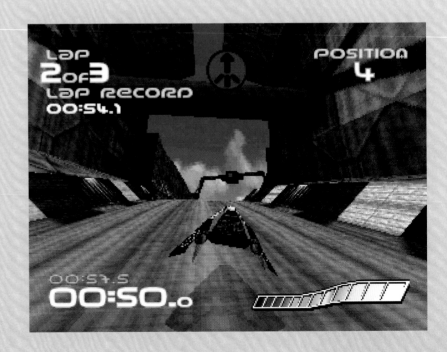

00:57.5
00:50.0

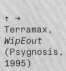
↑ →
Terramax,
WipEout
(Psygnosis,
1995)

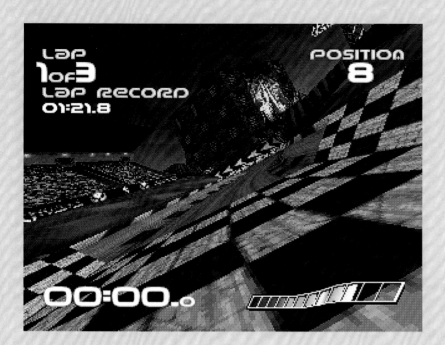

← ↓
Korodera,
WipEout
(Psygnosis,
1995)

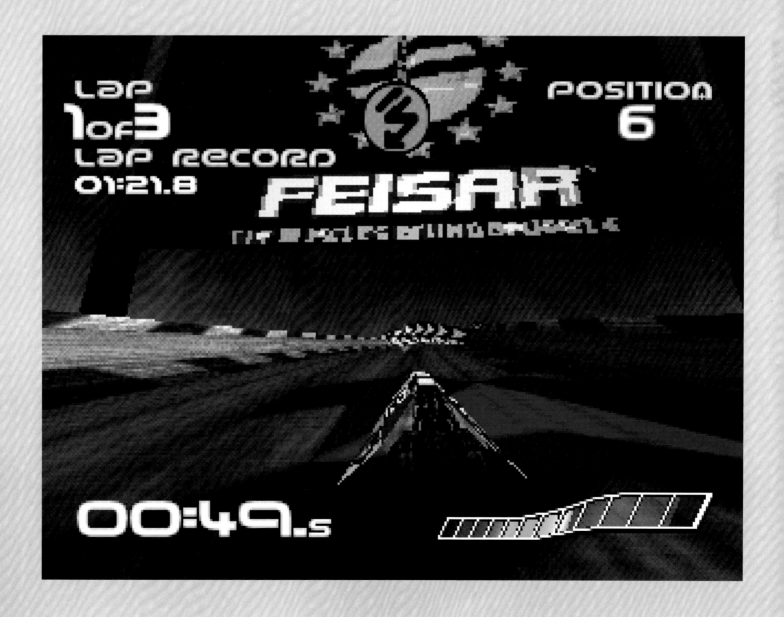

← ↓
Silverstream,
WipEout
(Psygnosis,
1995)

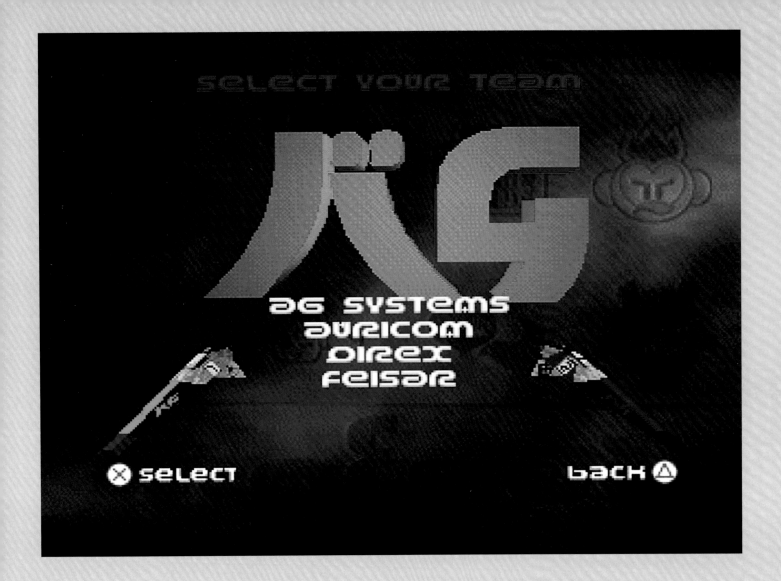

AG SYSTEMS
AURICOM
QIREX
FEISAR

⊗ SELECT BACK △

Venue *Terramax*

Class *Venom* Data Loading
 Hold Tight!

Track Details

 Profile Perspective

Location Germany
Length 4.1km
Max Height 121m
Surface F3600 Racing std

 Plan

↑ →
Team select, Class select
WipEout *WipEout*
(Psygnosis, (Psygnosis,
1995) 1995)

← Controls,
WipEout
(Psygnosis,
1995)

↓ Pilot select,
WipEout
(Psygnosis,
1995)

→ P4ul H4rtn0ll: P3tr0lh34d

For all the crates dug through in pursuit of its encyclopaedic soundtracks, and despite prime cuts from the cream of European techno, nothing still says *WipEout* quite like Orbital's 'P.E.T.R.O.L.', a fitful rush of electro-psychedelia composed for the game by Paul and Phil Hartnoll before landing on side two of their three-LP masterwork, *In Sides*. No wonder the series went back to the well for 2005's *WipEout Pure*, when Paul collaborated with artists Edd Wainright and Jon Kendrew to craft a gorgeous intro in which a ship essentially builds itself, apt for a game that by then knew itself inside and out.

→

We always felt that games and films were way too slow picking up dance music. When did *WipEout* happen? 1995? I mean Jesus Christ, that's seven years into the evolution of dance music from acid house, and eight if you want to include the house music year that came before it – and finally we were doing something commercial. That's the important thing: the vision to put contemporary dance music into a videogame, which hadn't happened on that level at that point. It hadn't even been in films, really, which is why something like *Hackers* was quite important. I couldn't understand why people weren't putting more electronic artists in films, because we'd been through the '70s and '80s, with Tangerine Dream and John Carpenter and all that, but it's only become fashionable now; just look at *Stranger Things*.

● 5YNCHR0N1C1T1E5
Our record company was London Records, but we were signed to Sony Publishing. We were connected to *WipEout* in another funny way – they put [Orbital track] 'Halcyon' in at the beginning of *Hackers*. We actually wrote the track 'The Girl with the Sun in Her Head' for that film, but it got turned down. Nick Burcombe and Tim Wright then came to show us a video of this game, and its own section from *Hackers*, and I remember going, 'How are we going to do this then?' They said it was 'CD quality: you just write a track and we'll put it on there.' I said: 'Okay. Now what's the "but"?' But there wasn't one. I really thought it would have to be converted somehow, like we'd be working with a programmer and putting it on a kind of SID chip, like on the Commodore 64. PlayStation was just mindblowing. Sony sent us one after launch and I didn't even put those black discs in for days because I just assumed they'd sent dummy ones.

Nick and Tim left us their video and then I made some sounds on an ARP 2600, just big industrial noises. I chucked a load of them in the sampler and made that opener, this kind of doppler-effect circular drone which, to me, was the sound of vehicles whizzing past you. Having grown up next to a railway line, it was the sound of the trains as they cut through the air while I was standing in the garden. That encapsulated speed for me, and so that's what I felt this needed to be. So yeah, I hustled something together quite quickly. It took a few weeks for them to be entirely happy with it, and there was a bit of to-ing and fro-ing.

What Nick said was, and I think this is a valid point, was that it didn't have enough of a climax – something like that. That's totally reasonable when someone's paying you to do a job. Artists have a reputation for being trouble when it comes to that kind of thing, which I know is fairly true for the most part. But there's also that thing where if you're collaborating with someone, that's surely the point, isn't it? You can probably tell what Nick was going for from Tim's stuff, which was more trance-based. 'P.E.T.R.O.L.'s more industrial; it was just that phase of dance music where a lot of us were going in that direction. It was around the time when The Prodigy were doing their *Fat Of The Land* album. Chances are that Nick was actually a bit behind the times in that sense, being a bit clubby and housey when everyone else was getting more aggressive.

There was no licensing model for music in videogames at the time, which is why we earned proper money from it. I got proper money for that and for *WipEout Pure* as well, because we kept our publishing rights. This is the thing we're constantly fighting against as musicians: the taking away of publishing and performing rights, which is what people like Netflix do all the time. They don't pay you properly, whereas in [Psygnosis'] naivety, they allowed us to keep the publishing because, guess what, that's actually the right thing to do. So every copy of *WipEout* that got sold, we got a bit of money, which was great, a fair trickle-down. It's not millions or anything like that, but every now and then your PRS gets a little bump and you're like, 'Oh yes, that's because of the videogame.' And that encourages you to want to get involved more. But when people rob you of your publishing – now – you just don't.

● FU3L F0R F1R3
'P.E.T.R.O.L.' was written for *WipEout* but, never one to waste a good track, I then put it on *In Sides*. That's why I always associated it with *Hackers*: because the track before it on that album, the first track, is 'The Girl With The Sun In Her Head', and the next is 'P.E.T.R.O.L.'. That *Hackers*/'P.E.T.R.O.L.' alliance to me represents a particular part of my life. The title is because I wanted it to have a dirty racing feel, and 'Diesel' didn't quite have the same ring to it. But it's also a tribute to my favourite electronic band, Severed Heads, because my favourite track of theirs is called 'Petrol'. We made it an acronym so they wouldn't go, 'What the fuck are you doing?'

WipEout Pure was all very straightforward. We didn't have a meeting, it was all done over the phone. All I remember was: 'Can you do us an intro? We've got a wireframe version of it, the timings are correct, we'll get you a full one as it comes – and can you do us a track for the in-game action as well?' I don't remember it being anything difficult, and the first track I composed was the one that worked for them on both accounts. There was a bit of tweaking, the usual 'Can you make that a bit bigger or tone that down?' that you get when you do any score work. It was all quite pleasurable, really.

As for the intro, I can't entirely say how well it worked because all the files are now on a computer in a landfill site somewhere. But when I saw the early visuals for the *WipEout Pure* intro, it was like this pure white version of *The Six Million Dollar Man* intro. That one's got this military snare-roll and all that, and men talking, but everything's got a sound effect, all these computer noises. So I tried to get a bit of that in there. It was very entertaining to do because of that. I had the visuals and I properly scored it to it, which is what's referred to as 'Mickey Mousing', where you make the score hit literally everything that happens on screen.

■ Together with brother Phil, Paul Hartnoll is one half of pioneering UK electronic music duo Orbital, formed in 1989 and still recording and touring today.

P4ul H4rtn0l p081 035C:020M:045Y:000K P3tr0lh34d

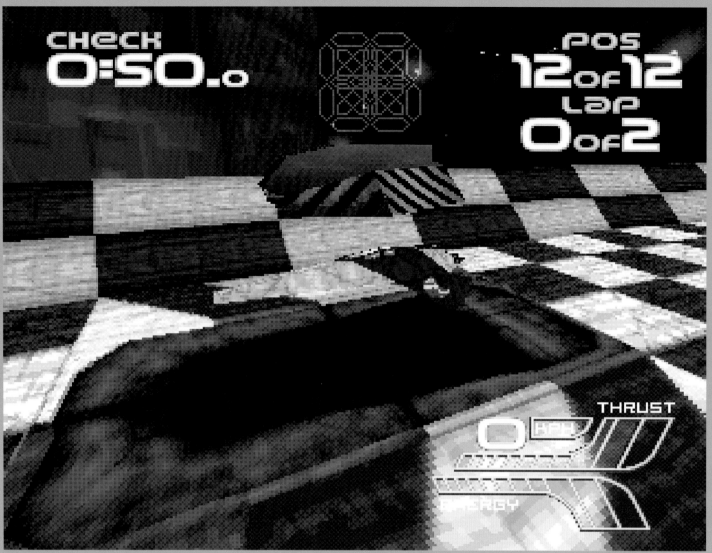

↓ ↙ ↓
Talon's Reach,
WipEout 2097
(Psygnosis,
1996)

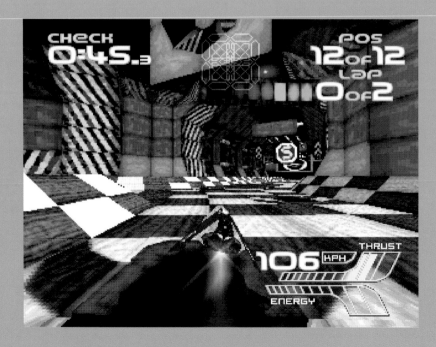

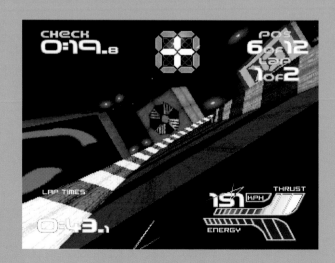

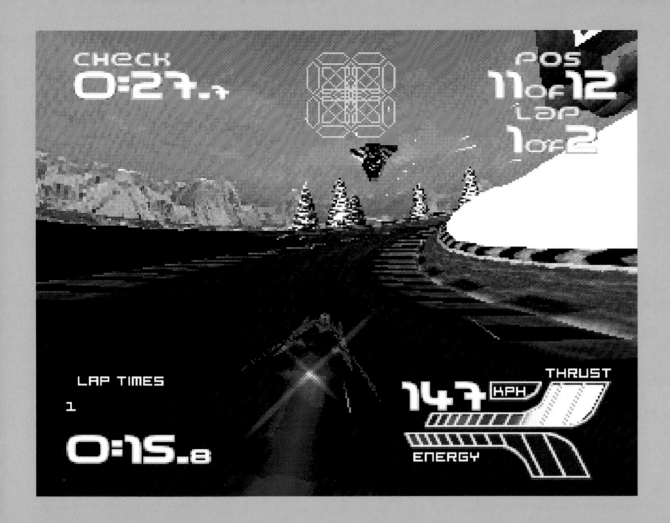

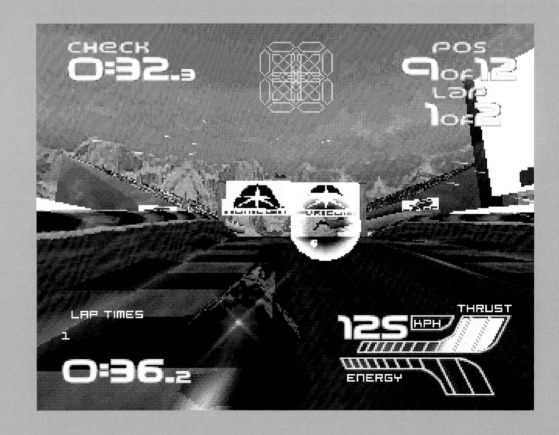

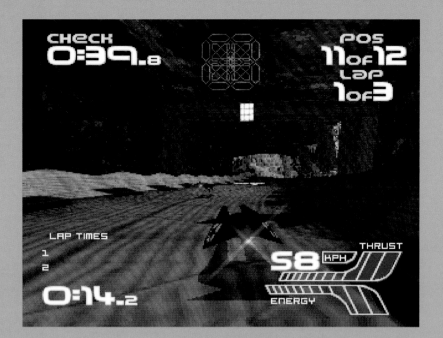

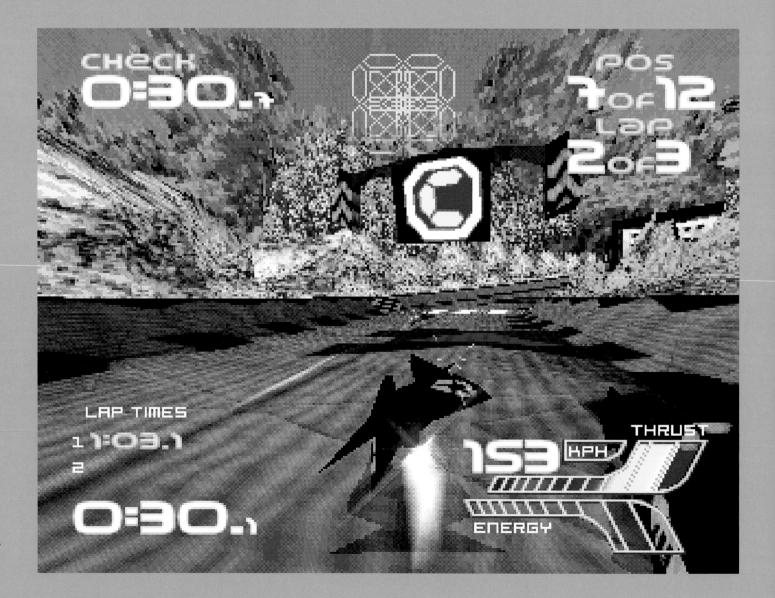

↑ →
Valparaiso,
WipEout 2097
(Psygnosis,
1996)

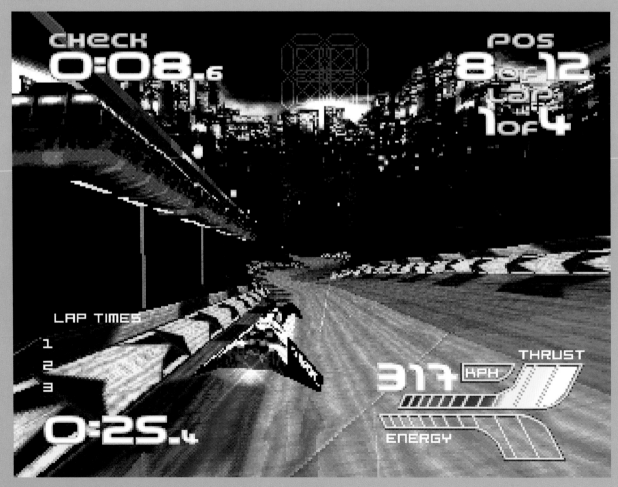

Gare d'Europa,
WipEout 2097
(Psygnosis,
1996)

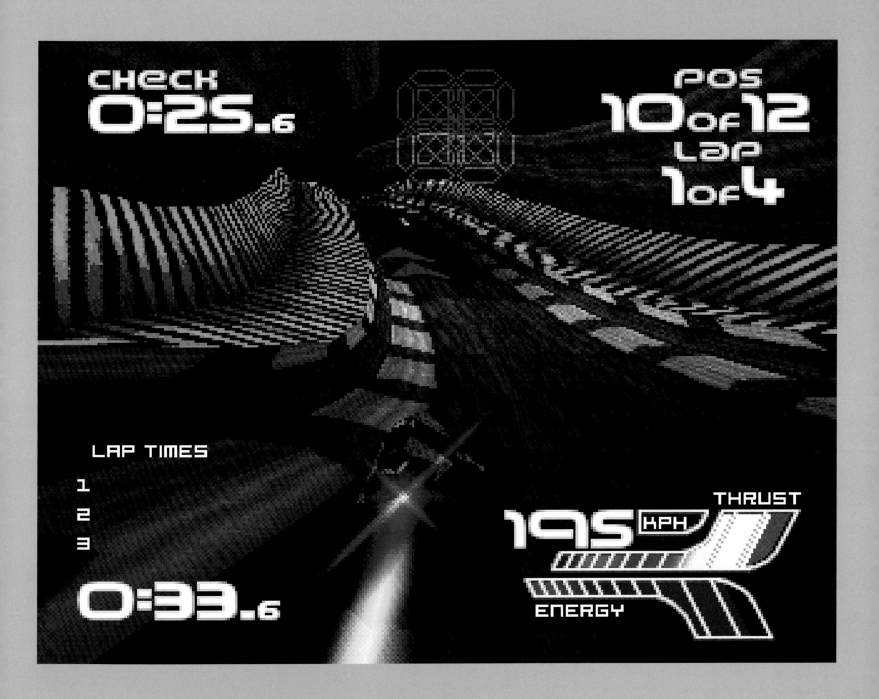

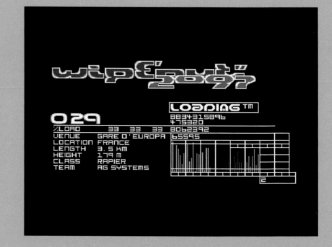

↑
Main menu,
WipEout 2097
(Psygnosis,
1996)

↗↗
Save and audio,
WipEout 2097
(Psygnosis,
1996)

→
Loading screen,
WipEout 2097
(Psygnosis,
1996)

→→
Team select,
WipEout 2097
(Psygnosis,
1996)

LOAD AND SAVE

DATA MODE

LOAD
SAVE
DELETE

EMPTY EMPTY

✗ SELECT BACK △

AUDIO CONFIG

PRECISION LEVELS

SFX

SOUND
MONO

CD TRACK O ARTIST RANDOM
TITLE RANDOM

✗ ACCEPT BACK △

TEAM MENU

TEAM MODE

FEISAR
AG SYSTEMS
AURICOM
DIREX

THRUST
TOP SPEED
TURNING ABILITY
SHIELD ENERGY
AERODYNAMICS

GOOD ACCELERATION AND TURNING ABILITY BUT
WEAK SHIELD. [AMATEUR]

✗ SELECT BACK △

→ 0f 5p4c3 4nd T1m3: [1995—2000]

45 years later, the constructors of the Anti-Gravity Racing League have learned how to take corners. 'Side-scraping,' whereby skirting the side of the track no longer brings you to a jarring halt, is how *WipEout 2097* drastically improves the flight model of its predecessor. WipEout years aren't real ones, though, and so the sequel had to be made in a truly Phantom-class eight months. →

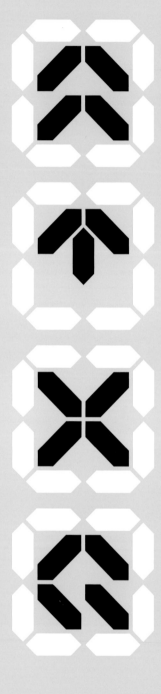

This is partly because it was never meant to be a sequel: Psygnosis had ordered nothing more than a disc of extra tracks for the original game, which is why we're not talking about 'WipEout 2'. Recalls producer Andy Satterthwaite: 'Everyone was a little surprised that the first game did so well. There were no plans for a sequel at all – though I was pleading for one from the moment I was made producer.'

The game was called *WipEout 2097* because games are typically dated for the year after they release – think FIFA, Formula 1, etc. – and this 1996 game just happened to be set a century into the future. However, in the US the game was called *WipEout XL*, following the move of Alan Bennett's *The Madness of George III* being renamed *The Madness of King George* lest cinemagoers think they'd missed two movies. 'Because Americans would think there'd been 2,096 previous ones or something,' laughs Satterthwaite. 'Then they tried to call it "WipEout XS" and I said, "Do you really want to call it 'Extra Small'?"'

In a mix of youth and 'spectacularly naive production planning skills,' Satterthwaite applied an equally numeric bias to the game's development. 'It was like, okay, we've got four artists, how long does it take to build a track? You can each do two, so that's eight, which is two more than last time. What else can we do more of?' Answer: two additional speed classes, a new team (Piranha), one additional ship on the track per team, meaning twelve in a race or 15 at the top end. 'Classic sequel stuff, really: bigger, faster, more.'

What's important here is the almost complete lack of managerial ambitions for the game; a team that built the entirety of *WipEout* was now tasked with, time considerations aside, a whole lot less. As Satterthwaite explains: 'That just doesn't happen. Normally you get so stressed about what you've been told to do that you don't tend to do what's right.'

Joining programmers Stewart Sockett and Nick Kimberly on the sequel was Chris Roberts, a graduate from Sheffield University who'd worked briefly for US Gold's in-house studio, Silicon Dreams. He confirms: 'Everyone's main bugbear from the first game, and the prime target for *2097*, was the wall collisions. Just thinking of the games that were around at the time – *Ridge Racer* and the like – I don't think

the general market had cottoned on to the fact that stopping the player dead was a bad idea in racing games. It was still emerging from an era of: get touched by an enemy and you're back to the beginning.'

The game's tracks had to be mapped out and playable before artists could even touch them, which meant the unenviable job of fixing all of the game's handling upfront. 'There was a thing where if you caught the wing then the nose would get dragged into the wall as well,' says Roberts. 'We needed proper nose collisions to be quite aggressive, not just a scrape, so this was a big problem.'

Letting *WipEout* off the leash by fixing it changed everything. Roberts continues: 'We had a designer called Nev [full name Nevin Gaston], who just had the most insane reactions. He was clocking 17-second laps of Sagarmatha, even on just our early splines, and you can imagine what happened when we added the Piranha ship at the end.' A concerted effort to speed-run rather than survive took hold of the game, alongside emergent behaviours like using the wall-grinding system to speed up even more. 'They fixed those collisions a bit too well,' nods Roberts.

'It was just ballistic speeds at the top end,' adds Satterthwaite. 'People finessing to the umpteenth degree. When we put the ghost ships in for the time trials, you'd come in each morning to find Chris shaving fractions of a second off Sagarmatha. There are only so many games you get to work on where you're telling the team to make it rather than play it.'

Those ghost ships were a problem, though. Thanks to a trio of US patents applied to Atari arcade racing game *Hard Drivin'*, any game released in America with a ghost car - anything, strictly speaking, involving a previous play session superimposed onto the current one - would have to license the concept from Midway Games West. Blockbuster franchises like *Out Run* and *Ridge Racer* coughed up, but WipEout lacked the spending power and so the feature was simply cut from America's *XL*.

Then there were new pit lanes. 'Morgan O'Rahilly [producer] insisted those go in while I was on holiday,' says Satterthwaite, 'and it meant a whole rebuilding of tracks to shove them in. I think I preferred the solution they implemented later [in the series] where you could just absorb your weapon for energy.'

● 5P33D BUMP5

WipEout 2097 is so revered that tracks including Gare d'Europa (a repurposed French metro system), Talon's Reach (Canadian industrial facility) and Odessa Keys (suspended over the Black Sea, notoriously hard) became fan favourites and were demanded in every sequel since. Yet this is where Nick Burcombe, who designed *WipEout 2097* alongside Gaston and Rob Francis, 'wasn't happy, personally: the designs weren't as adventurous as the set from the first game.' Indeed, while the tracks were now kinder to players, the same could not be said for the people having to make them, with Gare d'Europa given 'lots and lots of tunnels because they were easy and we were running out of time,' says Satterthwaite.

To make matters worse, *WipEout* supported the PlayStation Link Cable, which allowed local multiplayer so long as the two connected consoles never went out of sync. Satterthwaite explains: 'It ran fine in PAL, at 25 frames per second. But if the draw distance is relatively shit in *2097*, it's because of the extra five frames we needed for NTSC.'

Hardware wasn't always to blame, though. For all that was lost out of necessity, much was also traded. With its Star Trek-like torpedoes, *Akira*-like trails and an added electric beauty of its own, *WipEout 2097* fixes the first game but also breaks it for effect – or rather, effects. 'We could have had the richer environments, but this was a decision based on feel,' says Roberts. 'How important was it to have this enormous vista, and how important to try and move things forward a little, do something different. It's always a balance, and we tipped it.'

Roberts handled all of *WipEout 2097*'s rendering code while Sockett handled gameplay and Kimberly dealt with features like PlayStation Link. Despite everything, the first game was shockingly proficient, built without libraries, using COP2 instructions direct from Assembler, which meant little headroom for the sequel.

'PlayStation wasn't a complicated machine once you had those instructions,' says Roberts. 'It was actually really good to program on, very straightforward. You had a very prescribed way of doing geometry, and sorting geometry very crudely. By far the biggest pain was having to divide large polygons by yourself because there wasn't any clipping, but learning it wasn't difficult at all. It's not like the [Sega] Saturn, which had reams of documentation and yet was virtually unintelligible: that was super hard to get anything out of.

'Saturn had a couple of very esoteric pieces of hardware in it, like the Rotation Scroll Screen which was a bit like Mode 7 on the SNES. Sega had played it safe and gone for something halfway between the previous generation and the new one, with hardware for handling sprite maps but a very basic polygon engine, and Sony just put everything into the GTE [the PlayStation's Geometry Transform Engine] for doing transforms, and the actual rasterizer. It outperformed the Saturn in every way.'

So yes, something would have to give if Roberts was to combat what he calls the 'dryness' of the first game's effects, all while accommodating the new pit lanes and weapons, and the sparks produced when grinding walls, an important visual cue. Reduced draw distance meant pop-in of scenery, which perversely required new geometry to hide it. Recovery drones now came to the rescue if you flew off the track, but the game featured so many twists, turns and tunnels that something or other would routinely end up in the scenery.

The sequel also dispensed entirely with Gouraud shading, but thanks to the coarse unfiltered look of PlayStation textures this largely went unnoticed. More remarkable was that no one noticed the ships disappearing as well, Roberts using the bright new flares from their engines to cull them from the game at surprisingly short distance. Not only did this free the game up to have more ships in a race than before, but the visuals made races easier to read – not bad for a feature that wasn't meant to do any of it.

'Literally the only reason they went in is because I'd been to see *Akira* and was like, we've got to have them,' says Roberts. 'There was a lot of that. Less planning, more playing. I can't remember if the plasma weapon was designed or just me wondering what would happen with a charge-up weapon, but again the effect was the central part of it.'

As for the beloved quake disruptor, which fires a ship-and-track-rending wave into the distance: another happy accident. Tracks in *WipEout* aren't exported geometry meshes but rather stored in a structured fashion,

↓
The pre-rendered
intro to *WipEout
2097* (Psygnosis,
1996)

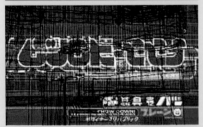

the game's entire track editor running in-game. This gave the game a complete and dynamic telemetric overview of race and track which meant 'in theory, you could disrupt the whole track and it could work. And when it did, the designers were like, "Yup, that's going in."'

● 51GHT 4ND 50UND

Figuring out The Designers Republic™'s role in *WipEout 2097* fell almost exclusively to artist Nicky Place, who, despite another brutal deadline, saw a chance to 'really fuse this stuff together.'

This would be despite the intrusion of a new brand, very much of our world, into the game's lexicon. Embracing its inner *Blade Runner*, *WipEout 2097* lent towering billboards, prime intro real-estate and even space on its UI to Austrian energy drink maker and sports promoter Red Bull. 'It was a bit much,' believes Satterthwaite. 'Dominating, a bit annoying – but not as much as having all our free cans stolen from the fridge by the cleaners.'

Sony, unhappy with how its logo was being deformed by PlayStation texturing, regulated its use after *WipEout*, leaving *2097* with a lot of empty ad space. Red Bull was an esoteric enough brand swap to sit comfortably in the game's fiction, though the team had to head off one small controversy when it came to the slogan: Red Bull improves your reaction time!

'We were like, "No it doesn't!",' recalls Satterthwaite. 'That was a step too far. We weren't getting pinged for misselling so we just rephrased it to: "Improve your reaction times! Red Bull."'

Place is especially proud of the game's CG intro, which wastes no time setting out its stall. Neon Red Bull and tDR™ logos interrupt a dark and stormy night, and a giant shopworn 'lucky cat' statue beckons us down to a tunnel, a track, when BOOM! Two ships blast around the corner, battling to an iconic cut from Future Sound of London's 'We Have Explosive'.

Storyboarding, rendering, cutting and compositing that sequence meant more all-nighters for Place and a returning Jim Bowers. One shot in particular had them both 'at the ends of our tethers,' she reveals. 'Jim just shouts, "I don't know what the fuck this needs!" and storms outside for a cigarette at four in the morning. Then he comes back in and says,

"The sun's coming up and I just saw these pigeons fly off. I think we need some light in there." So right there he renders this bird and we comp it into the sequence.

'Jim taught me so much. Little things like that, so many new ways to achieve what's on the storyboard. He was amazing. And sequences like the exploding ship at the end: there's no way I could have done that. It just came to him naturally.'

For Steve Gilbert, *WipEout 2097* was one of the first big titles to grace a new production facility at Wavertree – three edit suites and a machine room – joining *Colony Wars* and a bunch of demos and trailers for stores like HMV.

'Jim was exceptionally good at visualizing in his mind what he wanted to do,' he says. 'This was quite early days for virtual cameras, and he keenly followed the methodology that if you're filming something in a computer-generated world, the camera has to feel real, like there's a real camera crew there. In those days, the virtual cameras were just flying around all over the place, and it used to drive us nuts.'

Much of Gilbert's work on *2097*, as its FMV editor, can be seen right where you'd expect it: in the synaesthesia of the intro's second half, where the eccentric soundtrack had been cut into shrapnel by Tim Wright for the edit, the visuals following suit. tDR™ decals, slogans, ship vertices, flashes to white: a proto-cyberspace info rush. Bowers would render out wireframe versions of his footage, Gilbert would composite them on top, 'and I'd keep going back: "Can you do this bit? Something for here?"'

Psygnosis was using Silicon Graphics systems for both rendering and editing at this point, Bowers using the Onyx, while Gilbert used early node-based compositing system Illusion Digital Studio.

Negotiations for *WipEout 2097*'s soundtrack, meanwhile, had started early. Psygnosis recognized the impact of the first game's licensed tunes for both game and marketing; there was less confusion all round. The choice of 'We Have Explosive' came from Sony Music itself, in fact, which offered all the game music for free in return for branding to use on the soundtrack album, and whatever profits might come of it. 'Then someone forgot to sign the paperwork and it ended up being charged at the rates of a compilation album,' says

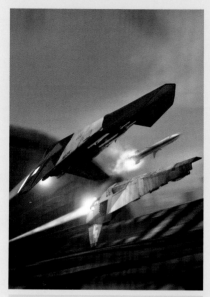

Satterthwaite. 'Eight pence per track, which, with eight tracks, meant 64 pence per unit, which in the end meant something like 640 grand. That was a head-slap.'

The Prodigy's 'Firestarter' had to go in. Ditto The Chemical Brothers, who provided the track 'Loops Of Fury' and played at the game's launch party. Satterthwaite winces. 'The imposter syndrome was through the roof. I was a very geeky 24-year old, bald before my time, being asked for an autograph by these kids at Cream who'd won tickets. What a fraud.'

● C4RT R4C3R

Psygnosis' share of PlayStation software sales was remarkable, and doubly so when you consider that despite it being as close to PlayStation metal as the chips on its motherboard, it was still releasing on competing platforms. As Satterthwaite puts it, 'the company just wanted to retain some semblance of independence.'

It also wanted to understand new technology, wherever it should appear. With Silicon Graphics providing its Onyx system for use in the Nintendo 64 – prematurely, goes the consensus, in terms of hardware support and costs – it stands to reason Psygnosis would take notice. '[Programmer] Andy Yelland was given an exercise to just learn how N64 worked, so he started porting *WipEout*,' says Satterthwaite. 'It was stupidly slow but it did the thing.'

It was enough, apparently, for Psygnosis manager Ian Grieve to shop the 'game' at once to US publisher Midway. '"We're doing *WipEout* on the Nintendo 64! Give us five million bucks!" And that was that, it was happening,' says Satterthwaite. That N64 favoured silicon over optical media, low-capacity cartridges over CD, didn't factor in. Nor the pitiful 4KB of usable texture memory which mandated the Gouraud shading abandoned by *WipEout 2097*.

'I've got a lot of time for Ian, but he really would just not ask about this stuff,' says Satterthwaite. 'He'd see it, he'd sell it. Consequences came later.'

By all accounts, *WipEout 64* had nothing like the resources needed to deal with those convincingly. Spared the complete saga by his honeymoon, Satterthwaite was producer for long enough to remember 'a bit of a shambles.' The project lacked the time, budget and tools

for new tracks, so the team reverse-engineered the first two PlayStation games, before mirroring whichever tracks could be dressed as new locations. This broke them, of course, so any offending corners and elevations were removed.

Tim Wright, meanwhile, had to break up tracks like Propellerheads' 'Bang On!' into cartridge-friendly loops that could be sequenced in real-time to sound like the full tune.

Despite everything, the game was generously received. Nintendo 64's analogue stick was a boon to the series' handling, and *WipEout 64* provided fresh competition to Nintendo's incumbent futurist racer, *F-Zero*. Split-screen multiplayer for up to four players can't be sniffed at either, even if the impact on pop-in and framerate deterred any future attempts.

By doing in the worst of times what it did in the best – adapting and innovating at breakneck speed – Psygnosis ensured a legacy for a game that should have been a disaster. What's more, by moving (quite) fast and breaking (some) stuff long before it was cool, it was certainly futuristic.

● R3PUBL1C4

The way Burcombe tells it, if a third WipEout had come along in the actual year 2097, it would have been too soon for the folks who made the second. 'The stress levels were through the roof. I don't recall anyone saying, "Let's make another one." We were sick to death of it.' Internal politics both in and around Psygnosis drove key members of the team, including Burcombe, art director Lee Carus and producer Satterthwaite, to form Curly Monsters in 1998. [More on that in Zone Four]

It's probably just as well, then, that when Psygnosis decided it did want another WipEout just four years after the second one, it had a whole other studio to give it to.

Psygnosis Leeds was staffed with a mix of industry veterans and hires from the city university, but there was at least one WipEout alum who carried the torch from Liverpool. Having helped Leeds find its feet with games *Global Domination* and *Retro Force*, Nicky Place would become art director on *WipEout 3*, arguably the most arty WipEout of all.

Known internally for its world-class coding, Leeds was also a studio of WipEout fans –

↓
The pre-rendered
intro to *WipEout
3* (Psygnosis
Leeds, 1999)

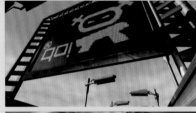

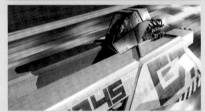

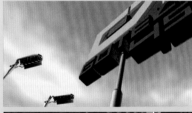

which helped given how few were left in Liverpool. That reverence could have been stifling, but a different studio culture won out. It was, to Place: 'the antithesis of *2097* in a lot of ways. The conversations went: " Let's not do what people expect. Let's invent. And fuck being deliberately cool, we can do that without trying."'

A game that works overtime to appear effortless, then. To understate the power of PlayStation using as much as it can provide. When *WipEout 3* deploys a front-end that's basically just a font, and skylines that are simply colour gradients, be in no doubt: 'That stuff was just nuts. It didn't make anything easy.'

WipEout 3 is also one of precious few, of the many hundreds of PlayStation games, to brave its 'high-resolution' display mode. Rendering its 3D world at a 512×256-pixel resolution, it then squashes into a 4:3 aspect ratio, and can look a full generation of hardware ahead of its predecessor, such is the bump in fidelity. Furthermore, when running a two-player game in vertical split-screen, the two halves are displayed side-by-side, giving each player almost the same resolution as a player of *WipEout 2097*.

'I'm pretty sure it was Pete Bratcher who said he thought we could pull that off at full framerate,' suggests David Jefferies, who programmed the game alongside Naresh Hirani, David Raynard and lead programmer Neil Patterson. 'No one really believed him.'

But when Jefferies showed a dump of the prototype's memory usage to colleague Mark Frazer, it confirmed what *WipEout 2097*'s programmers discovered four years prior: that tileset effects consumed huge amounts of PlayStation's VRAM – more, even, than the graphics for its tracks. Get rid of those and, with some renderer optimizations and new Sony libraries the team rewrote in Assembler, you've got your high-res display.

Technical artists like Frazer became increasingly important for game development, serving as a bridge between the Michael Places of the design world and programmers such as Jefferies. The kinds of conversations that drive the *WipEout* games in particular – between people who work in Macromedia Freehand and people who think in machine code – cannot happen without an interpreter.

Frazer confirms: 'Mike had the graphical vision for the game, David was doing the front-end and the HUD graphics and I sort of sat between them just doing implementation, getting Mike's original work into some kind of usable form.' Jeffries nods. 'Mike's really curious about how, say, a printer works, which is why he's so good. But there was a gulf between us professionally. We just didn't speak the same language.'

WipEout 3 is unquestionably the peak of the relationship between Psygnosis and The Designers Republic™. It's the game where all the walls of home gaming come down and Keith Hopwood's consumer journey – packaging, art and gameplay, as one – becomes real. It's the game happy to be carried on the winds of a whole other medium, even if took colossal amounts of thrust.

As Frazer continues: 'However much direction David was getting from me, I was getting it from Mike. He'd come in with his laptop and just sit there going, "Nope, not happy with that." And I'd have to move things a pixel to the left, a pixel to the right, and tell all this to David.'

Jefferies remembers thinking, '"My God, this minutiae." The amount of detail we were going into. Mark would give me all the graphics for, say, the in-game HUD, and I'd place them all to get them animating in a way I thought was correct. Then Mark would point out all the pixels that were missing, a line here and there…'

It was the high-definition mode, which in pushing screen and pixels that bit closer to paper and ink, swiped away a safety net that televisions had given games for years. 'We'd gotten away with murder,' says Jefferies, 'with assets that were wonky and blurry and just out. This had to be exact.'

Not to say that Place was a tyrant, or unsympathetic. 'Mike is one of the best print designers the UK's seen in a long time,' says Frazer. 'A graphic designer wouldn't walk into a print shop and just go, "I want this and this." They'd go, "How do we do this?" You've got to understand the job from [the printer's] end to direct them efficiently, but also happily. That's almost how I'd describe my working with a programmer.'

WipEout 3's front-end [p168] is remarkable when you consider its distance from those

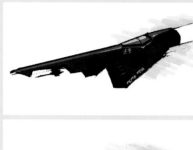

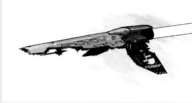

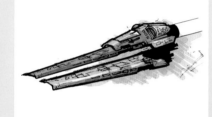

sacred cows of Psygnosis artwork: the slavish intricacies of the title screens, the rainbow metals of the logos. The font, known simply as 'Angular' during development, was designed for Detroit house musician Model 500. Place supplied that and the RGB values for the background, leaving Frazer and Hirani to think about the rest – more fool them.

'We were trying abstract images in the backgrounds: shapes, grids, a few top-down renders of the actual craft,' recalls Frazer. 'Mike said, "Can't it be completely blank?" Which raised a bit of controversy at the time. People were saying, "Is this it?" But we held our nerve and that's how it went out.' Serendipitously, it also made the front-end so uncommonly small that *WipEout 3*, unlike most PlayStation games, keeps it all in memory the whole time, saving a tremendous amount of disc IO.

● WØRLD 1N MY 3Y35

There's a rule of thumb in videogames when it comes to high resolutions: be careful what you wish for. This is doubly true when the machine behind those resolutions is the exact same one as before, with no bump in power to pretty up what's there when – to be very late-90s about it – the beer goggles come off. Just as well, then, that *WipEout 3*'s tracks are beauties.

The game's artists were given three or four tracks each: just splines drawn in Maya then bulked up with geometry for instant testing on a devkit. The game designers picked the best of them, 'and then Nicky did this fantastic trick,' recalls Frazer. 'Instead of letting the artist who'd done the track work on that level and dress it, she gave them to different people. The idea was to stimulate you to think more, because you've got preconceptions: this is a shipyard, a space port, whatever. This really pulled the rug out from people's feet.'

From the low-key realism of Stanza Inter to the architectural delights of Mega Mall, the results found opportunity in high-res where previous PlayStation games – even, yes, *WipEout 2097* – used low-res more as a crutch, devolving into a kind of toxic textural soup. This wasn't magic, either, just thinking as clear as the skies over Porto Kora, from which beautifully animated seagulls flock to the track.

'If we'd wanted a textured sky-dome in high resolution,' explains Jefferies, 'that's a lot more memory. And those sky textures are blurry at the best of times because they're never high-resolution enough. I think it was Neil Patterson who came up with: "Well, why don't we just render this globe around the track and, rather than texture it, we specify a colour for each vertex and let the PlayStation hardware interpolate between them?" The PS1 could do that beautifully: no blurriness, no artefacts, just perfect gradients.'

As for the seagulls: 'I'd just drunk way too much caffeine at that point. They've actually got all kinds of behaviours, way beyond what was needed. They were just two polygons representing the wings, going back and forth, and they'd hop around the track as though they were picking up seed or something. If the ships came nearby they'd detect this and fly up to the track sides or a billboard and sit there. If you were in the lead then they'd get really excited and bounce up and down faster. Ludicrous.'

● 4CC3PT NØ 5UB5T1TUT3

WipEout 3 entered development in January 1999 and was released in September the same year, giving it the kind of mach-10 development the series was accustomed to. Memories differ as to why it wrapped up earlier than the planned date of December, but fingers generally wag at one *Gran Turismo 2*. Never the most punctual of games, Polyphony Digital's sequel had slipped and threatened to hog Sony's marketing spend for the year's end – so Christmas would just have to come early for *WipEout 3*.

This had an unfortunate side-effect: rather than merely adopt a new anti-piracy system designed for *Gran Turismo 2*, *WipEout 3* would now introduce it as well. Chipped PlayStations – modified to run copied and imported discs – would refuse to boot even legal copies of the game. 'This might have seemed a good idea with a massive franchise like Gran Turismo,' explains Jefferies, 'but news went around: "If you've got a chipped machine, don't buy this game." And everyone had a chipped machine in 1998.'

WipEout would be entrusted with a great many more Sony inventions in the years to come, but it's a bitter pill to swallow. No one should have missed out on what Leeds built in those nine months: a reminder that while 'programmer art' has long been a pejorative, it's only through programmers that game art exists at all.

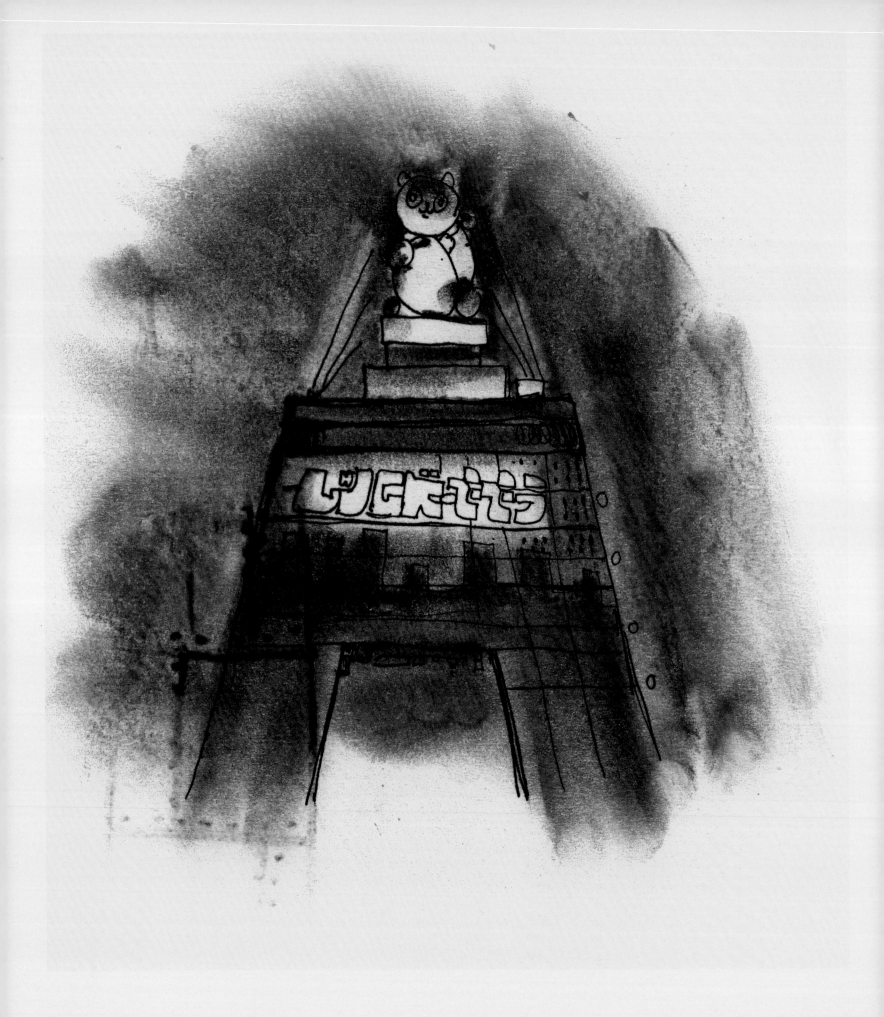

←

A Lucky Cat
sketch for the
intro to *WipEout
2097* (Psygnosis,
1996)

Nicky Place:
'You didn't have
a massive team
in those days.
These sketches
were just me
and Jim [Bowers,
artist]. I
directed it
and Jim was my
mentor, because
he had so much
experience.'

↓→

Sketches by Nicky
Place for the
intro to *WipEout
2097* (Psygnosis,
1996)

Nicky Place:
'These were
literally just
made to visualize
the intro – just
for us. It would
have been useless
for anyone else.
They wouldn't
have had a clue
what they meant.'

→

Storyboard
sketches for the
intro to *WipEout
2097* (Psygnosis,
1996)

Nicky Place:
'People knew we
were collectively
very capable
when we made
the second one.
That and the
timeframes meant
everyone was
just: "Get on
with it. If we
don't trust you
then we know it
won't get done."
There was a huge
amount of trust
and we were
really lucky to
have it.'

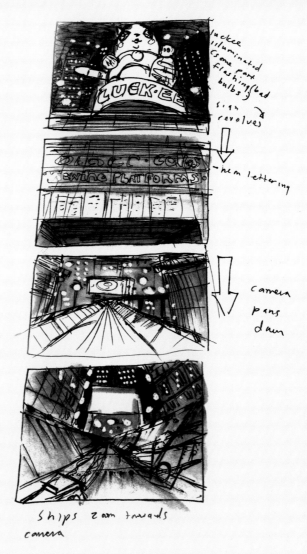

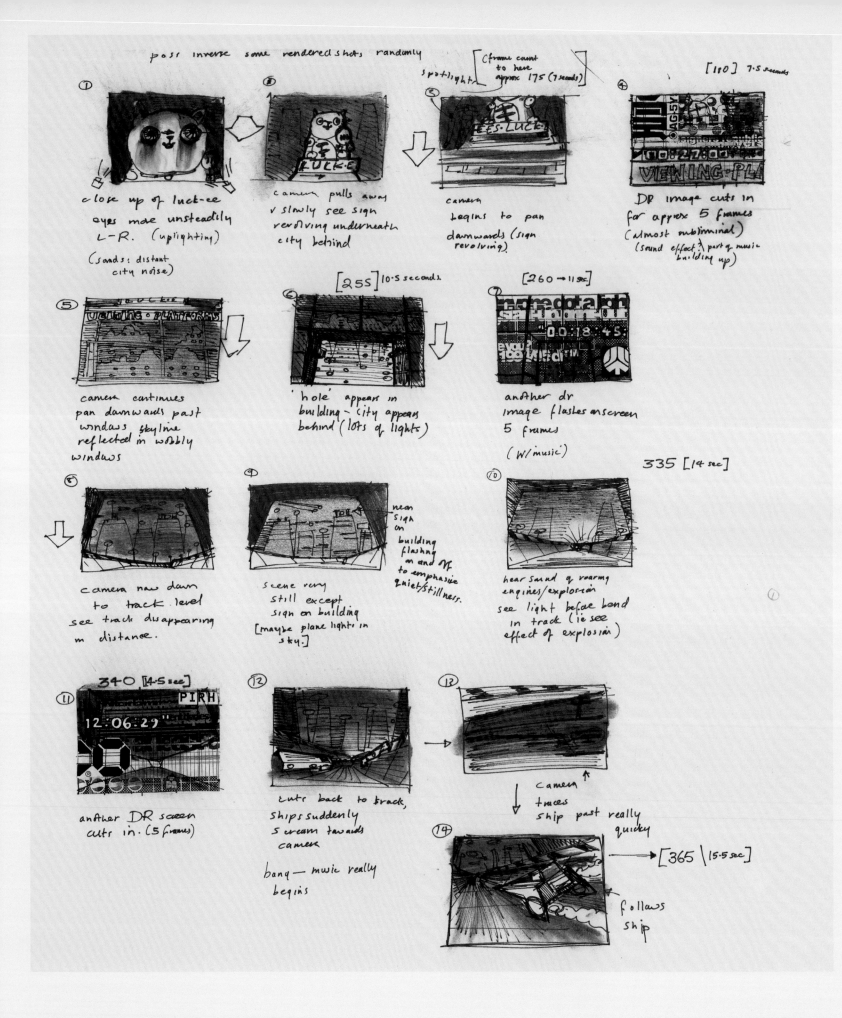

poss inverse some rendered shots randomly

spotlight [frame count to here approx 175 (7 seconds)] [180] 7.5 seconds

① close up of luck-ee
eyes move unsteadily
L-R. (uplighting)

(sounds: distant
city noise)

② camera pulls away
v slowly see sign
revolving underneath
city behind

③ camera
begins to pan
downwards (sign
revolving)

④ DR image cuts in
for approx 5 frames
(almost subliminal)
(sound effect + part of music
building up)

[255] 10.5 seconds [260→11sec]

⑤ camera continues
pan downwards past
windows skyline
reflected in wobbly
windows

⑥ 'hole' appears in
building — city appears
behind (lots of lights)

⑦ another dr
image flashes on screen
5 frames

(W/music)

335 [14 sec]

⑧ camera now down
to track level
see track disappearing
in distance.

⑨ scene very
still except
sign on building
[maybe plane lights in
sky.]

neon sign
on
building
flashing
on and off
to emphasise
quiet/stillness.

⑩ hear sound of roaring
engines/explosion
see light before band
in track (ie see
effect of explosion)

340 [14.5 sec]

⑪ PIRH 12:06:29"
another DR screen
cuts in. (5 frames)

⑫ cuts back to track,
ships suddenly
scream towards
camera

bang — music really
begins

⑬ camera
traces
ship past really
quickly

[365 | 15.5 sec]

⑭
follows
ship

← →

Storyboard
sketches for
WipEout 2097
(Psygnosis,
1996)

These sketches by
Psygnosis artist
Nicky Place
are remarkable
not just for
their meticulous
cinematography,
but for their
attention to
light as much
as texture – a
crucial component
of even early
CG graphics.

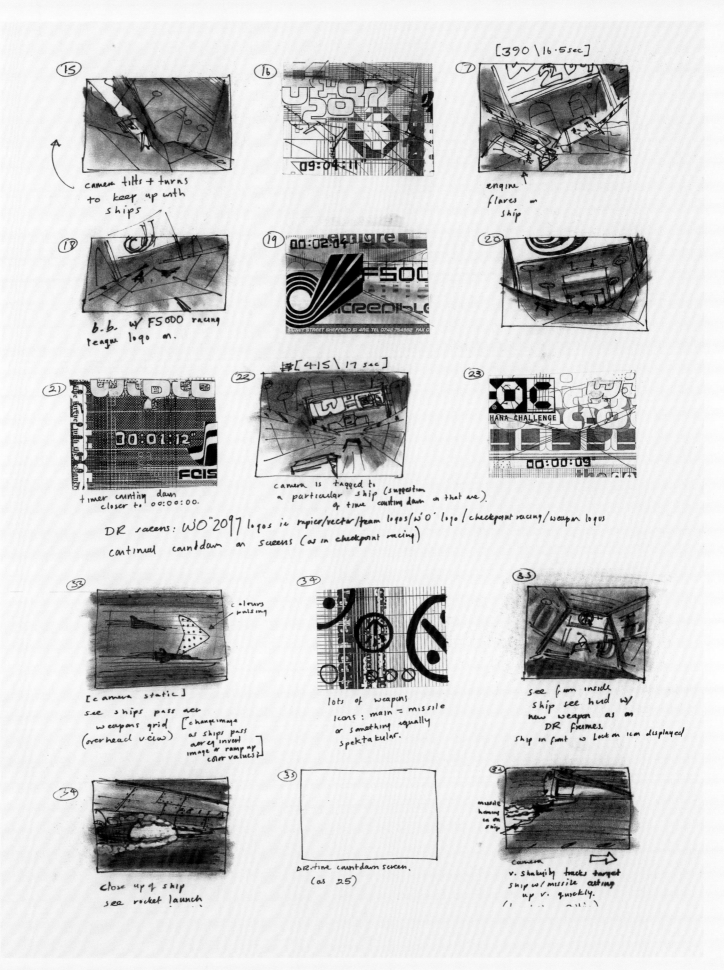

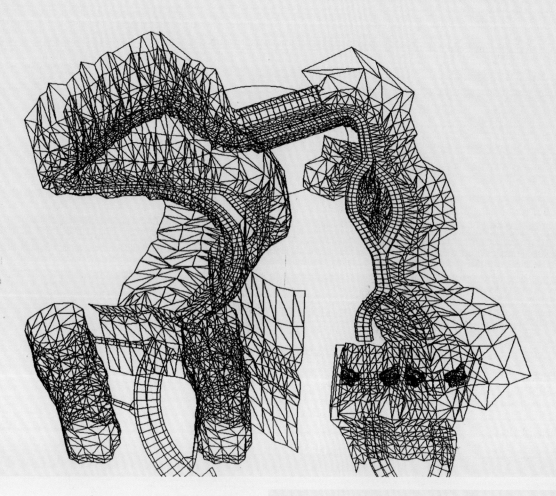

Wireframe images
of one of the
second game's
most challenging
tracks lay bare
the ruthless
economies of its
construction:
trackside
terrain given
a tiny fraction
of the polygon
count with much
of the track
simply floating
in space.

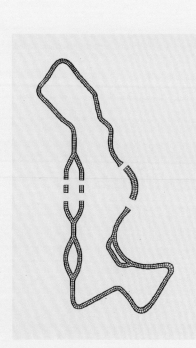

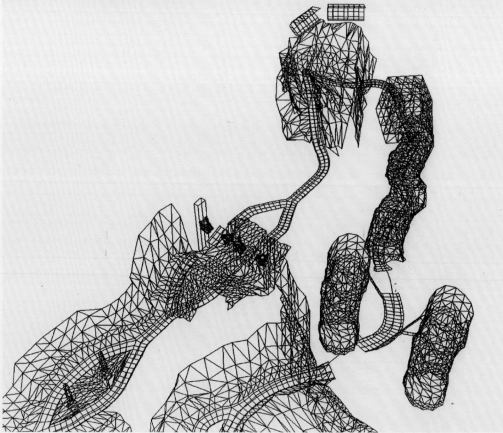

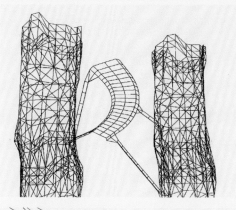

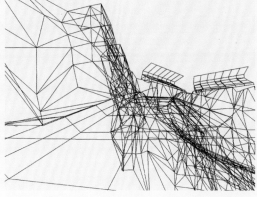

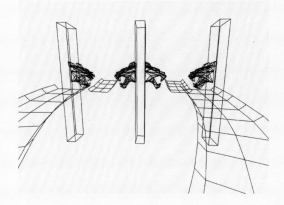

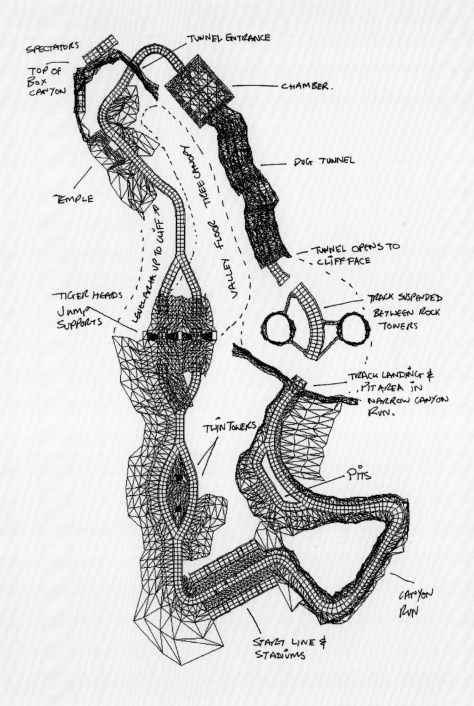

SPECTATORS

TOP OF
BOX
CANYON

TEMPLE

TUNNEL ENTRANCE

CHAMBER.

DUG TUNNEL

TIGER HEADS
JUMP
SUPPORTS

LEVEL WALK UP TO CLIFF A

VALLEY FLOOR

TREE CANOPY

TUNNEL OPENS TO
CLIFF FACE

TRACK SUSPENDED
BETWEEN ROCK
TOWERS

TRACK LANDING &
PIT AREA IN
NARROW CANYON
RUN.

THIN TOWERS

PITS

CANYON
RUN

START LINE &
STADIUMS

Development schedules for *WipEout 2097* (Psygnosis, 1996)

Michael Place: 'This shows how short the development time was. It's brutal. Not that we were just banging stuff out but it was very much like, "Here's a request, just do it." And that kind of instant sign-off really helps.'

Page 1

ID	Task Name	Duration	Start	Finish	Predecessors	Cost	Resource Names
1	Design	70d	2/26/96	5/31/96		$0.00	
2	Game Structure Design	70d	2/26/96	5/31/96		$0.00	
3	Two Player Structure	1w	2/26/96	3/1/96		$0.00	Nick B
4	Ship Handling	1w	3/4/96	3/8/96	58SS	$0.00	Nick B
5	Track Texturing	2w	4/1/96	4/12/96		$0.00	Nick B
6	Speed Ups	1w	4/15/96	4/19/96	5	$0.00	Nick B
7	Weapon Squares	1w	4/22/96	4/26/96	6	$0.00	Nick B
8	Checkpoints	1w	4/29/96	5/3/96	7	$0.00	Nick B
9	AI / DPA tweaking	4w	5/6/96	5/31/96	8	$0.00	Nick B
10	Artistic Design	25d	2/26/96	3/29/96		$0.00	
11	Team / Pilot logos	1w	2/26/96	3/1/96		$0.00	Designers Republic
12	F5000 Logo + Game Logo	2.5d	3/4/96	3/6/96	11	$0.00	Designers Republic
13	HUD Features (speedo / thrust	2.5d	3/6/96	3/8/96	12	$0.00	Designers Republic
14	Menu logos (race class / race ty	2.5d	3/11/96	3/13/96	13	$0.00	Designers Republic
15	Menu logos (options)	2.5d	3/13/96	3/15/96	14	$0.00	Designers Republic
16	Pit Lane / Checkpoint logo	2.5d	3/18/96	3/20/96	15	$0.00	Designers Republic
17	Loading Screen logos	2.5d	3/20/96	3/22/96	16	$0.00	Designers Republic
18	Weapon icons	2.5d	3/25/96	3/27/96	17	$0.00	Designers Republic
19	Track Logos	2.5d	3/27/96	3/29/96	18	$0.00	Designers Republic
20	Artwork	85d	2/12/96	6/7/96		$0.00	
21	Track Scenary	80d	2/12/96	5/31/96		$0.00	
22	Theta	7w	2/12/96	3/29/96		$0.00	Eve
23	Nu	9w	4/1/96	5/31/96	22	$0.00	Eve
24	Upsil	7w	2/12/96	3/29/96		$0.00	John
25	Alpha	9w	4/1/96	5/31/96	24	$0.00	John
26	Beta	7w	2/12/96	3/29/96		$0.00	Pol
27	Rho	9w	4/1/96	5/31/96	26	$0.00	Pol
28	Zeta	7w	2/12/96	3/29/96		$0.00	Dave
29	Eta	9w	4/1/96	5/31/96	28	$0.00	Dave
30	Movies + Renders	85d	2/12/96	6/7/96		$0.00	
31	Storyboarding	3w	2/12/96	3/1/96		$0.00	Nicky
32	Intro	4w	3/4/96	3/29/96	31	$0.00	Nicky

Page 2

ID	Task Name	Duration	Start	Finish	Predecessors	Cost	Resource Names
33	Title Screen	1w	4/1/96	4/5/96	32	$0.00	Nicky
34	Extro 1	2w	4/8/96	4/19/96	33	$0.00	Nicky
35	Extro 2	2w	4/22/96	5/3/96	34	$0.00	Nicky
36	Extro 3	2w	5/6/96	5/17/96	35	$0.00	Nicky
37	Extro 4	2w	5/20/96	5/31/96	36	$0.00	Nicky
38	Track loading screens	1w	6/3/96	6/7/96	37	$0.00	Nicky
39	Miscellaneous	80d	2/19/96	6/7/96		$0.00	
40	Finalise Ship Design	1w	2/19/96	2/23/96		$0.00	Jeff
41	Building / Texturing ships	3w	2/26/96	3/15/96	40	$0.00	Jeff
42	Drawing HUD textures	1w	3/18/96	3/22/96	41	$0.00	Jeff
43	Building Pit lane repair / start gr	1w	3/25/96	3/29/96	42	$0.00	Jeff
44	Drawing menu textures	1w	4/1/96	4/5/96	43	$0.00	Jeff
45	Building menu models	1w	4/8/96	4/12/96	44	$0.00	Jeff
46	Building weapon + explosion m	1w	4/15/96	4/19/96	45	$0.00	Jeff
47	Building Miscellaneous models	1w	4/22/96	4/26/96	46	$0.00	Jeff
48	Drawing ship shadows	1w	4/29/96	5/3/96	47	$0.00	Jeff
49	Drawing weapon icon textures	1w	5/6/96	5/10/96	48	$0.00	Jeff
50	Building menu track models (8)	1w	5/13/96	5/17/96	49	$0.00	Jeff
51	Drawing Track Bitmaps for Scal	1w	5/20/96	5/24/96	50	$0.00	Jeff
52	Drawing Track Logos	1w	5/27/96	5/31/96	51	$0.00	Jeff
53	Building new rescue / referee d	1w	6/3/96	6/7/96	52	$0.00	Jeff
54	Programming	85d	2/12/96	6/7/96		$0.00	
55	Stew	85d	2/12/96	6/7/96		$0.00	
56	Scanner (main code)	1w	2/12/96	2/16/96		$0.00	Stew
57	Menu Structure	2w	2/19/96	3/1/96	56	$0.00	Stew
58	Tweaking Player Control	1w	3/4/96	3/8/96	57	$0.00	Stew
59	Get PAL feeling like NTSC	1w	3/11/96	3/15/96	58	$0.00	Stew
60	HUD	2w	3/18/96	3/29/96	59,42SS	$0.00	Stew
61	Menu Graphical Effects	2w	4/1/96	4/12/96	60,44SS	$0.00	Stew
62	Prepare E3 Demo	1w	4/15/96	4/19/96	61	$0.00	Stew
63	End Race Screens	1w	4/22/96	4/26/96	62,47SS	$0.00	Stew
64	Multi-Player Code	3w	4/29/96	5/17/96	63	$0.00	Stew

ID	Task Name	Duration	Start	Finish	Predecessors	Cost	Resource Names
65	Credits	1w	5/20/96	5/24/96	64	$0.00	Stew
66	Scanner (implementing graphic	1w	5/27/96	5/31/96	65,51	$0.00	Stew
67	Memory Card Stuff	1w	6/3/96	6/7/96	66	$0.00	Stew
68	**Nick**	85d	2/12/96	6/7/96		$0.00	
69	AI / CONTROL	35d	2/12/96	3/29/96		$0.00	
70	Player Ship Collisions	2w	2/12/96	2/23/96		$0.00	Nick K
71	Opposition Ship Collisions	2w	2/26/96	3/8/96	70	$0.00	Nick K
72	Opposition Control	3w	3/11/96	3/29/96	71	$0.00	Nick K
73	Finish Ghost Ship	1w	4/1/96	4/5/96	72	$0.00	Nick K
74	Replays	2w	4/8/96	4/19/96	73	$0.00	Nick K
75	Auto-Pilot pick-up	2w	4/22/96	5/3/96	74	$0.00	Nick K
76	Multi-Player code	2w	5/6/96	5/17/96	64FF,75	$0.00	Nick K
77	DPA	3w	5/20/96	6/7/96	76	$0.00	Nick K
78	**Chris**	85d	2/12/96	6/7/96		$0.00	
79	Droid Code	1w	2/12/96	2/16/96		$0.00	Chris
80	New Weapons	2w	2/19/96	3/1/96	79	$0.00	Chris
81	Sound Effects + Speech	3w	3/4/96	3/22/96	80	$0.00	Chris
82	Pit Lane repair graphics	1w	3/25/96	3/29/96	81,43SS	$0.00	Chris
83	Race start sequence	1w	4/1/96	4/5/96	82	$0.00	Chris
84	Menu Graphical Effects	1w	4/8/96	4/12/96	83	$0.00	Chris
85	"Explosion" for dead ship	1w	4/15/96	4/19/96	84,46SS	$0.00	Chris
86	"Game Over" sequences for dea	1w	4/22/96	4/26/96	85,47SS	$0.00	Chris
87	"Smoke" effect when craft dama	1w	4/29/96	5/3/96	86	$0.00	Chris
88	Ship Shadows	1w	5/6/96	5/10/96	87,48SS	$0.00	Chris
89	Initial load time / progress bar	1w	5/13/96	5/17/96	88	$0.00	Chris
90	Initial / Track / Menu loading scr	1w	5/20/96	5/24/96	89	$0.00	Chris
91	Movie code	2w	5/27/96	6/7/96	90	$0.00	Chris
92	**Music + SFX**	17d	2/26/96	3/19/96		$0.00	
93	Sound Effects + Speech	3w	2/26/96	3/15/96		$0.00	Tim W
94	CD Audio Tracks	1d	3/18/96	3/18/96	93	$0.00	Various Artists
95	Movie Music	1d	3/19/96	3/19/96	94	$0.00	Tim W
96	**Deadlines**	172d	3/14/96	11/8/96		$0.00	

Page 3

ID	Task Name	Duration	Start	Finish	Predecessors	Cost	Resource Names
97	Demo 1	0d	3/14/96	3/14/96		$0.00	
98	Demo 2 (CD)	0d	4/11/96	4/11/96	22,24,26,28	$0.00	
99	E3 Demo submitted to test	2w	4/22/96	5/3/96	62	$0.00	
100	Submit E3 Demo	0d	5/3/96	5/3/96	99	$0.00	
101	Music & SFX Fully Implemented	0d	3/19/96	3/19/96	92	$0.00	
102	Alpha	0d	6/7/96	6/7/96	20,54	$0.00	
103	Alpha Period	20d	6/10/96	7/5/96	102	$0.00	
104	Beta Test	0d	7/5/96	7/5/96	103	$0.00	
105	Beta Test Period	20d	7/8/96	8/2/96	104	$0.00	
106	Publishing Demo(s)	0d	8/2/96	8/2/96	105	$0.00	
107	BBFC/VSC Certification Submitted	0d	8/2/96	8/2/96	105	$0.00	
108	**Submission Phase (PSX)**	45d	8/5/96	10/4/96	105	$0.00	
109	Delivery	0d	8/5/96	8/5/96		$0.00	
110	SCEE Approval	40d	8/5/96	9/27/96	109	$0.00	
111	DADC Master Production	5d	9/30/96	10/4/96	110	$0.00	
112	Master (PSX)	0d	10/4/96	10/4/96	111	$0.00	
113	Production (PSX)	25d	10/7/96	11/8/96	112	$0.00	
114	Product Launch (PSX)	0d	11/8/96	11/8/96	113	$0.00	

Page 4

↑ →
Development schedules for *WipEout 2097* (Psygnosis, 1996)

Nicky Place: 'It was a very small group of people and I don't remember any problems with the higher-ups. The thing is that time was so ridiculously short that decisions just had to be made. That changed a lot as the games went on.'

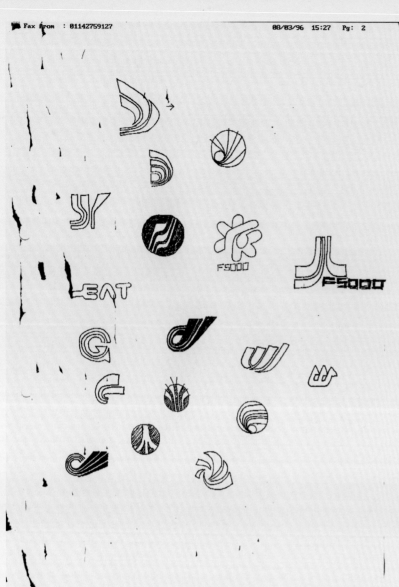

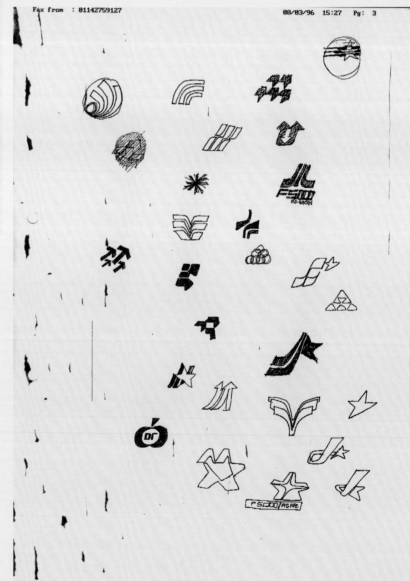

↑ ↗ →
Early sketches
for *WipEout 2097*
(Psygnosis,
1995)

Michael Place:
'I'm cringing
and laughing
at the anarchy
sign in "tDR" up
there. Some of
the team logos as
we went through
the different
games were really
questionable,
but you could
see in that the
whole exercise:
that these
companies were
rebranding.'

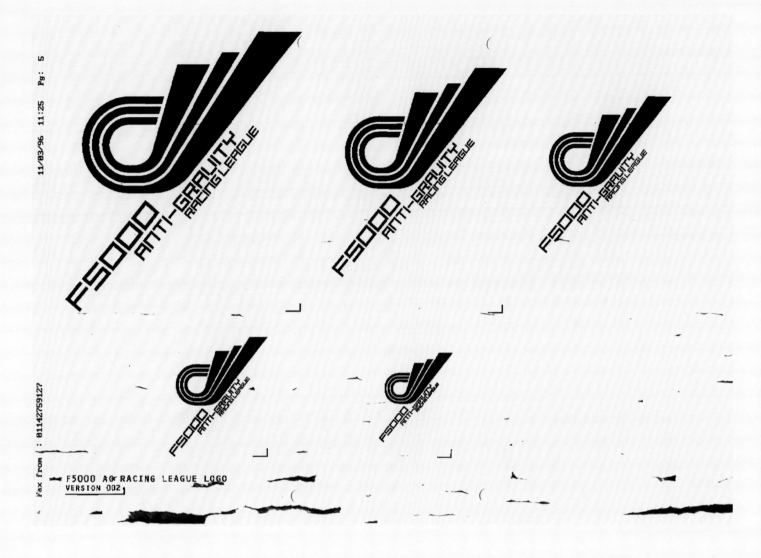

11/03'96 11:25 Pg: 5

Fax from : 81142759127

F5000 AG RACING LEAGUE LOGO
VERSION 002

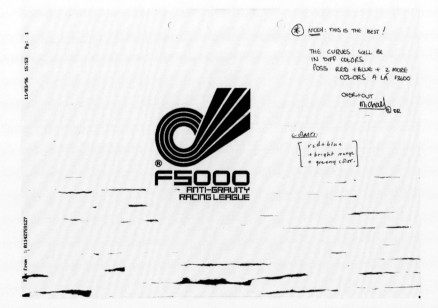

11/03'96 15:53 Pg: 1

Fax from : 81142759127

NICKY: THIS IS THE BEST!

THE CURVES WILL BE
IN DIFF COLORS
POSS RED + BLUE + 2 MORE
COLORS A LA F3600

OVER + OUT
Michael ©DR

COLORS:
red + blue
+ bright orange
+ greeny colour.

ワイプアウト

FAO: NICKY, HOW ABOUT THIS UN!?
MICHAEL EDR, 9108M7X87Y

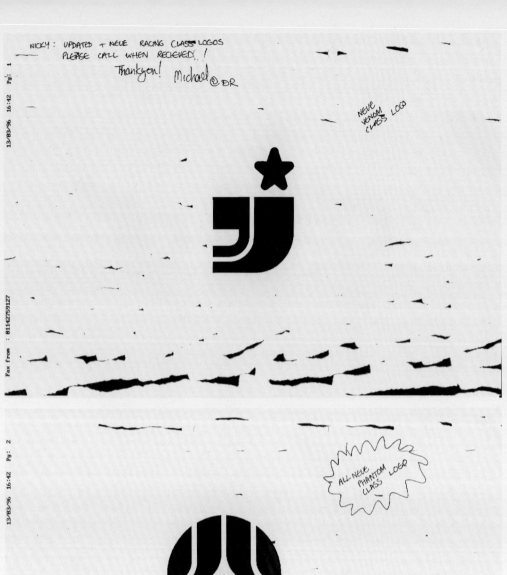

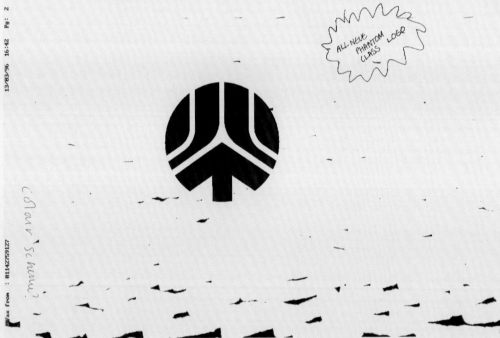

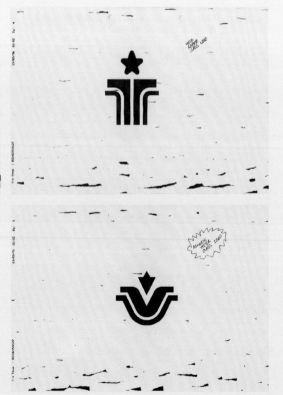

← ↙
Logos and lore
for European
team FEISAR

→
Logos and lore
for Brazilian
team Pirhana

PIRHANA

PIRHANA PIRHANA PIRHANA

CORPORATE IDENTITY TO BE DISPLAYED ON THE MODELS OF THE NEWLY FORMED PIRHANA RACING TEAM. THE LOGO MIRRORS THE DIGITAL PRECISION OF THE 2300 QUASI-DRIVE I-PULSE ENGINE. THE PIRHANA LETTERING IS STILL SUBJECT TO FINAL APPROVAL BY THE CHINESE DEMOCRATIC REPUBLIC.

THE ORIGINAL LOGO FOR FEISAR (FEDERAL EUROPEAN INDUSTRIAL SCIENCE AND RESEARCH) WAS COMPLETED JUST IN TIME FOR THE 2050 COMPETITION. FEISAR COMMISSIONED A REDESIGN FOUR DECADES LATER BUT IT WAS EVENTUALLY AGREED THAT THE EXISTING SYMBOL WAS STILL VERY EFFECTIVE AND ONLY MINOR ADJUSTMENTS WERE REQUIRED.

AG-5Y5™

AURICOM

AURICOM AURICOM AURICOM

INTRODUCING THE NEW CORPORATE IDENTITY FOR AURICOM RESEARCH INDUSTRIES (USA). THE REDESIGN ALLOWS FOR USE OF THE LOGO WITH OR WITHOUT THE ACCOMPANYING UNIQUELY FORMULATED LETTERFORMS. THE SURGING DYNAMISM SYMBOLISES THE NEW PULSE© THRUSTMASTER VII ENGINES UTILISED BY THE AURICOM© T-80E SERIES 4 MODELS. HAVE A NICE DAY...

↗ →
Logos and lore
for Japanese
team AG Systems

←
Logos and lore
for American
team Auricom

AG-5Y5™ AG-5Y5™ AG-5Y5™

IN THE YEAR 2096 AG SYSTEMS COMMISSIONED A REDESIGN OF THEIR LOGO MORE IN KEEPING WITH THE INCREASINGLY PREVALENT USE OF INTERGLOBAL TECHNOSPEAK. THE LOGO CAN BE USED WITH OR WITHOUT THE NEWSPEAK AG SYS™ (SIC). AG HAD ALREADY MODIFIED THEIR COLOUR SCHEME TO DARK RED/WHITE TO REFLECT A GROWING JAPANESE NATIONAL PRIDE PROPORTIONAL TO THEIR REGAINED POWER IN THE INTERNATIONAL COMMUNITY - THANKS TO AG SYS™'S LEAPS FORWARD IN OFFWORLD AG TRANSPORT.

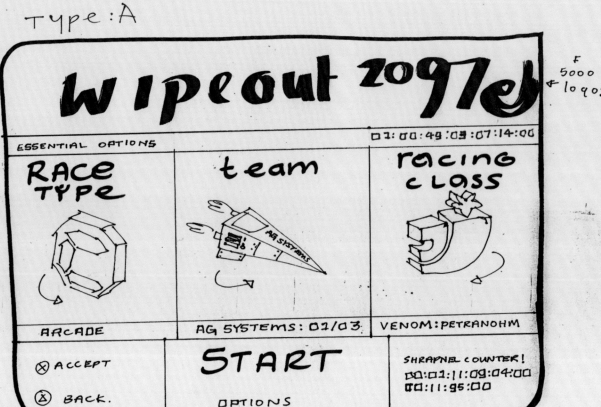

TYPE:A

Wipeout 2097el

5000 logo!

ESSENTIAL OPTIONS

01:00:49:03:07:14:00

RACE TYPE	team	racing class
ARCADE	AG SYSTEMS: 01/03	VENOM:PETRANOHM

⊗ ACCEPT

△ BACK.

START

OPTIONS

SHRAPNEL COUNTER!
00:01:11:09:04:00
00:11:95:00

←
Nicky Place's
design sketch
for the main
menu in *WipEout
2097* (Psygnosis,
1996)

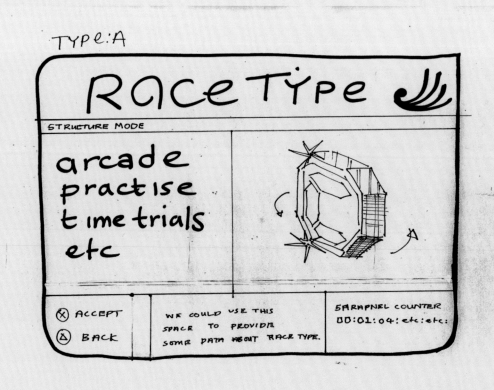

TYPE:A

RaceType

STRUCTURE MODE

arcade
practise
time trials
etc

⊗ ACCEPT

△ BACK

WE COULD USE THIS
SPACE TO PROVIDE
SOME DATA ABOUT RACE TYPE.

SHRAPNEL COUNTER
00:01:04: etc:etc:

→
A design sketch
for the race
select menu in
WipEout 2097
(Psygnosis,
1996)

Colour guides for Font metrics
teams in *WipEout* for *WipEout*
2097 (Psygnosis, *2097* (Psygnosis,
1996) 1996)

18/03/96 14:41 Pg: 2

Fax from : 01142759127

W'O"20'97 FONT
(6X6.1)

SMALL FONT
SIX X SIX PIXEL/RATIO

Composite

14/03/96 16:42 Pg: 1

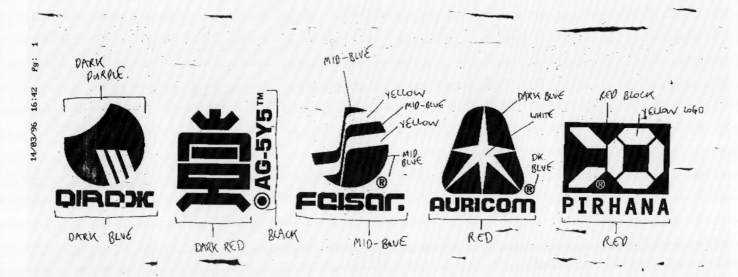

Fax from : 01142759127

ATT: NICKY

FROM: NICK @ DR™.

NICKY:- HAVE YOU TRIED IMPORTING THE FILES
INTO PHOTOSHOP AS "PICT RESOURCE"?

←↙↓
Sketches for
the racing HUD
in *WipEout 2097*
(Psygnosis,
1996)

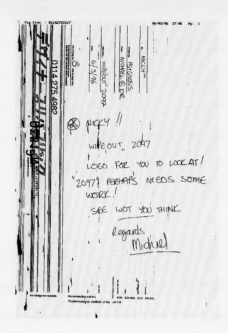

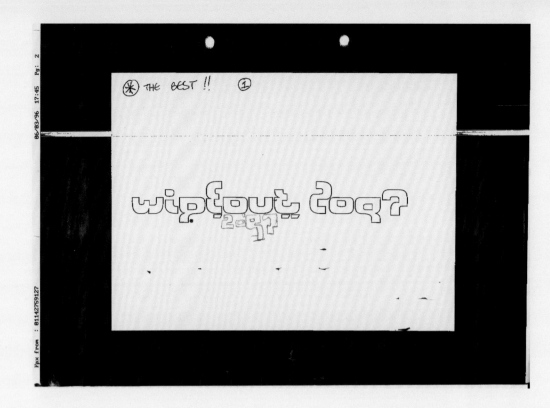

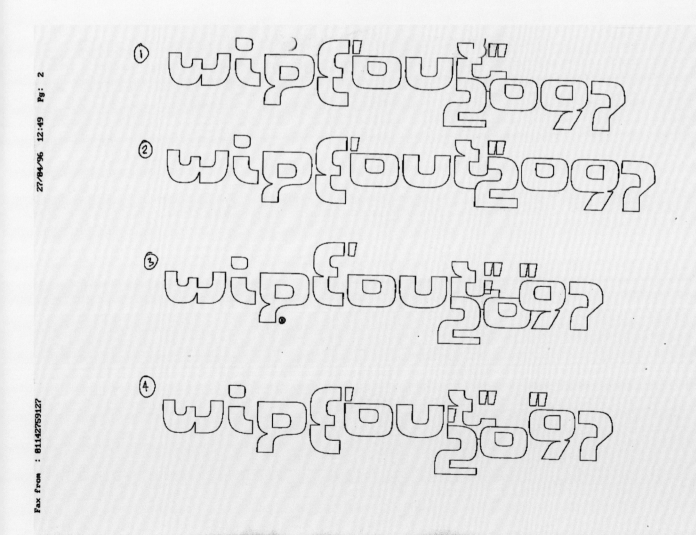

← ↖ ↑
Variations on
the final logo
for *WipEout 2097*
(Psygnosis,
1996)

RACE TEAMS

DIREX
FEISAR
AG-SYSTEMS
AURICOM

PRO-TO'TYPE PIRANHA

WIPE'OUT"/V0.2

WIPE'OUT"2097 "ACCELERATED ADRENALIN RUSH FOR FUTURE PEOPLE"

PlayStation

PAL

COMPACT
disc DIGITAL™
»32BIT™ F5000 AG-RACING LEAGUE
OFFICIAL MARCA REG

wip€'out" 2097

ACCELERATED ADRENALIN RUSH ™

ワイプ®アウト─ 2097 ツ'ロ"

'33 '33 '33 •••••• SOK A-G RACING ﾌﾞﾚｰﾝ™ W'O"2097

QIRD-X 賞 ◉AG-5Y5™ Feisar. AURICOM™ PIRANHA

03 02 01 GO!

COMPANY SPONSORSHIP PRO-TO'TYPE WO

0.00144 040.301 09800.4 OOW.1P3OUTSP33OS.O68OO.4

KID'S GAME IN DRUG AD' ROW

AN ad for a Sony computer game aimed at kids as young as three has been blasted as glamorising drugs. Tory MP Terry Dicks called it "an outrage". The magazine ad for WipEout shows teenagers slumped in chairs who appear to have over-dosed. The letter E is always in capitals — like a reference to Ecstasy.

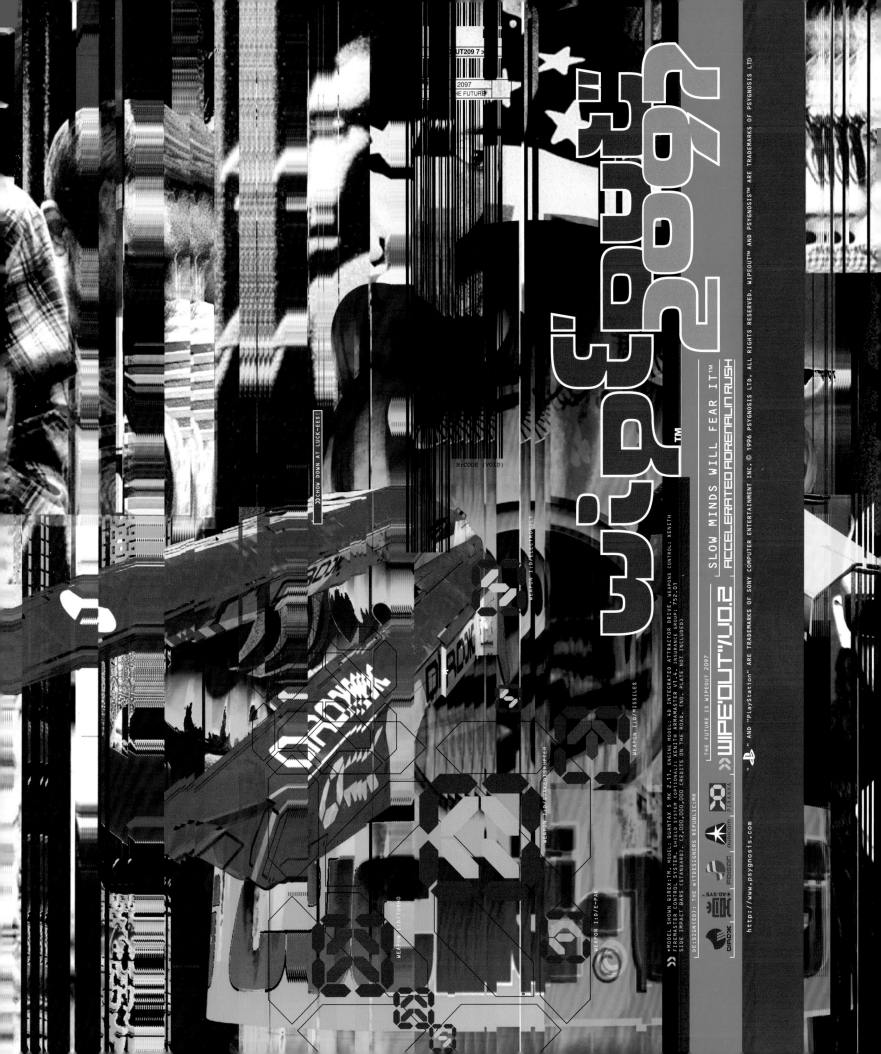

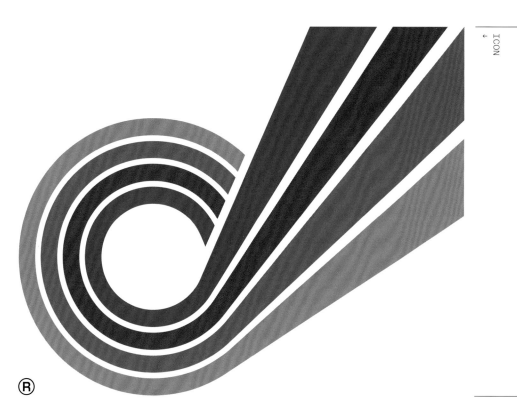

® ICON ←

F5000

TYPE-A →
←

ANTI-GRAUITY
RACING LEAGUE

TYPE-B →
←

ABC

ABCDEFGHIJ
KLMNOPQR...

PALETTE →
←

A	B	C	D
#214D78	#8F3268	#746724	#C77D17

ORDER
A: IN
B > C > D:OUT

QIROX DX
DX
-POCT
THE
BOST®

→
ANGLE

3
22.5°

→
COLOUR
HEX
CODES

HEЖ 4b1e4b

QIRОЖ

HEЖ 023346

→
QIREX
QUSTOM
TYPE

QIRОЖ

QIRОЖ

tha
of
thq.

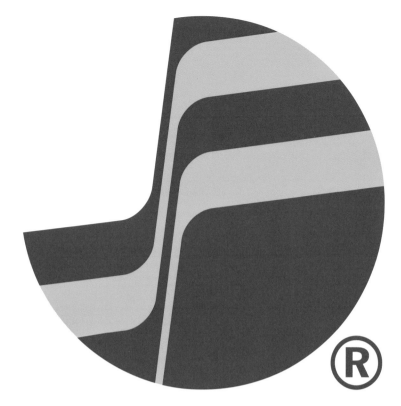

feisar.

↑
LOGOTYPE

say

PRONUNCIATE
↓

fai·sar.

→
CUSTOM
TYPE

abcd

e-feisar.

FEISAR
BLUE
#005792

FEISAR
Y-ORANGE
#fabb00

FEISAR
THE ORIGINAL
AND BEST

FEISAR

THE LONG GAME

AURICOMAURICOM
AURICOMAURICOM
AURICOMAURICOM
AURICOMAURICOM

AURICOM.COMAURICOMAURICOM
AURICOM.COMAURICOMAURICOM
AURICOM.COMAURICOMAURICOM®

↑
MAIN
NEW STAR SPANGLED BANNER® VARIANT
↓

NEW GLORY® VARIANT
↓

↑
VEX

AURICOMAURICOM
AURICOMAURICOM
AURICOMAURICOM
AURICOMAURICOM

AURICOM.COMAURICOMAURICOM
AURICOM.COMAURICOMAURICOM
AURICOM.COMAURICOMAURICOM®

6-POINT® VARIANT
↓

AURICOMAURICOM
AURICOMAURICOM
AURICOMAURICOM
AURICOMAURICOM

AURICOM.COMAURICOMAURICOM
AURICOM.COMAURICOMAURICOM
AURICOM.COMAURICOMAURICOM®

GOD BLESS AMERICA®
GOD BLESS TRADEMARKS®
GOD BLESS AURICOM®

AURICOM

IN T®ADEMA®K WE T®UST.
IN T®ADEMA®K WE ENFO®CE.
NEW O®DE® OF THE AGES.
OUT OF MANY, ONE.
AU®ICOM IS A#1.

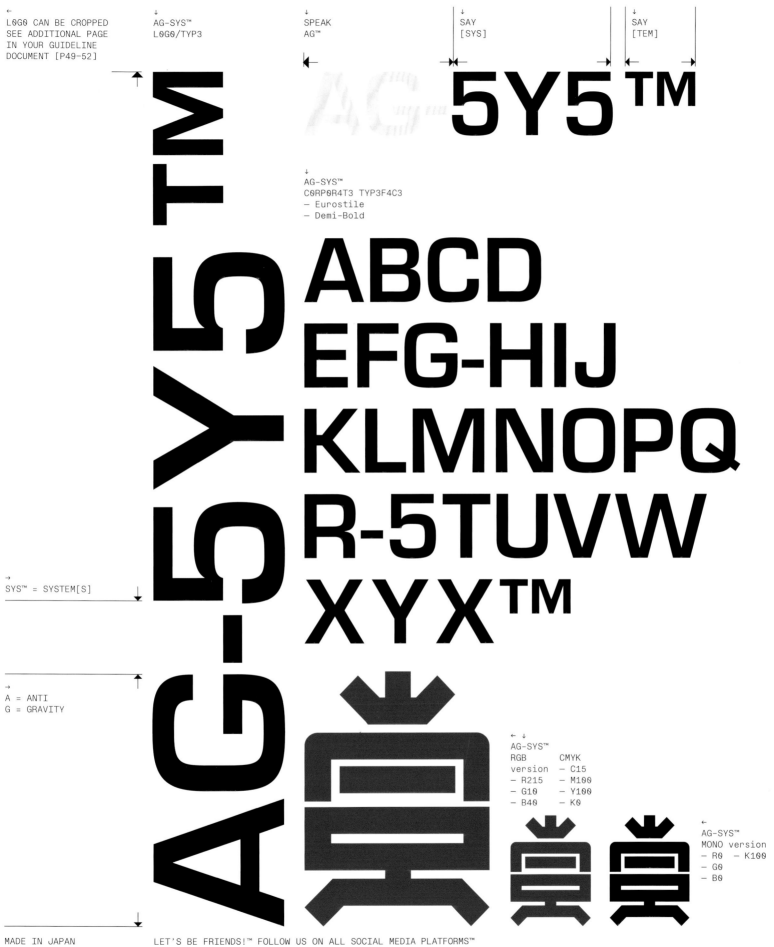

AG-SYS™
LOGO/TYP3

SPEAK
AG™

SAY
[SYS]

SAY
[TEM]

5Y5™

AG-SYS™
C0RP0R4T3 TYP3F4C3
— Eurostile
— Demi-Bold

ABCD
EFG-HIJ
KLMNOPQ
R-5TUVW
XYX™

SYS™ = SYSTEM[S]

A = ANTI
G = GRAVITY

AG-SYS™
RGB CMYK
version — C15
— R215 — M100
— G10 — Y100
— B40 — K0

AG-SYS™
MONO version
— R0 — K100
— G0
— B0

↑
COLLECTIVE NOUN:
A POD* OF PIRHANAS

↑
ORIENTATION:
MUST ALWAYS POINT FORWARDS (RIGHT),
NEVER BACK (LEFT)

*GUIDELINES – P49

→
PIRANHA
ORANGE
R255
G190
B15

C0
M30
Y100
K0

®

←
NOTE:
REMOVE TRADEMARK
SYMBOL FOR SMALL
USE

↑
PIRANHA LOGO/MASCOT

↓
PIRANHA CUSTOM LOGOTYPE

↓
PIRANHA-DEATH-RED R215/G10/B40

↓
C10/M100/Y100/K0

PIRANHA

PIRANHA

←
MONO-VERSION
R130 K50
G130
B130

PIRANHA

↑
MONO-VERSION
R0 K100
G0
B0

↑ LOGOTYPE FOR USE AT SMALL
USE (COLOUR OR MONO)
→ CONTAINER SHAPE LOCKUP

PIRANHA

*N0 PR0M1535!

T1M3'TR1AL" MODE

D1DN'T TH1NK 50...
P05T Y0UR B35T T1M3, #W0-FUT-B3AT-TH15
D0N'T B3 5HY, W3 W0N'T LAUGH*...

↑ PRACTICE MODE [UNUSED]

↓ ARCADE RACING MODE

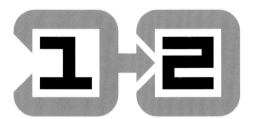

↑ TWO PLAYER MODE

↑ T1M3'TR1AL"

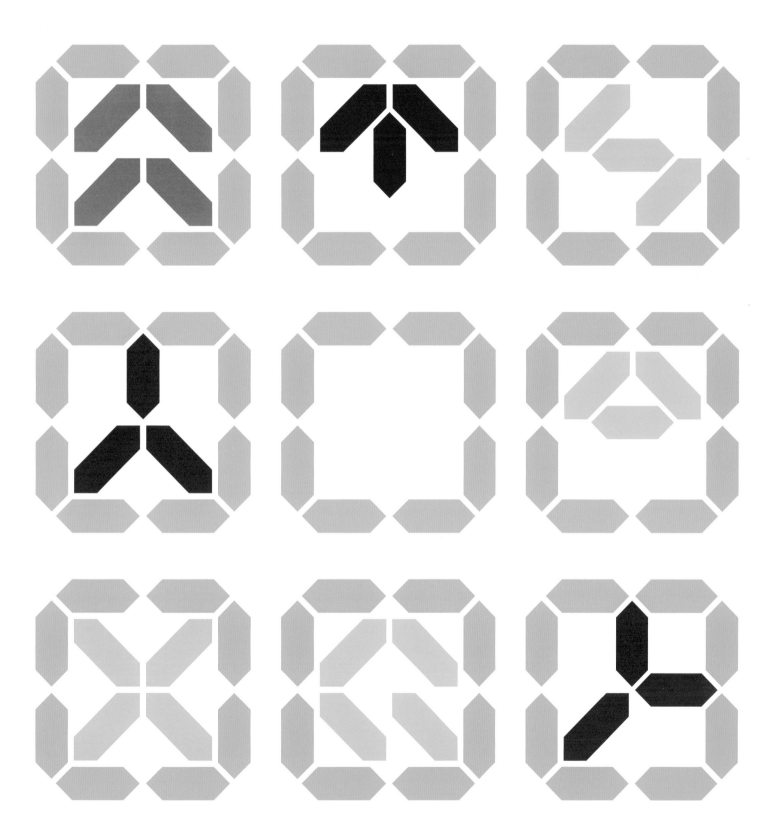

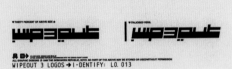

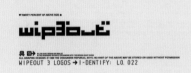

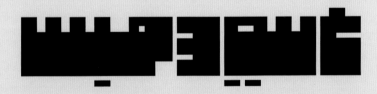

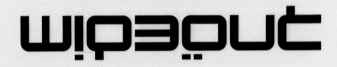

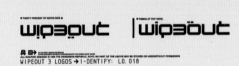

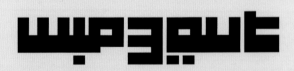

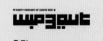

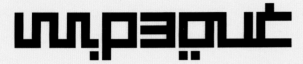

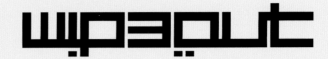

WII.p3out

▼ THIRTY PERCENT OF ABOVE SIZE ▲
WII.p3out
© 1999 DESIGN AND SCALE
ALL GRAPHIC DESIGNS © 1999 THE DESIGNERS REPUBLIC, SCIYO. NO PART OF THE ABOVE MAY BE STORED OR USED WITHOUT PERMISSION
WIPEOUT 3 LOGOS ➔ I-DENTIFY: LO. 002

▼ THIRTY PERCENT OF ABOVE SIZE ▲
wip3out
© 1999 DESIGN AND SCALE
ALL GRAPHIC DESIGNS © 1999 THE DESIGNERS REPUBLIC, SCIYO. NO PART OF THE ABOVE MAY BE STORED OR USED WITHOUT PERMISSION
WIPEOUT 3 LOGOS ➔ I-DENTIFY: LO. 009

wip3out

wip3out

▼ THIRTY PERCENT OF ABOVE SIZE ▲
wip3out
© 1999 DESIGN AND SCALE
ALL GRAPHIC DESIGNS © 1999 THE DESIGNERS REPUBLIC, SCIYO. NO PART OF THE ABOVE MAY BE STORED OR USED WITHOUT PERMISSION
WIPEOUT 3 LOGOS ➔ I-DENTIFY: LO. 017

▼ THIRTY PERCENT OF ABOVE SIZE ▲　　　▌ITALICISED VERS.
wip3out　　**wip3out**
© 1999 DESIGN AND SCALE
ALL GRAPHIC DESIGNS © 1999 THE DESIGNERS REPUBLIC, SCIYO. NO PART OF THE ABOVE MAY BE STORED OR USED WITHOUT PERMISSION
WIPEOUT 3 LOGOS ➔ I-DENTIFY: LO. 014

WII.p3out

wip3out

▼ THIRTY PERCENT OF ABOVE SIZE ▲
WII.p3out
© 1999 DESIGN AND SCALE
ALL GRAPHIC DESIGNS © 1999 THE DESIGNERS REPUBLIC, SCIYO. NO PART OF THE ABOVE MAY BE STORED OR USED WITHOUT PERMISSION
WIPEOUT 3 LOGOS ➔ I-DENTIFY: LO. 002

▼ THIRTY PERCENT OF ABOVE SIZE ▲
wip3out
© 1999 DESIGN AND SCALE
ALL GRAPHIC DESIGNS © 1999 THE DESIGNERS REPUBLIC, SCIYO. NO PART OF THE ABOVE MAY BE STORED OR USED WITHOUT PERMISSION
WIPEOUT 3 LOGOS ➔ I-DENTIFY: LO. 023

↑ ←
Logo concepts
for *WipEout 3*
(Psygnosis,
1999)

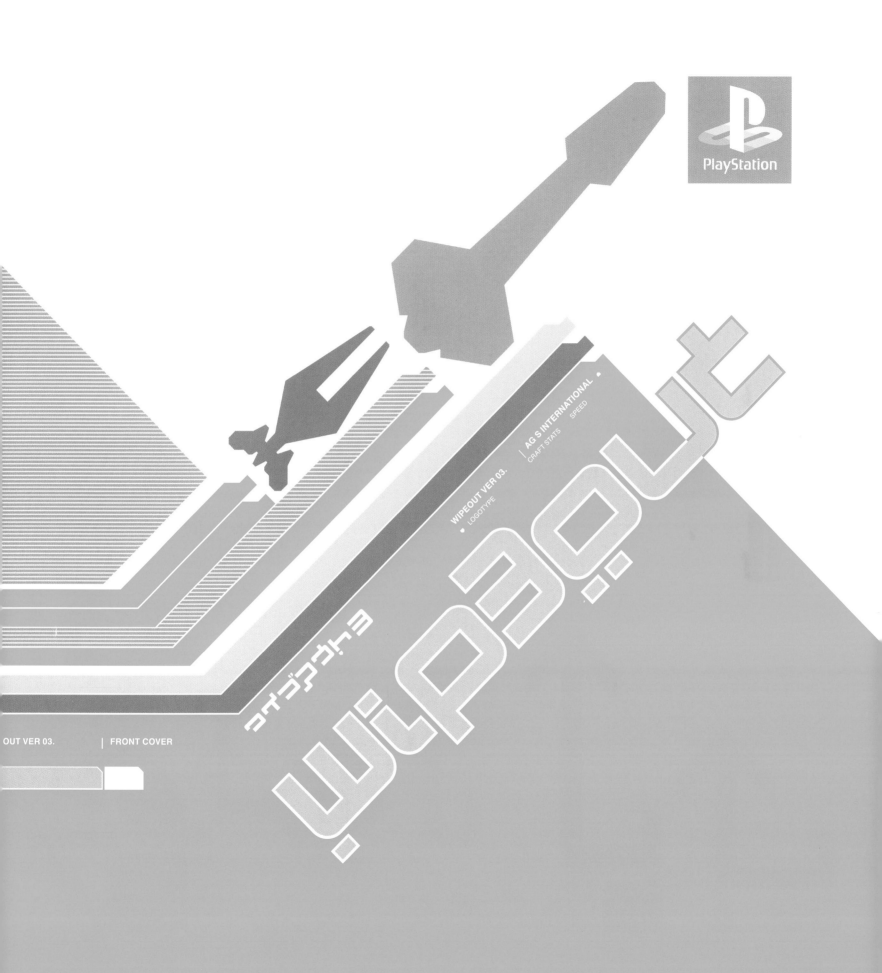

PlayStation

WIPEOUT VER 03.
● LOGOTYPE

│ AG S INTERNATIONAL ●
CRAFT STATS SPEED

ワイプアウト3

WIPEOUT VER 03.

OUT VER 03. │ FRONT COVER

W1p30ut

LOGO

LOCK-UP

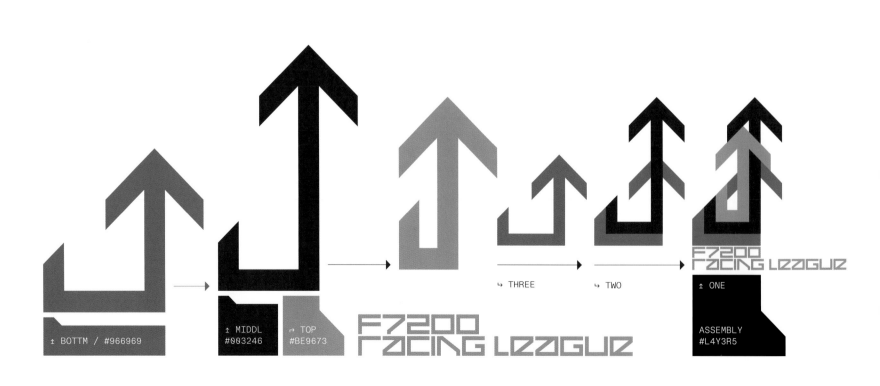

↕ BOTTM / #966969

↕ MIDDL
#003246

↪ TOP
#BE9673

↪ THREE

↪ TWO

↕ ONE

ASSEMBLY
#L4Y3R5

the quick anti-gravity ship jumps over the slow

F1-car

Pan-gram-ular Text 100pt ●○ ●○ 20mm ●○ 17mm ●○ 2mm

F500 ANG-ular

Text 70pt ●○

● **F500 Ang-ular** [Reg-ular] © F7200 Racing League

abcdefghijklmnopqrstuvwxyz
0123456789

Text above 40pt ●○ ●○ 8.5mm ○ 7mm ●○ 9mm

120R
185G
225B HEX #78B9E1

220R
000G
025B HEX #DC0019

INTERNATIONAL

000R
000G
000B HEX #000000

↓
The [FULL] AG-FAMILY™

↑
FATHER™

↑
MOTHER™

↑
SON™

↑
DAUGHTER™

↑
EXAMPLE TESSELATION
SEE GUIDELINES (PGS 30–36)

↑
EXAMPLE TESSELATION
SEE GUIDELINES (PGS 30–36)

↑
ASSEGAI BLUE™
CMYK COLOUR: C060:M015:Y000:K000

→
TWO LINE 'STACKED'
LOGOTYPE

↓
SINGLE-LINE
LOGOTYPE

←
RGB
COLOUR
R185
G190
B150

↓
MONO
VERSION
R30
G30
B30

←↑
CMYK
COLOUR
C035
M020
Y045
K000

↑
LOGO + LOGOTYPE
LOCKUP

↓
ORIENTATION (ALLOWED) (NOT ALLOWED)

↑ YES ↑ NO

↑ YES ↑ YES

←
THE ICARUS BUTTERFLY LOGO CAN
BE CROPPED. SEE 'LOGO-USES'
SECTION IN YOUR ID:GUIDELINES —
[PGS 15-17]

R120 R0 K100
G120 G0
B120 B0
↓ ↓ ↓

→
K055

→
MONO
VERSION

↓
COLOUR
VERSION

↑ ↑ ↑
BURNT BURNT CMYK COLOUR
ORANGE RED C025
RGB R165 M100
COLOUR G20 Y040
R185 B85 K000
G65
B25

CMYK
COLOUR
C020
M080
Y090
K000

↑
NOTE: REMOVE THE TRADEMARK SYMBOL
WHEN USING THE LOGOTYPE OR LOCKUP
AT SIZES BELOW 30MM WIDTH

↑
BURNT RED
R165
G20
B85

→
MONO LOGO/
LOGOTYPE
LOCKUP

↑
IN TRADEMARK WE TRUST™

↑
THE STAR SPANGLED BANNER™
IS A REGISTERED TRADEMARK
OF AURICOM.

ANY INFRINGEMENTS ON COPYRIGHT
WILL BE DEALT WITH SWIFTLY
AND SEVERELY.

NOW HAVE A GREAT DAY Y'ALL!

↑
AURICOM CUSTOM TYPE
MADE IN AMERICA™

↑ ↑ TRADEMARK EVERYTHING™
NO MAXIMUM SIZE FOR OUR LOGOTYPE...
THE BIGGER THE BETTER!

BLUE C100
R0 M100
G45 Y000
B105 K020

RED— R240/G20/B45

WHITE— R255/G255/B255

C000:M100:Y100:K000

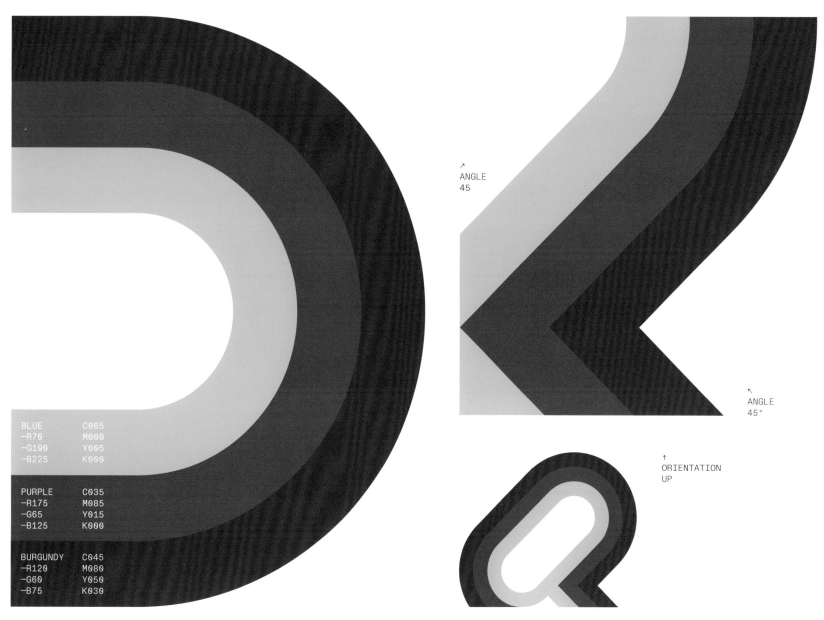

ANGLE
45

ANGLE
45°

ORIENTATION
UP

BLUE	C065
—R70	M000
—G190	Y005
—B225	K000

PURPLE	C035
—R175	M085
—G65	Y015
—B125	K000

BURGUNDY	C045
—R120	M080
—G60	Y050
—B75	K030

[QIREX-RD]

[QIREX-RD]

↑
[QIREX-RD]
LOGO/TYPE [BURGUNDY]
CUSTOM BUILT AND MADE
FOR QIREX-RD

←
LOGO CAN BE CROPPED
PLEASE SEE ADDITIONAL
PAGE IN YOUR [GUIDE-LINES]
DOCUMENT [PGS 87-90]

↑
LOGO/TYPE CAN BE USED
IN MONO [R0 G0 B0]
[K100]

C000
M100
Y000
K000

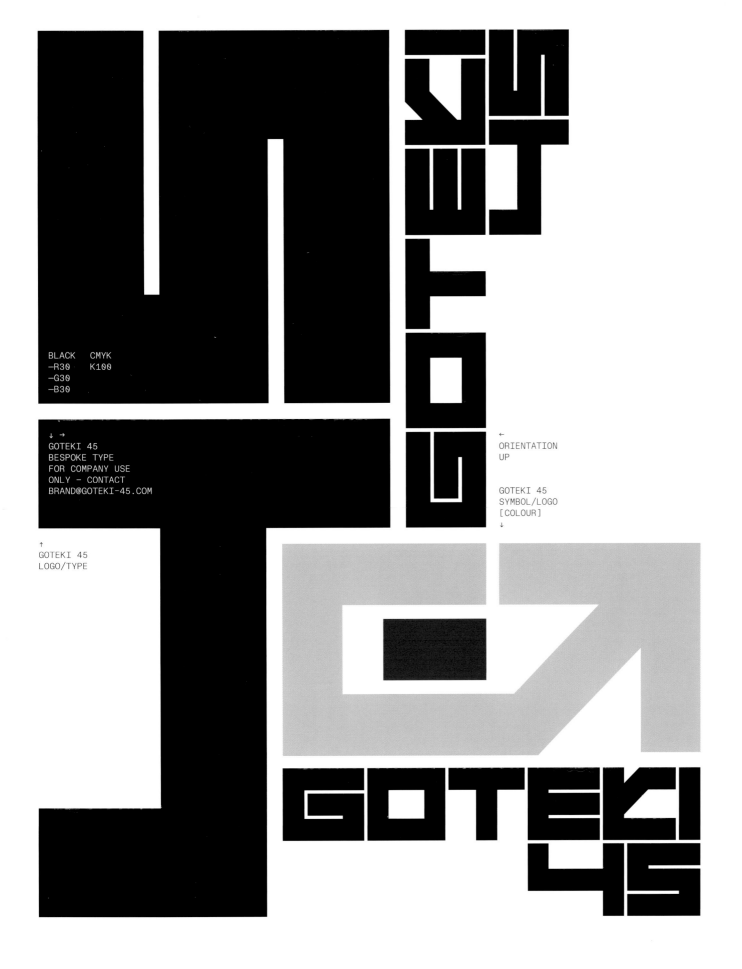

BLACK CMYK
—R30 K100
—G30
—B30

↓ →
GOTEKI 45
BESPOKE TYPE
FOR COMPANY USE
ONLY — CONTACT
BRAND@GOTEKI-45.COM

←
ORIENTATION
UP

GOTEKI 45
SYMBOL/LOGO
[COLOUR]
↓

↑
GOTEKI 45
LOGO/TYPE

←
THE FEISAR LOGO CAN BE CROPPED AND
REVERSED OUT OF FEISAR-BLUE. SEE
ADDITIONAL PAGES IN YOUR GUIDELINE
DOCUMENT — (SECTION:8/PGS 74-76)

↑
FEISAR LOGOTYPE
COLOUR VERSION

↑
THE FEISAR LOGOTYPE IS BESPOKE
AND UNIQUE TO FEISAR

↓
FEISAR COLOUR PALETTE
FEISAR-BLUE
FEISAR-YELLOW

↓
ISOLATION AREA

FEISAR-BLUE	C005	FEISAR-YELLOW	C005
R100	M000	R255	M000
G200	Y100	G250	Y100
B255	K000	B0	K000

THE FEISAR LOGOTYPE SHOULD
HAVEA MINIMUM CLEAR AREA
SURROUNDING IT. THE ISOLATION
AREA IS DEFINED BY 100% OF
THE HEIGHT OF THE 'F' ON ALL
FOUR SIDES. THIS SPACE SHOULD
ALWAYS BE CLEAR AROUND THE
WHOLE LOGOTYPE.

↓ FEISAR LOGO
FULL COLOUR VERSION

↓
MONO VERSION(S)

←
STRIPE(S) 1+2
K100

←
BASE SEGMENT
K025

← REGISTERED TRADEMARK SYMBOL: K100

PIRHANA ADVANCEMENTS

I'M HAVIN' IT

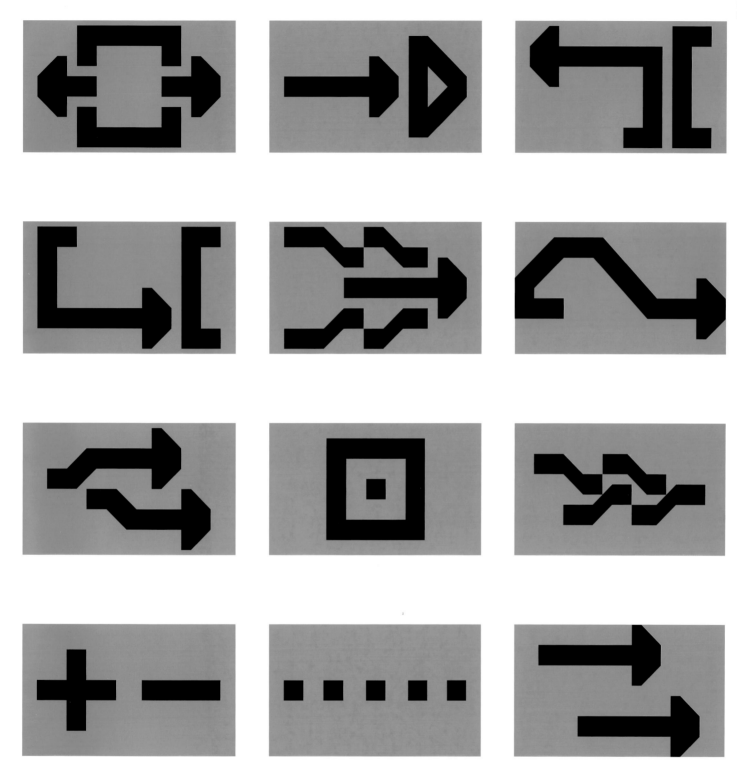

INSTRUCTIONS FOR USE:
INTERCHANGEABLE
DUST COVER SLIDES OVER
THE TOP OF YOUR EDGE
MAGAZINE. THERE ARE
2 DR COVERS TO COLLECT
EDGE MAGAZINE [2 DR COVERS]
DUST COVER

WIPEOUT VER. 03.00.02. • PROTECTIVE COVER
INDICATES RIGHT

DEVELOPED: PSYGNOSIS [LEEDS]. PUBLISHED: PSYGNOSIS.
FONT: F500 AND JLI/AN BY THE DESIGNERS REPUBLIC. MODIFICATION [OF THE X-CHARACTER] BY MARK FRAZER

OPEN

logo
threee
wipeout
logo
zdp[e]z

EDGE MAGAZINE. WIPEOUT. VERS. 03
E3 SPECIAL EDITION. WIPEOUT. VERS. 03
TYPOGRAPHICAL DESIGN BY THE DESIGNERS REPUBLIC

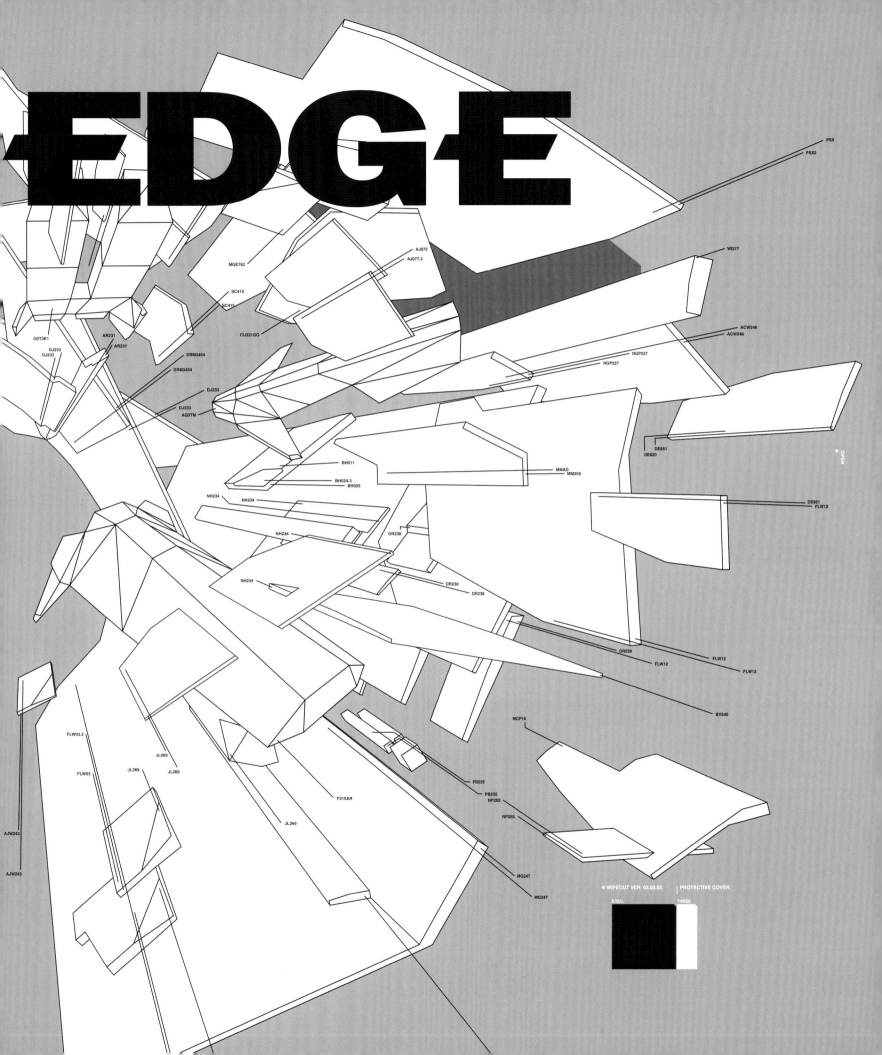

tDR™ Special
Edition
cover for *EDGE*
magazine issue
72 (June 1999)

↘
tDR™'s newstand
cover design for
EDGE magazine
issue 72 (June
1999)

BARCODE SCANS
PLEASE USE ONLY LEFT TO RIGHT TO ENSURE READABILITY
YOUR GUARANTEE OF OFFICIAL SCAN EQUIPMENT IS ASSURED
INDICATES RIGHT ▲ UP

▶ICARAS BUTTERFLY BARCODE HOLDER

9 771350 159014 04

CONNECTING THE W

⊢ ─ ─ ─ ─ ─ ─ ─ ─ 20° ANGLE ●

CREDITS
ALL WIPEOUT GRAPHIC DESIGN IDENITY BY THE DESIGNERS REPUBLIC
THE DESIGNERS REPUBLIC WOULD LIKE TO THANK THE WIPEOUT 3 DEVELOPMENT TEAM AND EDGE FOR LETTING US TAKE LIBERTIES WITH THEIR MAGAZINE

▶ ICARAS BUTTERFLY LOGO

● WIPEOUT VER. 03.00.02. | BARCODE APPLICATION [MAGAZINE]

B/C/A. THREE

⬆
└──────── INDICATES UP

EDGE

WIPEOUT THREE IS A REGISTERED TRADEMARK OF PSYGNOSIS LTD

wipzout 3

Issued 15.03.19.00.00.90.00.09. FUTURE/EDGE.

Identity: MITDR.

60 X 40 BILLBOARD ADVERTISEMENT

FLY™

iicaros™

♠ ICARAS
[MAN]

► Logotype.

icaros

Slogan: "FLY ICARAS™"
courtesy of Pho-Ku Corporation Advertising

● ICARAS
[BUTTERFLY]

10C 33M 10Y 0K 20C 80M 90Y 0K 25C 100M 40Y 0K UP

● ICARAS

WIPEOUT VER. 03.00.02. ICARAS ADVERTISING

S/C/A. THREE

Unused tDR™
cover for *EDGE*
magazine issue
72 (June 1999)

Michael Place:
'Some of these
EDGE covers
were bonkers.
The "3D" ones
were all done in
Freehand, the
perspectives and
everything. All
in layers, with
no 3D software
whatsoever. What
a nightmare.'

555pt ●○

EDGE

● F500 Ang-ular [Reg-ular] © 1999 The Designers Republic

abcdefghijklmnopqrstuvwxyz
0123456789

● ○ 73mm	
● ○ 63mm	
● ○ 53mm	
● ○ 43mm	
● ○ 33mm	
● ○ 23mm	
● ○ 13mm	

Sample

Numerals

Text above 20pt ● ○ ○ ● 133mm ○ ● 113mm ○ ● 83mm

3

73mm ● ○

3

36mm ● ○

3

27mm ● ○

Text

three

99pt ● ○

three

62pt ● ○

Z0n3 Thr33

loading_

wipeout three
title screen

PRESS START ▼ FURTHER INFORMATION

[US]
▲

▼FORMAT: ▶PSYGNOSIS
NTSC LOGO

single race
time trial
challenge
eliminator
tournament
[options]

●WIPEOUT v3.0 | Use the directional buttons to select menu options
 | X button SELECT △ button RETURN

MAIN MENU THREE

track
porto kora

▶PORTO KORA ▶MEGA MALL

▶SAMPA RUN ▶STANZA INTER

LENGTH [K/M]
▼
3.39

CIRCUIT RECORD
▼
2:01.78

LAP RECORD
▼
1:00.80

●WIPEOUT v3.0 | Use the directional buttons to select track
 | X button SELECT △ button RETURN

VECTOR CLASS THREE

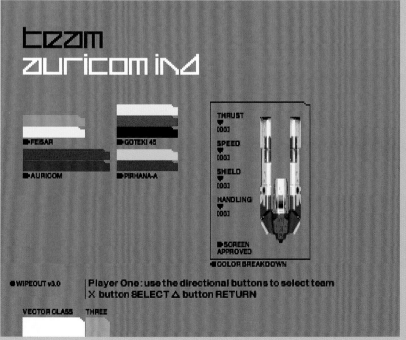

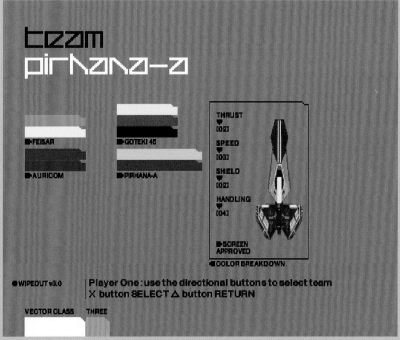

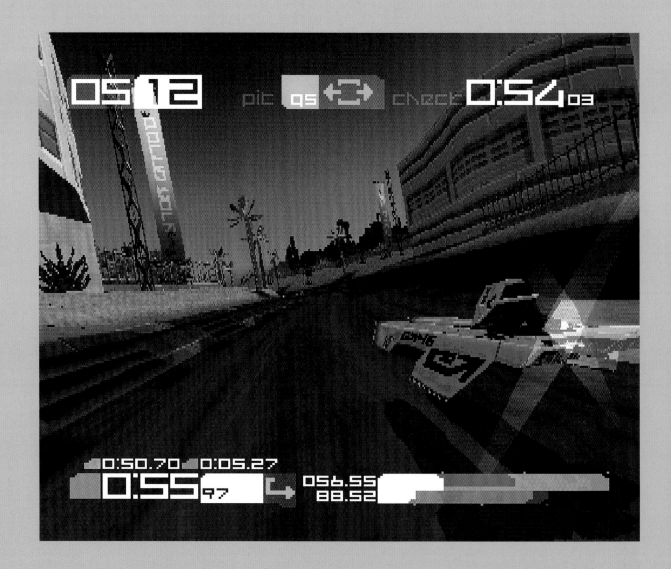

↑ ↗ →
Porto Kora,
WipEout 3
(Psygnosis
Leeds, 1999)

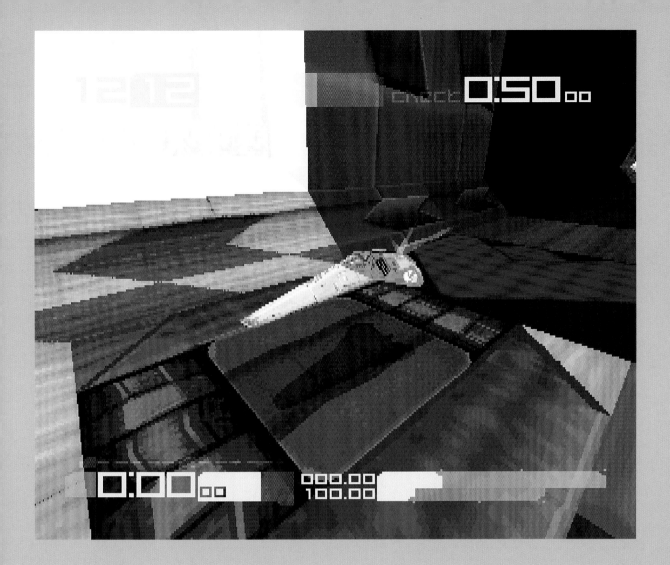

← ↙ ↓
Mega Mall,
WipEout 3
(Psygnosis
Leeds, 1999)

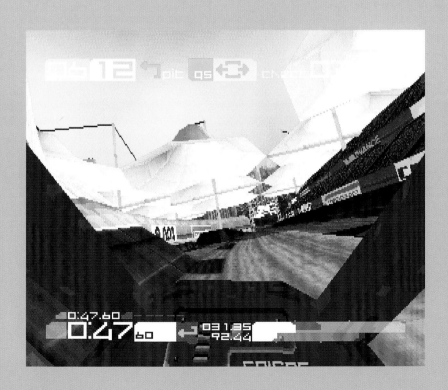

Sampa Run,
WipEout 3
(Psygnosis
Leeds, 1999)

←↓
Hi-Fumii,
WipEout 3
(Psygnosis
Leeds, 1999)

↑ →
Manor Top,
WipEout 3
(Psygnosis
Leeds,1999)

← ↙ ↓
Terminal,
WipEout 3
(Psygnosis
Leeds,1999)

↑↑↑ A–C
↑↑ D–L
↑↑ M–S
↑ T–Z

Michael Place: 'It was a crazy thought: "Here's an 8, let's try and make an alphabet out of it." And there's something really nice about taking what's inherently a display typeface that's also used in a shitload of old science-fiction and making something new out of it. It's the whole remix thing, just cutting up type, chopping bits out of it.'

It didn't have to be this way. Perhaps The Designers Republic™ would have stayed around for the advent of PlayStation 2 had Sony not decided to make those 'born rebels' an offer they could *totally* refuse. As Michael Place puts it: '"You're joking, yeah? Fuck you!" I remember at the time being asked to pitch for doing the fourth game, and we weren't gonna entertain that for something we'd been such a massive part of. It was crazy — and just genuine disappointment. You could see it coming with *WipEout 3*. We'd still occasionally get visits from the marketing team in Liverpool but it was different, you know? It didn't quite gel like it had before. It was becoming more prestigious, but also more of a franchise, a machine.'

R00t5/
M4n03uvr3
[2002–17]

→

'*WipEout Fusion* was supposed to be the homecoming,' begins former Studio Liverpool head Clemens Wangerin, before a rather pregnant pause. Instead, the fourth game in the series remains its undeniable black sheep; a post-tDR™ comedown that also jettisons the sleek Psygnosis brand, outwardly completing Sony's takeover. Without them, much of WipEout's futurism now rested with the PlayStation 2, an inscrutable black monolith that at least looked the part, like a prop from the movie *WarGames* built to nuke rival consoles. This was precisely how it was hyped, too, with headlines about Japanese export restrictions over its 'military-grade' hardware. →

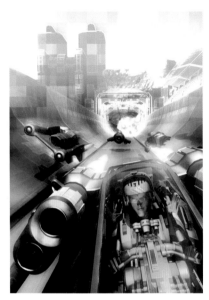

Suffice it to say that if the PS2 guided missiles like it did the WipEout franchise, we'd still be fishing them out of the sea. '[*Fusion*] almost got canned and the whole studio shut down,' Wangerin continues. 'The hardware was just incredibly difficult to get to grips with.'

Liverpool had spent so long preparing for the PlayStation 2 that third instalments of both WipEout and Colony Wars were made at Psygnosis Leeds. 'But what came with that lull in productivity was a bit of a brain drain, a natural bit of attrition. There was a lot of reshuffling of the deck, if you like, not all of it intended.' Wangerin stops again. 'Liverpool was really – yeah, it was drifting.'

Things had taken a turn back in 1998, when six key veterans left Psygnosis to form breakaway studio Curly Monsters in nearby Birkenhead. In Nick Burcombe, Lee Carus, Chris Roberts and Andy Satterthwaite, Studio Liverpool lost heads of design, art, technology and production. In programmer Martin Linklater and artist Neil Thompson, furthermore, it lost the next-best thing: people who were 'always in the room,' as Linklater puts it, even if they working on WipEout stablemate *Codename: Tenka*.

Curly's first game was PS1's *NGEN Racing* for Infogrames. 'As in: "Next Generation! Engine!" groans Satterthwaite. 'We told them no one would get that.' Sony then sent the studio PlayStation 2 development kits, and faced with more PlayStation system tribulations, instead opted to make *Quantum Redshift*, a futuristic racer, only released for Microsoft's Xbox. 'Mostly out of utter disgust,' declares Roberts.

'Programmers who've actually achieved something with PS2 will sing its praises all day, but I think that's confirmation bias. If you spend that long and sweat that hard to get anything at all out of something, the sense of achievement is such that of course it's the best piece of hardware ever made. It really, really wasn't.

'It was very flexible, but with the same problems as PS1. You shouldn't have to be writing your own clipping routines or rolling your own vector code. It made the people who were good at doing that very valuable – but if that person isn't on your team, or a person with time to learn it…Some games on PS2 were just catastrophically bad because of the lack of low-level experience. So yeah, we sidestepped that because the Xbox was great!'

Prototyped on an Xbox-spec PC and ported with blissful ease to a devkit, *QR* was eagerly snapped up by Microsoft at that year's ECTS (European Computer Trade Show). But however much Xbox was not PS2, Microsoft was also very much not Sony. 'We wanted to call the game "Neon" but that was too close to the Chrysler Neon car for them, so they came back with "Quantum Redshift," which we tried to tell them didn't mean anything,' says Linklater. 'The box art was also horrendous.'

Released in September 2002, *Redshift* could have staked a claim as being a kind of anti-*WipEout* – which is certainly what Microsoft was banking on – had *WipEout* itself not got there seven months earlier. It was as thought the departure of Curly's founders, together with Nicky Place's exit following *WipEout 3: Special Edition*, asked questions of *WipEout Fusion* no one was equipped to answer – meaning everyone ended up trying to.

'More people were working on it but no one was saying yes or no,' recalls artist Darren Douglas. 'Everybody's track became a little window into their mind, for better and for worse. I put a storm drain into the Moscow track, not to mention a red light district with [Curly Monsters artist] Paul Bahr-Naylor's face on one of the billboards just to spite him. Someone should have taken one look at that and gone, "Come on, mate, don't be daft."'

Not even Florion Height, a track memorable for its dusty canyons and *F-Zero*-like girth, can help dating *Fusion* with its debt to *Star Wars: Episode I*'s podracing, which was over two years old upon *Fusion*'s release. Future *WipEout* designer Karl Jones was just a QA technician at that point, but heard the stories: 'I believe someone in management just kept fiddling; one of those creative people who'd go home, watch a film, get a new idea and them come back and change everything. There are plenty of those in the industry, and a lot of money to be paid to the wrong people to make those calls.'

But, in its defence, *Fusion* did lay the foundation for the series' beloved Zone mode, while its technology helped Douglas address some longstanding bugbears with its art. By adding rounded and bevelled meshes to buildings, which would have been digital cereal boxes on PS1, he gave the Anti-Gravity Racing League its first tangible cities to race in. *WipEout Fusion*

is also the only *WipEout* to even start to convey the scale of its 'fucking massive ships,' as he puts it, thanks to pea-sized pilot heads visible in every cockpit.

'Jim Bowers had kitbashed this ship for the first game, with an Action Man pilot in there, and it was just the bee's knees. I remember being heartbroken that we couldn't get pilots in the game back then, just as it used to ruin it for me when you bought model aeroplanes and there wouldn't be a little man inside.' Describing his relationship with Bowers in terms of reverential awe, Douglas was acutely aware that 'Jim basically knew everything about everything, including every corner you'd cut.' Bowers greets this with a magnanimous nod, then proves it completely right: 'It wasn't kitbashed, though, it was cut from plastic sheets and built. Now I'm really pissed off with him.'

Fans assuming the return of The Designers Republic™ to the series were in for a shock. Sony spelled out its readiness to shop that contract around by inviting the agency to pitch, effectively, for its old job back. That was 'politely' turned down, and the work went instead to London agency Good Technology, which checked off a list of in-game assets and team idents before going on its way. 'There were too many delays on the software side to engage them all the way through,' explains Wangerin. 'They left and we still had a year to figure out how to ship this fucking thing.'

All of which would have been a lot more surprising if the *Fusion* that released in February 2002 had lived up to its name; the whole greater than the sum of its parts. But while technically robust and certainly fast, it can feel more knock-off than sequel, such is the lack of vision. Even ignoring the heretical swapping of AG Systems for a Good Technology vanity team called G-Tech, the game can feel arbitrary and forced, boasting loop-the-loops and ship upgrades, which earlier WipEouts had shunned.

'It was just dead,' complains Linklater. 'No feel at all. One of the things Nick always wanted in WipEout, from the very first one, was the feeling of slipping sideways with the air brakes on – of inertia. They completely lost that in *Fusion* – the suspension and the anti-grav stuff – because you're very much locked to the track ribbon.'

By the time *Fusion* came out in February 2002, Wangerin tells how in a studio of just over 40 people, 'there wasn't a week gone by when someone wasn't leaving. Management was doing the best it could, but morale was low.' Critics were generally kind to the game, at least, though perversely it was UK allies like *Eurogamer* and *Edge* who broke rank, the latter with a score of five-out-of-ten. Not even those two could agree whether the soundtrack, so key an ingredient, was 'excellent' [*Edge*] or 'a practical joke' [*Eurogamer*].

To understand what kind of near-death experience was underway at Studio Liverpool, consider that Sony had been dismantling the publishing apparatus at Psygnosis since 1999, closing down many of its global offices, shuttering *WipEout 3* creator Leeds, consolidating its London team into a new Soho studio and altogether shedding around 300 staff. Living in Liverpool at the time, Wangerin was desperate to avert what must have felt almost inevitable. 'It was painful to see,' he says, 'knowing all the magic that had been created there.'

Seeking a sympathetic ear in Sony executive Phil Harrison, it appears he was successful: Harrison gave Wangerin nothing less than custody of the studio itself, spurred by a freshly-inked four-year deal with Formula 1. Studio Liverpool would make six F1 games in total before Codemasters secured the licence in 2008, earning critical acclaim but also, crucially, 'the breather that we needed,' says Wangerin. 'It let us regroup. Even though we didn't know it at first, that deal was where *WipEout Pure* began.'

● TH3 WH1T3 4LBUM
The early years of PlayStation had signalled a paradigm shift in western gaming, moving its technological frontiers from the amusement arcades into the home, leaving the former to a twilight of dance machines, arcade-ified console games and God-let's-not-even-talk-about-the-rest. Ten years into WipEout's life and it was starting to happen again, only now the games you'd expect to find in your living room were creeping onto buses, planes, or wherever you took your new PlayStation Portable (or PSP for short). That was the idea, anyway.

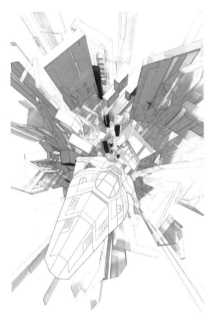

Sony's handheld may have lacked the control scheme to really live up to its name – its twin shoulder buttons and delicate analogue nub put several key genres out of reach – but for a time that didn't matter to those bewitched by its gorgeous screen, capable 3D graphics and cute optical discs. Gaming had arrived at the future once again, it seemed, only this time WipEout was waiting.

Fusion had been 'a real bonebreaker,' says Wangerin. 'There just wasn't a lot we could re-use. Something that tended to happen with launch titles is that everything was bespoke: you had to get the game out, and there just wasn't time to build nice things.' A somewhat traumatized Liverpool thus embarked on a concepting phase designed to create all-new IP, which it must be said backfired spectacularly. Sony was (and remains) keen for its studios to develop their own cultures and identities. 'We were the owners of WipEout, its birthplace,' Wangerin continues. 'There was nothing formal, but we were where it should stay.'

Preproduction on *WipEout Pure* began in August 2003 with *WipEout Fusion* designer Colin Berry and programmer Dave Burrows. It was a pet project at first, recalls Karl Jones, which was less a pitch than a detox plan after *Fusion*. '*WipEout* with all the shite taken out, basically.'

Jones, like Berry, had worked his way into game design via QA testing. *Pure* was to be his first gig, 'and I shit myself when I saw the stuff I thought I'd have to learn. It was all numbers: turning circles, maths…I was like: "I'm screwed. This isn't fun, it's like being back at school."' But he'd read wrong: 'Those hard maths were for coding, more of a physics document. I realized this whole thing was more like a washing machine: you've got all these options but [as a designer] you only end up using some of them, the ones that make all the difference.'

It's a great analogy, and not just because '*WipEout Pure*' sounds like something that's tough on stains. This is a game that's all about making simple the terrifying circuitry of modern game dev: the pipelines and workflows expected to turn ideas into assets, code and something you might actually want to play. Lessons, explained Burrows during a 2005 GDC post-mortem, that *Fusion* taught the hard way.

With ship and track design split between 3DS Max and SoftImage, and a custom editor that required constant maintenance, *Fusion* was crippled by a lack of experts in its various tools. As Chris Roberts identified earlier, PS2 wrought havoc on the ill-prepared. Furthermore, 'designers would design a track and then hand it to the artists, but designers would then want to tweak the designs all the time,' said Burrows, describing a scene of perpetual bickering. With *Pure* given a full year's head start on actual PSP devkits, however, the chance was there to solve this problem for good. The result was a system that not only facilitated every WipEout thereafter, but also all of Studio Liverpool's Formula 1 games.

'The track editor was a seminal piece of technology in the history of the studio,' says Wangerin. 'It allowed Karl and Colin to design in a way that just hadn't been possible before.' Gone were the complicated editors, and in came a tool by programmer Andy Jones, which could export track ribbons straight from 3D app Maya for near-immediate play. 'You just lay a spline down, put some profiles on it for things like banking and height, and could be racing on it a minute later,' Jones enthuses. 'I had to demonstrate this thing to some real high-ups from Sony Japan, and they were blown away by how quickly you could get there from literally nothing.'

A prodigious number of tracks were auditioned this way, which could be textured by artists just as quickly, opening the door to all kinds of experimentation. Jones recalls one demo where guests to the studio had their photos taken, and seconds later were flying around looking at themselves on billboards. 'The tools weren't massively future-proofed because you couldn't evolve them too much, but even now I miss how quickly we could turn that stuff out.'

Over in Birkenhead, meanwhile, Curly Monsters' experiment with Microsoft had combusted in 2003. Coming a very distant second in its race against PlayStation 2 – the less said about its Japanese sales, the better – Xbox had the power, but not the pedigree. Curly made stunning demos and showed them to publishers such as Eidos, but according to Linklater, the answer was always the same: '"If you just had this up and running on PS2, we'd snap you up." We hadn't much money but a load of technology, and Xbox just hadn't taken off at all.'

↓
In the *WipEout
Pulse* (Studio
Liverpool, 2005)
intro, an AI
supercomputer
examines a ship
by new team EG-X

Citing a fear of seniority as one of the drivers behind Curly's exodus from Sony – 'You'd get pushed into those roles because you'd been there the longest, and suddenly you just weren't making games anymore' – Linklater returned to Studio Liverpool, via a dead-end stint at EA, a born-again coder. A 'fantastic' programming team, sympathetic manager in Wangerin, and a love of videogame physics made *Pure* 'the best project I've ever worked on,' he says. 'Everyone knew what they were doing and it just hummed along.'

Linklater's handling system for *Pure* can be credited with the feel of every WipEout game made since, inspired as it was by the initial three games. 'We all knew the fan favourite was *2097*, so we had to keep the scraping. The momentum had to stay high, even if you touched the walls. We had to get the suspension and the airbrakes, powersliding into corners, turboing out, bumping over bumps and doing big air. We had to nail them all.'

Because the game's data-driven engine could be tweaked with a bare minimum of coding – the entire UI, for example, was abstracted into XML – track design and handling could be balanced in sync, with designer Berry and physics coder Linklater literally at each others' side in the office. And when the PSP itself finally turned up over halfway through production, 'it was a dream,' says Linklater. 'Simple architecture, very simple tools: Sony got it right with that one. A lovely machine.'

The only caveat, he says, was that it lost a third of its power right off the bat for the sake of conserving battery life. It would be a year-and-a-half before the game *God Of War: Chains of Olympus* was allowed to run its CPU at the full 333MHz, which meant *Pure*'s framerate was a battle. 'I remember spending a couple of weeks on *Pure* just Assembly-coding the core of the physics engine. The vector-coprocessor, the SPU, was a really nice piece of silicon, but you had to code it by hand. A lot of bits of physics and weapons code had to be converted like that, but that's just what you had to do with mobile hardware.'

Released on 24 March 2005 after 18 months of development, *WipEout Pure* was a sly return to form. In its handling, track design, soundscape and looks, critics saw the kind of back-from-the-brink course correction that turns nostalgia into progress, lauding the game's commitment to the purity of its title. However, in raving over how the game literally shone on PSP, providing a full-spectrum workout to a quite incredible screen, those same reviews signalled a very different WipEout: a lens through which to analyze Sony's latest hardware and services. The series' final years are the story of that role.

● 4C1D J422
Flying by the seat of its pants through the jet streams of PlayStation hardware, even prior to *Fusion* and *Pure*, WipEout has never had the luxury of pretending there was some long-term plan. But there was always, out there in the skydomes of its universe, 'WipEout X', the mystery project which 'generally just means the next one, the one we hadn't designed yet,' says Jones. 'It was like, "Right, what are we doing for WipEout X?"'

All things considered, the answer appears to be: what didn't they?

Of course it's a coincidence that this 'project' shares its name with 'Area X,' the free-roaming VR dreamscape added to 2018's *Rez Infinite*. But they do hold something in common, which is that they're more like places than games – zero-G palaces of technology and ideas. They don't know it, but whenever fans share their dream WipEout game they become tourists in this realm, just a dimension of game dev secrets away from Studio Liverpool's own vision quest. And what a blinding spectacle that is.

Take for example the open-world WipEout, which exists in the form of a prototype of a smaller, more nimble ship swooshing around a white-box city – coming after *Pure*, the idea isn't nearly as off-putting as it could be – skimming waves, hitting ramps and wringing honest-to-goodness powerslides from Linklater's flight model. Comparisons to Criterion's *Burnout Paradise*, both in gameplay and audacity, would not be unjustified.

Then there's the 'WipEout X' with bikes – bikes! – speeding along the treacherous anti-grav highways, where the vehicles magnetically repel each other to avoid accidents. Surely the only entertainment product ever likened to 1985 TV show *Street Hawk* by a developer: 'It was a little bit more story-driven,' explains designer Jones. 'You were left a bike by your older

↓
Feisar through
the ages, as
told by the
intro cinematic
of *WipEout*
2048 (Studio
Liverpool, 2012)

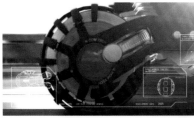

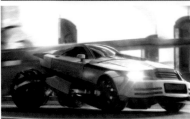

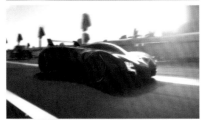

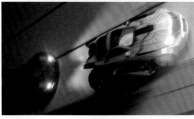

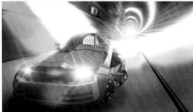

brother, and you'd upgrade it over time. There'd be a guy in a room somewhere telling you where to go, and you'd end up in races, delivery missions, stuff like that.

'For me, the big thing was that there's this sea of energy on the roads, and it was about how you used that energy; the smaller the gap, the more concentrated it was, so you were encouraged to take risks. Imagine lots of blocks of soap where everything's slipping through one another – I made a rubbish Maya video trying to explain just that.'

Then, in nothing even remotely close to chronological order, comes 'rollOut', a spiritual sequel to Psygnosis' topsy-turvy 1999 racer *Rollcage*. This one gained a bit more traction, one of its Darren Douglas-designed cars given a cameo in the intro to *WipEout 2048*, where it mounts a wall and lifts the heart rates of fans thinking, 'Is that..?' It so very nearly was, too. 'We had artwork done for it and everything,' says Jones. 'It was going to be the dirty cousin of anti-gravity racing; if WipEout is F1, this was the rally side.'

If those last two ideas feel more like the stuff of WipEout imitators – bikes appear in no fewer than four Extreme-G games – Jones isn't arguing. But, he counters, it's the curse of the clone to misread WipEout as a game of nauseating extremes. 'Anyone can make it ten times faster and higher, and that's what a lot of those games latch onto. But they miss the feel. They may have got there first but it's about what happens when you've got them in your hands and it feels wrong. I was constantly reining in our track designers on *2048* because they just wanted to do that crazy shit all the time.'

On which note, we really need to talk about 'WipEout Kart'. High in the running for 'Peakest WipEout Thing Ever' is a relatively obscure Europe-only download called The Omega Pack, which invited hip non-gaming artists to design four new tracks for *WipEout Pure*. Each collaborator received templates of track geometry from Studio Liverpool, which they'd paint over and send back. Game artists empowered by *Pure*'s game-changing tools would then port the assets to create Burgertown (drawn by Jon Burgerman), Cardcity Run (Mark James), Paris Hair (Neil McFarland) and 123Klan (Scien). It was in the last of these, amid buildings

formed of spray cans and city-wide graffiti, that the monkey happened.

'It was this huge stylized thing looming over the track,' recalls Jones, whose natural response as a designer was to create a super-deformed version of a FEISAR ship, scale the mega-monkey down, sit it on the cockpit and send it round the track. 'It looked cool, so on my local machine I swapped all the ships for the monkey ones, lowered the speed class, disabled weapons, kicked off an AI race and watched it from the replay cameras. It looked awesome. Who wouldn't wanna play Monkey WipEout Kart?'

Assuming the answer to be quite some number of people, the team succumbed to commercial pressure and turned the monkeys into squat vinyl toys instead, which players could customize and level up. Branding and concept work was done, and the idea was triumphantly pitched to Sony upper management, at which point: 'Phil Harrison said, and I quote: "Kart games are where franchises go to die."'

Lesson one from all of this is that developers, contrary to popular opinion, can be fanboys and fangirls too; it's just that they have to pitch their bright ideas to boardrooms rather than Reddit. Lesson two is that, for all its creators' imagination, WipEout has stayed more or less the same, proving that anti-gravity can be just as unyielding as gravity itself. Such are the forces upon this franchise that little ever escaped 'WipEout X' without being crushed and bent into those iconic triangles, with a Zone mode here and a Detonator there, doing what they largely always had. 'It's one of the biggest things that hamstrung us,' Jones laments, 'the DNA, or what that was perceived to be. Whenever we threatened to deviate, people got scared.'

Case in point: WipEout's hotly anticipated arrival on PlayStation 3, known (eventually) as *WipEout HD*.

● B1RD5 0F PR43

'It just became part of the process for us,' says Jones, 'that need to sell whatever was new.' This meant two things for PlayStation in 2008: so-called HD gaming, predicated on 1080p resolutions that games seldom achieved; and PlayStation Network, Sony's fledgling online service and storefront. If *WipEout Pure* had shown the potential for expanding games through downloadable content, *WipEout HD*

↓
A promotional
render for
WipEout HD
(Studio
Liverpool,
2008) depicting
Metropia

↓↓
A promotional
render for
WipEout HD
(Studio
Liverpool, 2008)
depicting Sol 2

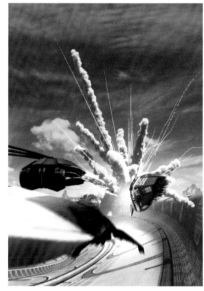

was the logical next step: the game itself as a download. For £11.99, too! 'We were all surprised by that,' says Jones. 'The amount you got for that price was insane.'

With eight tracks bumped to a whopping sixteen (Zone mode included) by the eventual *Fury* DLC, *WipEout HD* was revolutionary not just for its value, but for its means of securing those HD credentials. One of the first games to use a dynamic framebuffer, it scaled its resolution between the dream (1080p) and de facto (720p) number of pixels to maintain not just a higher perceived quality, but blistering 60 frames-per-second performance.

'It didn't seem particularly ingenious, just sensible,' states programmer Gary Roberts, another veteran rotating back to Liverpool from Curly. 'We knew *Gran Turismo* had come out at 1080p, in inverted commas, but was really only 1280×1080 – yet they were still allowed to put 1080 on the box. I was looking at that thinking, "Hang on, if that's still considered 1080p, what if I just change the resolution horizontally on-the-fly?"' This happens in steps of 32 pixels whenever the game nears a tolerance threshold, but only affects the backbuffer: the 3D scene. Everything else – HUD, tonemapping, bloom, etc. – is still drawn at bona-fide 1920×1080px.

Roberts continues: 'The great thing was that it allowed us not to care so much. We didn't have to scale back the effects. It typically happened when there were lots of clouds, smoke or neon things going off. The PS3 had its own particular foibles, and still had the equivalent of the vector units from PS2, but the SPUs [Synergistic Processing Units, designed to complement the main Power Processing Element in PS3's idiosyncratic Cell architecture] were just so quick you had to forgive it. "I see what you've done here: this is a direct analogue from what you had on PS2, but just insanely levelled up." If you had a scene with two-million triangles, which is too many for the GPU to draw, you could send it to the SPUs first and have them strip out all the triangles that weren't on-screen, then send it to the GPU. You still had a problem with memory bandwidth and raw throughput, though, so if you're running 1080p at 60Hz, you're going to go over.'

With its massively more detailed world stamped with tDR™-esque decals, it's tempting to say *WipEout HD* was everything you'd expect of a WipEout game and more. Its tracks manifested a universe that was always on the horizon in the early games, popping their underpowered skyboxes into multistory 3D. Still, though, something felt a little off about this one.

For one – cover your eyes, Psygnosis tribe – *WipEout HD* has no intro, no CG cinematic to dazzle and reassure. The DLC, meanwhile, by doubling the content and adding its own new UI, didn't so much expand the game as split it in two. Players would have to choose between whitewashed *HD* or crimson *Fury* before either half would start, evoking less of a luxurious concept album and more of a generous box set. To understand *WipEout HD*, then, is to discover what should have gone in between.

Before Karl Jones briefly left Studio Liverpool to join Bizarre Creations – to design *Blur 2* and *Blur* in that order (another story) – he added something new to the WipEout lexicon: PRAE, short for Performance Related Attribute Enhancement. In his words: 'It was about how the way you played would affect what you did. Just a nice way of hanging a lot of environment and gameplay changes on a single bar. I was really proud of the acronym, too.'

With Zen at one end and Fury at the other, the PRAE bar would respectively monitor players' agility and aggression (for lack of better term), then apply a dynamic makeover to suit. 'Every time you did something aggressive like fire a weapon, take damage, hit a wall or get overtaken, it would pull you towards Fury. If you did something we deemed Zen, like take a corner well, hit a speed-pad, or barrel-roll in the air, you'd go the other way.'

This would trigger all manner of effects, from the cosmetic (tracks would adopt a blissed- or glitched-out look reflected in the processing of music and sound) to track and vehicle functionality. A Fury player crossing a speed-pad would enjoy an 'instant smash forward' versus a Zen player's traditional whoosh. Fury vehicles would gain mass to encourage collisions and receive more offensive power-ups; Zen mode would call out corners and racing lines, and fade out decoration. On and on this goes through design docs and pitches, which seem doomed to confuse almost everyone. The more Jones tried to explain it, the less simple it became.

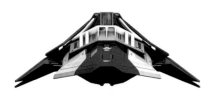

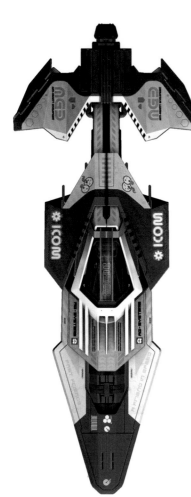

Chris Roberts was in charge of Liverpool's core tech group at this point, working on the studio's rendering engine. 'But I did do a kind of shader prototype [for PRAE] which was these auras around the ships. Basically, you had this radius around the ship which influenced the environment: if you were Zen it went blue, red if you were Fury. But it also rippled across the environment, and these auras would interact and push against each other as ships passed each other. It actually looked really pretty – but I never really understood the concept.'

Jones concedes that 'it was difficult to get across.' The game's prototype was a version of *WipEout Pure* successor *WipEout Pulse,* which spat out its thoughts on your racing style. 'We told it what triggers were Zen and what were Fury, and what weight those should have. Just seeing those numbers, we could have balanced the game there and then.'

This piqued the interest of concept artist Rita Linsley, whose abstract fractal shapes define the Zone modes of *WipEout Pure* and beyond, and which you have to suspect are the blueprint for how Zen may have looked. Likened by the artist to 'an atom in a particle accelerator' and, rather wonderfully, 'a cosmic piece of fractal consciousness in a golden state of flow,' Zone players accelerate indefinitely while trying not to bash their ship to oblivion, as tracks adopt luminous, prototypical forms.

'As above so below,' remarks Linsley in her studio dev diary. 'Fractal energy flows through everything on this planet. We see it in cloud formations, and in the majesty of epic mountain ranges. Symmetries, self-similarity, and branching systems are everywhere.'

Linsley assigned each of her four Zone tracks its own 'family' of abstract shapes based on patterns in nature – the most arresting, Zone 4, was inspired by Cambrian creatures and ferns – mixing them 'with graphic design and graffiti aesthetics' to create something otherworldly.

'I was working to an extremely tight schedule,' she says. 'With such a fast turnaround I had to come up with a workflow that enabled the fast construction of objects that could be tested on the fly. I liken the process to a bunch of blues and jazz musicians...They riff off a pattern until that pattern becomes something else entirely, a fresh expression of something familiar.'

'Fucking hell, man, what a visionary she was,' says Nick Burcombe, shaking his head. 'Difficult to put her stuff in the game, but to simply follow the direction was fantastic.' Jones chuckles: 'Rita always got deep with the conversations. I was talking to her about the concept of PRAE and she said, "It's almost like a trinity between the pilot, the ship and the track," and everyone was like, "That's a good word!"'

It looks good, too, on a variety of logo tests, internal trailers, concepts and other signs that *WipEout Trinity* was well on its way to fruition. 'It was a headscratcher but a really interesting idea,' says artist Darren Douglas. Moreover, it would have been buttressed by a dramatic new art style which remains, somewhat, in tracks like *WipEout HD*: *Fury*'s Metropia. 'Trinity was on a whole new level,' believes artist Eddie Wainwright. 'The skies on the courses were going to be full of ships, as though the whole Earth was overrun with people. It was a darker, moodier environment.'

'It was a little rudderless, though, that project,' says Roberts. 'They kind of assumed there was a path through it because Zone mode had gone well on *WipEout Pure*. But it's true of any project: there'll be a critical juncture near the start where serious decisions have to be made, and you're always going to have your little checklist of people you trust to make the right calls. And if they're not there, you're in trouble because major risks haven't been mitigated, lines haven't been drawn, and you can be ambitious without any real understanding of what problems you're going to cause yourself.'

Little wonder, then, that *WipEout HD* can feel whimsical at times, in ways its distribution model alone can't explain. 'Trinity was on people's minds when we were talking about *Fury*, obviously, the idea of the polar opposites,' explains Jones. 'The more aggressive modes, like Detonator, and this idea that the *Fury* DLC was going to take over the game over time, like a virus. But that didn't make it, either.'

Jones is still proud, rightly, of *WipEout HD*. 'I wouldn't say it needed more thought because we were kind of hamstrung on that side of things, but we could have done more with the content we had, with the meta-game. It's disjointed and yet, in some ways, the most comprehensive WipEout we ever made.'

↓
Render of a
FEISAR ship from
WipEout HD:
Fury (Studio
Liverpool, 2009)

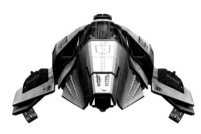

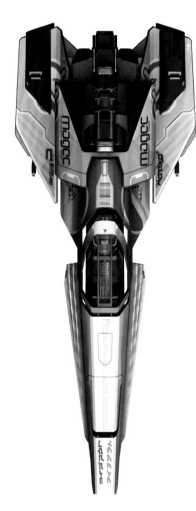

● B4CK T0 TH3 FUTUR3

Follow WipEout's journey across PlayStations big and small, with all their adventures in control schemes and services, and a story of two games emerges: one the dutiful Sony flag-bearer, the other growing anxious about who was loyal to it. In other words: if there wasn't a new console to sell, could WipEout sell itself? To see what happens when this fear turns into panic, look no further than the latter days of Ridge Racer, full of reboots and micropayments.'

'It did always feel like we were underdogs,' says former Studio Liverpool game director Stuart Tilley. 'We were like the noisy kid with the slimmer budget, trying to do some amazing things and work in a super-optimal way to, in a sense, get noticed. We'd go to events, do what we could and were like: "Right, other people are going to spend all this on their games; we're going to compete with those bastards for a fraction of it."'

This was post-*HD*, though, and videogame racing wasn't what it used to be. It was cruel, punishing games like Black Rock's *Pure* (2008) and *Split/Second* (2010), Bizarre's aforementioned *Blur* (also 2010) and Evolution's *MotorStorm: Apocalypse* (2011) daring to try something different. All of those studios are now closed. 'And it's not like Nintendo has been making loads of F-Zero games, either,' says Tilley. 'Are there enough fans of that genre to make something companies will spend millions of pounds on? People would join Studio Liverpool, do one or two games and then leave; and because we were the custodians of WipEout, that would always mean, "It's not going wrong on my watch."'

The Catch-22 of WipEout's later years was a growing need to attract new players without alienating older, inevitably more vocal ones. 'There's a very specific number of people who want WipEout,' Tilley continues. 'But the industry became more hit-driven during its lifetime, and so every iteration was more difficult for the guys and girls working on it.'

With such a vast universe on its periphery, whispering stories of pilots and tech messiahs from Sicily to the surface of Mars, it must have galled Liverpool to be entrenched so completely in the racing of WipEout, feeling the track walls closing in. It's not like making it more futuristic would have helped much, either: the game is so far-flung already that time is immaterial. That *WipEout Pure* was made 20 years after *WipEout* feels important; that it occurs a whole century after *WipEout 2097* less so. Fiction, sadly, was a luxury the series could never really afford.

Studio head Wangerin recalls a short-lived 'non-game' project, 'WipEout Chronicles', which was inspired by *The Animatrix*, an anthology of animated shorts that fleshed out the story of The Matrix movies. Darren Douglas produced artwork but a medium was never chosen. Wangerin muses: 'I guess it would have been real-time 3D animations. But the project was abandoned and nothing came close to replacing it.'

'If you take a game like *Mario Kart*, you already have a relationship with the characters, and that's even true to a degree with *F-Zero*,' says Tilley. 'We were always nervous that if we put our efforts there, we'd have to take them from somewhere else. It's that reticence again: no one wants to be the director on the one with a shit story.'

There's something quite ingenious, then, about where WipEout went next. With time still (just about) on its side – now a new handheld, the PlayStation Vita, needed selling – it found a point in future history that actually did make a difference.

WipEout 2048 is a great example of why so many franchises, when returns start to diminish, end up going backwards. Set during the dawn of Anti-Gravity racing, in a track-embroidered New York City (Nova State City in the fiction), it's the missing link between jets and wheels, anti and gravity. Ships that still remember being cars audibly fight to stay in the air, roaring through subway tunnels, past brownstone tenements, across the Hudson River, and to the impossible heights of skyscraper Sol. It's the maximalist yin to the yang of *WipEout Pure*.

'The top-level goal was that the higher up in the city you were, the more futuristic it was,' says Tilley. 'So at ground level it was old-school, then contemporary skyscrapers and then these giant mechanical spiders building Sol. Daz [Douglas] was the creative visionary for a lot of that stuff; we put a lot of faith in his concept art.'

It took a bit of effort just getting Douglas on board, though, spellbound as he'd become by a Tarzan game being co-developed by Liverpool and

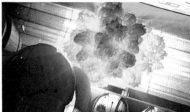

Evolution Studios. 'It was just Tarzan punching monkeys and stuff,' he swoons. 'Daft people running around jungles. Giant lizards. Amazing. They spoke to me and I was like, "Oh God there's nothing left to do in WipEout, surely." But then Lee Carus goes: "We're paring it back, making it more real-world. Real, identifiable windows. We're doing it like *Blade Runner*, buildings on top of buildings."'

This created a game that would not be cowed by the smallness of PlayStation Vita's screen, giving its 5-inch OLED display plenty to get on with. Going retro wasn't just an aesthetic, either, but a pretext for more contemporary, marketable and potentially controversial gameplay. A spoonful of sugar to help the medicine go down.

The challenge was the tracks, many of them built for cars and trains rather than prototype rocket ships. Tight chicanes and corners required greater agility – and WipEout had enough of a problem selling the scale of its giant ships already. Dressing tracks with tiny lamp posts and street furniture only went so far. Shrinking the ships themselves had, says Jones, been a long time coming:

'The thing is, if you've got two Star Destroyers and they're zipping about at the speed of WipEout ships, they're no longer Star Destroyers, they're just cars and bikes at that point. The agility and how they make those turns just adds up to a smaller vehicle at some point, which we'd accepted before with the open-world one because it was more stunt-orientated.'

That was just fine for Douglas, though, who finally got to put pilots in the cockpits again, not to mention grid girls on the tracks, revellers in the night clubs and a bunch of builders getting front-row, mile-high seats in a tribute to Charles Ebbet's famous *Lunch atop a Skyscraper*. [p267] None of it in-game, of course, so nothing new there, but what had changed was the concept art: the need for it, the appetite and the use.

'Concept art was all bullshit back in the days before *Pure*,' laughs Douglas, 'just there to fill out magazine articles. There was no preproduction. We knew the magazines wanted artwork, so after the game we'd all be sat there in a frenzy drawing stuff up so we could tell everyone, "Yup, this is how we designed it!" And yet that was the most fun you could have as an

artist because afterwards you were back with your head in the shit doing the next game.'

Dovetailing with a new gig drawing for *2000 AD* and *Judge Dredd*, Douglas cites *2048* as the most fun he ever had on a WipEout. Delivered upfront in direct service of the game this time, his concepts nonetheless work better as standalone pieces than anything he'd done before. There's the one where, having drawn 'just a twirly, spiral bit of track', he decided to draw the ground in place of the horizon, the ships now plummeting down the face of a skyscraper. [p274]

In another, feral bands of street kids try to rob the metal cladding from the track, the idea being that they'd run a bit too close to the action and spend half the race as red smear on the floor. 'You'd see 'em squished and then notice a bit of track had gone, which would be this hazard to contend with. That's the world my head was in; everyone else could deal with making the bends right and all that.'

Predictably, it's Douglas who's kept in WipEout the humanity that's often beyond its budget or scope. 'I shoehorn people into just about anything in those images. My friend Ami [Nakajima, the game's community manager and 'real life FEISAR pilot'] says, "Dan, what is it with you and cheerleaders?" but that's Formula 1, isn't it. The prep is what excites me: the guys working on the ships, putting the fuel in, tinkering underneath them; the pilots sitting at rest. I get bored of the racing, so the perspective is always of the people watching.'

In a delicious sleight of hand, the ostensibly most historical WipEout game is actually as far from its roots as ever, repositioning a series that seemed incapable of change, turning a headlong rush into a crossroads. Call it chicanery, call it street smarts, but WipEout handled its identity crisis with familiar chutzpah.

'Graeme Ankers was studio manager at the time, and in order to sell *2048* up the management chain, he basically said, "We're going to have an online multiplayer campaign!"' explains Jones. 'Were we fuck. He just promised this thing and the execs were like, "Yeah! Let's do it!" Then he told me and I was like, "Sorry, what's a multiplayer campaign?"

'We had to figure that out. I was talking to a network coder, Fejiro Bateren, and we hit on this idea of: what if the scenario I'm playing in

↓
The 'WipEout
Zero' pitch
cinematic
starring an AG
Systems hybrid
vehicle, inspired
by Kaneda's bike
from *Akira*

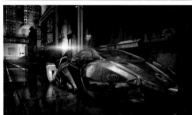
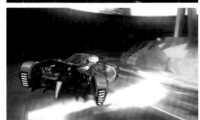
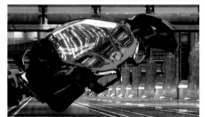
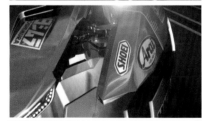
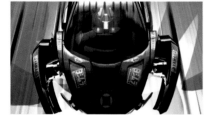

doesn't have to be the scenario you're playing in. We can be in the same game, at different points in the progression. It worked really well. We even made board game versions to try it out. I dare say we'd have built on it with the next game.'

Would have.

● TH3 B3G1NN1NG 4T TH3 3ND

On 22 August 2012, workers at Studio Liverpool were called to the main shop floor, where Michael Denny, vice president of Sony Worldwide Studios Europe, was waiting. Artist Edd Wainright explains that, 'You'd only ever see him when something bad was going to happen.'

Having joined in 2005, Wainright's first experience of 'the cull' came the following year, when finding yourself redundant meant a studio-wide briefing and, for the unfortunate, emails waiting in your inbox before it was even over. The next time, 'they literally told us to go home there and then and come back the next day – and there'd be a letter that would tell you if you still had a job.'

It wasn't always people that got the chop, either. Wainright remembers 'three or four times over eight years' when a team had presented its project to Sony Japan, and the outcome had been no project at all. 'You'd be working non-stop, get really into it and it'd just sort of end. I think that's just how big companies operated, at least in them times.'

This time, though, no one was left guessing. The official statement read:

'As part of this process, we have reviewed and assessed all current and planned projects for the short and medium term and have decided to make some changes to our European Studios.

'It has been decided that Studio Liverpool should be closed. Studio Liverpool has been an important part of SCE Worldwide Studios since the outset of PlayStation, and have contributed greatly to PlayStation over the years. Everyone connected with Studio Liverpool, past and present, can be very proud of their achievements.'

'They gave us all, I think it was three months to keep using all the facilities to get our portfolios together, and we were getting paid for that,' recalls Wainright. 'We could go in at nine in the morning and work until half-five or whatever. It was really good in that respect.

Three months' gardening leave and then we got the redundancy payout, which was very good!'

Liverpool's closure was felt deeply by gamers still grappling with the previous year's loss of Bizarre Creations, whose breakout title *The Killing Game Show* was discovered and published by Psygnosis. By pushing a certain type of person to be a certain type of creative for 28 years, whatever name was above the door, Studio Liverpool still was Psygnosis for many a Britsoft romantic – but no more.

Sadder still, the vehicle for all that endeavour was at that moment prepping its boldest invention to date: *WipEout Zero*, the game that would reinvent WipEout completely.

It would be naive to suggest that the gameplay prototypes, internal promos, interconnected device aspirations and other products of *WipEout Zero*'s months in development were a lock for PlayStation 4. Make no mistake, though: this Tokyo-set, rain-drenched car game was built from the ground up for one specific purpose:

'We'd identified WipEout's niche and wanted to rectify it over time,' says Jones. 'We took steps with *WipEout 2048*, but not enough. The thing was always: if mum is going into a shop to buy a racing game for her son, she's going to pick up *Need for Speed* before she ever even gets to us. If you've got cars on the cover, you're the racing game. An abstract couple of triangular ships? No chance. It was stupid obvious stuff we started to address, and we were onto something special.'

In the internal trailer for *Zero*, the hero car pops open entirely like Kaneda's iconic bike in *Akira*, its cockpit coming alive with the game's HUD. Its engine starts and it flexes its 'limbs', whereupon are mounted headlights and wheels, linked to the chassis by crackling electricity. A drift race follows through the streets of Shibuya. Rain runs sideways across the windshield: neon rivers of the world sliding by. Cars drop into harbour waters and jostle, undulating, almost pawing at their opponents. Somewhere in the middle of *WipEout*, *Ridge Racer* and *Blur*, this is 'fusion' on a whole other level.

This was to be a rival sport to the Anti-Gravity Racing Championships, with all-new teams but more than the odd hint of a shared universe. As Jones explains: 'Later in the game it'd be like, "Oh shit, FEISAR have joined up."'

↓
Render of a
FEISAR ship from
*WipEout HD:
Fury* (Studio
Liverpool, 2009)

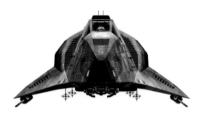

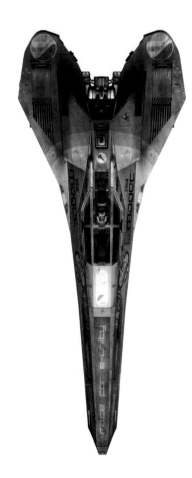

And they'd bring their version of this car to this kind of Japanese street racing, with the tech they've developed in the AGRC. Our car was nowhere near finished but we had the articulation, where it absorbed all the bumps in the road, and it was looking great. We were going to see if we could get away with not having projectiles, see if it could have run without that. And I'm sure it could 'cause it was fun already.'

The game 'clicked' almost immediately, which is unusual, says Jones. Built on the first all-new WipEout engine since *Pure*, it was already thinking beyond core handling – 'we'd broken the back, as it were, it just felt great taking these big, arcing declines and carving your path out' – to a heavily social metagame which straddled phones and tablets. Players around the world could earn followers, bet on each other's performance and, it was hoped, give the series the global reach it deserved. Because WipEout, it was feared, had no choice.

'It was a niche game, right, in a declining genre,' states Roberts. 'We had the F1 licence for a while, and obviously Sony let that one go They were clearly not enamoured about paying for that again, presumably because of market demand.' But 'WipEout Zero', he agrees, 'would have been really good.

'We had a cool constraint system for the cars. We didn't just want to have suspension that was skinned and flexed; we wanted gears and shafts and flywheels that were spinning. We spent quite a bit of time exporting those from Maya and having them be automatic, so in the game you could move these pieces around and have them respond in the right way, all these little components. That prototype got quite a long way. It's a shame it didn't go forward.'

● TH3 L45T 0F U5

John McLaughlin worked at Sony between 1995 and 2022. A producer at its external development unit XDev, his job was to rally games and studios from across Europe to bolster PlayStation's immense portfolio. Augmented reality, motion control, virtual reality, apps, TV shows, merchandise…If it's good, he cares. And he's always cared about WipEout.

'I'd have been the first to pitch in for a new one,' he declares. 'Never say never. I remember

talking to someone in the office about it and they said, "John, they'll never go for it." And so I left it, and only a year-and-a-half later went, "Sod this, I'm putting something together."' And so he did, and it became the first WipEout game ever to hit the top of the UK charts.

WipEout Omega Collection is a heavily remastered PS4 (and thus PS5) compilation of tracks from *WipEout HD: Fury* and *WipEout 2048*, the latter added at the behest of SCE president Shuhei Yoshida 'because he really likes that game,' says McLaughlin. 'So we had a look at the Vita code, and funnily enough it has more in common with PS4 than the Cell and SPUs of PS3. So we ended up using Vita as the codebase for the whole thing.'

With no Studio Liverpool to develop, McLaughlin turned at first to Sweden's EPOS, maker of the game *Crash Commando* on PS3. With permission to stick Liverpool's code on a hard drive, and himself on a plane, he asked founders Staffan Langin and Olof Gustafsson (old-school demoscene guys who just happened to co-found *Battlefield* developer DICE) for a cost and schedule to port it to PS4. 'I knew they couldn't do it all by themselves,' he says,' so we had a discussion in the office and someone mentioned Clever Beans.' With some WipEout veterans on its staff, that Liverpudlian studio had worked with XDev on PS3's *When Vikings Attack!*.

With further assistance from Sony's studio network of sound designers [p292] and engineers, this band of developers brought WipEout to PS4 at nothing less than 4K resolution, in HDR, at 60 frames-per-second – a feat worthy of Studio Liverpool itself.

It then brought the game to virtual reality, where previous attempts had failed. 'The old team had a prototype a long time ago,' says McLaughlin, 'but it just didn't work. The general opinion from others within Sony was it *wouldn't* work, either.' The sheer speed of the games, it was assumed, would make motion sickness inevitable. McLaughlin asked Michael Denny to 'just give me a couple of milestones to try and get it running, and I went back to EPOS and said, "How long?" – meaning, "You've got two months to prove that it works."' Langin had it running in one, and month two was spent making it better. Which is to say: better for the stomach. 'The first time I played it we had the original

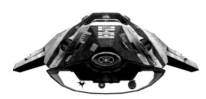

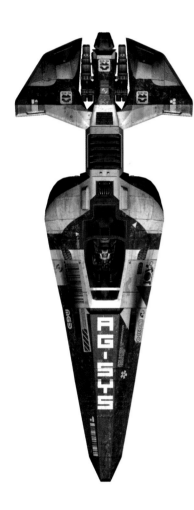

cutscene camera views, with the panning and stuff, and it really was the vomit comet. I felt terrible playing that. But when we took those out and gave people motion options, everyone was surprised. No one thought it could be done.' More surprising still was that this wasn't just a tacked-on VR sandbox but the whole game in VR.

McLaughlin's only regret is that, being one himself, he couldn't give fans even more. An attempt to put The Prodigy's 'Firestarter' in the game ran into licensing issues – the track samples 'SOS' by The Breeders – which frustratingly would have been void had the game released a month later. Expansions for circuits from *WipEout* and *WipEout 2097* were explored, 'but the cost would have been the cost of the whole of *Omega*,' he explains. 'The tracks don't have as much camber, they'd need to be totally rebuilt and designed for the new handling model, and there wasn't a thing about them materially that we could use.'

Perhaps we should be thankful for what we got, then, considering how remarkable it is that *WipEout Omega Collection* even exists at all. McLaughlin concedes that his colleague was probably right: if he'd pitched that game a year-and-a-half earlier, the answer may have been no. 'Sometimes, the timing is just right. Sometimes it's not.' And with headlines in early 2024 dominated by reports of seismic game industry layoffs, the cycle augurs badly for a new game any time soon. Studios the world over are being closed, games cancelled, beloved franchises scorned; this is not the usual bear market. But then WipEout maybe isn't your typical franchise, either.

It was, after all, as recently as 2023 that filmmaker Neill Blomkamp, fresh off a movie adaptation of PlayStation racer *Gran Turismo*, put out a call on social media for WipEout lore – which he then deleted. There was also the peculiar 2021 mobile game *WipEout Merge*, where players didn't fly the ships but watched them during brief vignettes while tapping occasional prompts to fire weapons. There is, dare it be said, this thing in your hands right now. 'It's shocking and humbling the sheer number of people who reach out to talk about WipEout or pitch work on related projects, on a daily basis, from all over the globe,' notes community manager Nakajima. 'It's almost 30 years old. Very few games have had such longevity in

people's minds, and even fewer which are so representative of everything British, so reflective of the passion and swagger of Scouse culture in each game. Its spirit is the history of the city and the resilience of the people here. Hundreds of people, a whole lifetime of work, chronicling and redefining style aspirations for each generation who've grown up with it.

For now, at least, what's known for sure is that next comes more uncertainty – but maybe also potential. This, after all, is the age of 'peak TV' and 'streaming wars', where games are often cited as goldmines of untapped fiction with loyal built-in fanbases. Nectar, you might say, for Netflix. No one knows that better than Sony, which has already seen two racing adaptions to completion in *Twisted Metal* (for television) and the aforementioned *Gran Turismo*. Critical and commercial acclaim for HBO's *The Last Of Us*, adapting the acclaimed survival horror by Sony studio Naughty Dog, has paved the way for so many projects and rights acquisitions that it's almost harder to find games that *aren't* attached to some production company or network.

Something else we know: if WipEout never does come back – if the torus really does have an end – it will never be for lack of trying. 'Every single WipEout developer I know wants it to live again,' says Nakajima. 'We all love WipEout.'

If memory serves, it was four young men from Liverpool who said that's all you need.

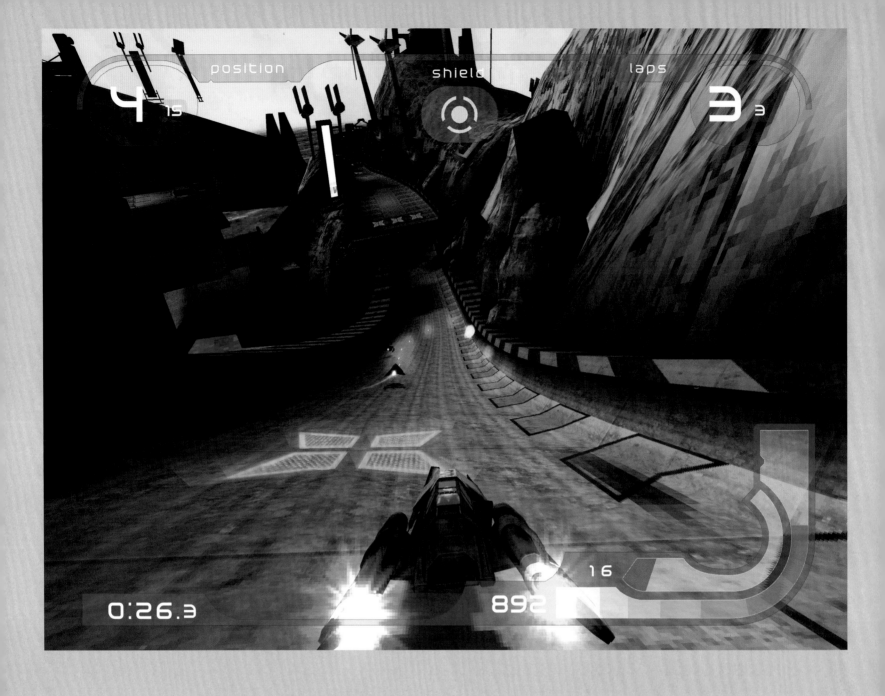

← ↑
Mandrashee,
WipEout Fusion
(Studio
Liverpool, 2002)

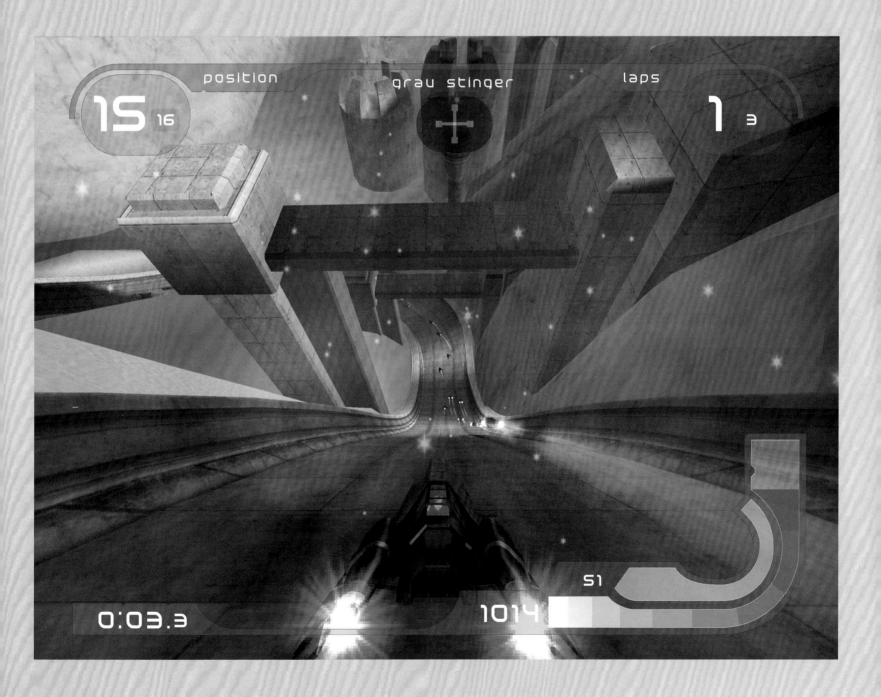

leuel 02.9 1.200.787

12

2

shield energy critical

1

laps

03

1525

↑ →
Florion Height,
WipEout Fusion
(Studio
Liverpool, 2002)

← ↑
Katmoda 12,
WipEout Fusion
(Studio
Liverpool, 2002)

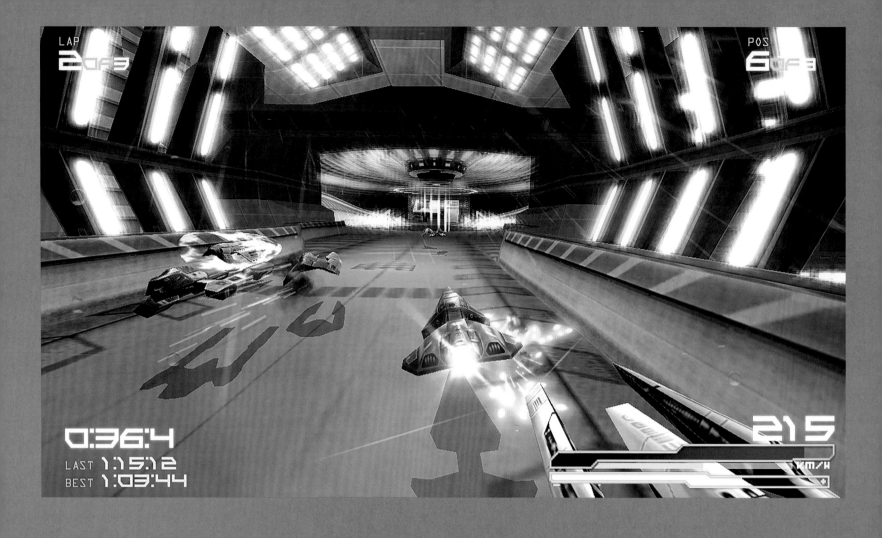

0:36:4
LAST 1:15:12
BEST 1:03:44

215
KM/H

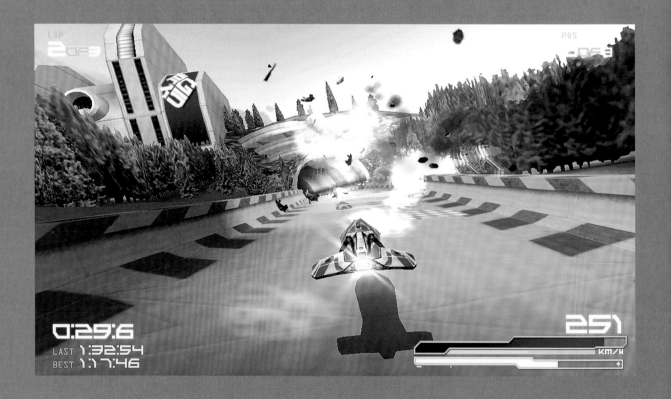

↑
Sinucit,
WipEout Pure
(Studio
Liverpool, 2005)

→
Blue Ridge,
WipEout Pure
(Studio
Liverpool, 2005)

0:29:6
LAST 1:32:54
BEST 1:17:46

251
KM/H

→
Modesto Heights,
WipEout Pure
(Studio
Liverpool, 2005)

↓
Sebenco Climb,
WipEout Pure
(Studio
Liverpool, 2005)

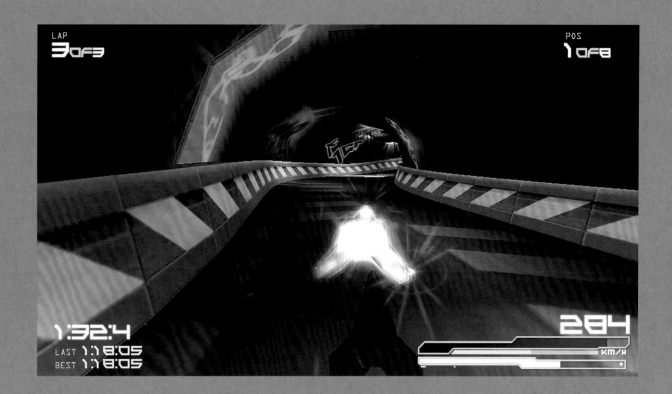

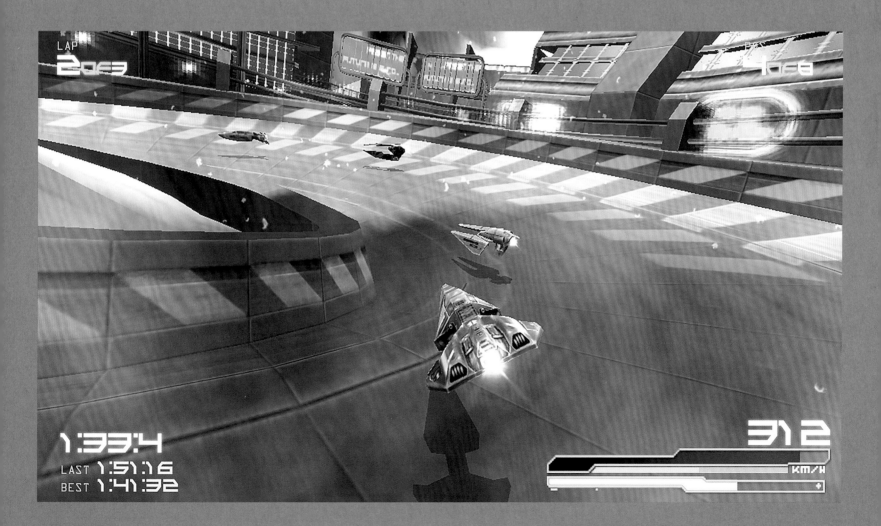

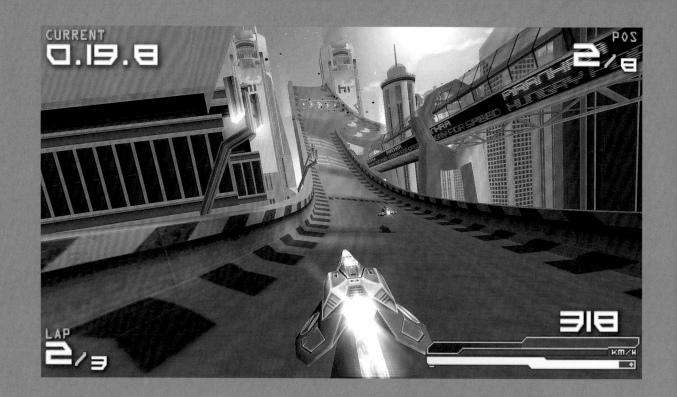

→
Citta Nuova,
WipEout Pure
(Studio
Liverpool, 2005)

↓
Sinucit,
WipEout Pure
(Studio
Liverpool, 2005)

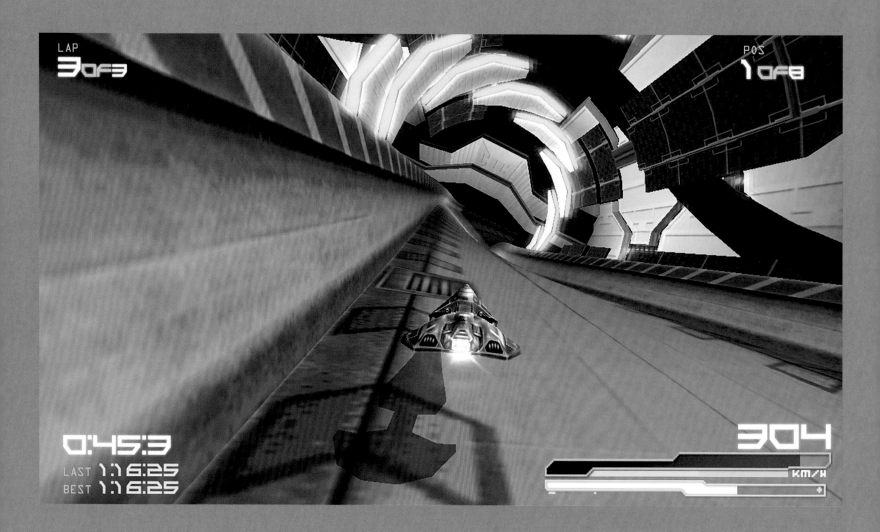

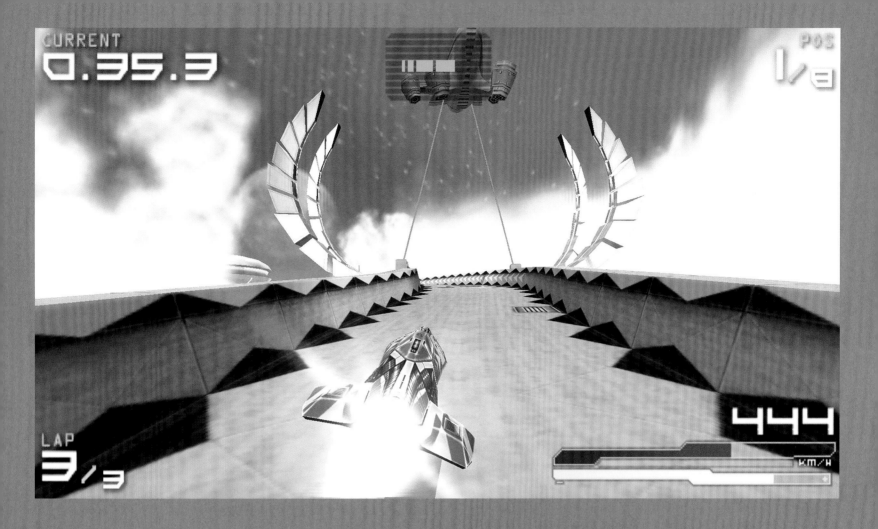

LAP
3/3

444
KM/H

LAP
1 OF 3

POS
4 OF 8

0:21:3
LAST 0:00:00
BEST 0:00:00

173
KM/H

↑
Sol 2,
WipEout Pure
(Studio
Liverpool, 2005)

→
Blue Ridge,
WipEout Pure
(Studio
Liverpool, 2005)

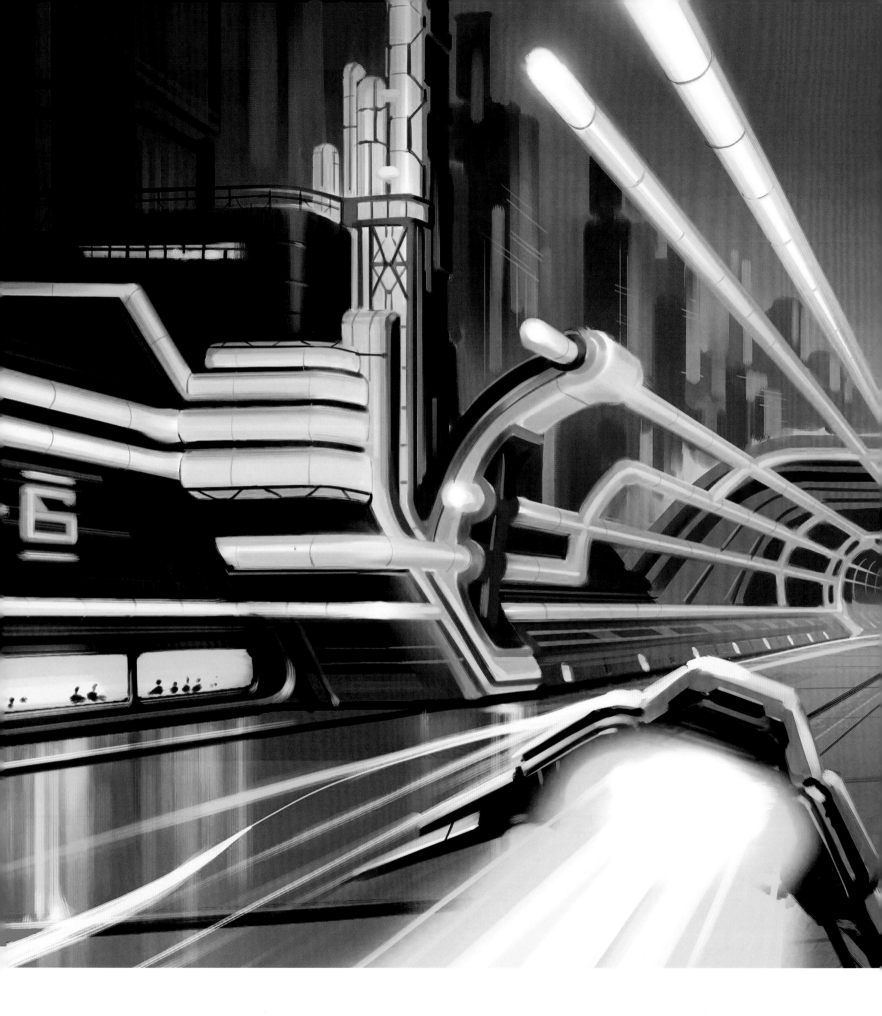

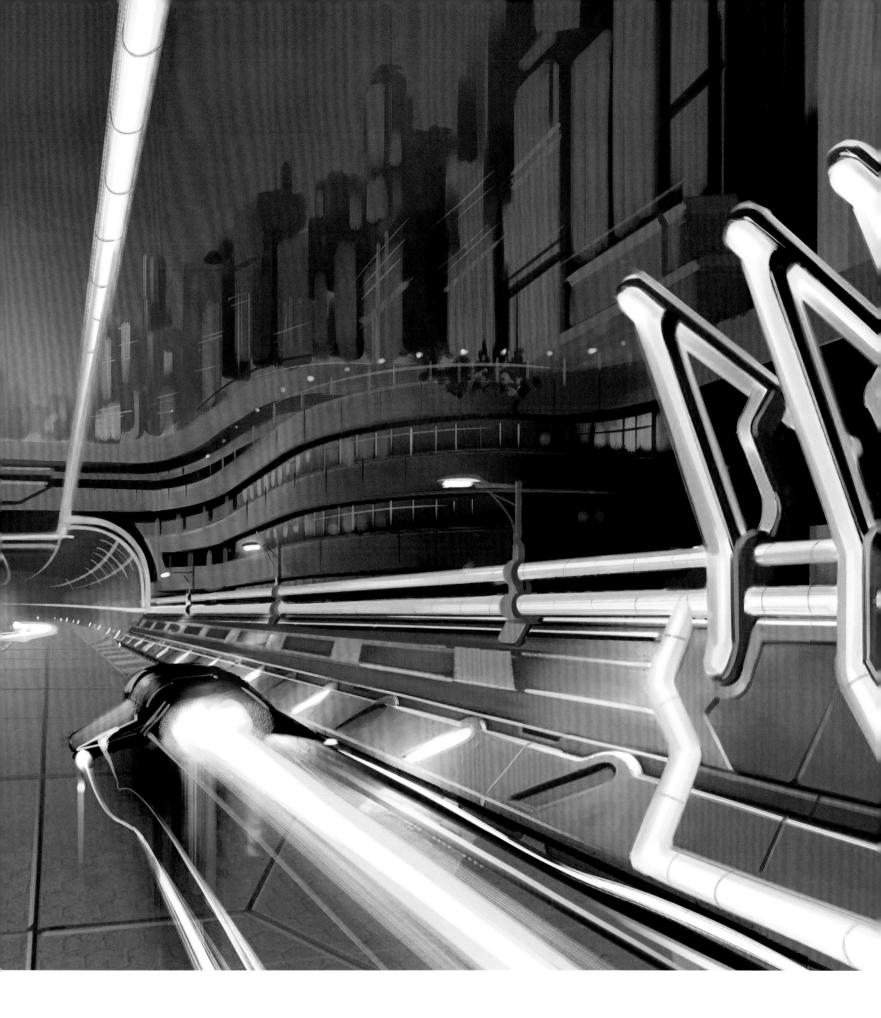

→
An early concept
for the Assegai
in *WipEout*
HD (Studio
Liverpool, 2008)

←
A concept for
an unlockable
FEISAR craft

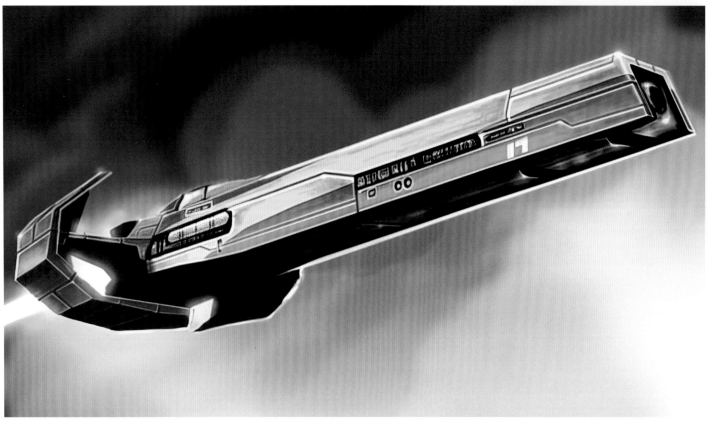

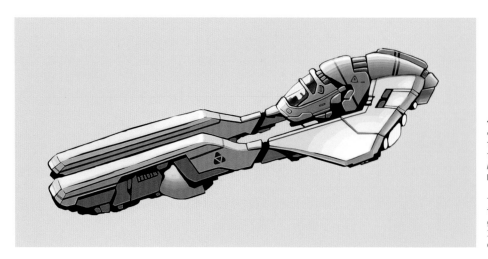

←
Jon Eggelton's
first drawing
for *WipEout*
HD (Studio
Liverpool, 2008).
'The idea was to
take my designs
from the PSP
games and add
lots of hull and
cockpit detail.'

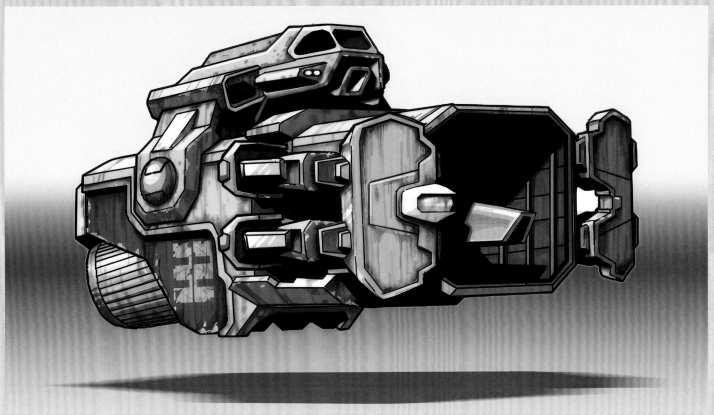

←
A 'carrier designed to deliver ships to the starting grid', by Jon Eggelton

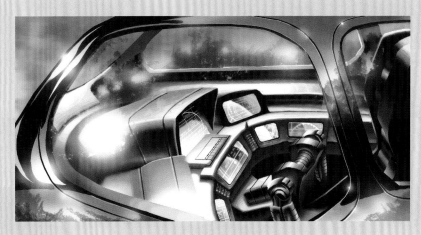

→
A luxury vehicle in the WipEout universe

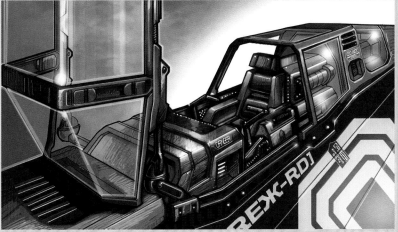

←
WipEout Pure (Studio Liverpool, 2005) had a cockpit view designed for it which, alas, took up too much space on the small PSP screen

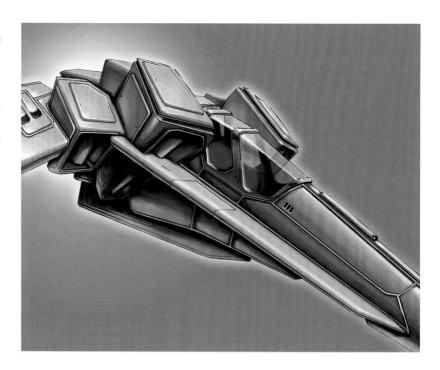

↓ →
A team-agnostic
exploration of
ship shapes by
Jon Eggelton

→→
A sleek Assegai
ship concept
with a 'used
universe' paint
job.

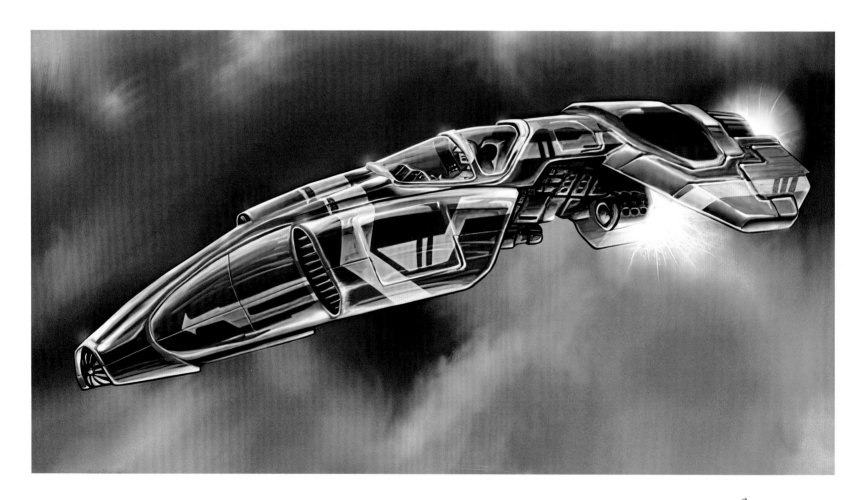

→
A journalist is
taken on a white-
knuckle desert
test of the NX
1000 prototype

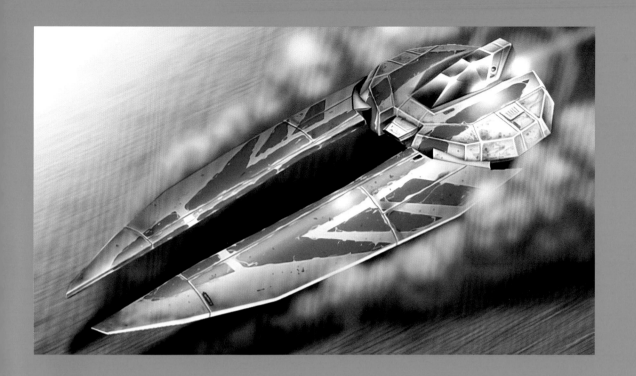

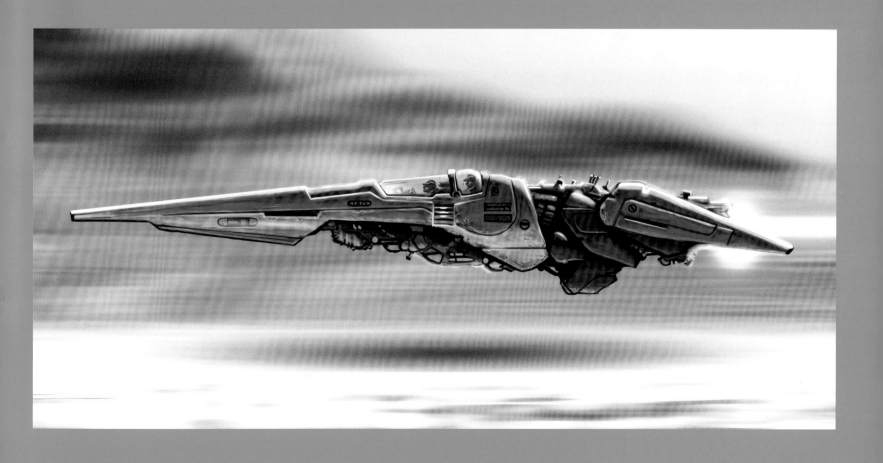

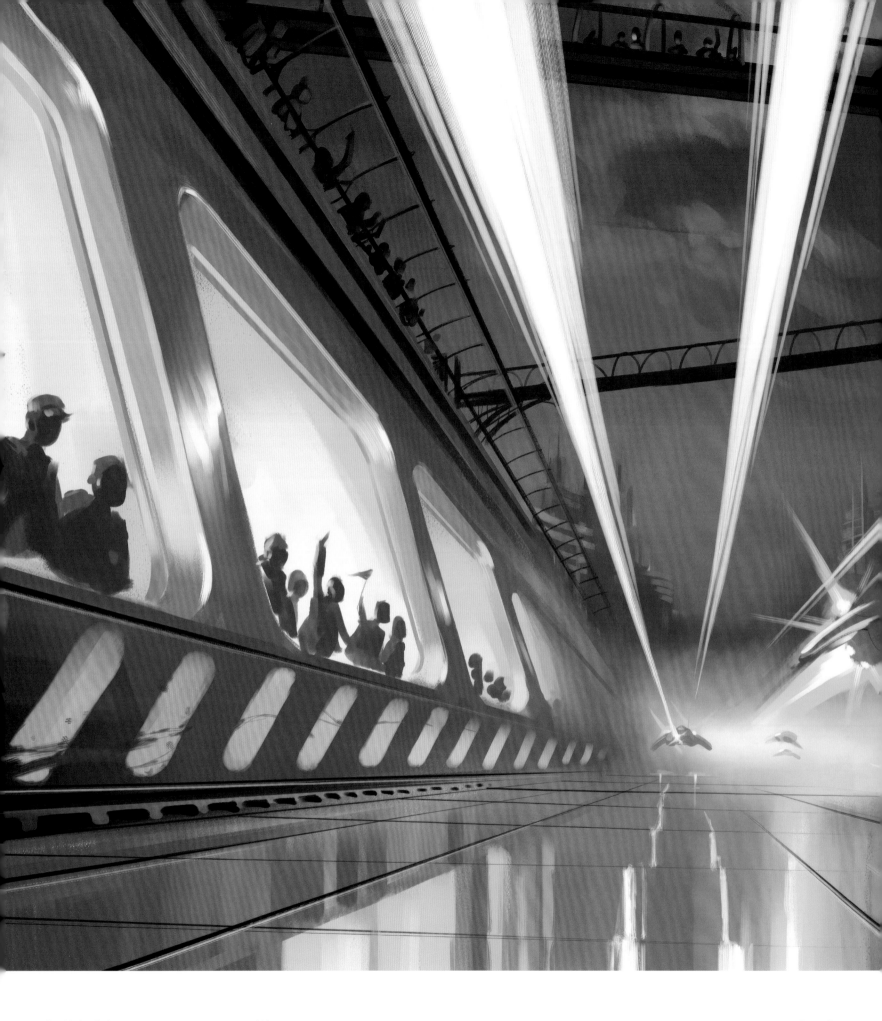

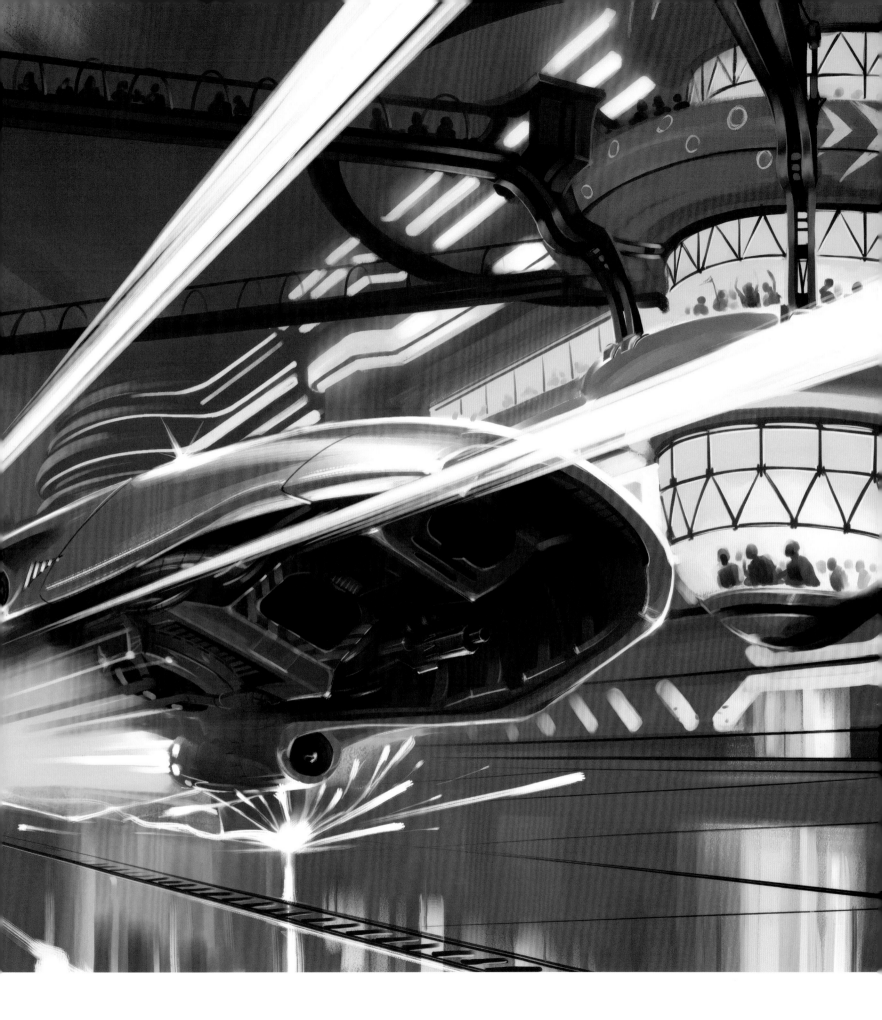

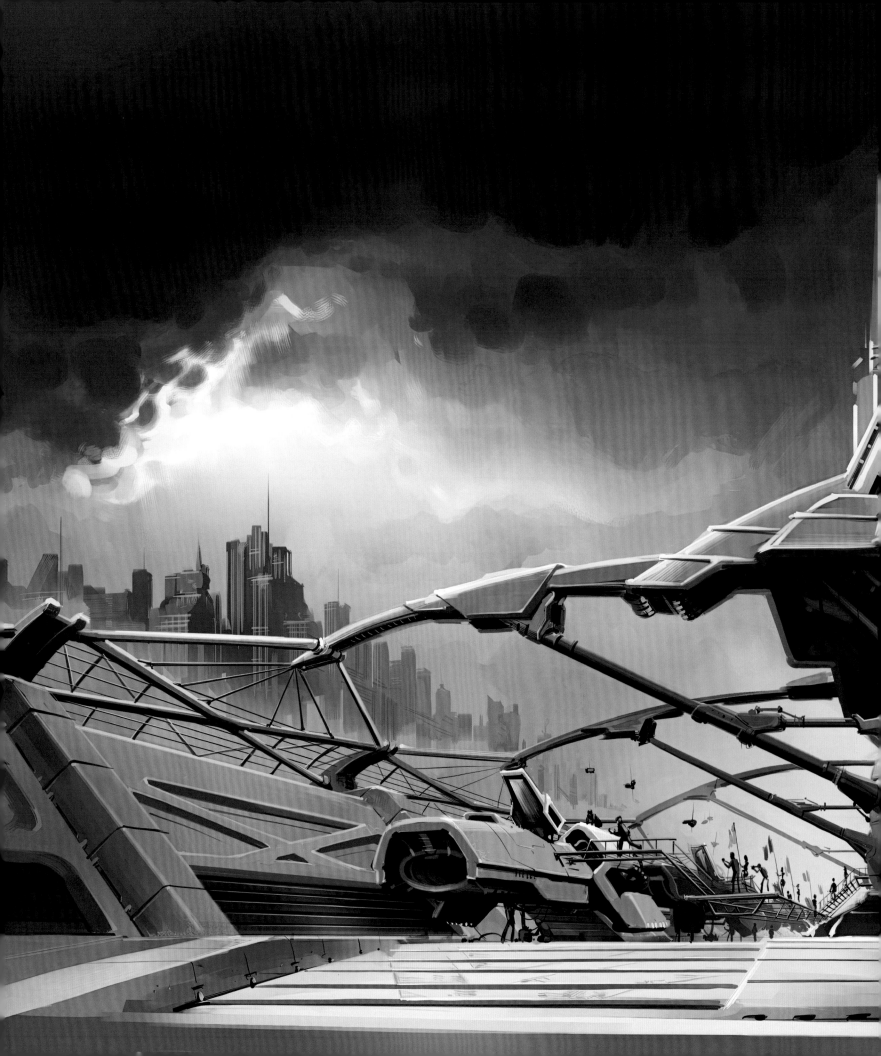

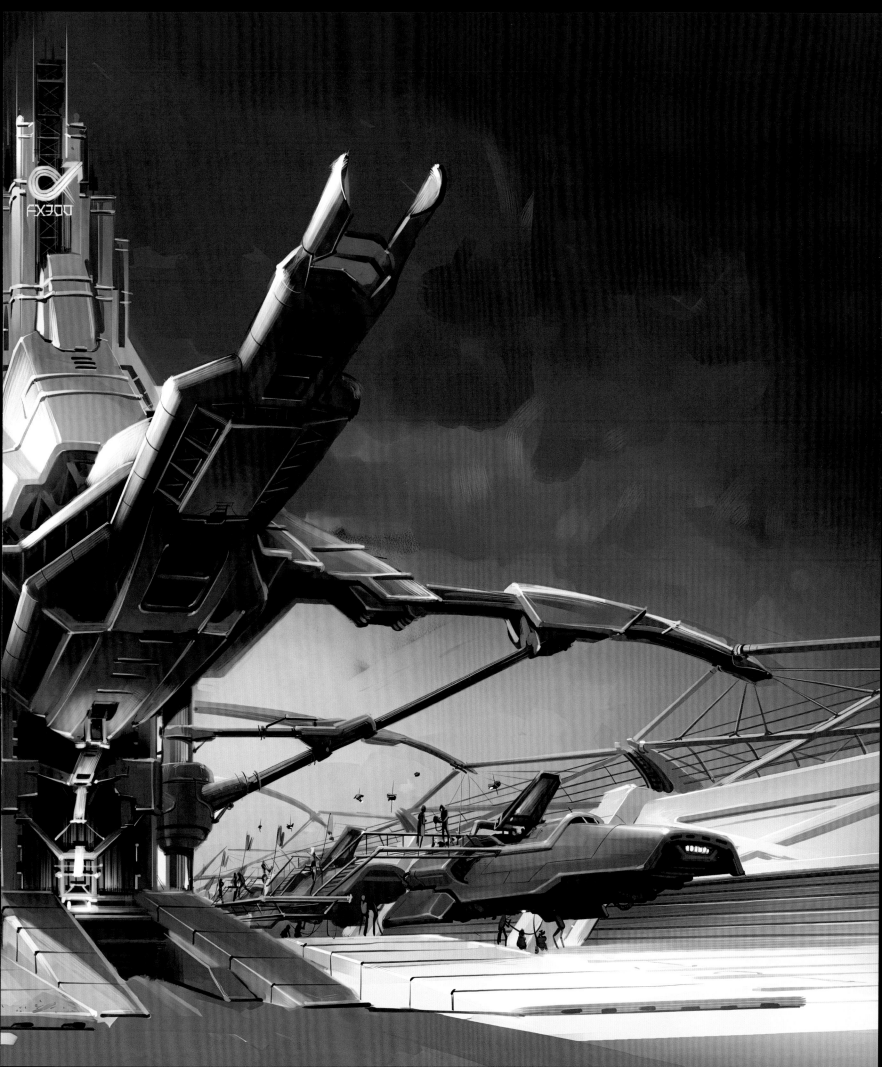

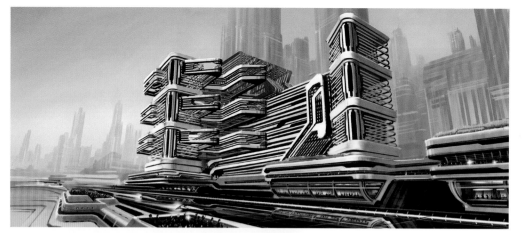

'Carrier Grid' by
Darren Douglas

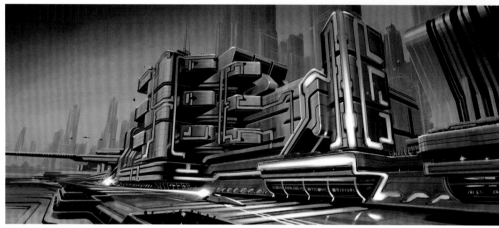

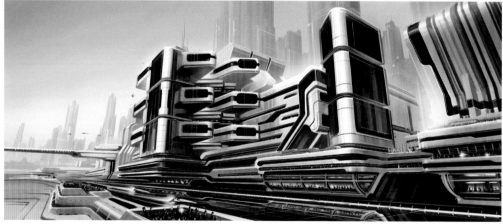

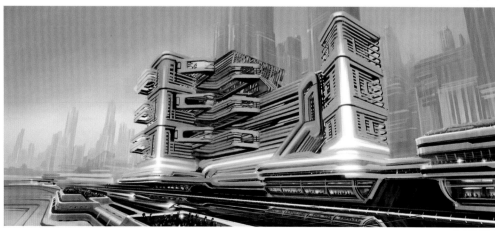

'Carrier Grid' by
Darren Douglas

← ↖
A 'WipEout
Trinity' concept
for the 'Fury'
(top two) and
'Zen' (lower
two) states
of a track

↗ →
Another 'Fury'
and 'Zen'
comparison, this
time for gameplay

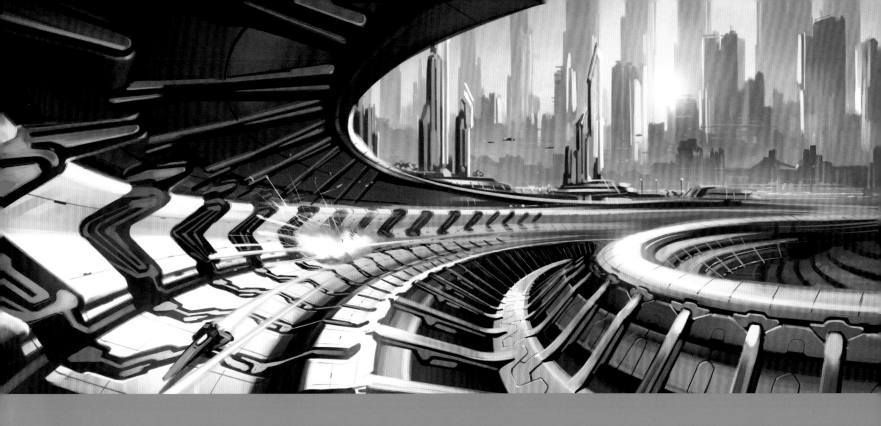
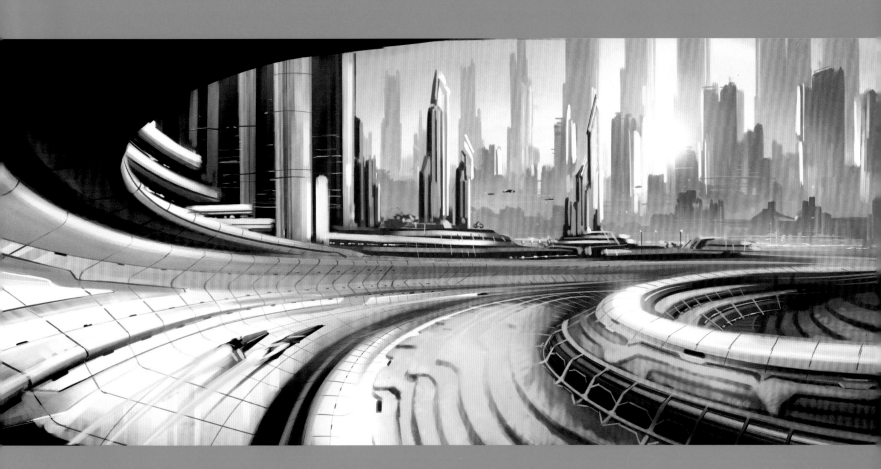

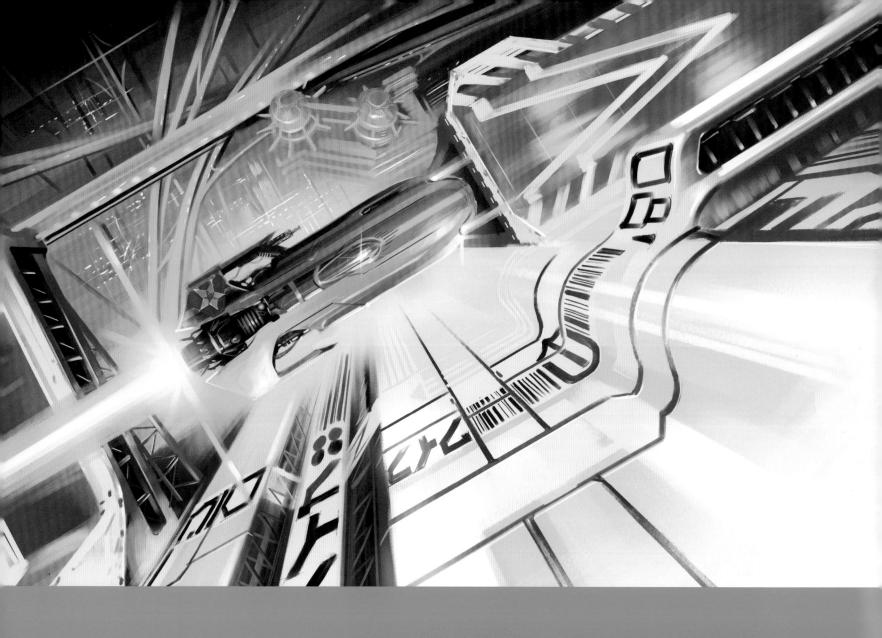
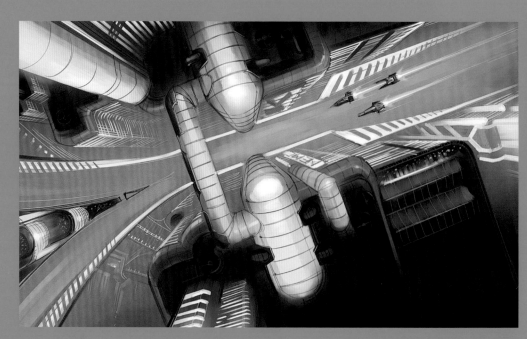

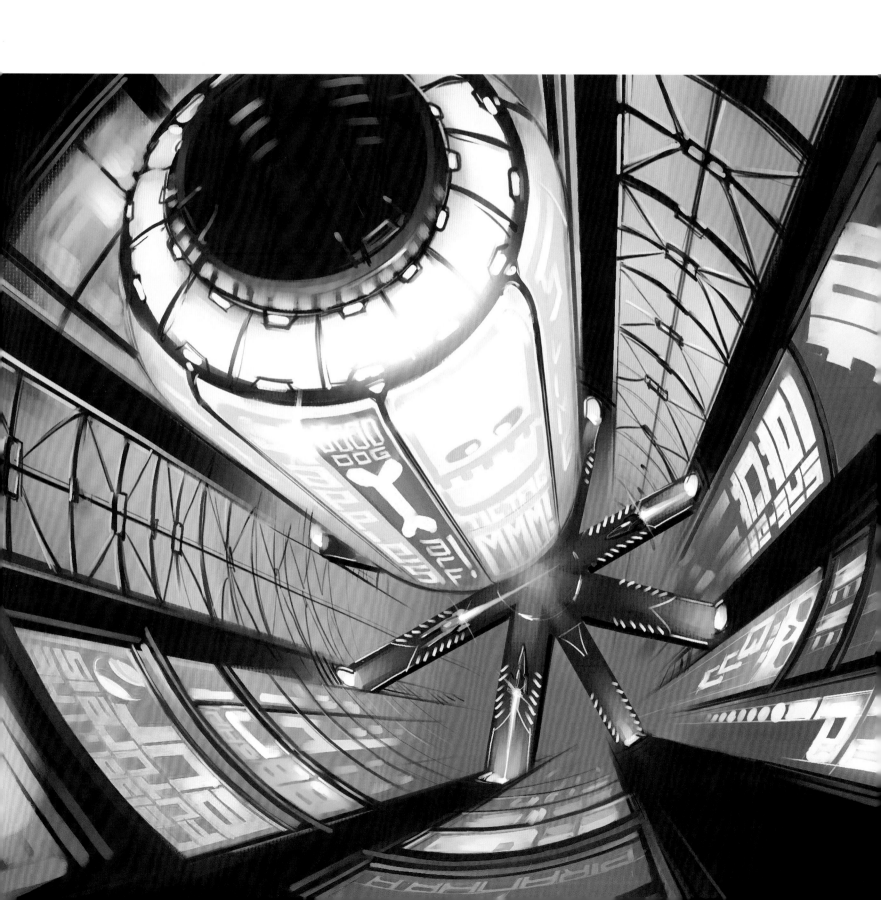

↑ ↓ →
The free-roaming
WipEout concept
was due to be set
on a tropical
island, complete
with tourist
areas, mountains
and forests.

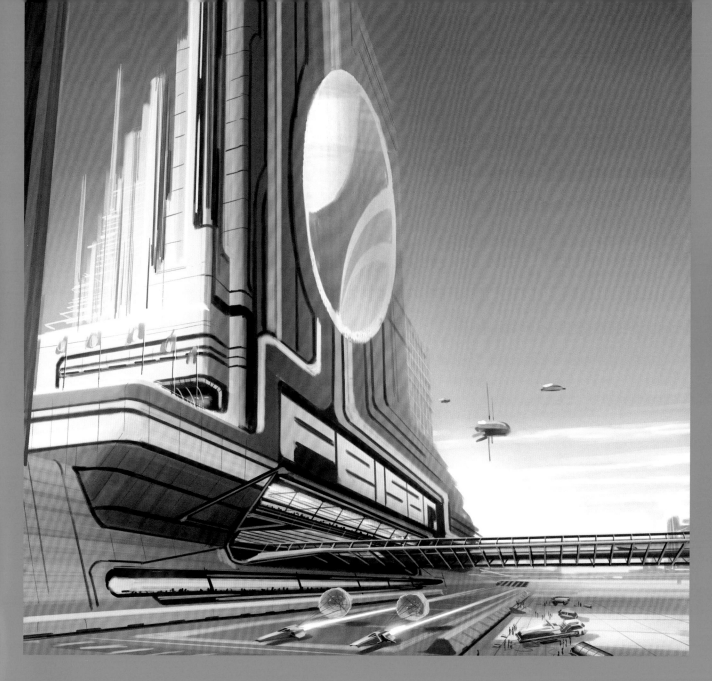
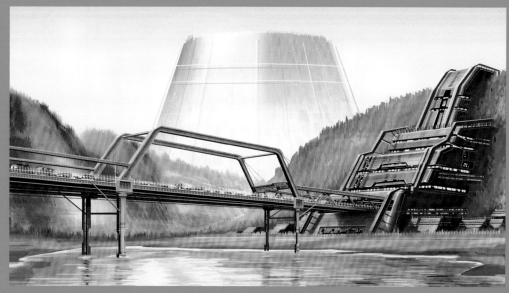

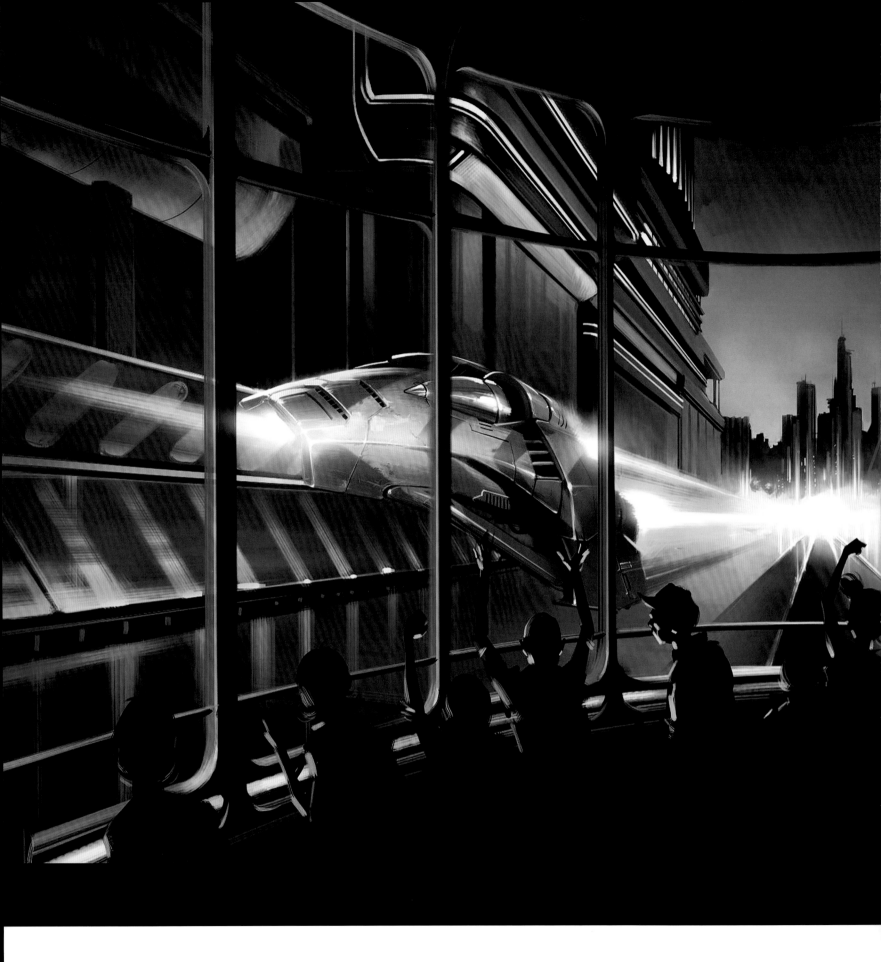

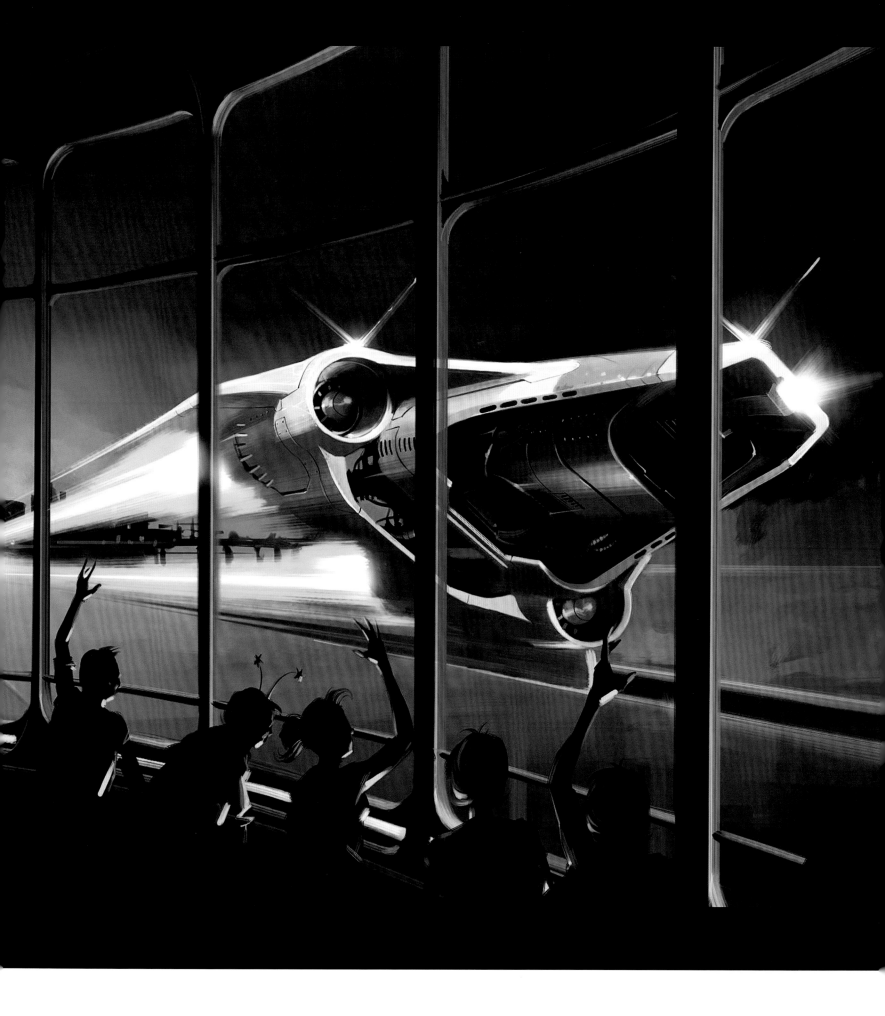

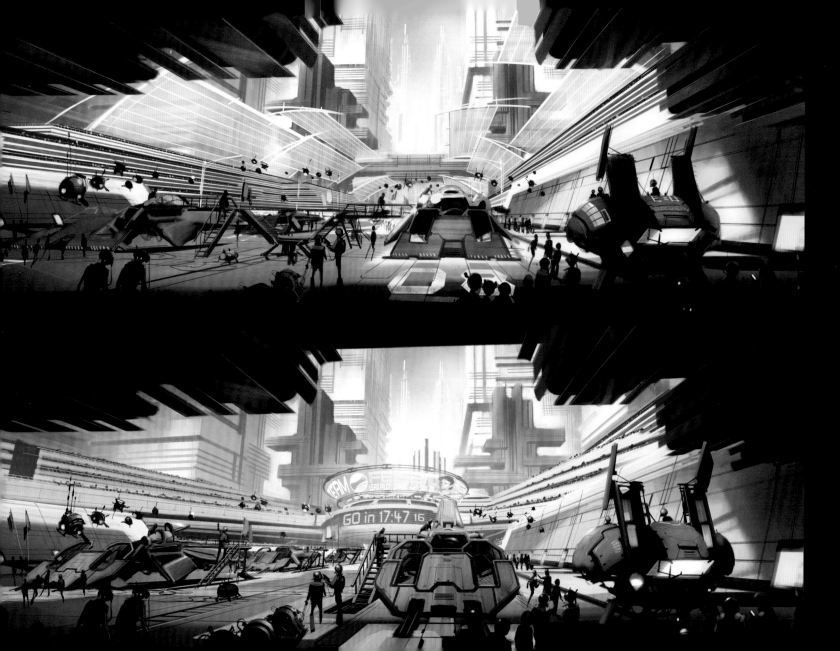

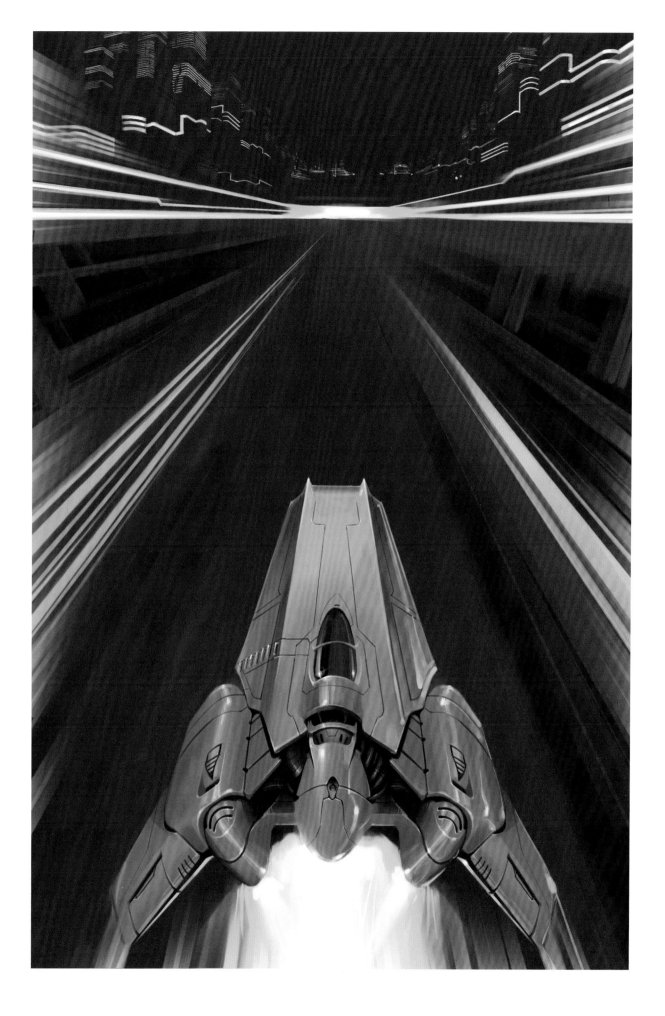

↑ ↗ →
Building concepts
for *WipEout
HD* (Studio
Liverpool, 2008)

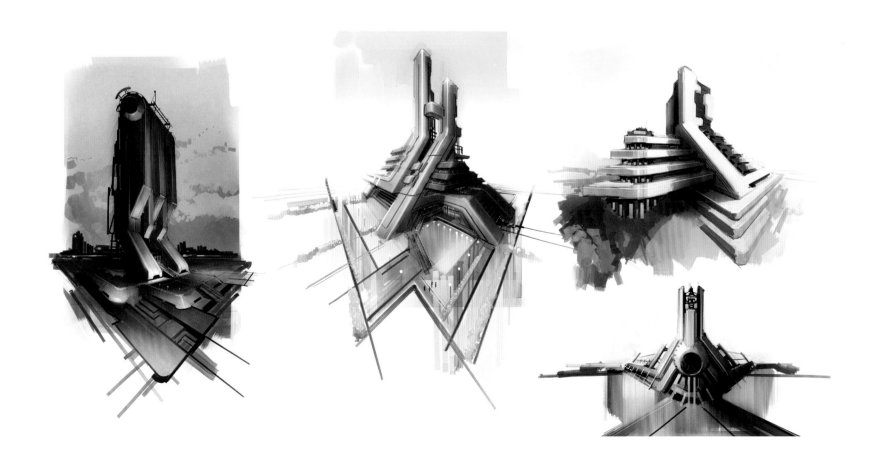

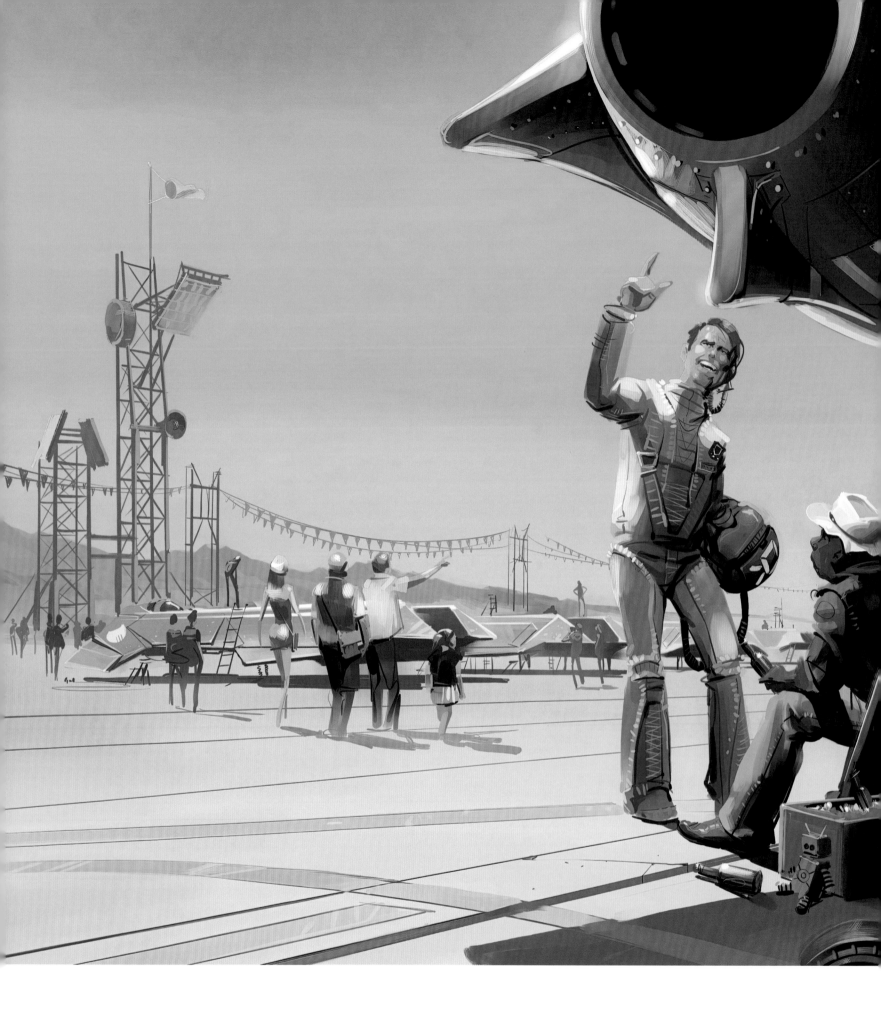

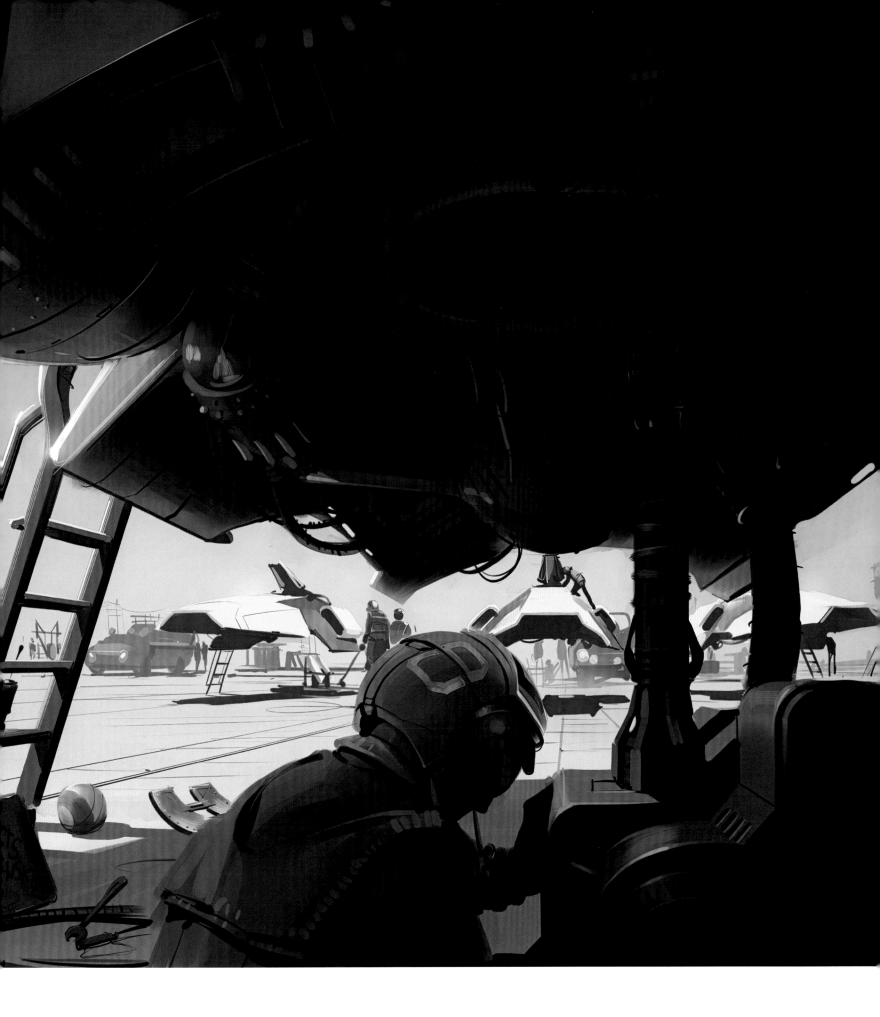

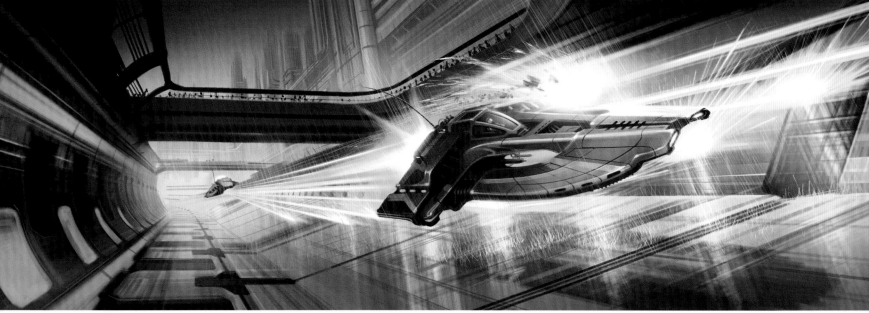

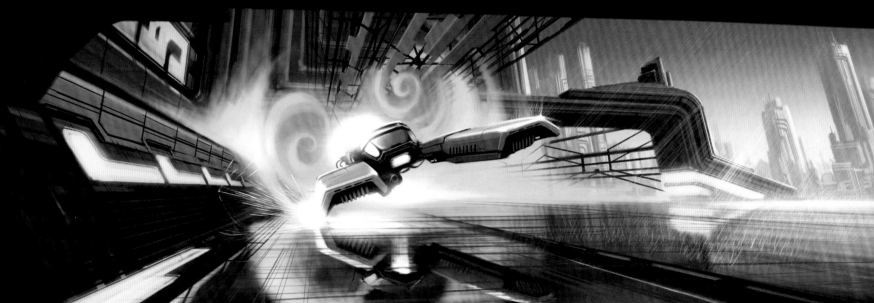

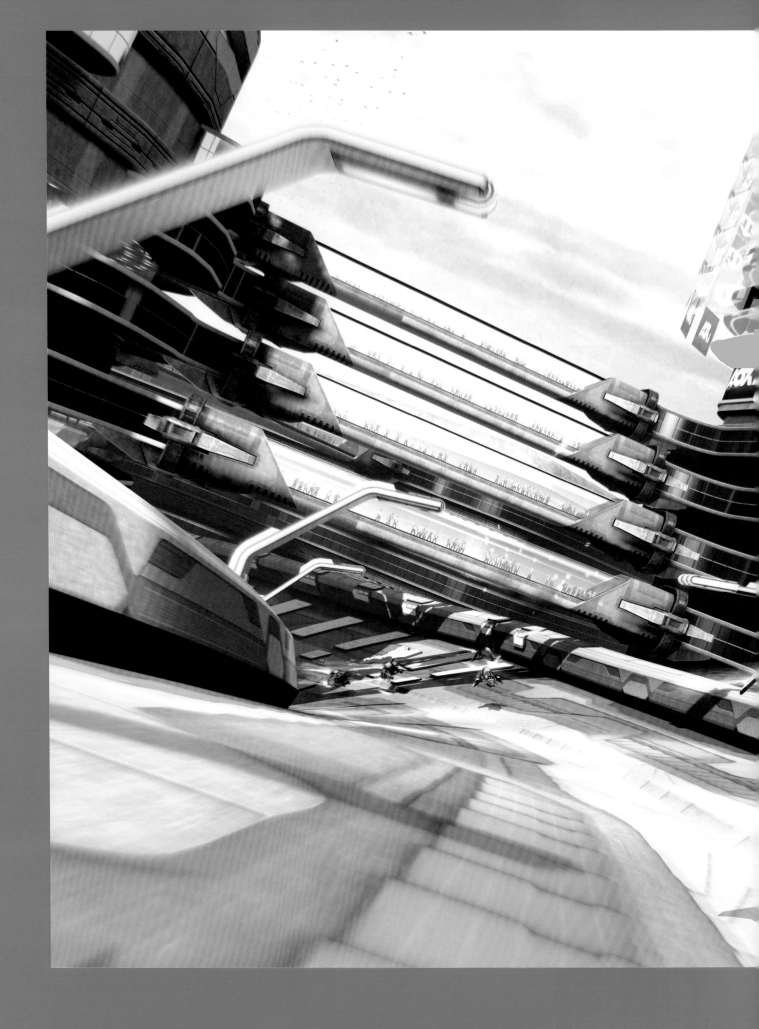

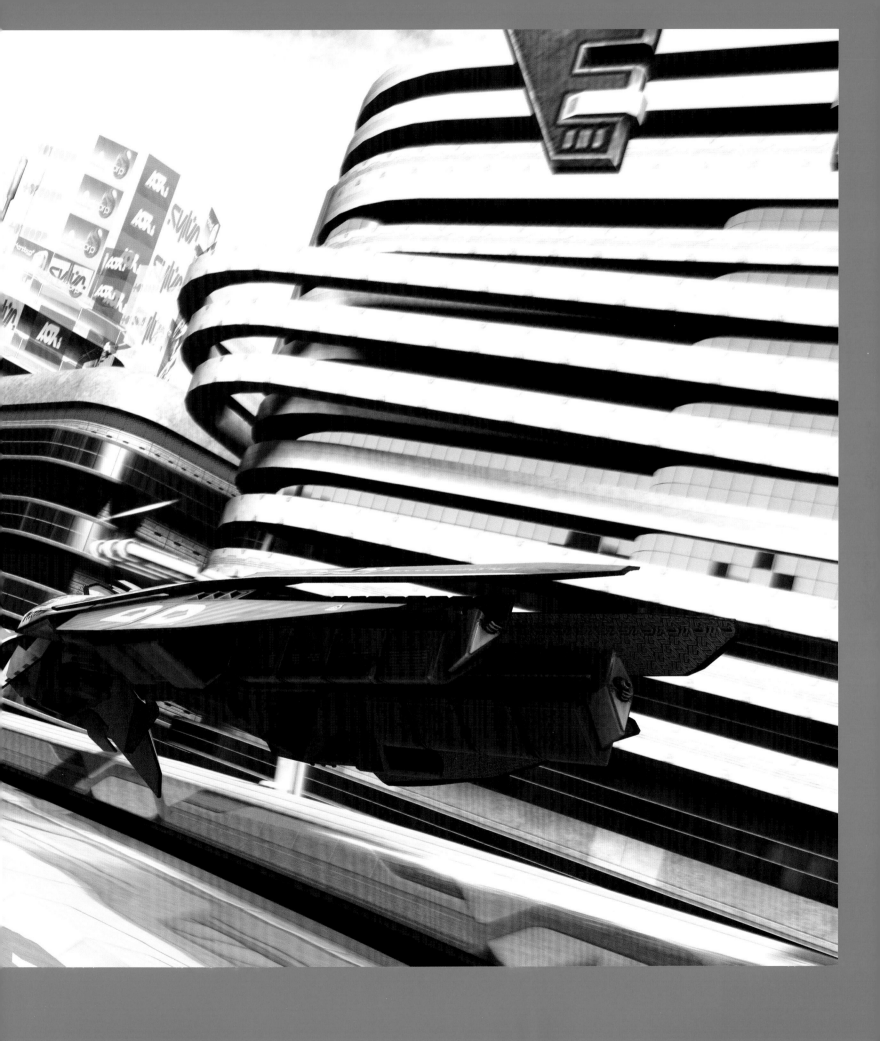

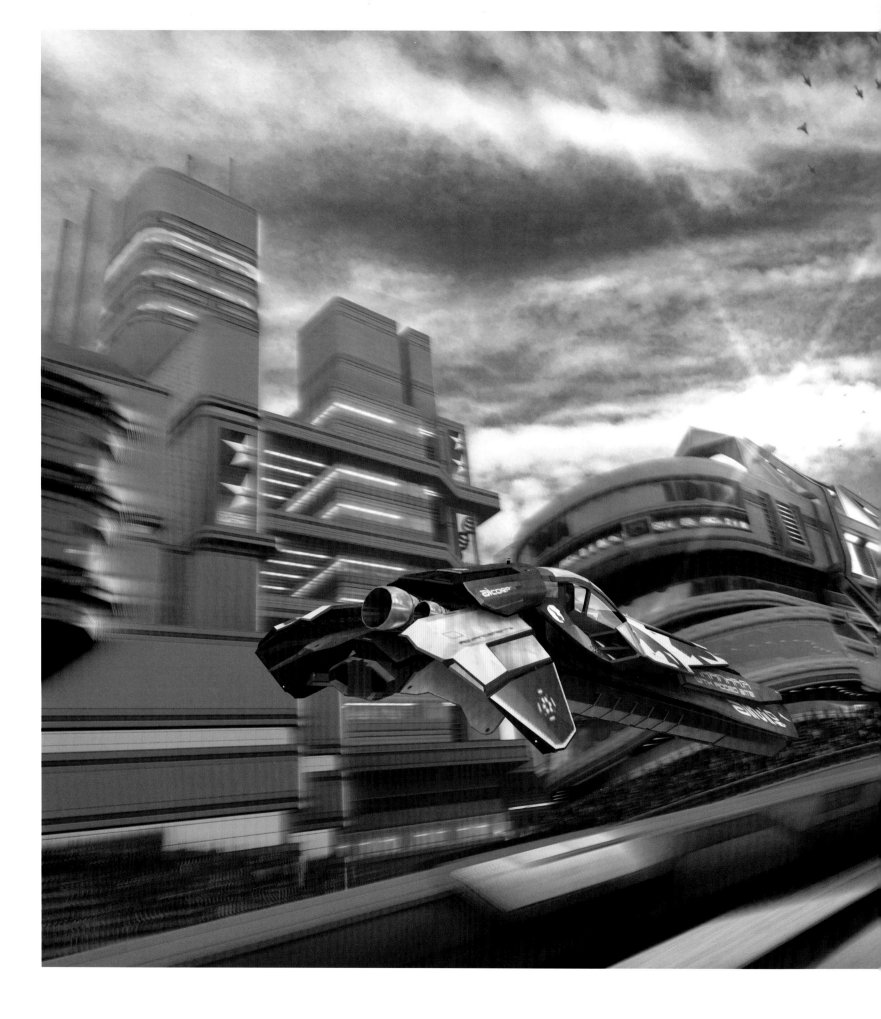

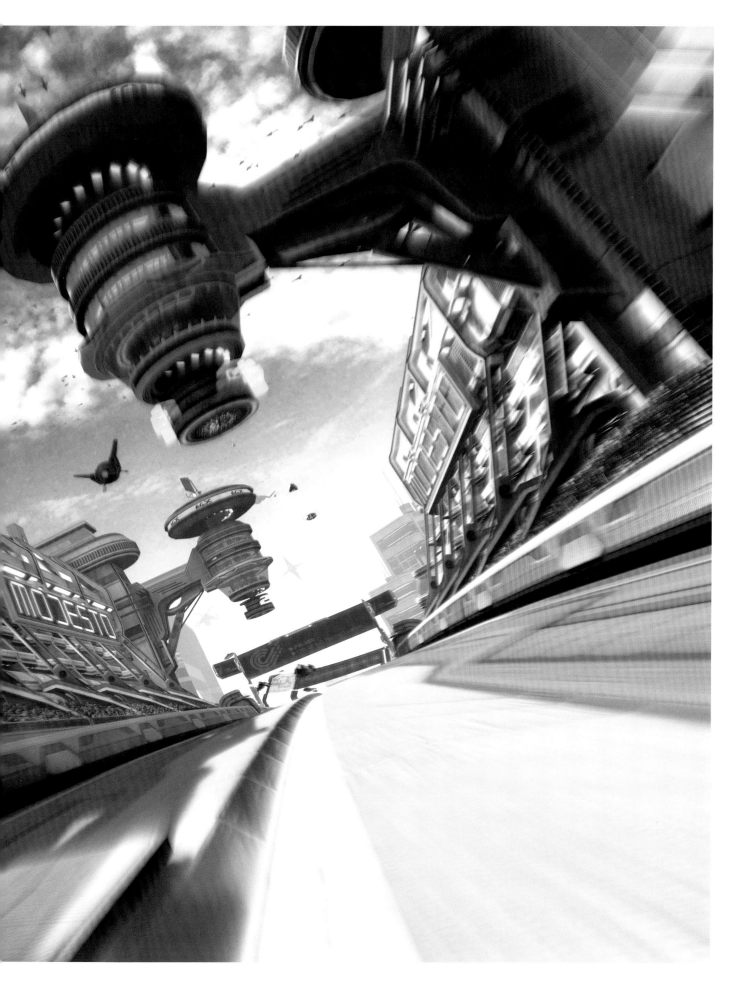

←←
Modesto Heights,
*WipEout HD:
Fury* (Studio
Liverpool, 2009)

←
Modesto Heights,
*WipEout HD:
Fury* (Studio
Liverpool, 2009)

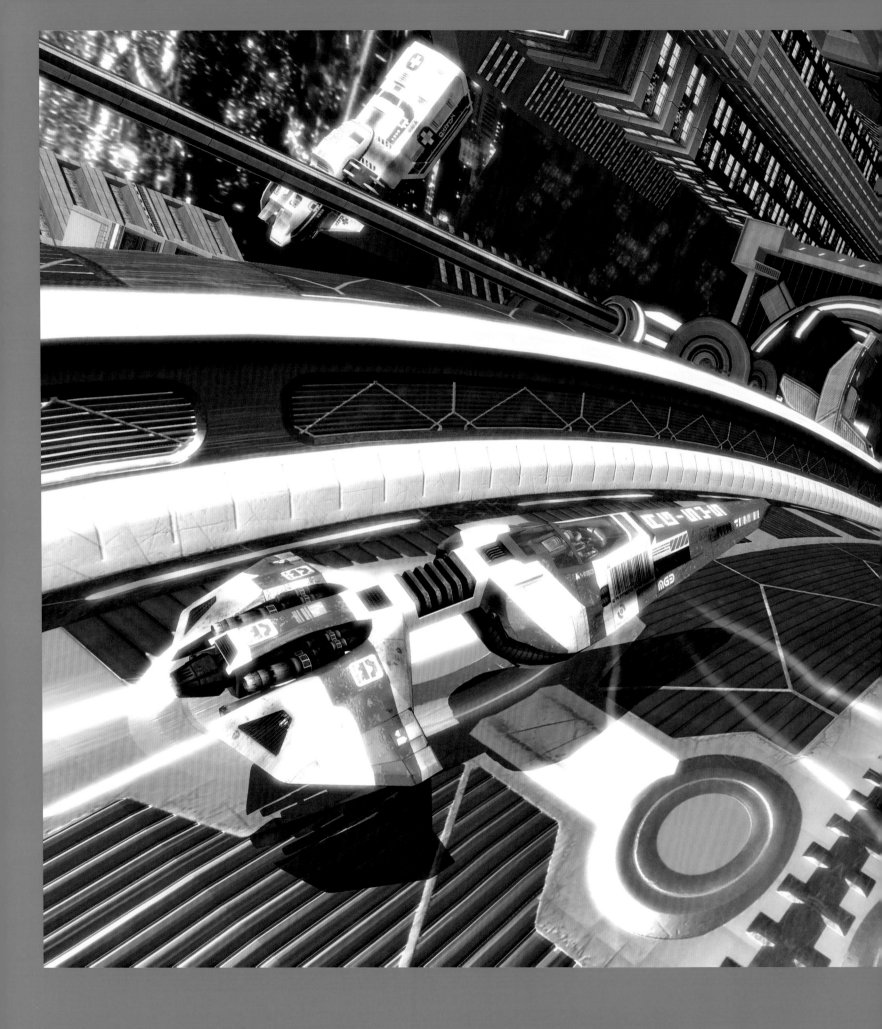

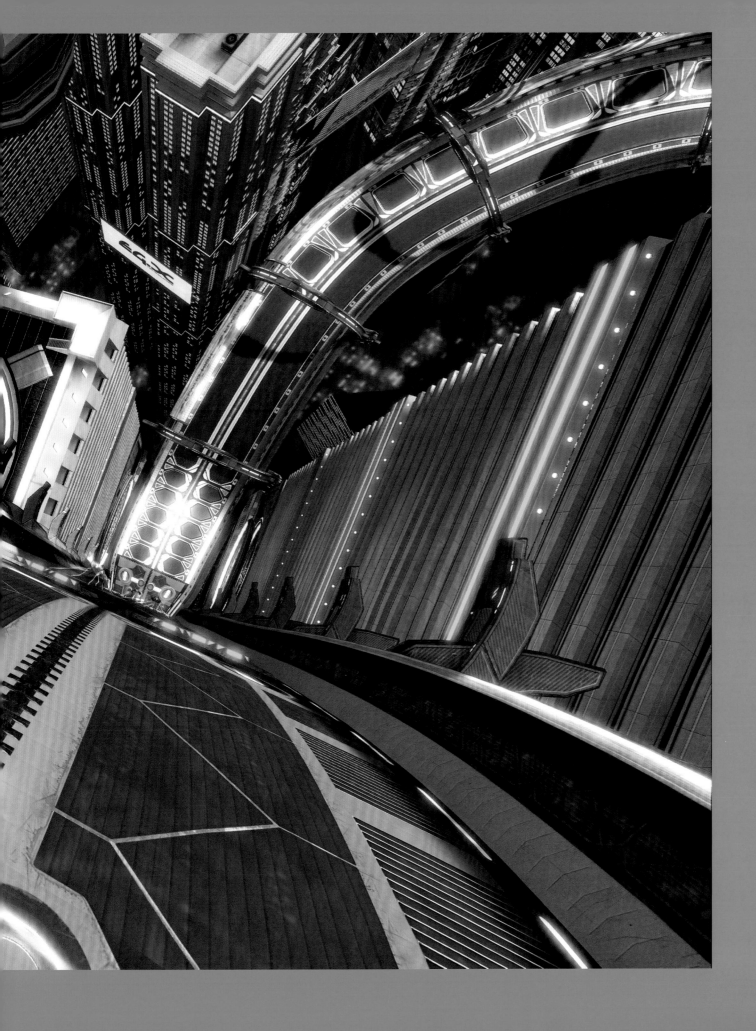

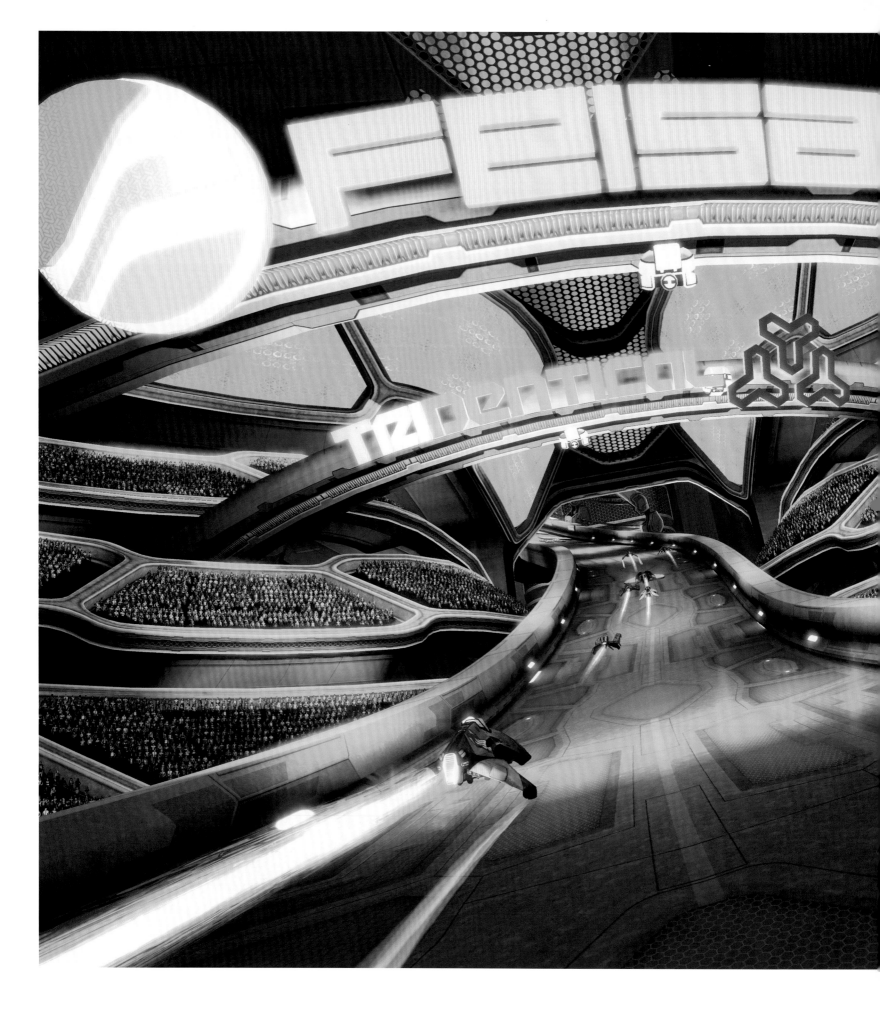

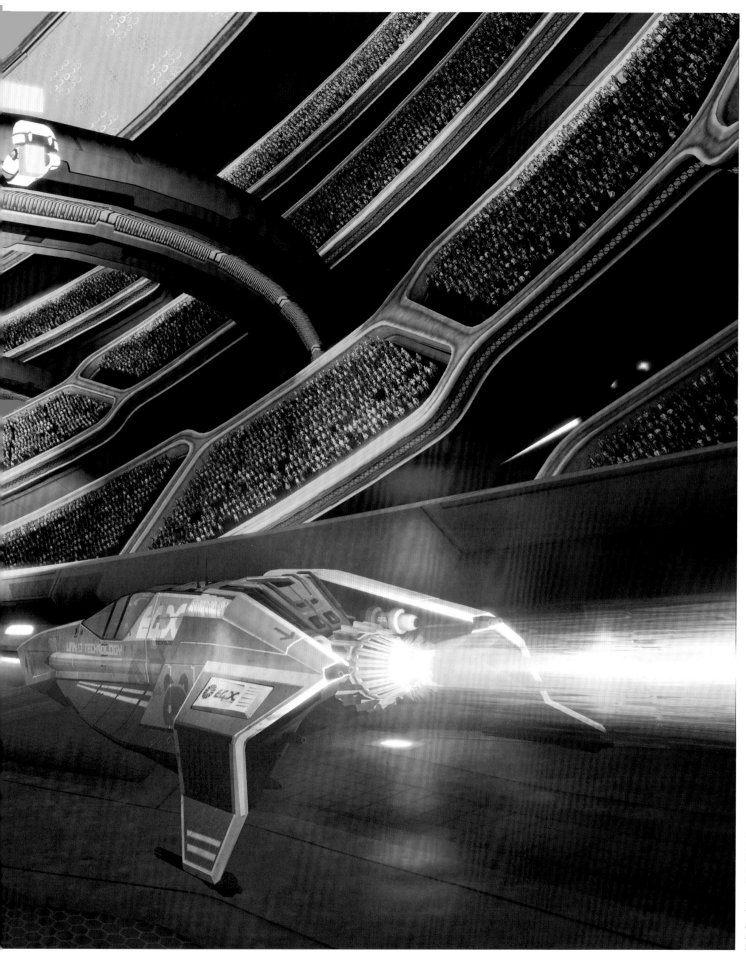

← ←
Metropia,
WipEout HD
(Studio
Liverpool, 2008)

←
The Amphiseum,
*WipEout HD:
Fury* (Studio
Liverpool, 2008)

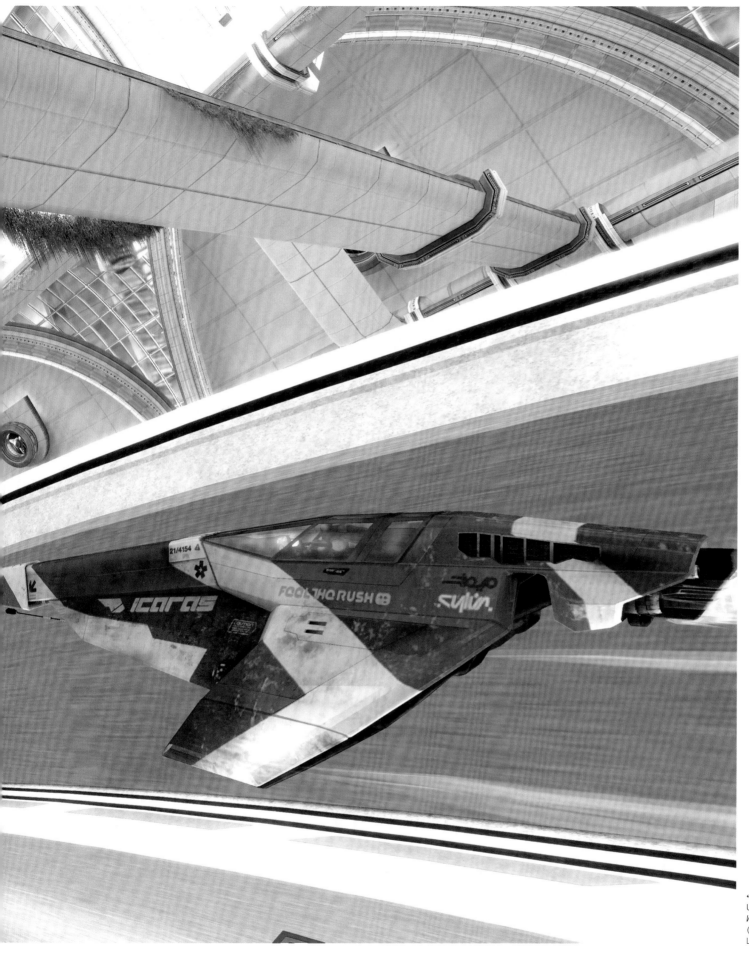

←
Ubermall,
WipEout HD
(Studio
Liverpool, 2008)

→
Zone mode
in *WipEout*
HD (Studio
Liverpool, 2008)

→ →
Zone mode
in *WipEout*
HD (Studio
Liverpool, 2008)

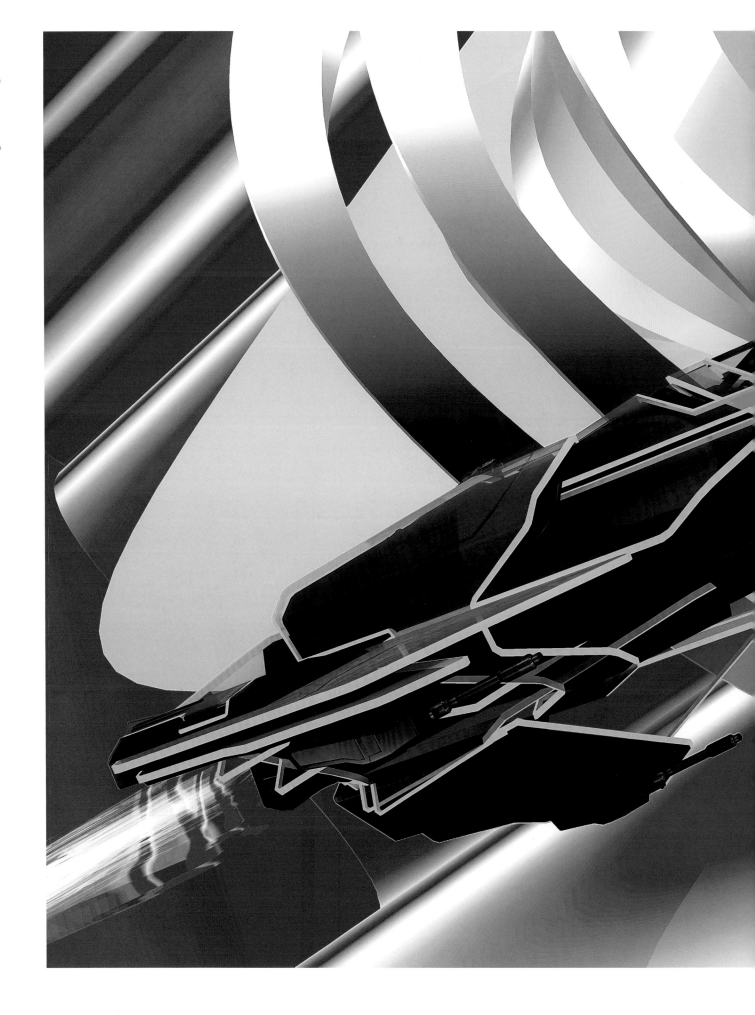

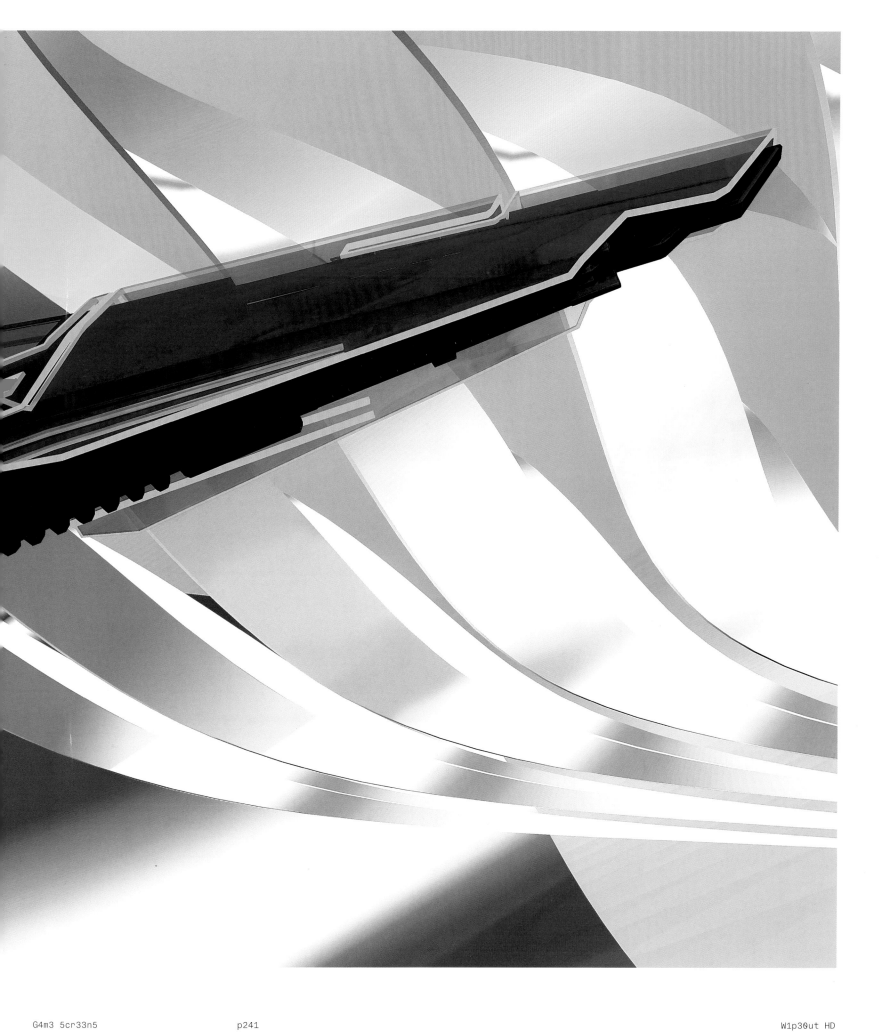

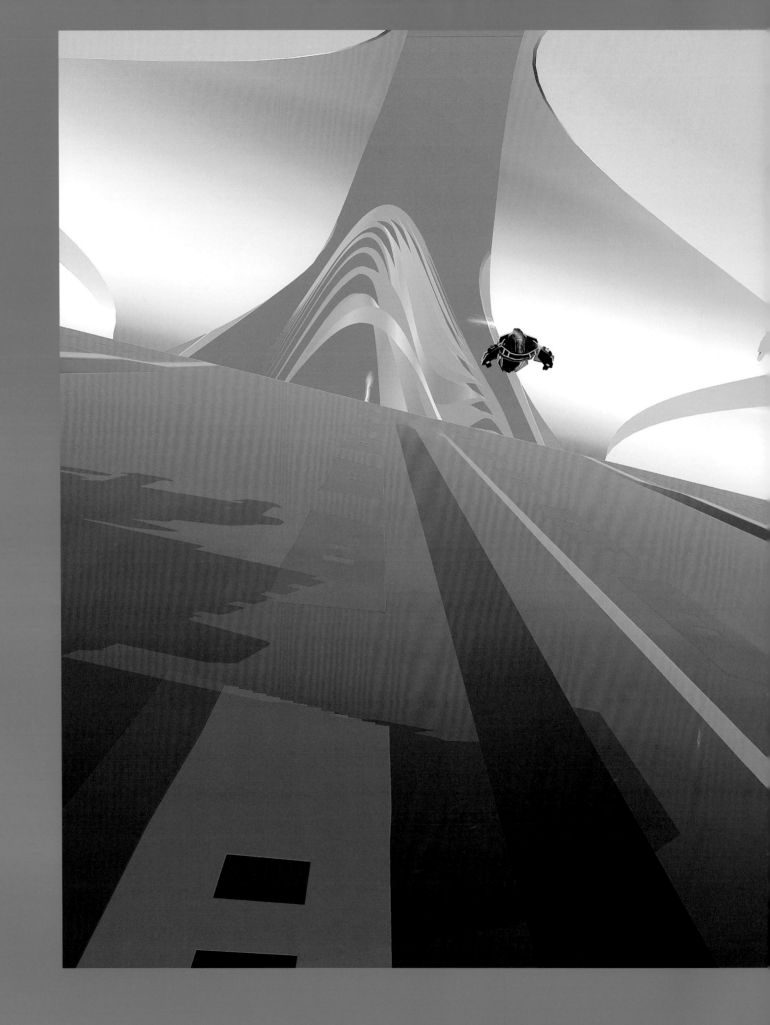

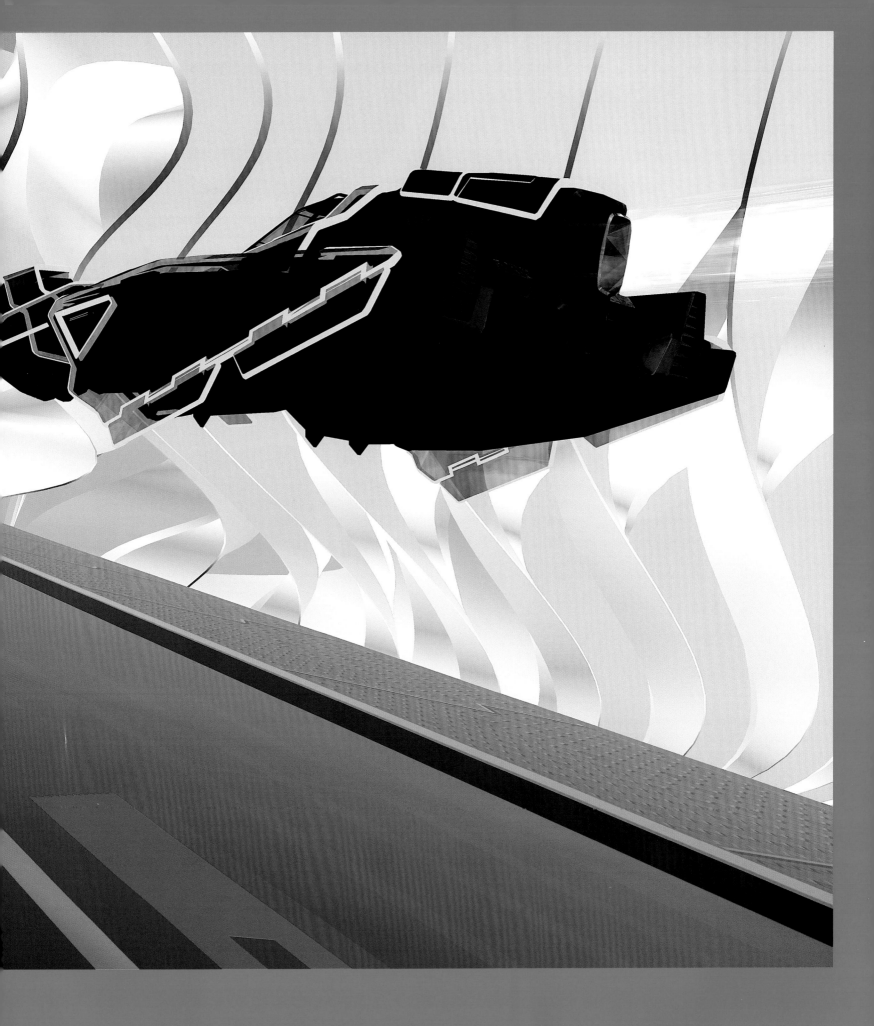

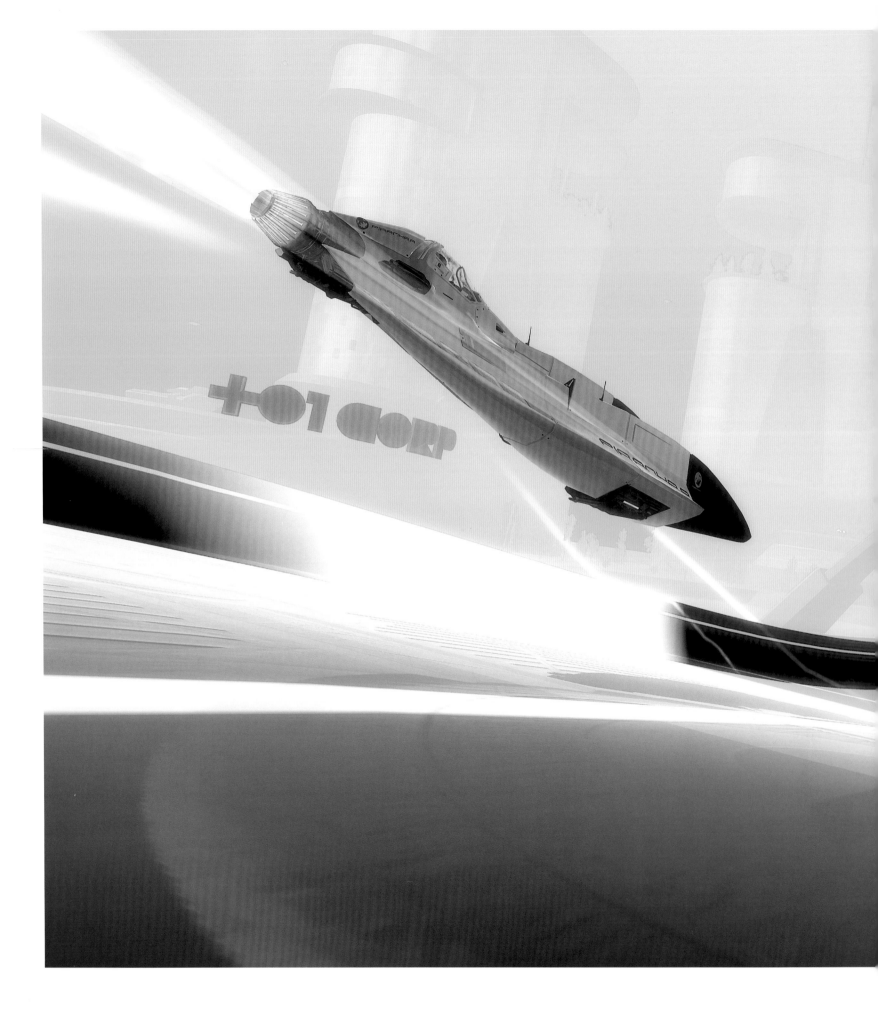

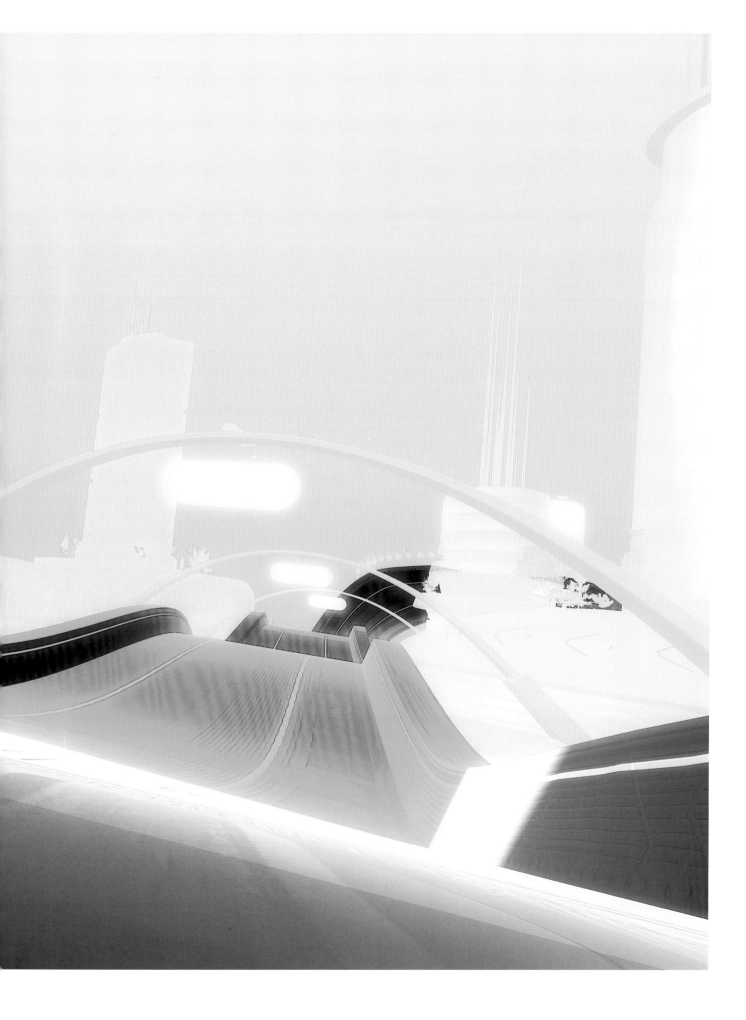

←
Zone mode
in *WipEout
HD* (Studio
Liverpool, 2008)

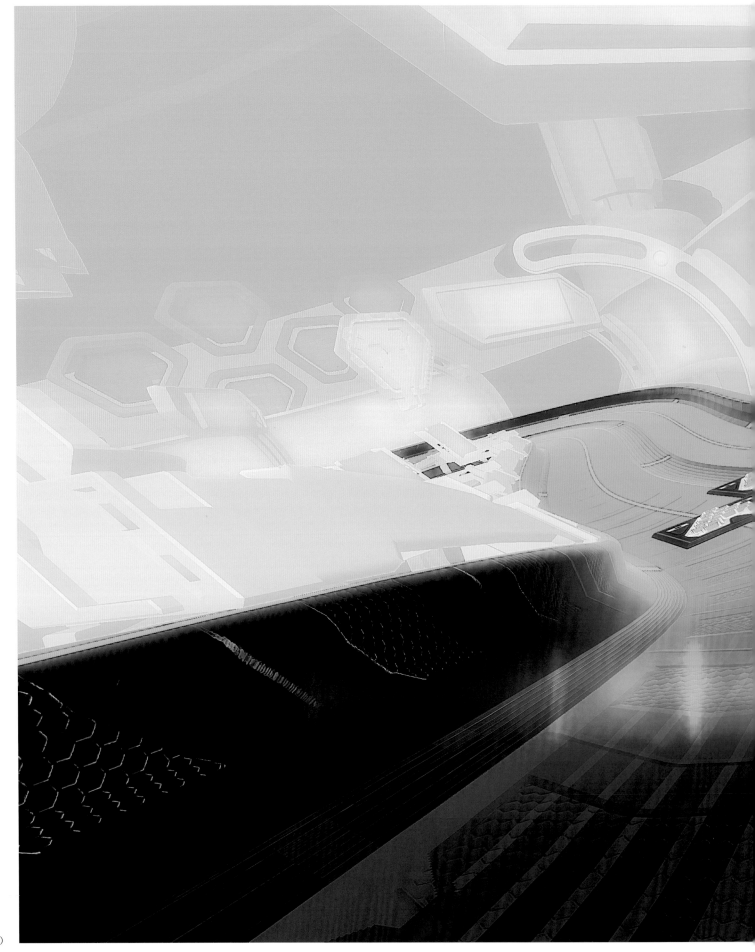

→
Zone mode
in *WipEout*
HD (Studio
Liverpool, 2008)

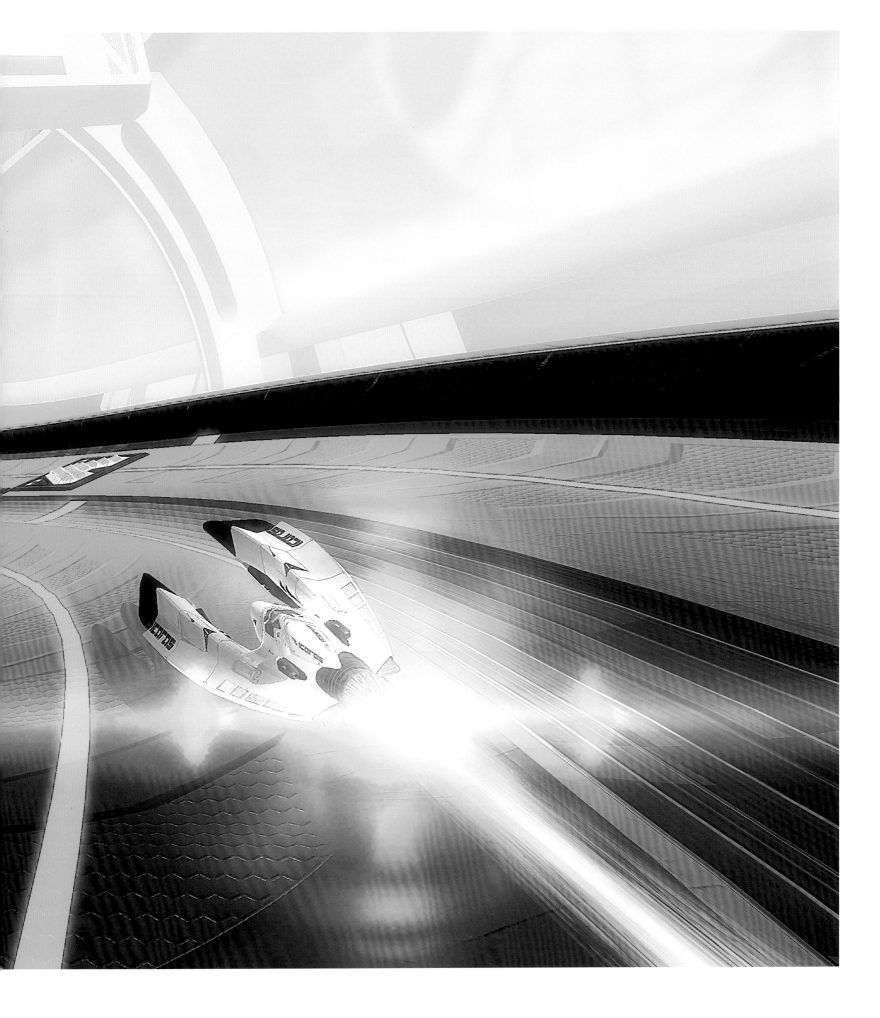

↓ 5tu4rt
T1ll3y:
N3w Y0rk T1m35

Though risky for a game with an aging niche audience, there was an obvious upside to WipEout's consistency in later years: it was consistently great. With prescience of PlayStation hardware and even greater knowledge of its game, Studio Liverpool rehabilitated itself post-*Fusion* as the go-to studio for dazzling console launch titles. Much comes down to process, as *WipEout 2048* director Stuart Tilley explains. →

I remember two things in particular from *WipEout 2048*: the desire to put some fresh content in, because obviously some of the other games had up-rezed previous designs. It was time to add some new playable content, new things to learn. The other was that there was a drive at the director level, above the studio if you like, to see if we could make it easier to get into, because it was always a hardcore game.

Building city streets and the like made the tracks that little bit tighter, so we adjusted the handling model accordingly. We were very much dependent on the flight model, as that and track design are very tightly related. You tend to develop them at the same time, and if the content is going to be different (compared to *HD* and *Fury* in this case) then you know it's going to be a lot more challenging.

We lock down the tracks quite early in development. The track designers place ribbons, essentially, to get the basic shapes. The handling model's pretty mature, so you can get a really good idea of whether they're going to work well, and how the difficulty level works.

● TR4CK R3C0RD
There were various things we'd put into each track. We had the concept of rhythm, where we'd mix up areas that felt more open with areas that felt tight and challenging. We'd lay it out and actually colour-coordinate those: 'This is the bit where you can take two deep breaths and go again, into a really technical section.' We even did that with the art, so there'd be an open section where you can see a vista, then we'd hit you with another seven or eight seconds of really tight, claustrophobic environment. It wasn't a one-note symphony, I suppose.

But yes, the actual driving surface is sorted relatively early, because that's when the art production happens. And it's all bespoke for each track, so you have to give the guys enough time to do a good job. I've got to say that it wasn't the most popular decision in the studio if you ever changed the tracks later on; normally you'd try and fix it in the handling model first. Like with the sidestep move: you know it's going to be in a certain section, but not how it's going to be finessed, or whether you'll have to do a bit of surgery. We weren't a mega-studio who could suddenly put three man-years into a modification, and that did hamper our ability to iterate.

The design guys were really smart, though. They had this concept of 'skillcuts',

and were upfront and confident about that, so a lot of the really challenging sections went in early. They were like: 'You know what, it might take you 100 attempts to get good at it, but if you're going for lap times or winning competitions then you need to get good. So keep practicing, you can do it.' Playing the tracks so much while making it, the guys got ridiculously good, to the extent where you wouldn't expect to touch the sides on any of the tracks on the fastest classes. So, we always felt we could get there, however frustrating things might get.

● URB4N15M
For art we had separate designers, with Daz [Douglas] doing mostly world art and ship design. It was a pretty slick operation because we had this understanding that the higher up you go, the more futuristic you get. We knew where each track would be set, and we'd take screenshots of the ribbons, which Daz would paint over and build around. If there was anything too noisy on the small Vita screen then we'd maybe take a raincheck and try to simplify some materials, but we generally tried not to. The idea is to let the creative people be as creative as possible – and Daz is a creative guy!

There was this concept for the tracks we call 'racification', which for the most part means sticking massive great arrows everywhere, so you can see where the corners are before you get there. Some of that you do with visual storytelling, where you corner buildings in a certain way to draw the eye, so a track actually looks like it's going to the left. Something like a little dip in the track can really throw the eye on the smaller screen, so we'd go through that. It was quite an elongated process, actually, because you think it's fine and then it's not, and you watch people crash and, yup, put big red arrows up.

● 5H4D0W W0RK
It's fine to do that iteration on the skybox and the buildings around the track, but the actual gameplay surfaces are the tricky bit. Same with the time of day and the lighting: where the shadows fall on the track. If you bake in some of those shadows then sometimes they can cover where your turning point should be into a corner, so that's really annoying. But it's part of the process. The light bakes took forever as well; one of those things where you set it going before the weekend and hope it's okay on the Monday.

Knowing you can rely on a studio to get a high-quality launch title adds a lot of value if you're thinking two-and-a-half years out from releasing a piece of hardware. What happens is that teams get involved in what the hardware and controllers may or may not be able to do, so we knew early on there'd be two joysticks on PlayStation Vita, stuff like that. The rear touchpad came in relatively late, though, so you just have to keep an open mind and then work towards those things.

To be honest, we always went after new things like that – 3DTV, PSN, etc. – to be the guys who do it all on day one. It's a mindset thing: you don't know what the hardware's going to be, but you figure out and learn. You start doing graphics way before you know the graphical power of the device, which was fascinating. It adds a layer of complexity to the project, which may go some way to say why the game has stayed so pure; it's not just about getting there, but getting there and being brilliant.

■ Stuart Tilley is the co-founder and game director of Liverpool-based PlayStation studio Firesprite. He has worked in the industry for over 20 years.

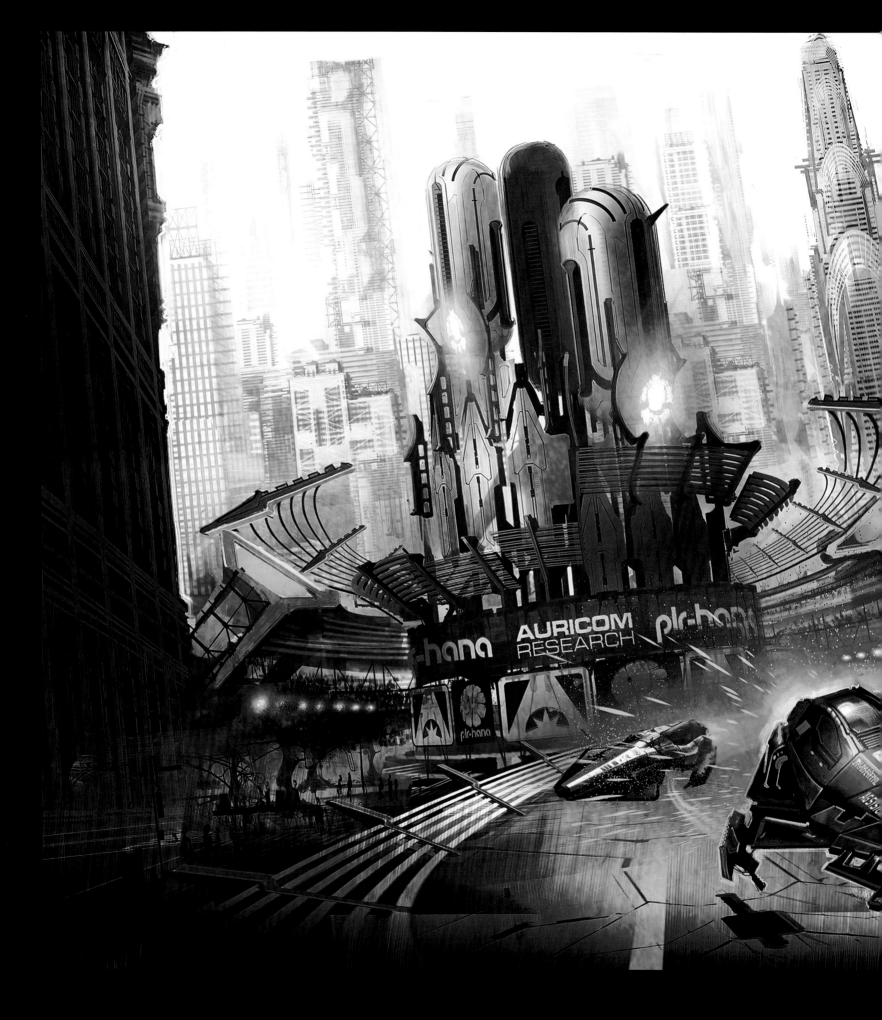

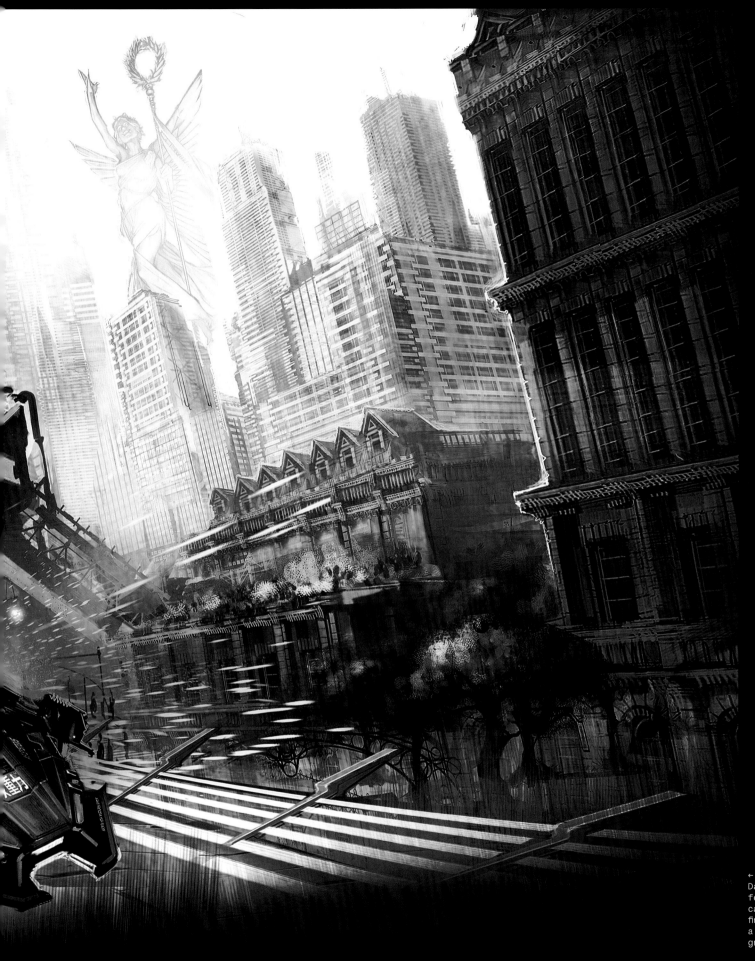

← →→
Darren Douglas'
fetish for
carnival minutiae
finally finds
a home in
grounded 2048

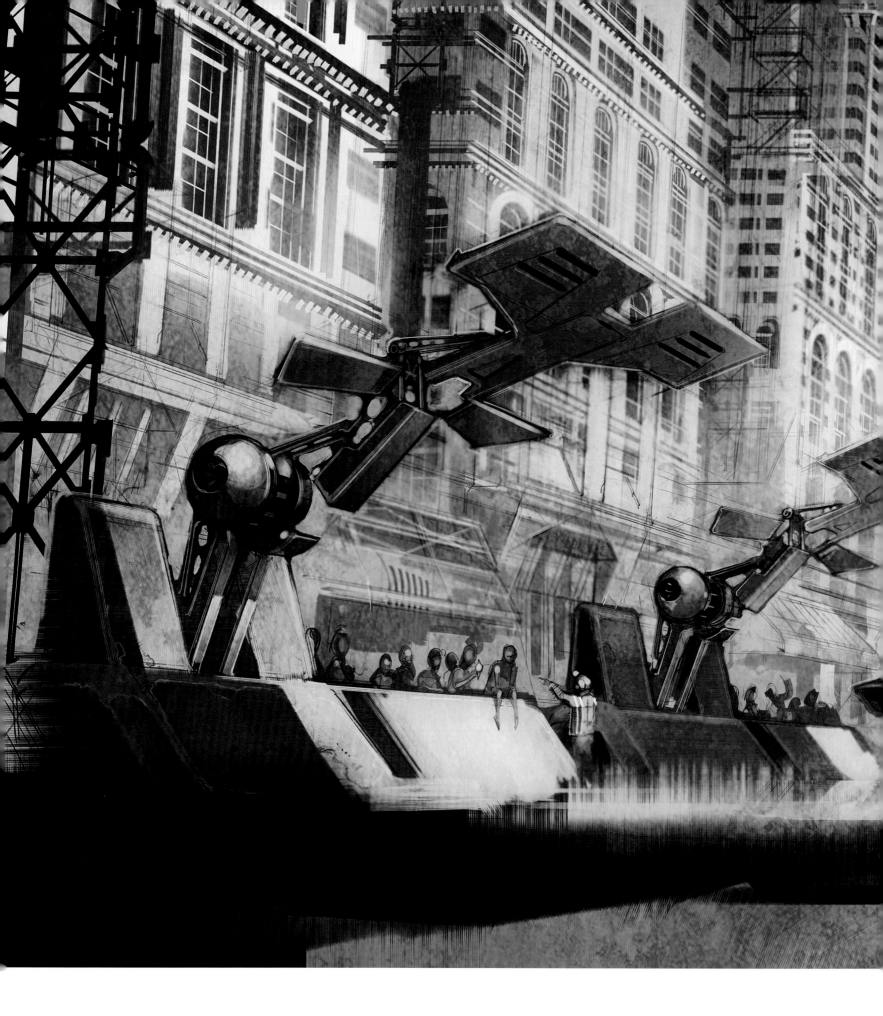

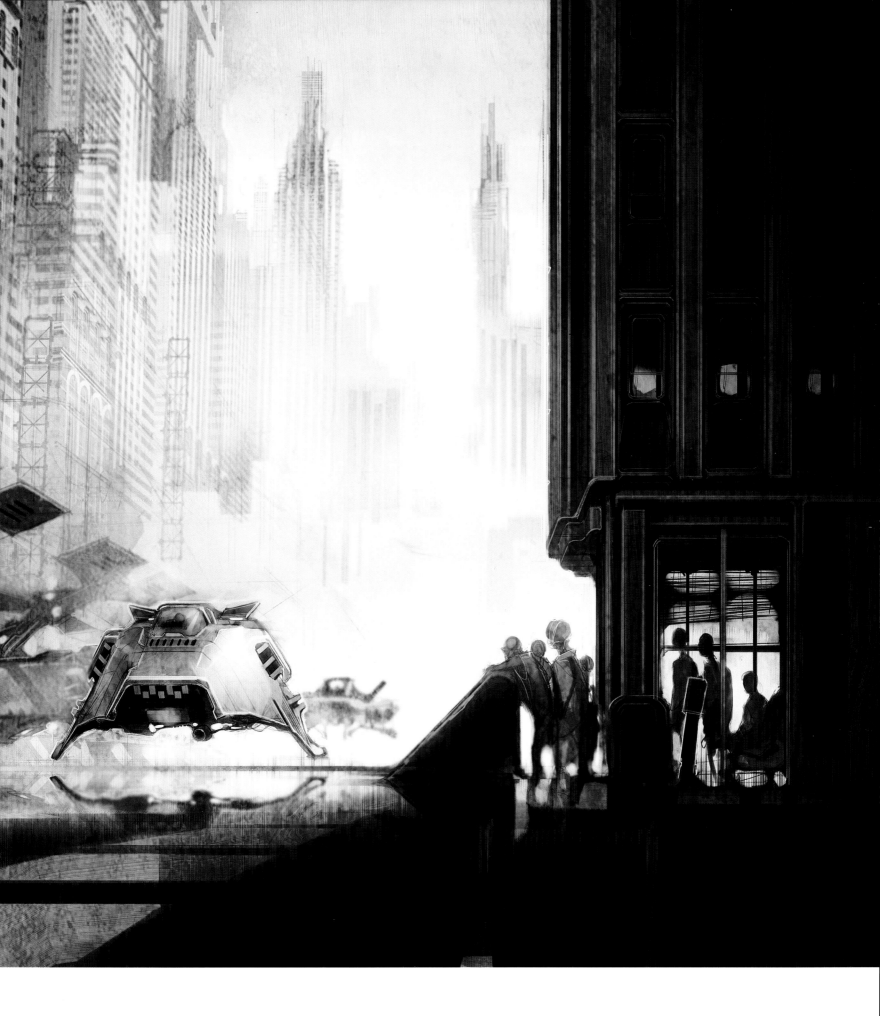

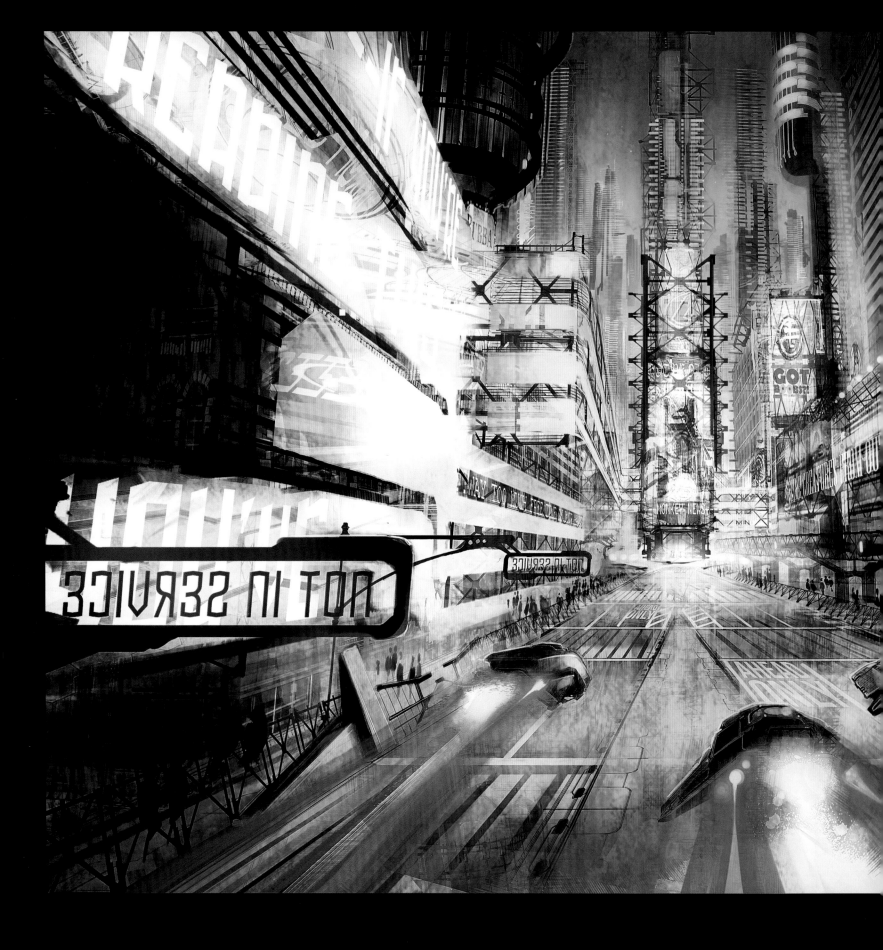

↑
Spiritual
successors to
WipEout 2097's
Lucky Cat

←←
Times Square
is a-changin'
in 2048's neo-
New York

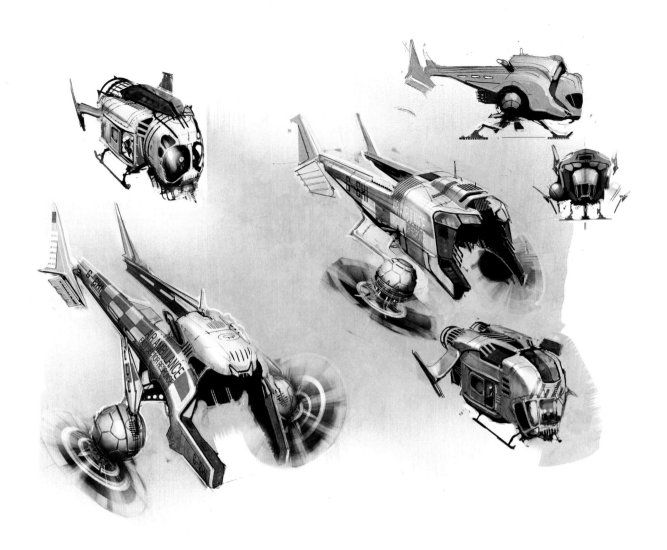

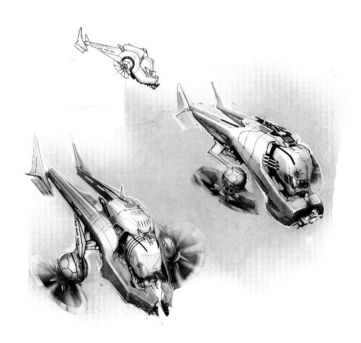

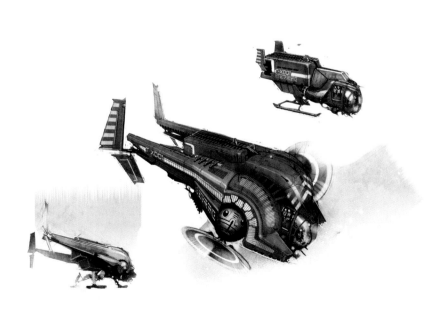

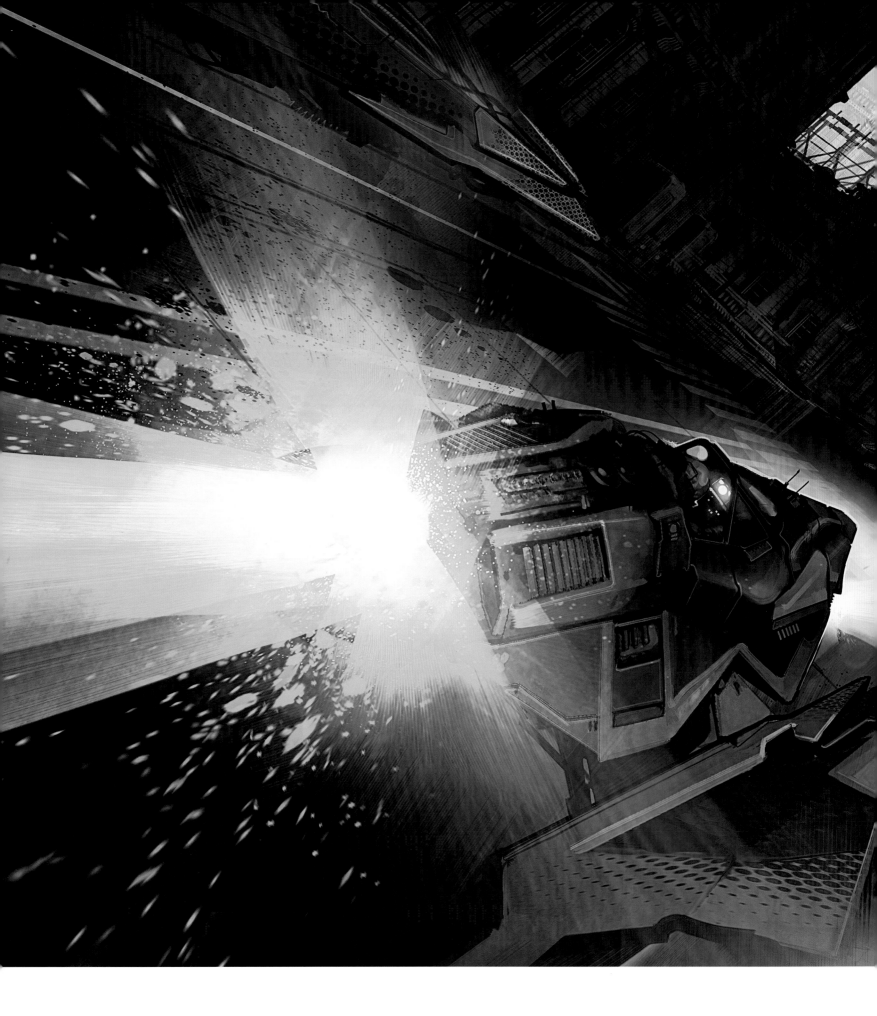

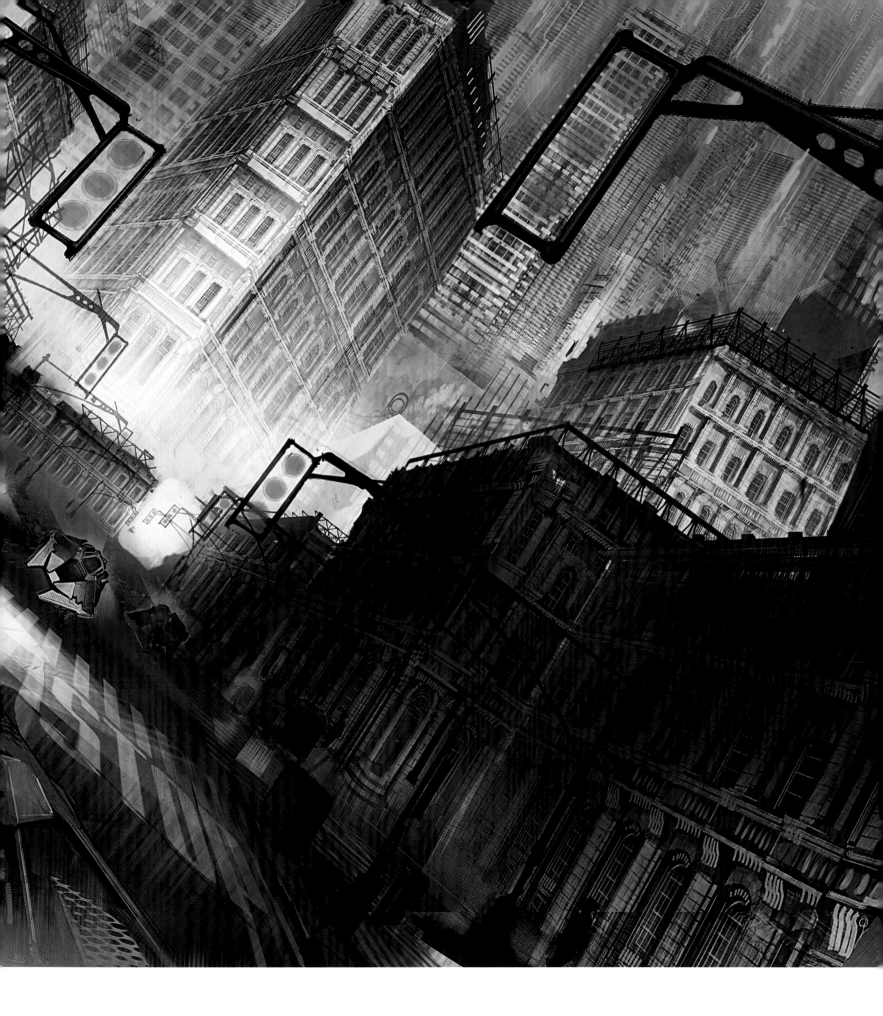

←←
A concept for a
tongue-in-cheek
2048 mode where
the player takes
out 'zombie'
ships with a
cannon, which was
unfortunately
dropped due to
time constraints

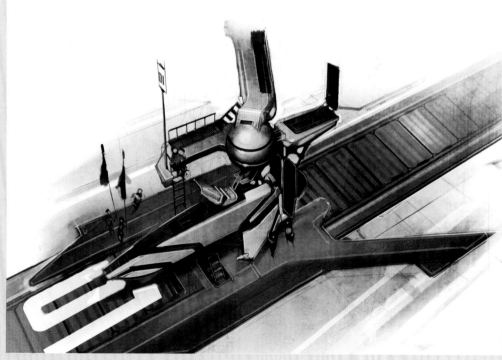

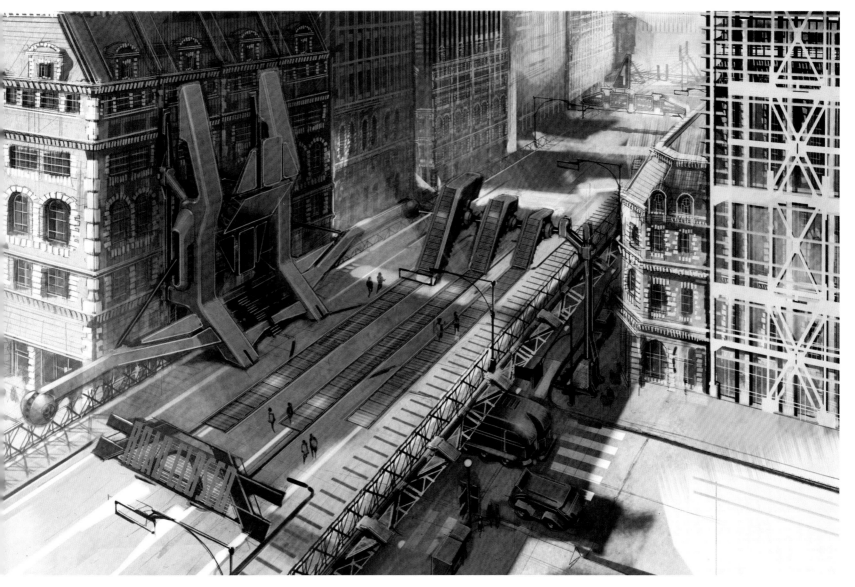

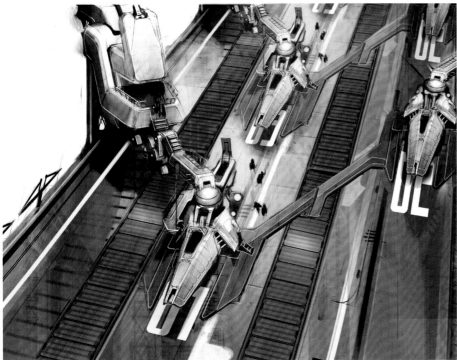

← ↖
New York's
elevated railway
inspired the
placement of
2048's track,
giving it
a relatable
human scale

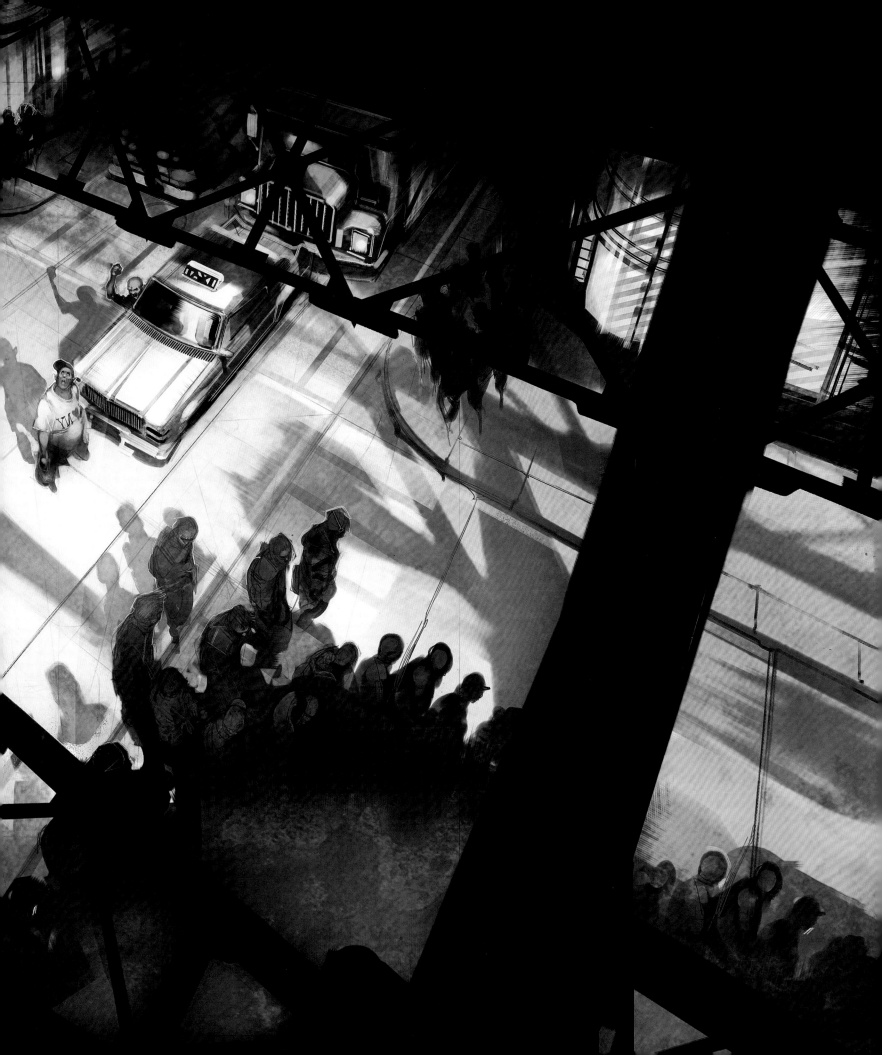

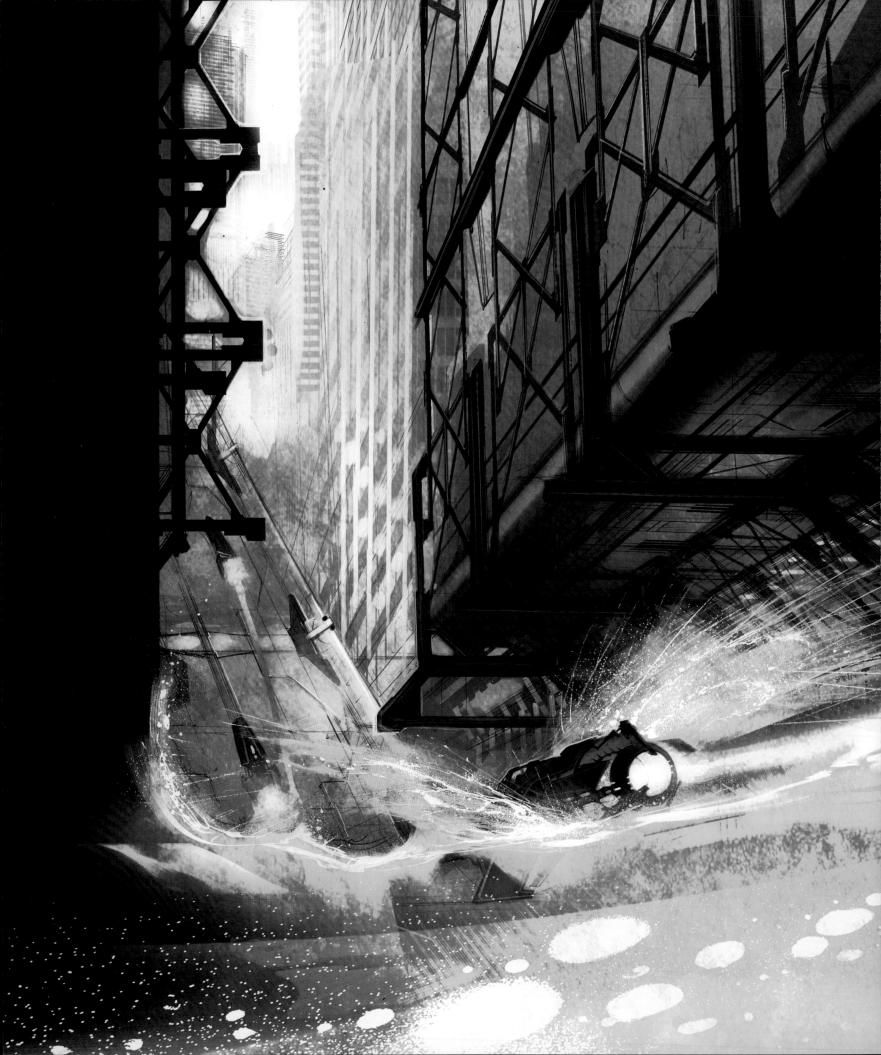

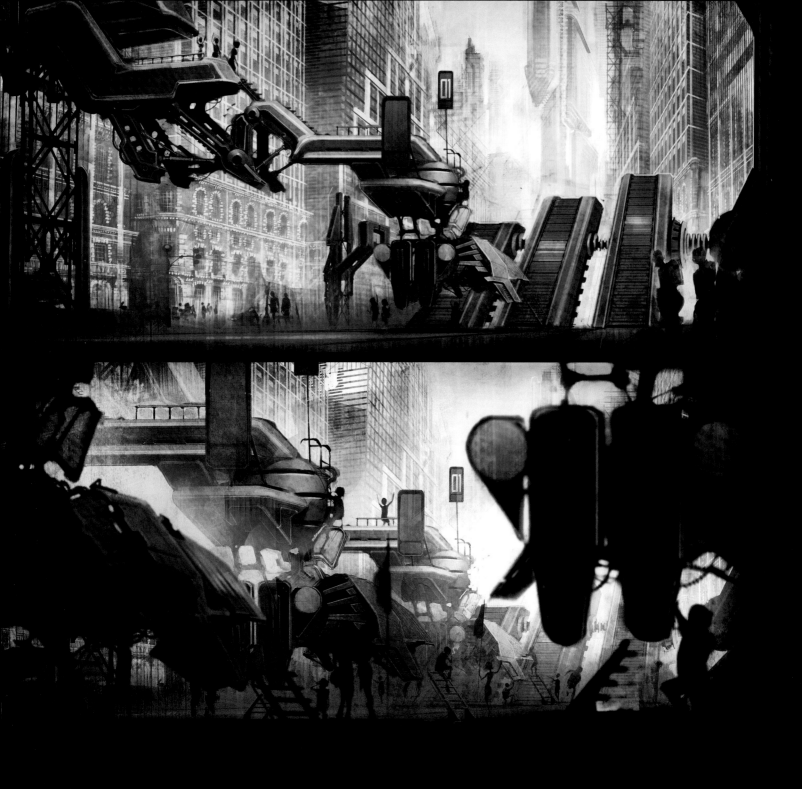

→
Darren Douglas'
riff on 1932
photo 'Lunch atop
a Skyscraper'.
'Note that
one of them is
missing; the guy
pointing out the
ship just lost a
poker buddy.'

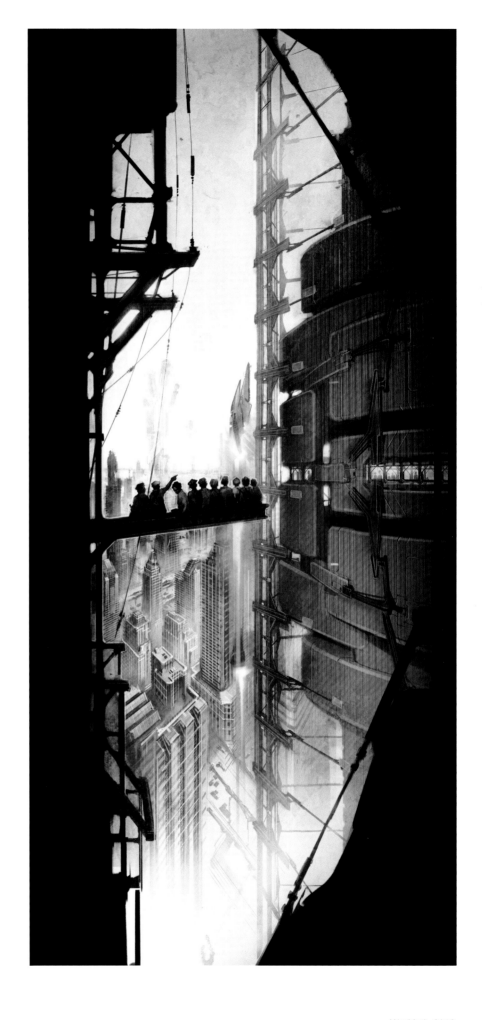

Artist Rita
Linsley brings
the organic lines
of Zone mode to
this street art

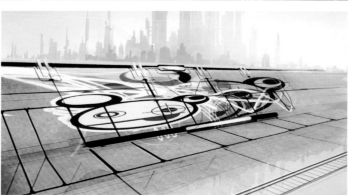

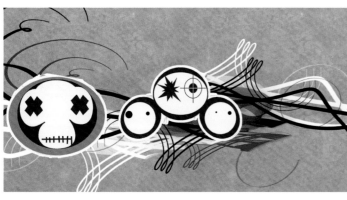

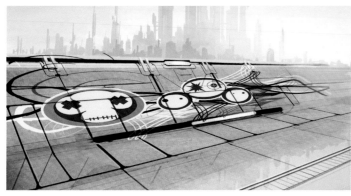

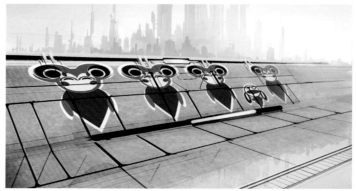

↓ ↘ →
More trackside
shenanigans,
this time from
artist Paul Bar
Naylor

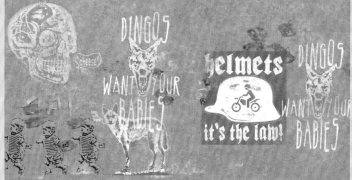
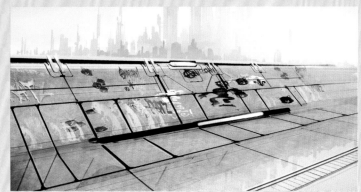

→→
A concept for
'Rollout' sees
wheeled racers
drive 'wherever
they want,'
recalls Darren
Douglas. 'The
bizzies don't
like it!'

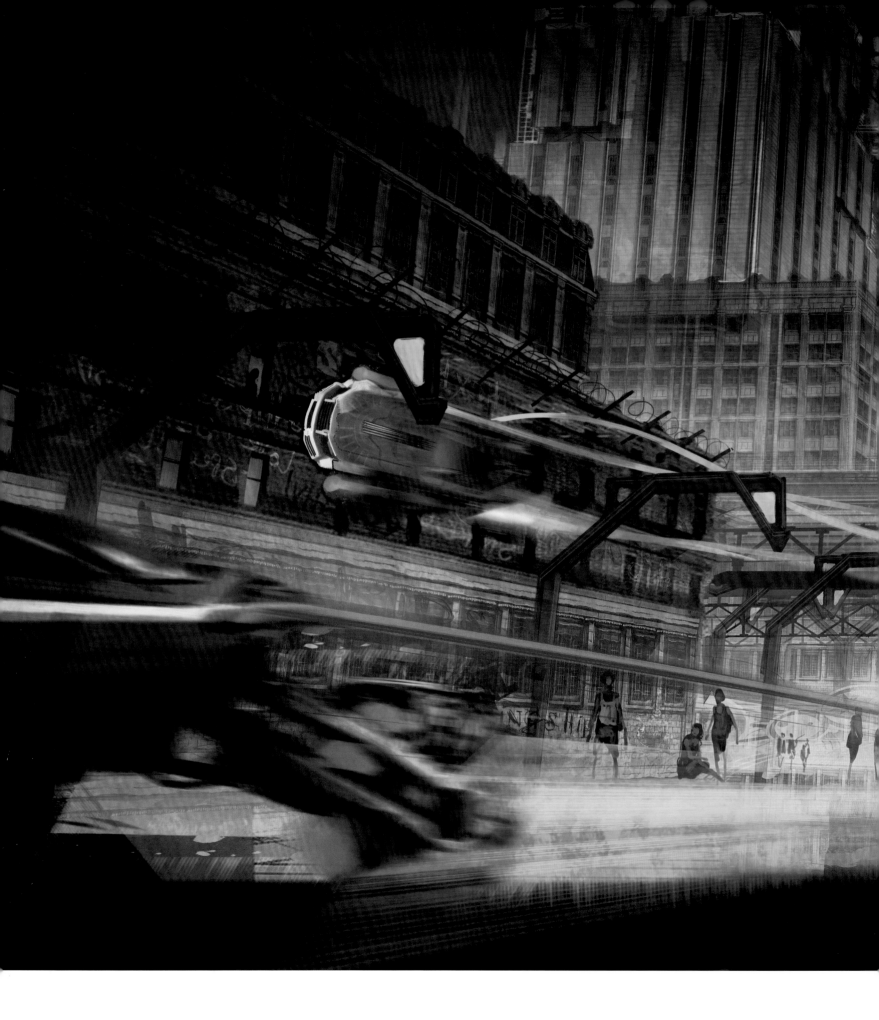

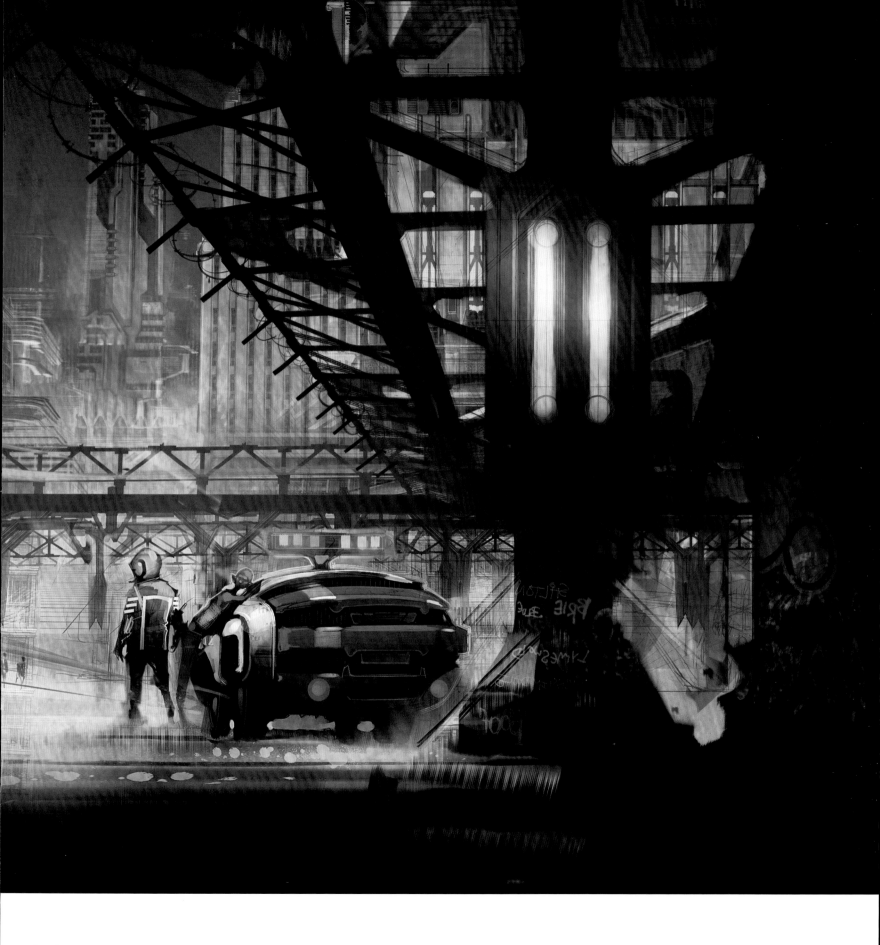

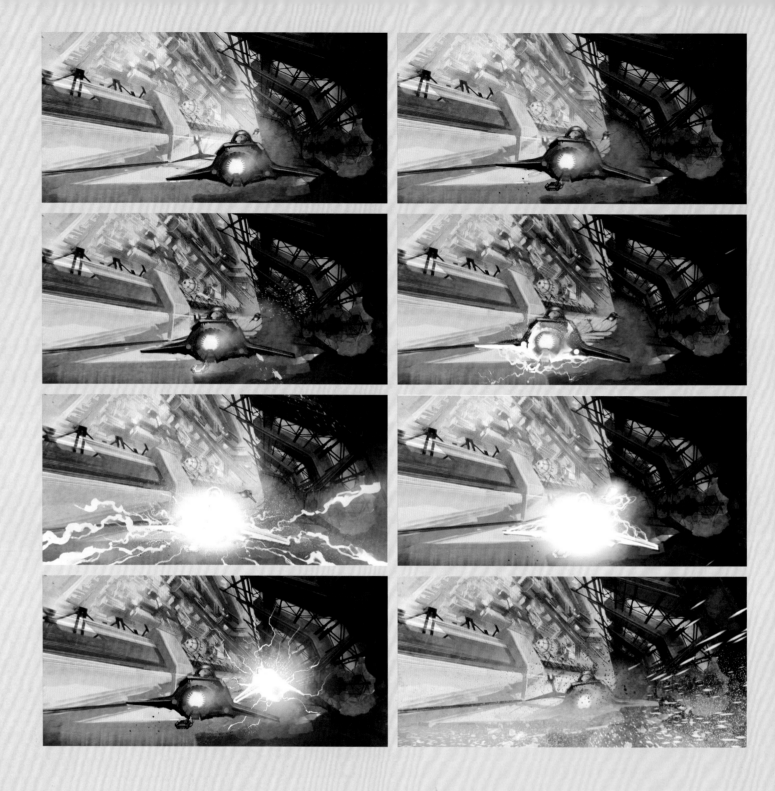

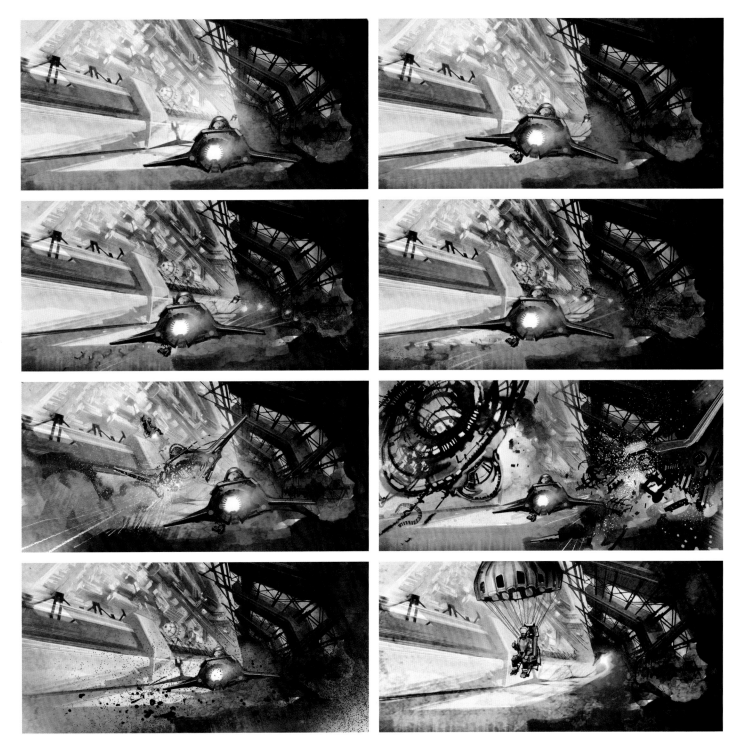

→
Darren Douglas:
'Rita Linsley,
who provided the
graffiti designs,
generously
described the
lads as "free
spirits". I
called the
image "Yobs".'

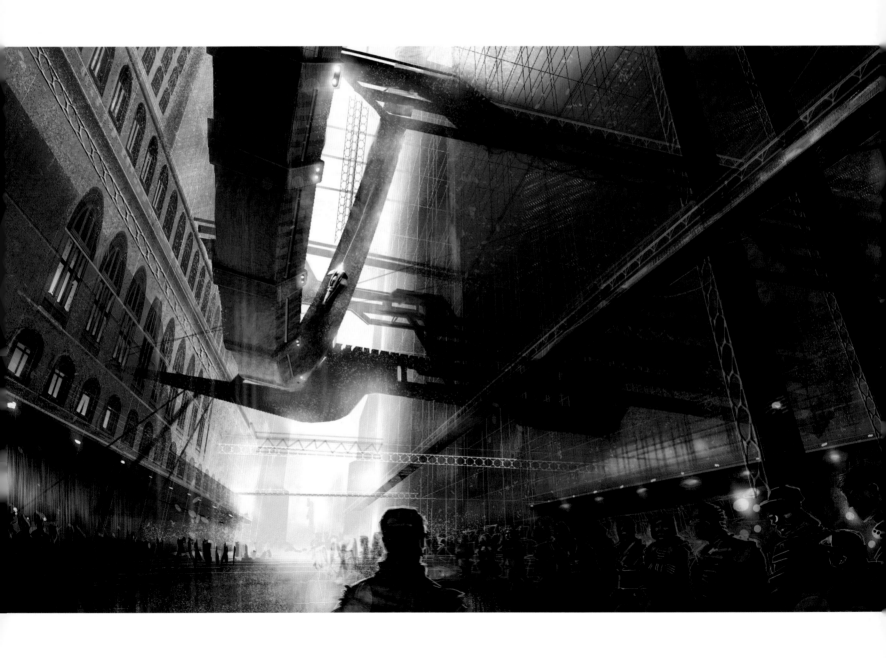

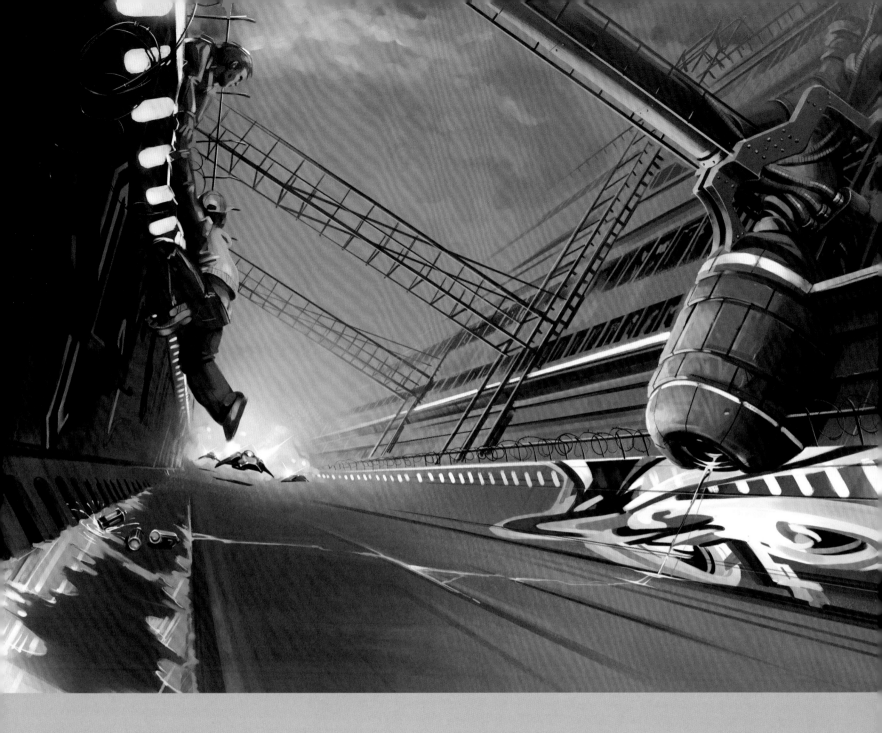

←

Shades of Mega-
City One come as
little surprise:
Douglas' first
cover for
2000AD came the
following year,
in 2013

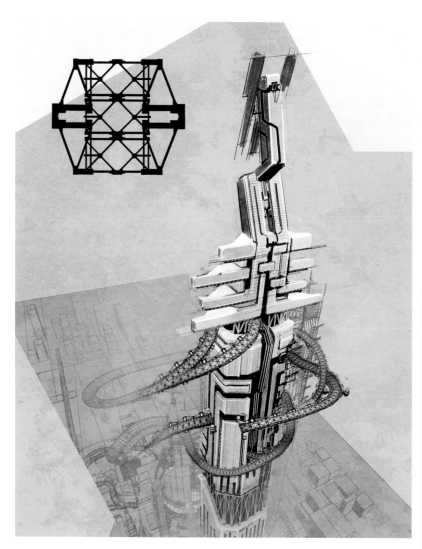

← ↙ ↓
Concepts
for *WipEout
2048* (Studio
Liverpool, 2012)
track Sol, the
predecessor
of *WipEout
Pure* (Studio
Liverpool, 2005)
track Sol 2

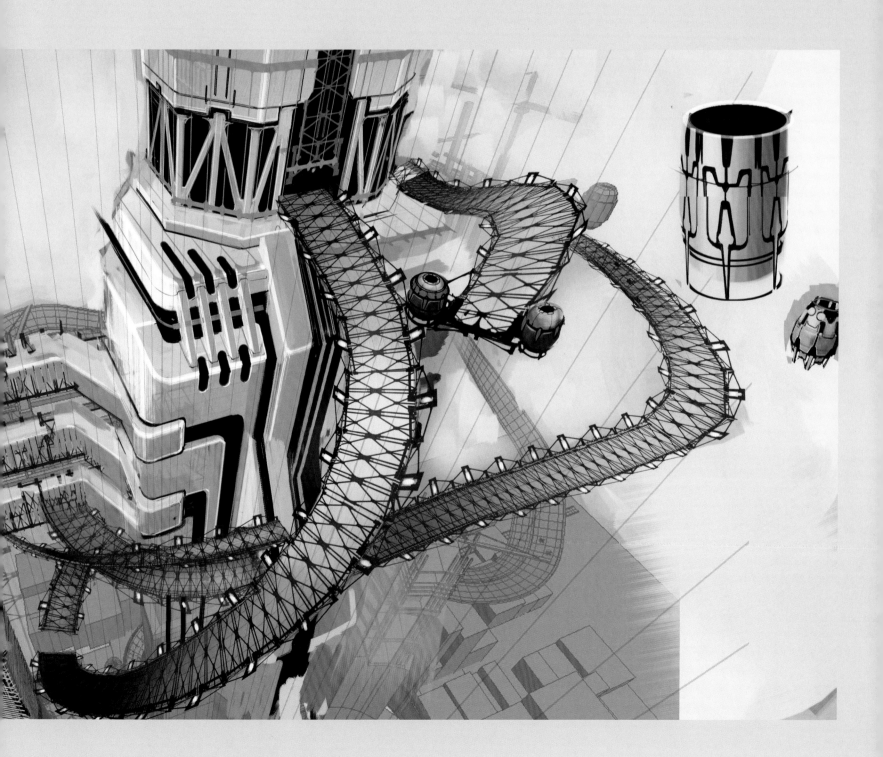

←
The open-world
WipEout for
PlayStation
Vita, abandoned
during early
development

→
The open-world
WipEout for
PlayStation
Vita, abandoned
during early
development

←
Racers in the
open world would
be rewarded for
buzzing traffic

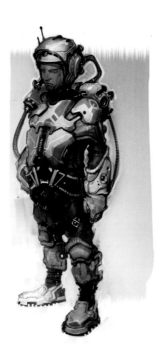
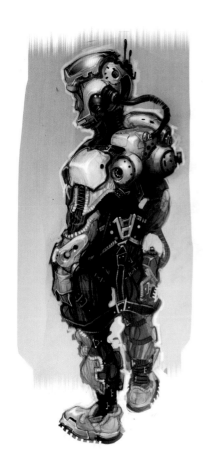
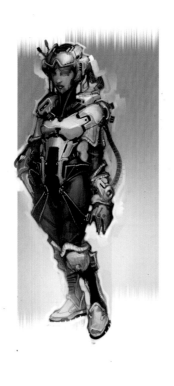
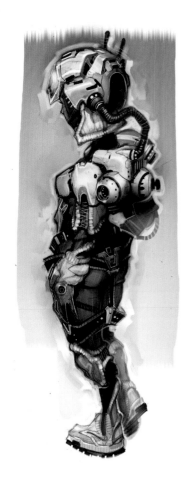

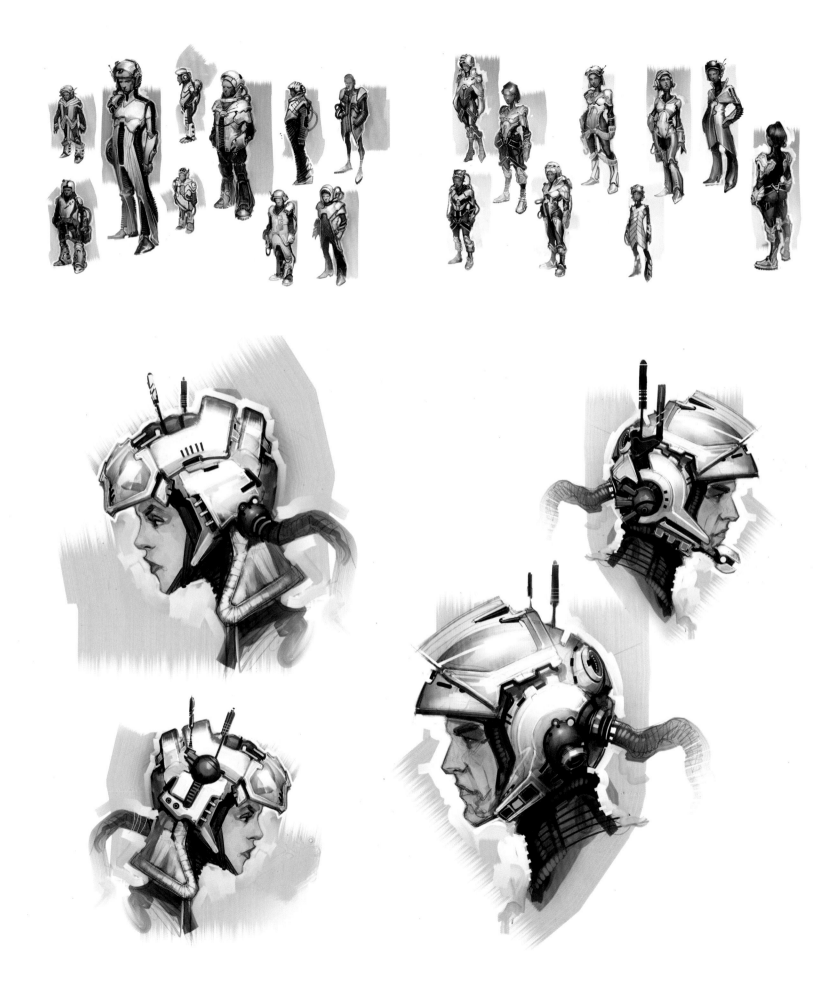

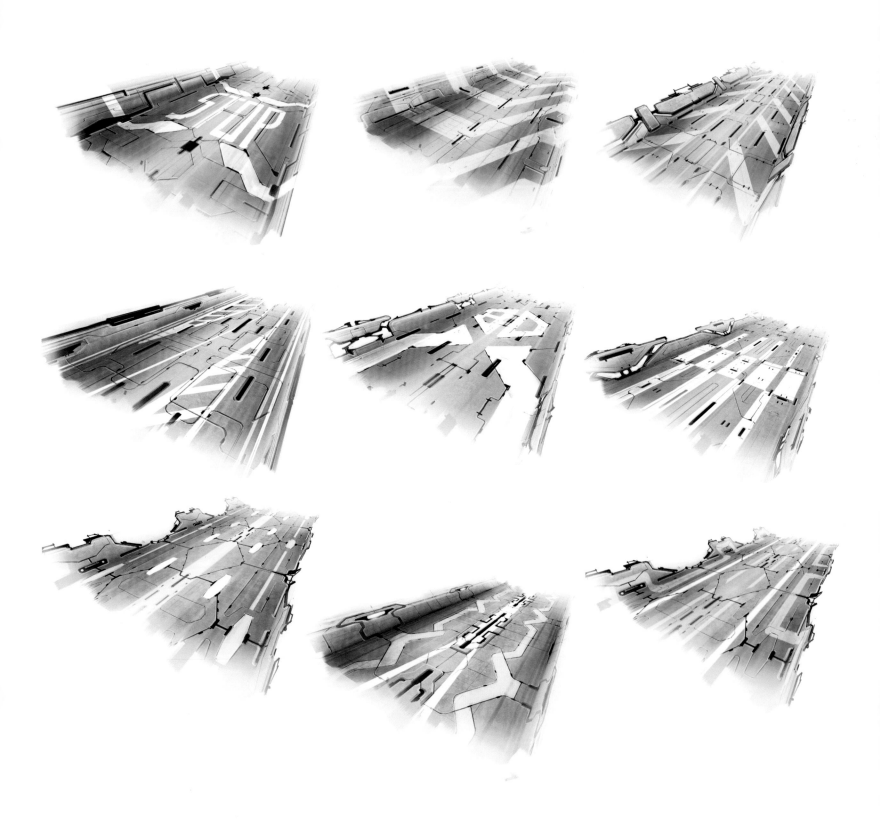

↓ ↘ →
Ground-level
and suspended
raceway concepts
for *WipEout
2048* (Studio
Liverpool, 2012)

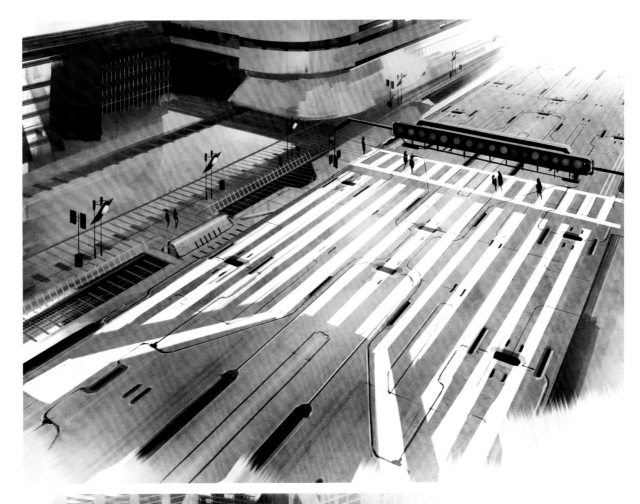

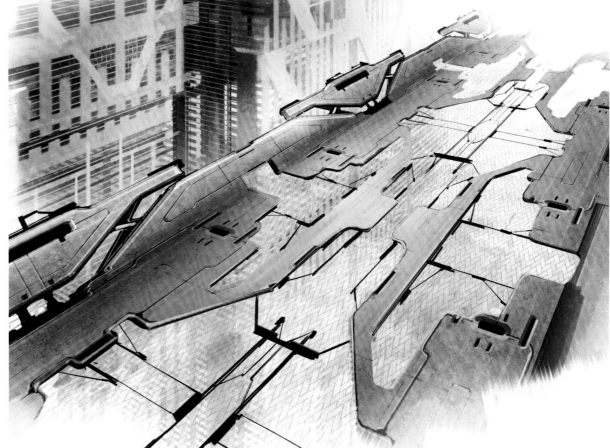

↓
Another WipEout
experiment called
for illegal
street racers
dodging traffic
and freight...

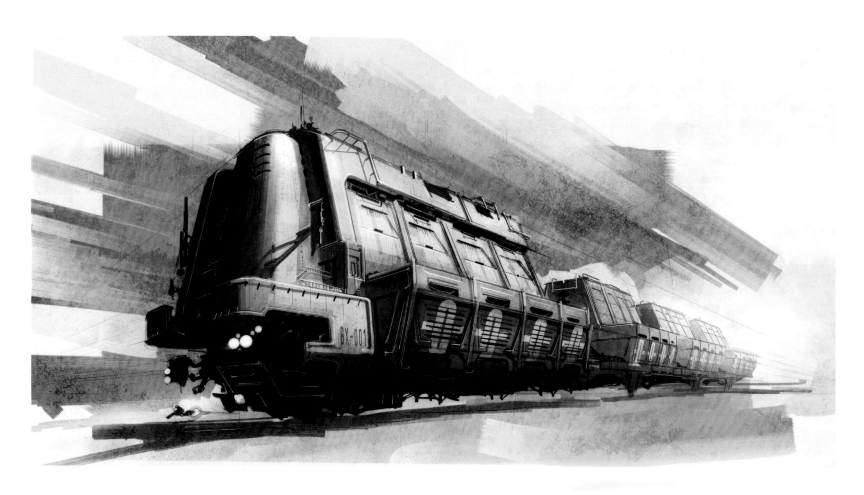

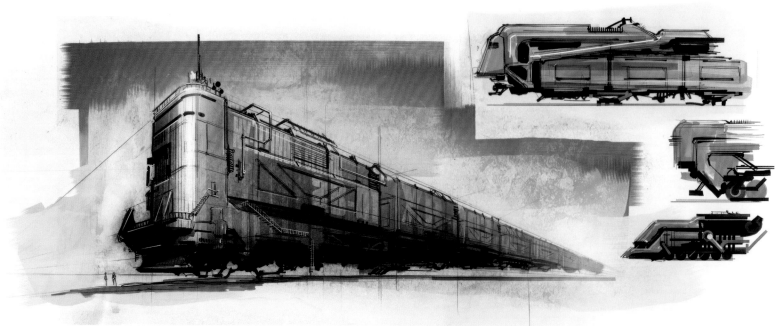

...riding bikes
drawn by Darren
Douglas in 2008

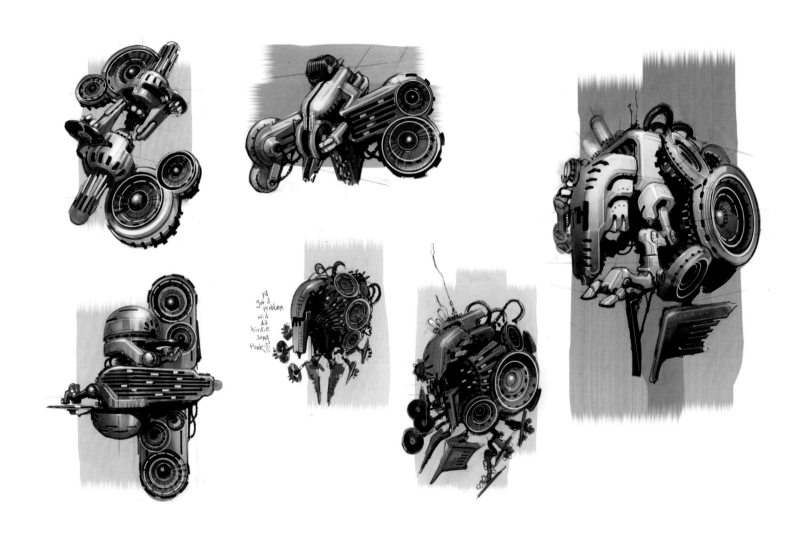

y'd got a problem wid da birdie song punk?!

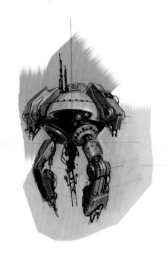

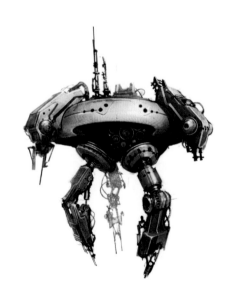

↑ ↗ →
A robot DJ by
Darren Douglas

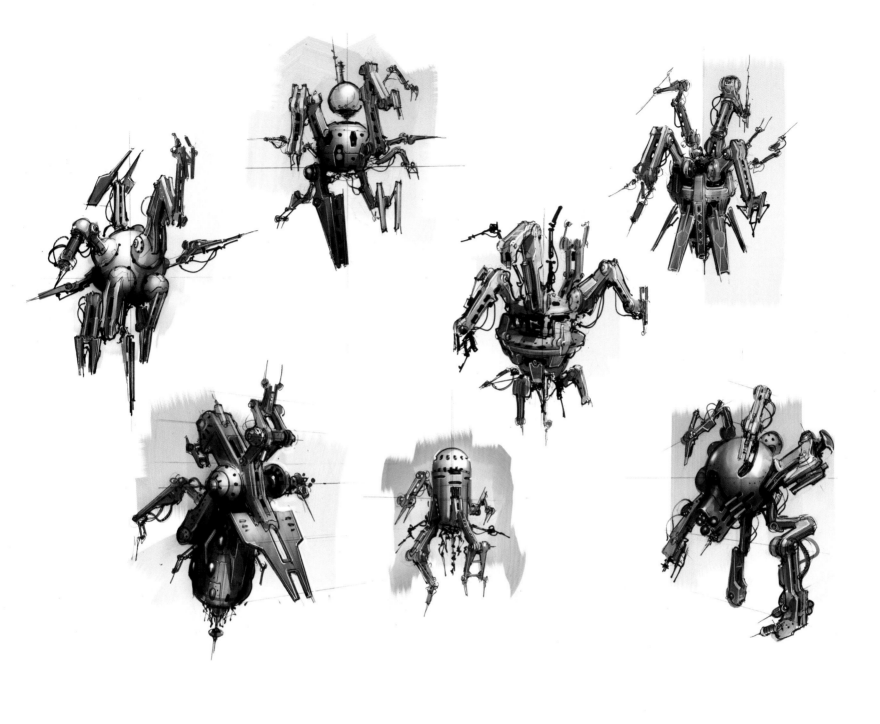

↑ ↗
Repair droids by
Darren Douglas

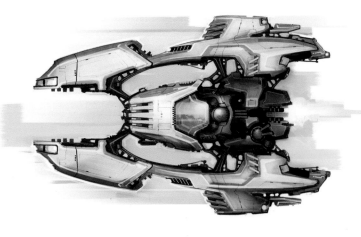
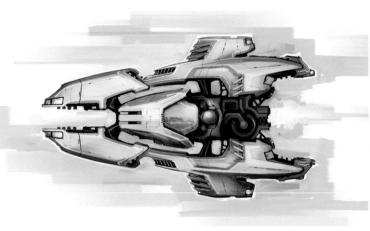
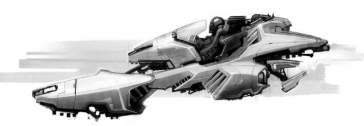
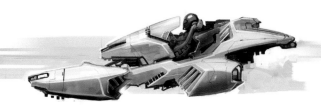
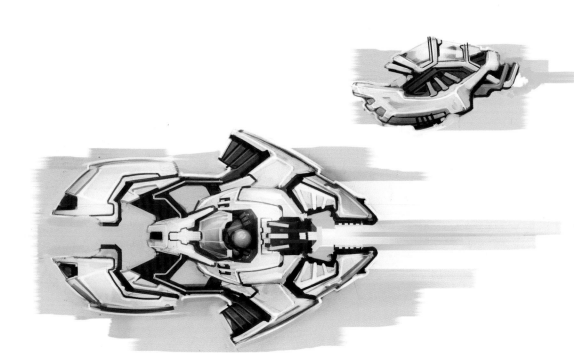

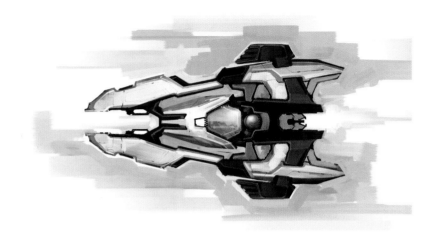

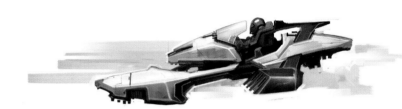

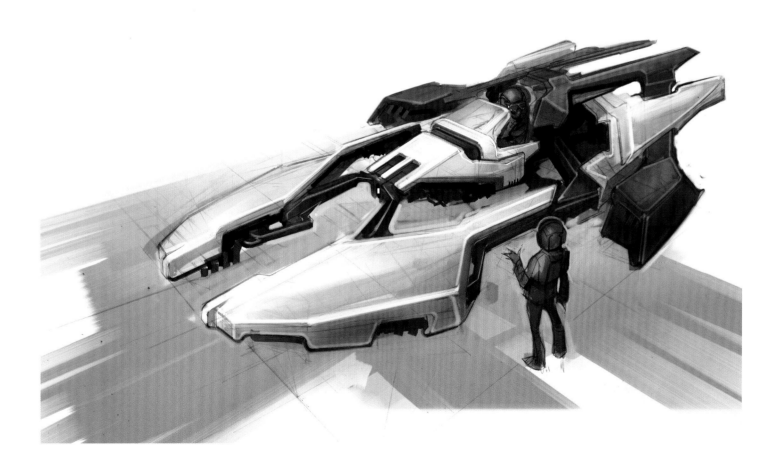

→ Dunc4n
5m1th:
Tr4ck 5u1t

Mixing work in a record store with a residency at a London nightclub, Duncan Smith discovered *WipEout* during his lunch breaks — and it left a big impression. Now head of music for Sony Interactive Entertainment Europe, he assembled the soundtrack for 2017's *WipEout Omega Collection*, which, with its 28 licensed tracks, far outweighs the mere three of the first game. The shadows of 'Afro Left', 'Chemical Beats' and 'P.E.T.R.O.L.' loom large, though, which leads to a dilemma when making a 'greatest hits' game. How do you pay tribute to a game that copied no one? →

It's interesting. I'm a fan of the franchise, and I'm aware of how iconic it was. That's a daunting responsibility. My mind was blown by the art and music of *WipEout*; you just didn't hear those artists and that kind of music on daytime radio or in any other type of media. The guys at Psygnosis would go out clubbing, hear a tune, get back to the office and figure out how to license it – because that was a long time before music supervisors like myself were around. The game was driven by instinct, not committee, which is why it sounded so different.

● D15C0V3RY PH453

When I was DJing, I turned up one week and they'd installed a load of those standalone PlayStation cabinets around the bar and chillout areas of the club. Halfway through my set I looked up and there was Richard D. James of Aphex Twin, deeply into his game of *WipEout* with his back to the dancefloor. You simply can't buy that kind of endorsement nowadays.

We had a choice with *WipEout Omega Collection* of whether to license music people already knew from the earlier games, or go for new, contemporary artists and have a fresh soundtrack. We went with the latter because I felt it was within the philosophy of the game; The Chemical Brothers and Leftfield were breaking back then, and it wouldn't be in keeping with that ethos to go and license those tracks again. But, at the same time, I wanted tracks that shared some of that DNA: a sense of rave, of breaks, some drum 'n' bass and techno.

As a music supervisor I'm responsible for the music that's in the games, as well as some ads and promo videos around them. It's up to me to work closely with the producer, audio director or whoever the key stakeholder is in terms of music. Some directors have a very clear idea of what music they want, and maybe even what artists or composers. Others will leave that up to me. But it's always collaborative. I then go out and use my knowledge of music, and my contacts in the industry, to find that music, speak to artist management and labels, and get them excited about the project.

We had some established artists in there – Swedish House Mafia, Chemical Brothers, Noisia, DC Breaks, Boys Noize – but mainly it was me going out and finding them. Everybody has an opinion about the selection, of course, and it's partly my job to manage all of that, because otherwise it can get unwieldy. People on the *WipEout* team certainly had their ideas, and I did license two or three tracks based on that.

A lot of it comes down to budget. You don't want people playing a game for hours to be hearing the same track over and over again, but there are limitations, so it's a balancing act. I can't say specifically how much an artist costs, but there are tiers based on status. There were three levels of fee on *WipEout*, to allow us to get some big hitters but also embrace the new breed that was coming through. And it was worldwide, too: Australian artists, Dutch, American…We wanted a global feel for it.

The fee can be a relatively minor thing for some of the artists we speak to. If they're relatively new or left-field then a much bigger part can be the exposure, and the opportunity of being discovered in the right kind of game, and heard in the right context. It can be incredibly difficult to get on Radio 1 daytime, for example, so to get your music heard by a mainstream audience outside of niche gigs and clubs is an amazing opportunity – to have your music discovered from Kansas to St Petersburg to Reykjavik. A percentage of those people will love it. Games are a genuinely powerful vehicle for recognition these days.

● 50UND B4RR13R

Music became very disposable over the last 15 years or so, and it's become a lot more about 'sync', whether it's to films, TV, ads…It's about finding powerful ways to add value. Because we can be interactive in games, and have a captive audience that plays for 40 hours or whatever on average, that emotional connection is much stronger: the music is working its way deep into people's brains. It's a virtuous circle of being involved in the game and immersed in that experience.

Games do require some extra work, though, and additional approval. First of all, the artist needs to go and find the stems: the individual sounds and instruments involved in the song. If we're going to do the music interactively, those might need to be triggered at different times. Some people can't provide that, and others have to go back to the studio and dig them out. While it didn't happen with *WipEout Omega* at all, some people are also reluctant to hand those stems over, or to have their music remixed – 'messed with' – in any way. But most of the time people are positive about it.

I had Noisia's manager come in for *WipEout Omega*. We got the stems and remixed it in 5.1, and he was blown away.

This was a track he'd heard thousands of times, yet he was hearing things he'd never heard before. He said it reinvented it for him. And because this is electronic music, it makes that side of things very easy. It's not like I'm trying to get stems from Led Zeppelin. Also, it's such a famous franchise that people in the electronic music scene just want to be part of it. They have a great sound and a great attitude, and that energy is so important for this game.

■ Duncan Smith is the senior music supervisor at Sony Interactive Entertainment Europe / SIEE. He licenses commercial recordings and commissions bespoke music for PlayStation games and campaigns.

H3r0

→ L01c C0uth13r: 50n1c H3r0

The last thing you'd expect to be calling the 'unsung hero' of anything is audio design, yet here we are. Without memes or screenshots or numbers as impactful as framerates and pixel resolution, even the best sound struggles to be heard in today's online discussions. It's sad, really, because audio is so important to WipEout and received an incredible update in the lauded *WipEout Omega Collection*. Tasked with rebuilding an entire audio engine and soundscape in 7.1, in just four months, sound designer Loïc Couthier recalls facing challenges from every direction. →

You're always asked when working on a game to make it sound unique, and nobody wants to say something is not. But of course WipEout has its own identity – the curated soundtrack, the VO for the cockpit, the announcer, those few key effects – so a lot of my job was identifying which sounds a player might want me to keep, what could be better and what could be different. Much of the iconic soundscape was actually established in *WipEout HD*, which also added the high-pass filtering effect when you're moving, which works really well in this game. We re-did that completely for *WipEout Omega Collection*.

It's about giving the game the atmosphere it's always had, which is this futuristic, stylized world with very powerful ships. You want the player to be like a kid dreaming of having those ships, playing with them. Star Wars and Transformers are good references for that. There aren't many futuristic racing games to compare to; you have the likes of *F-Zero* and *Extreme-G*, but their soundscapes aren't even close in terms of how nicely everything flows.

● RUMBL3 4ND 5W4Y
The first WipEout had a very quiet jet noise for the ships, which is pretty safe from a sound design point of view, but kind of unrewarding as well. It's never really fun in itself but at least it doesn't make a mess. You have that problem a lot in racing games: the music is loud, the engines are loud, and it's very easy to have something where suddenly everything is loud. *Omega* is different from the first WipEout because we're absolutely full-power on engines, weapons and music, so it takes a lot of mixing to make that work.

It would sound very strange, for instance, if two of our ships made the exact same sound at the same time. You get those artefacts in real life, too, and every racing game has to make sure the engine noises aren't going to be phasing, which means playing on top of each other and having their signal mixed together. In real life, there are so many parameters to even two vehicles of the same model that it's unlikely they'd do the exact same thing, and part of the development process is deciding how much complexity you need to model to avoid it.

If we'd had more time, every single ship in *Omega* would have had its own sound. We didn't, though, so we just made it so every team has a sound. Another thing is that we made the sound of the engines super

connected to the engine physics, whereas what happened in previous WipEouts was that the engine would go from nothing to maximum in a couple of seconds and then stay there. Our system wasn't just a loop, more a sequence of fake gearing systems that took the angles, acceleration values, speed values, and some new parameters we added, so it could react to player input is as many ways as possible.

We did have quite a complex layering system for the engines, too. When you start accelerating, you have the sound of electric racing cars, which then mixes into fighter jet engines, and at maximum power it becomes rocket engines. Then you have a synthesizer layer on top – the character layer – which is different for each team. Designing that meant matching it to the team's identity. Qirex is a heavier and more menacing ship, so it's more like a futuristic zeppelin engine; FEISAR and AG Systems are more agile, so it's more of a Formula 1 feel.

In movies they do this trick of using layers from many different things. Animals are a big one because you can get tonal sounds that have a special character to them. The TIE Fighters in Star Wars make the sound of a baby elephant crying, which is an organic sound they've moved out of its normal spectrum. But the guys working on *Star Wars: Battlefront* struggled a lot, I believe, to get that working in a game environment, where it can be playing for ten hours and subject to player control. So, we didn't have time to go that crazy.

● Y0U 5URR0UND M3
A lot of the sounds in WipEout are already very tonal because it's a sci-fi game, and that matters for player feedback. If a sound has lots of character then you're able to tell what it is, even when it's behind you or off-screen, and that helps players understand the battlefield, you might say. *WipEout HD* was in 5.1 on PS3, but even then the mix was very fake, with a lot of positions placed in a static way: 'That sound is only going to be placed on the right speaker, or the left.' It was a very 2D way of doing things, and we changed that completely in *Omega* so it would pan correctly in surround.

You have this notion with surround of the player looking at the screen, so there's an orientation for the soundfield. The music in *Omega* was mixed in 7.1, and the game is panning stems dynamically in the surround field depending on speaker setup. But you'd never have drums anywhere but at the front; everything bass-heavy comes

from front speakers or the sub. We did have some light percussion from the back just to increase the range in surround, but nothing high-energy would normally come from behind. You want it to feel enveloping, not distracting.

Even in a cinema, you never have something big happening in audio outside of the screen, because it's just confusion for the audience. If something's coming towards you and is then suddenly behind you, that's fine because the audience understands why. But the experience must always be disciplined, especially now, with formats like Dolby Atmos, where all the speakers are full-spectrum, meaning the same power.

That process of just making sounds come from the right positions produces an awful lot of bugs, and a lot of things you'd never really catch if you weren't playing in 7.1 or VR. A lot of them in WipEout are musical, in that you can't have the music drawing your attention to the wrong places and things. But the most important thing is to just make a more satisfying musical experience. Then you discover how cool it is to have phrases in tracks by Noisia, for example, where it feels like one sound is replying to another, from front to back. This is the only place in the world where you can have those tracks in surround.

My original plan for *WipEout Omega Collection* was for a year-and-a-half, but in the end we only had four months to work on the audio. The game didn't have a long development phase, so what you're hearing is just the best bits of something much bigger. If a new WipEout ever came along, we'd have a lot more in mind.

■ Loïc Couthier is the supervising sound designer at the Creative Services Group of PlayStation Europe. His credits include *WipEout Omega Collection* and *Returnal*.

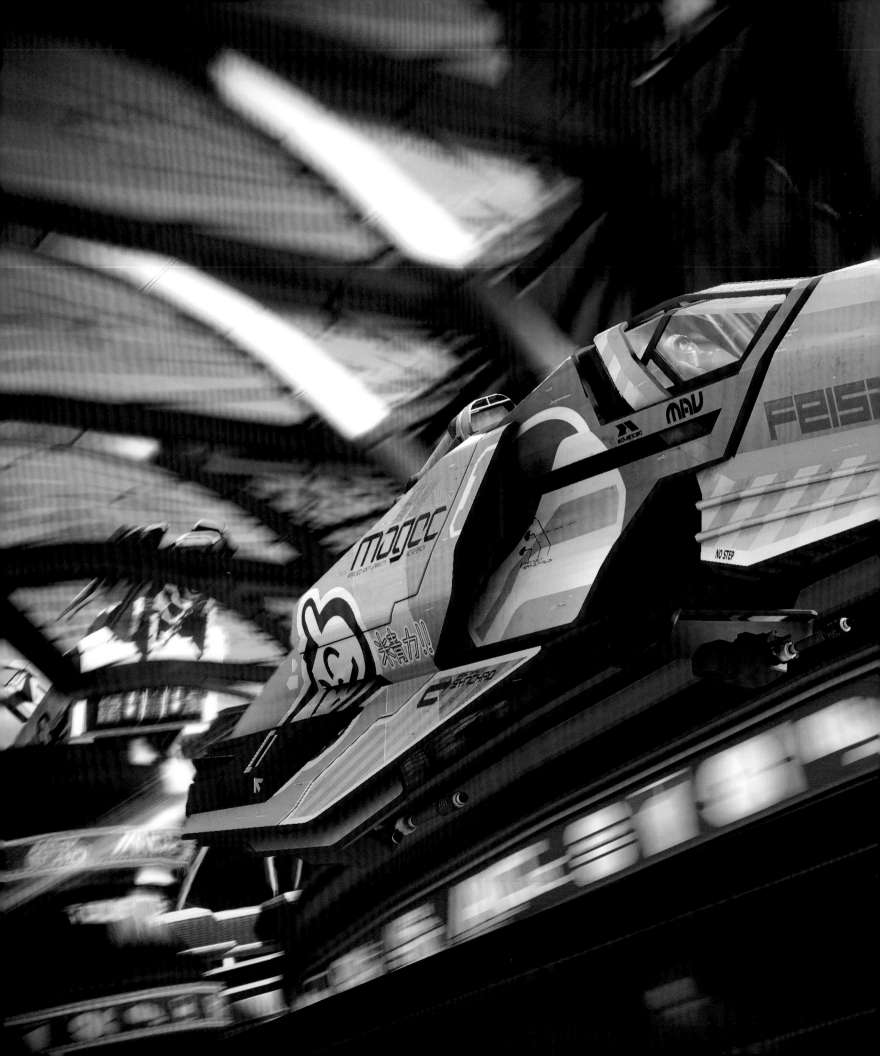

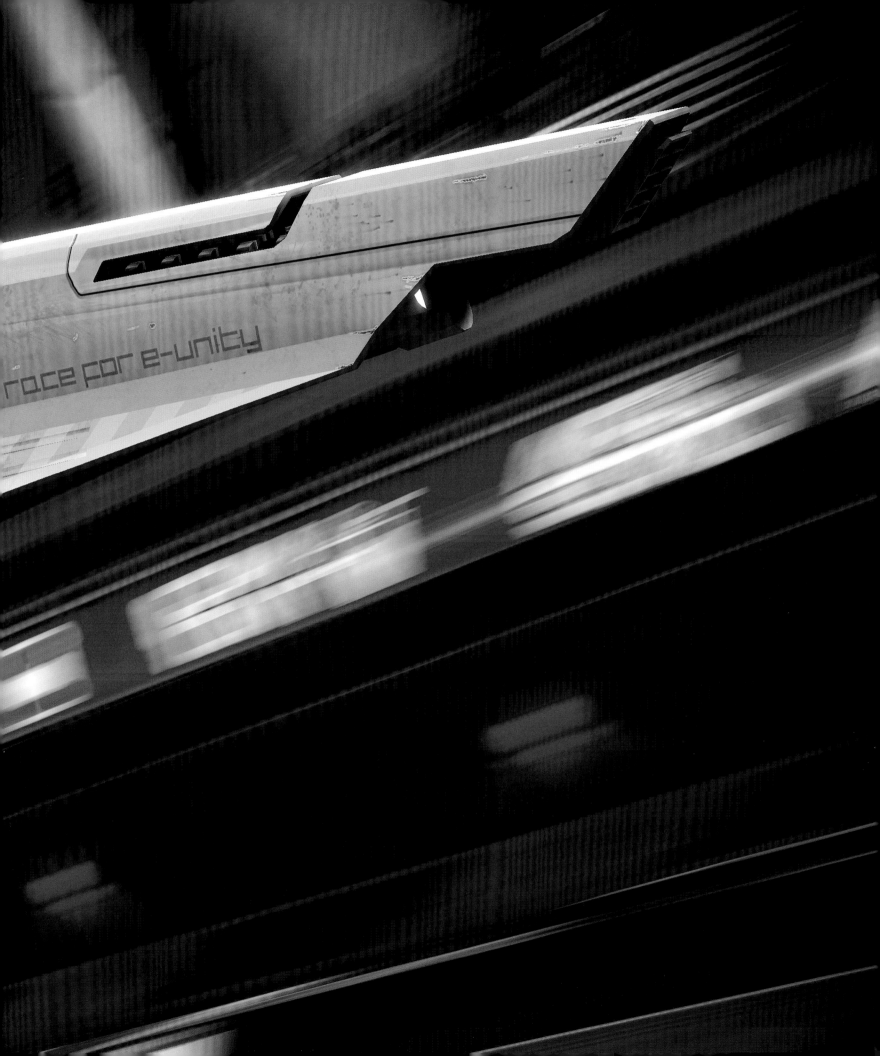

race for e-unity

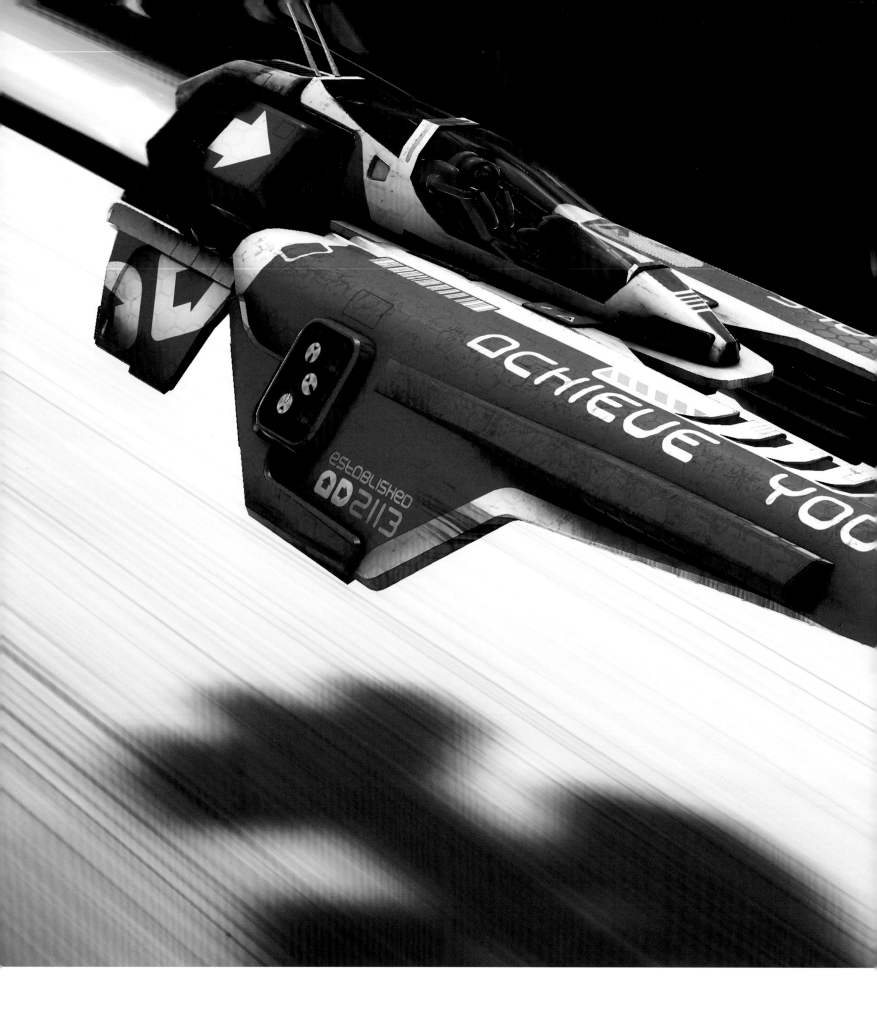

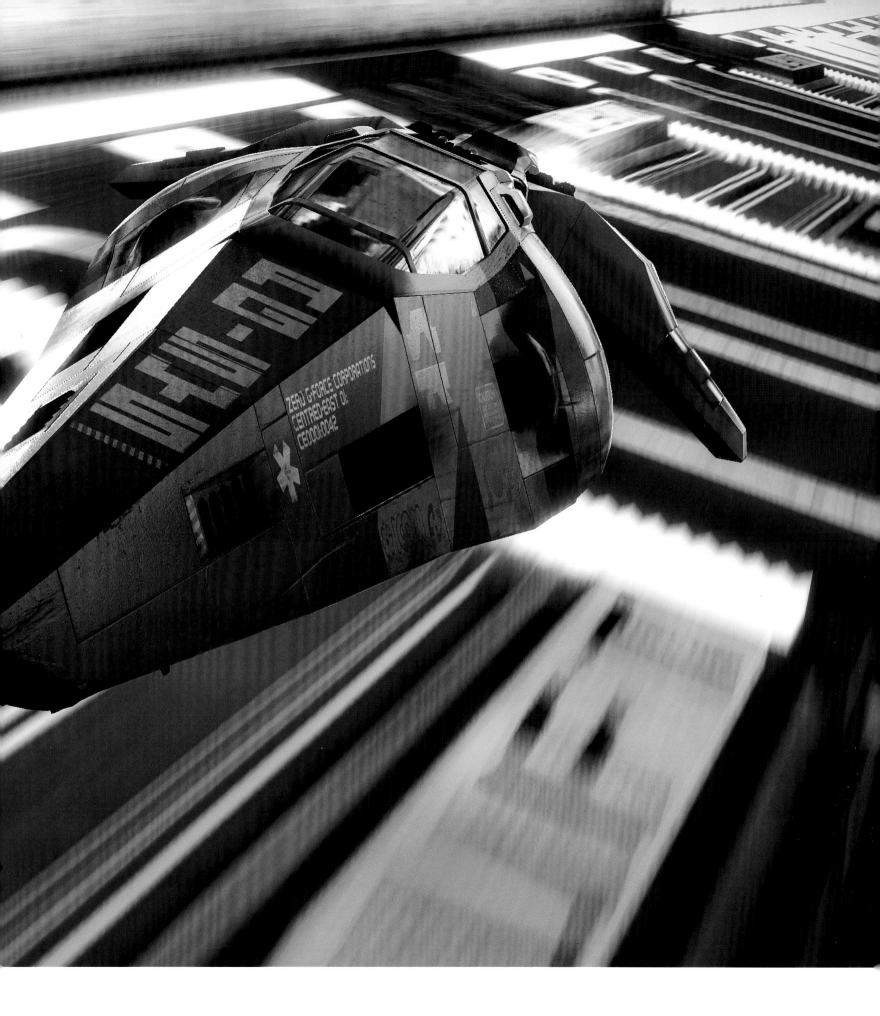

The text on the spacecraft reads:

ZERO G-FORCE CORPORATIONS
CENTRED-EAST 0t
CE000L0042

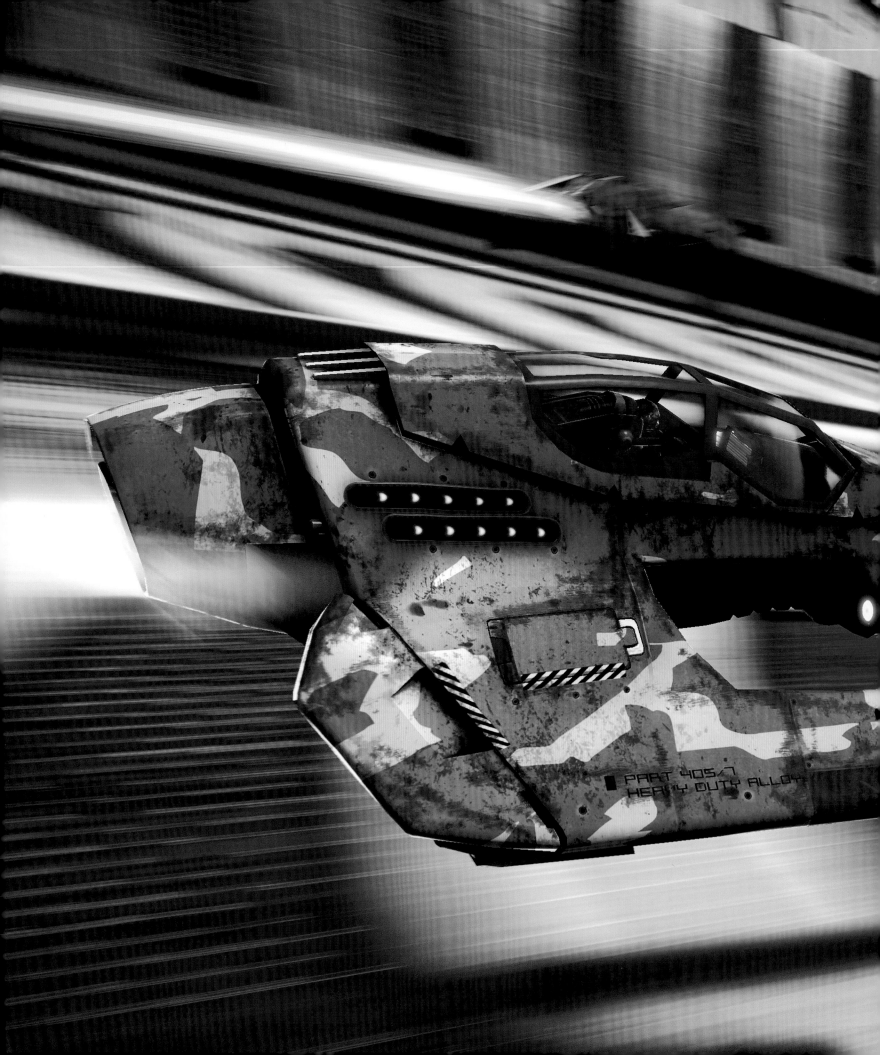

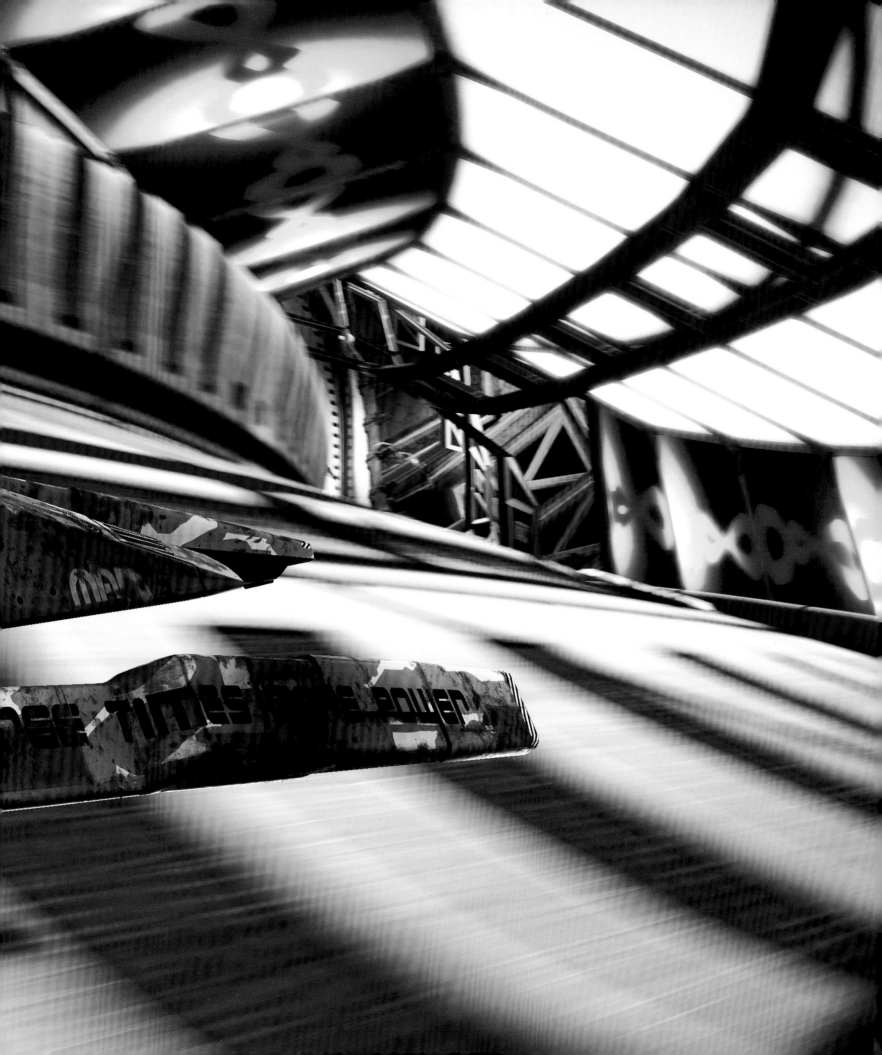

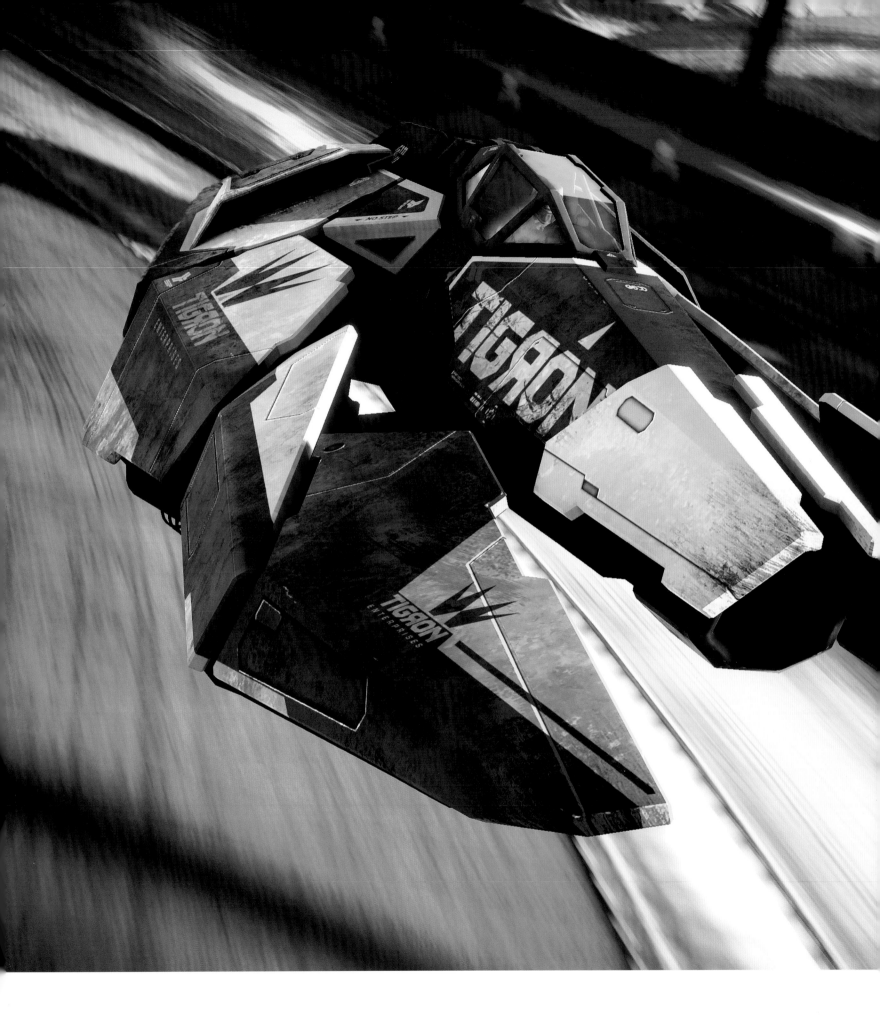

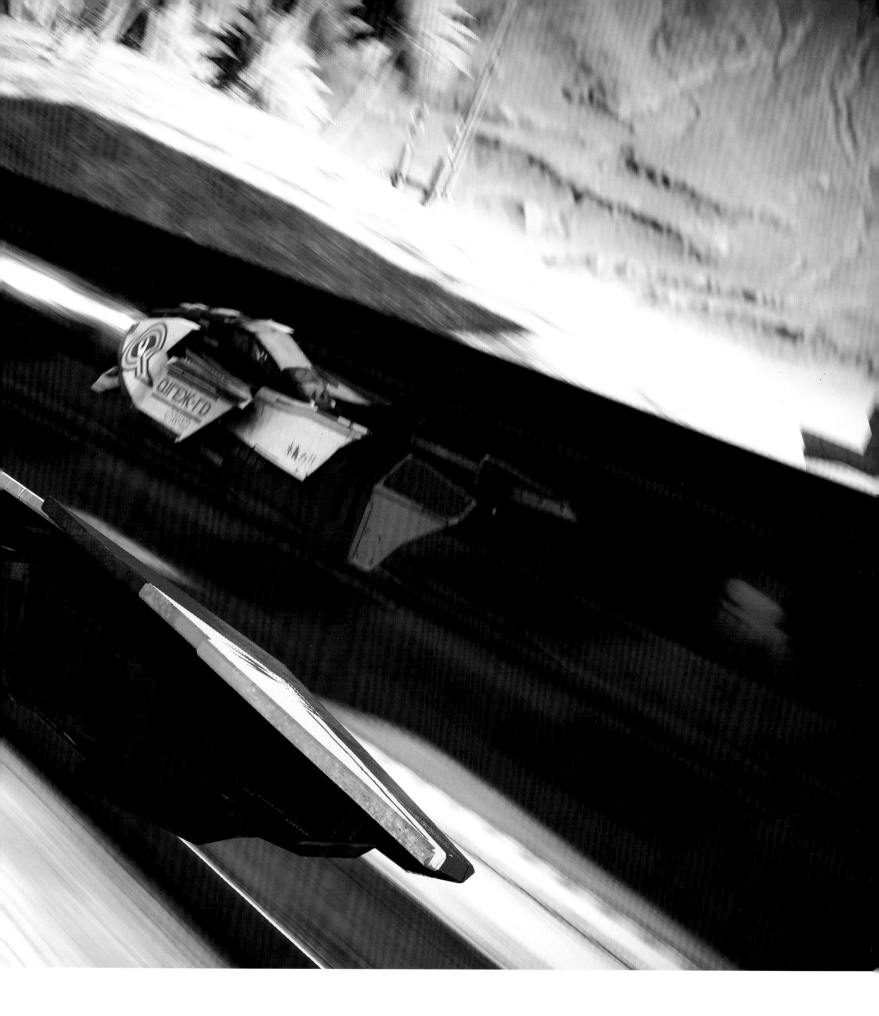

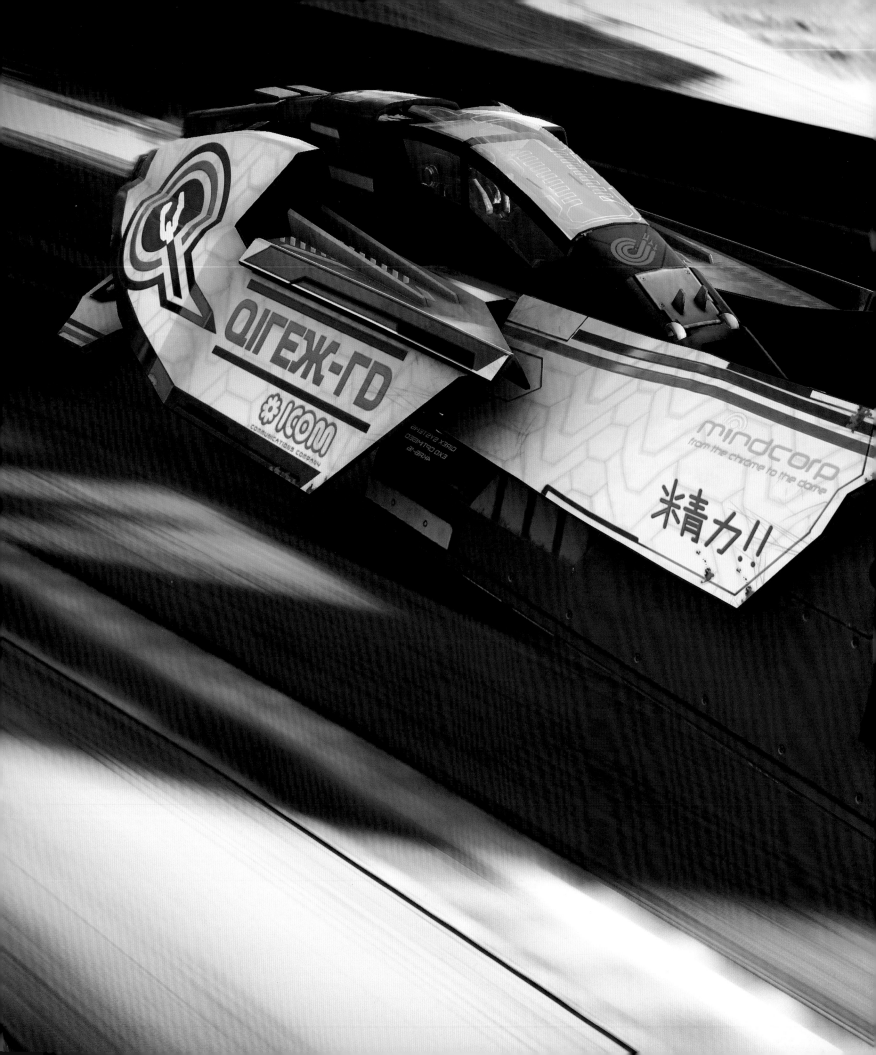

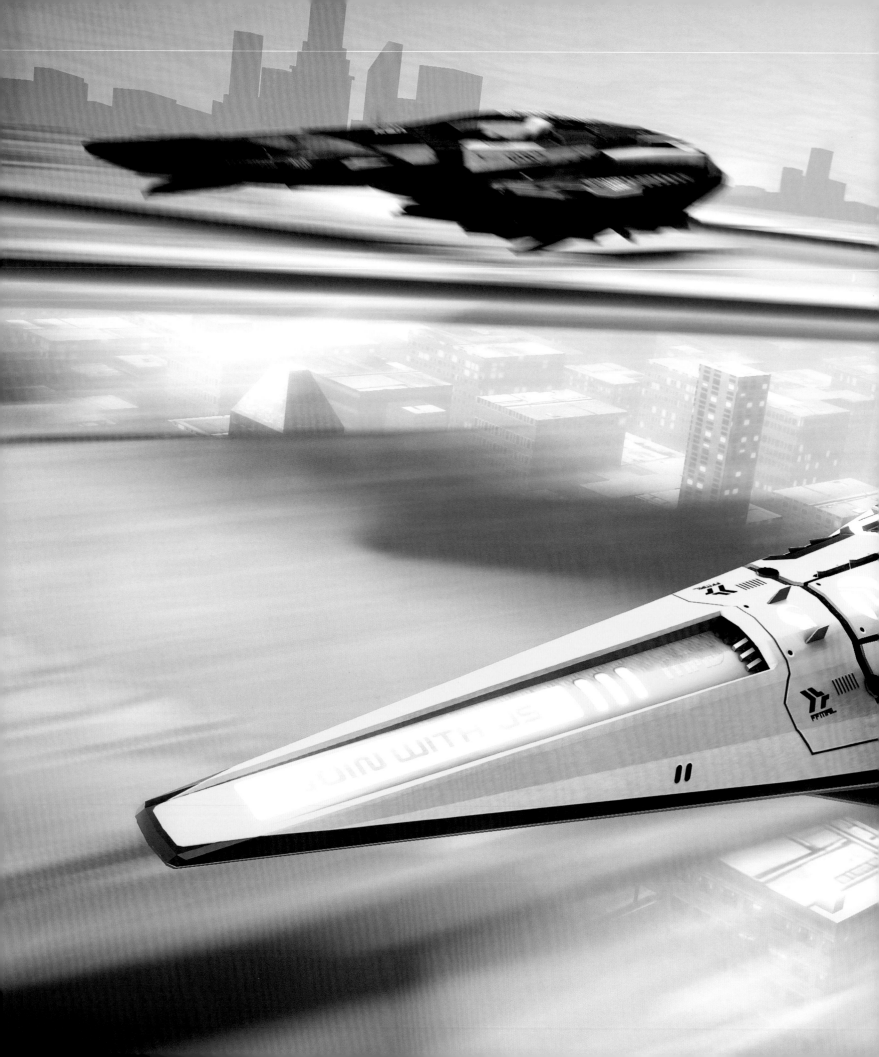

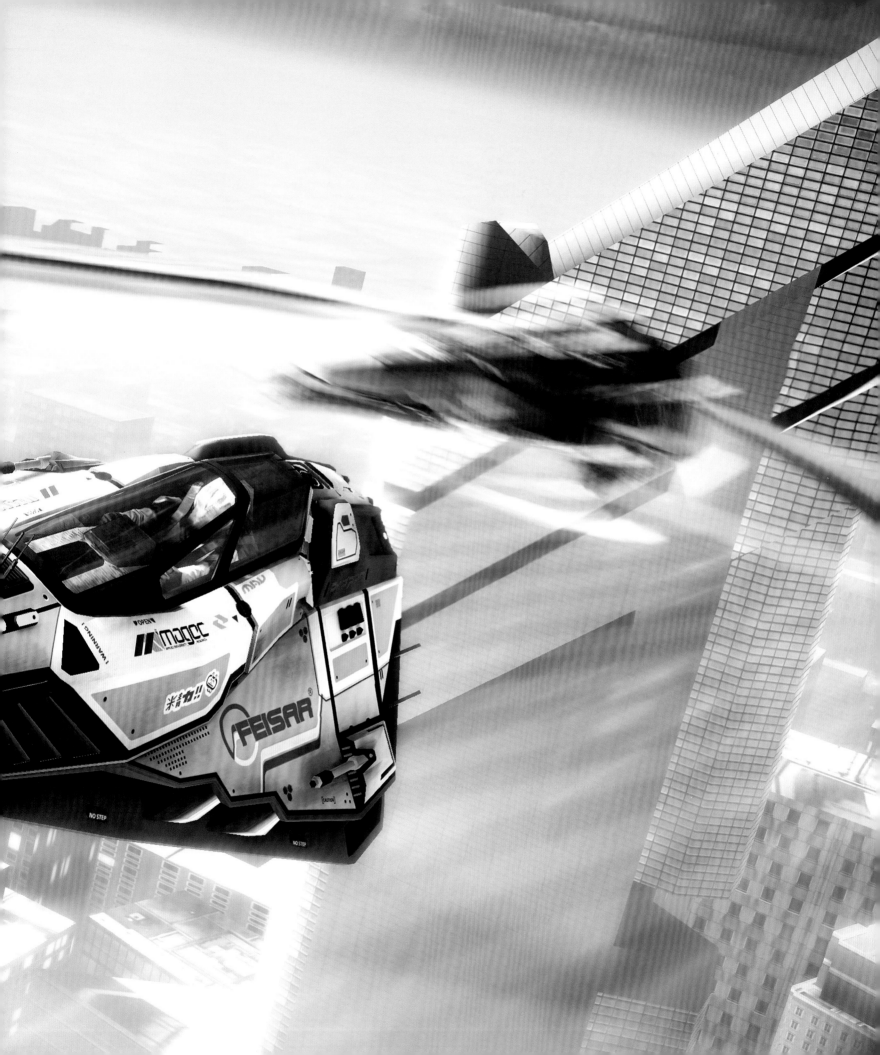

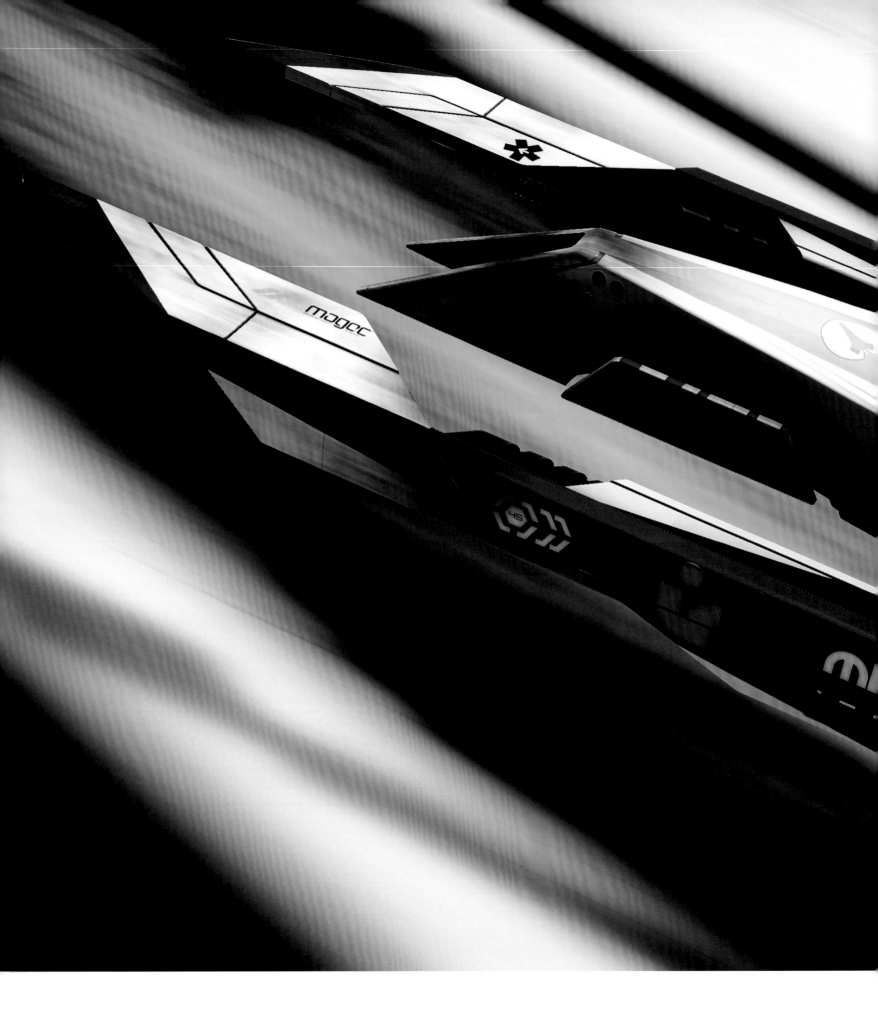

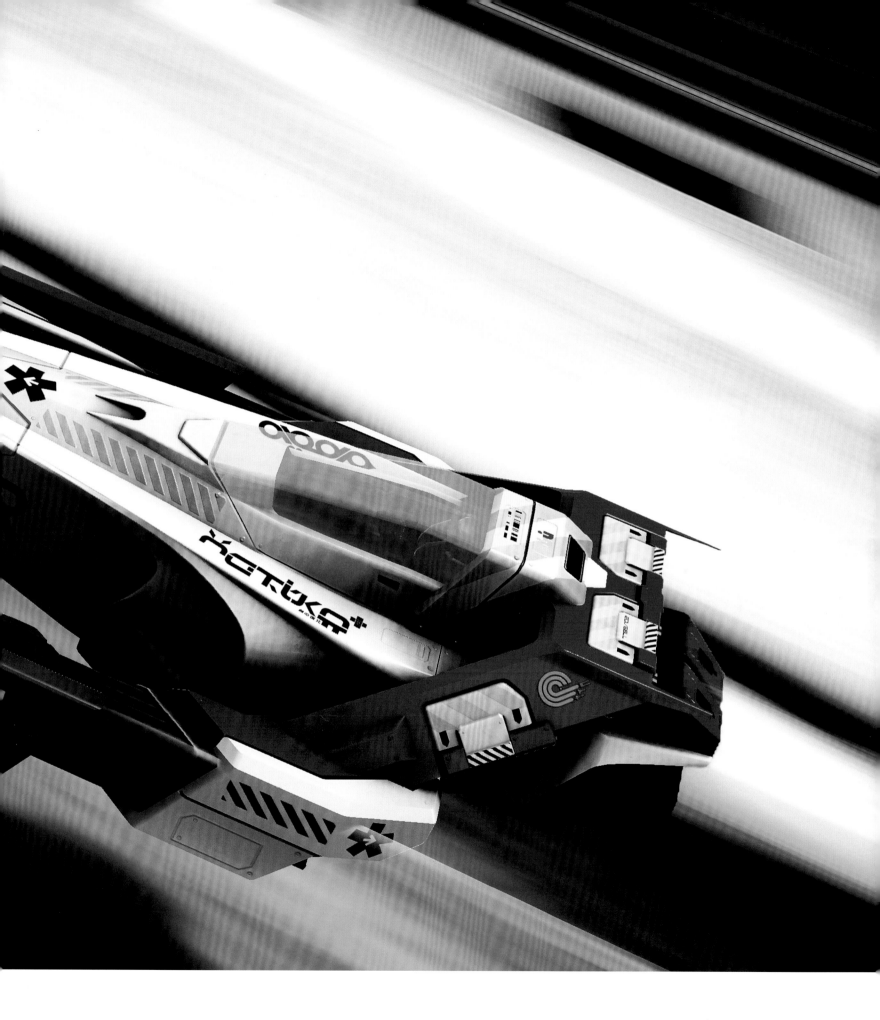

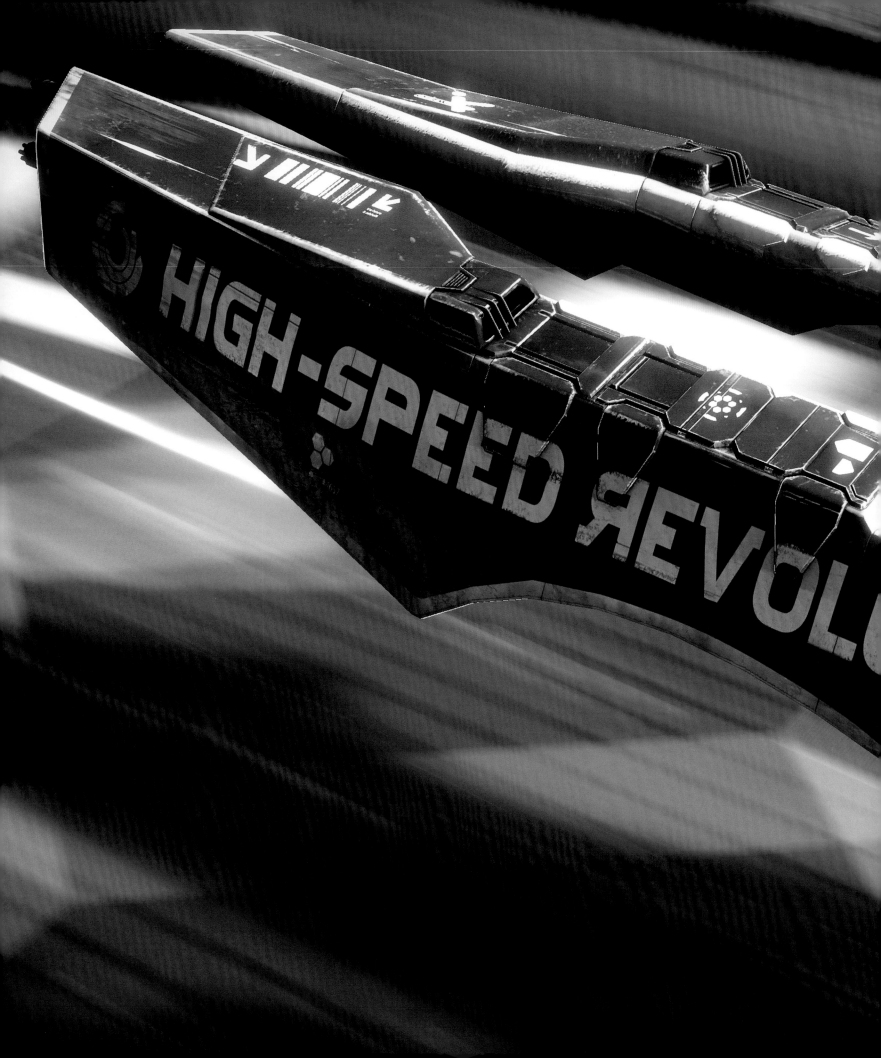

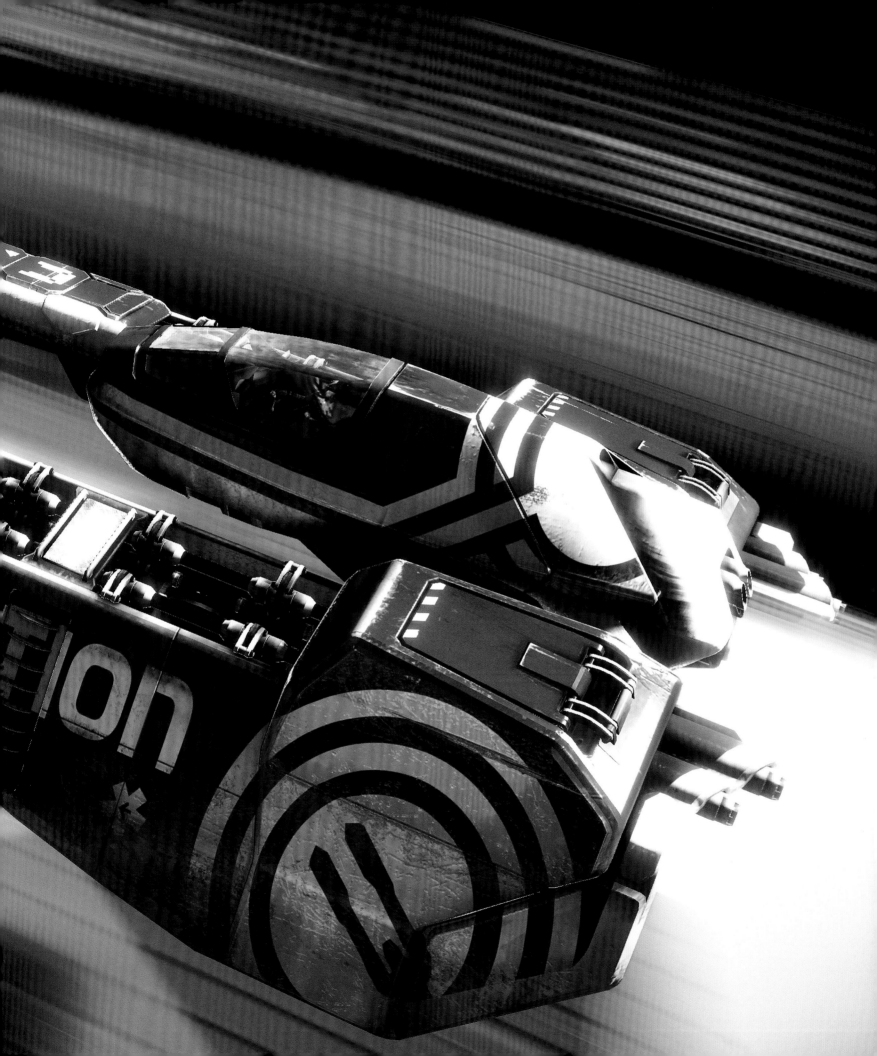

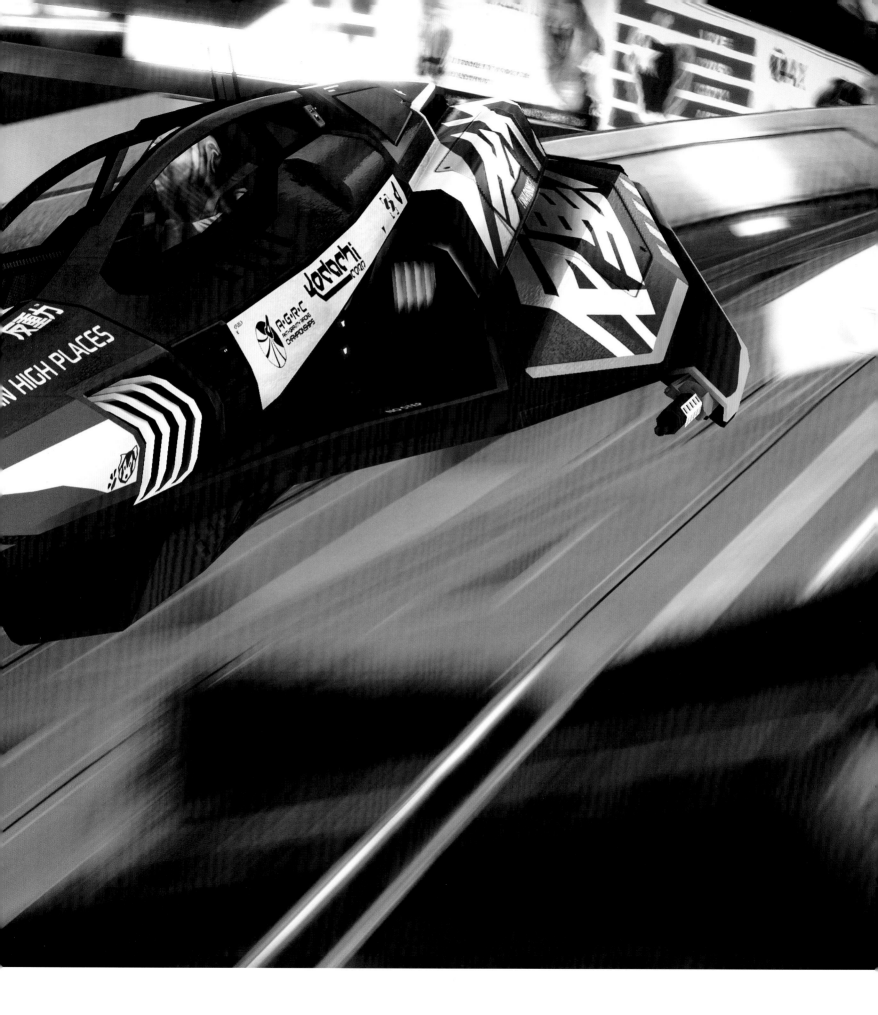

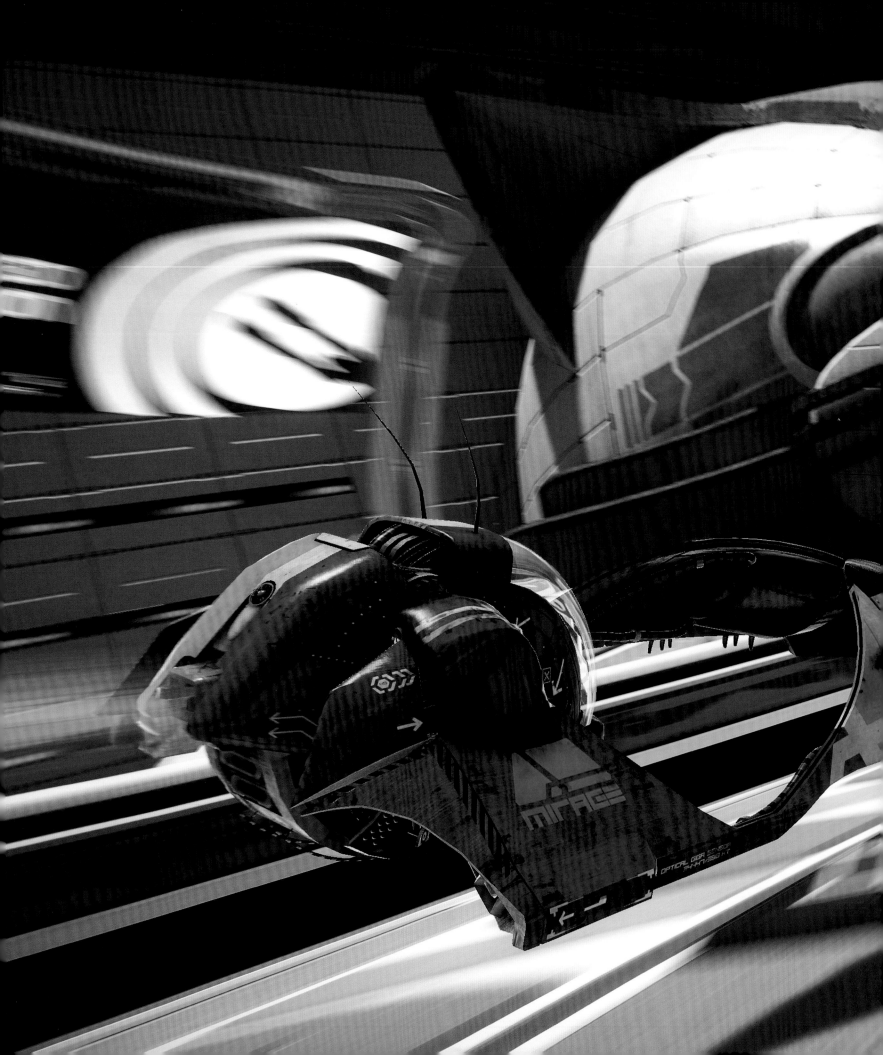

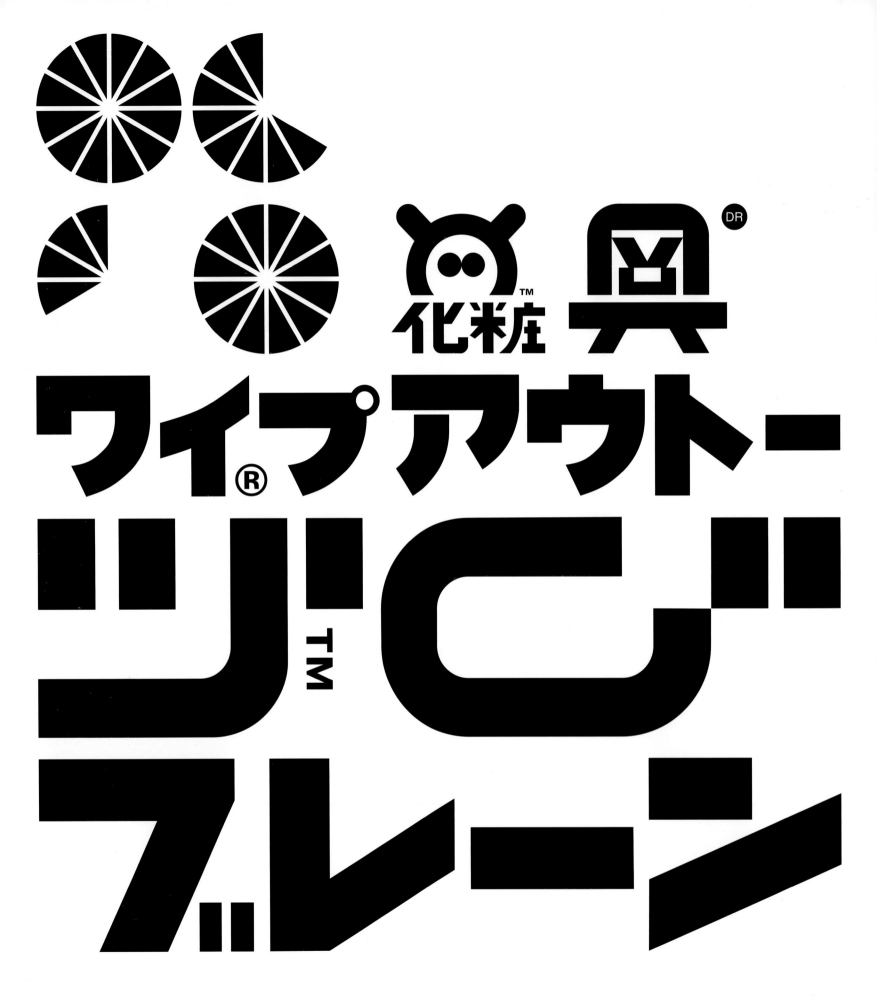

Special thanks: John Mclaughlin,
Damon Fairclough, Nick Burcombe,
Karl Jones, Clemens Wangerin,
Darren Douglas, Edd Wainwright,
Xavier Guinchard, Dominic Szablewski,
Kiyonori Muroga, Paul Whitaker

In memory of: Colin Fawcett,
Ian Hetherington and David Lawson

This edition published in the United
Kingdom in 2024 by Thames & Hudson Ltd,
181A High Holborn, London WC1V 7QX

First published in the United States
of America in 2024 by Thames & Hudson
Inc., 500 Fifth Avenue, New York,
New York, 10110

WipEout: Futurism
The Graphic Archives © 2024
Thames & Hudson Ltd, London

Text by Duncan Harris © 2024
Thames & Hudson Ltd, London
Art Direction: Studio.Build

British Library Cataloguing-in-
Publication Data
A catalogue record for this book
is available from the British Library

ISBN 978-0-500-02176-7

Library of Congress Control Number
2024935916

Printed and bound in China by
Artron Art (Group) Co., Ltd.

Duncan Harris is a screen capture artist
for videogames, with over a decade of
game industry experience. He has created
official in-game imagery for titles such
as *Tomb Raider*, *Hitman*, *Crysis*, *Minecraft*,
EVE Online and *The Evil Within*. His clients
include EA, PlayStation, Crytek, the V&A
and many more.

Ian Anderson studied Philosophy at The
University of Sheffield (1979–1982), but as
a designer he is self-taught. He declared
The Designers Republic on Bastille Day 1986
in Sheffield (which he dubbed SoYo™ North
of Nowhere™). In 25 years Ian has lectured
to over 70,000 people around the world,
had over 25 'solo' TDR exhibitions, launched
The People's Bureau For Consumer
Information and The Pho-ku Corporation.

4NGRY-M4N™ 54Y5
SC4N M3!